DISCARDED
MISSING
REJECTED
ATTACKED
DESTROYED
ERASED
EPHEMERAL
TRANSIENT
UNREALISED
STOLEN

First published 2013 by order of
the Tate Trustees by Tate Publishing,
a division of Tate Enterprises Ltd,
Millbank, London SW1P 4RG

www.tate.org.uk/publishing

A catalogue record for this book is
available from the British Library.

ISBN 978 1 84976 140 6

Designed by
The Studio of Williamson Curran
based on *The Gallery of Lost Art*
website, designed by ISO

Colour reproduction by
DL Imaging Ltd, London

Printed in China by
Toppan Leefung Printing Ltd

Measurements of artworks are given
in centimetres, height before width.

————

MIX
Paper from
responsible sources
FSC® C104723

Jennifer Mundy

LOST
ART

MISSING ARTWORKS OF THE TWENTIETH CENTURY

Tate Publishing

Preface

This book originates from an award-winning online exhibition that sought to explore the potential of the digital realm to bring back to life artworks that no longer exist – not through virtual replicas but through the stories that surround them. Set visually in a warehouse-like space through which the visitor could wander at will, *The Gallery of Lost Art* presented these stories through documents and films laid out on different tables (or, when the scale of the missing work warranted it, on the floor). Alongside these materials were captions, sound clips and links to other resources. The virtual space thus offered the visitor a place for engagement, private study and reflection. Digital images were transformed into likenesses of research material of the sort that might have been accumulated by someone investigating what had happened to the missing artworks. Photographs and computer printouts were shown slightly crumpled or mounted on dog-eared paper; press cuttings were arranged casually spread out or stacked in untidy piles; and throughout the site were signs of research under way: people bent over the various tables, card files and folders with bulldog clips and yellow Post-It notes, and open laptops (a home for the project's commissioned films). The invitation to new visitors to join these researchers as they studied documents and read associated texts, or while they listened to audio tracks and viewed films about the missing works, was clear.

Although the online exhibition presented itself as a site for restoring to consciousness particular examples of modern art that had been lost, the project also explored the subject of cultural loss more generally. The conventional ways in which artworks can be lost – fire, war, attacks and neglect, for example – were all examined. But loss was also seen as varied in nature: both temporary (in the case of stolen works) and permanent; intentional as well as accidental; and the result of deliberate decisions made by artists and not just of events beyond their control. Loss was seen as matter of deep regret, but also sometimes as a source of creativity, with damaged or destroyed works taking on a second life as 'relics' or documents of their existence that inspired artists to create new art. Some of the works featured were well known in part because they were lost, though most were at risk of being forgotten.

Museums such as Tate normally tell stories through the objects they have in their collections. This project posed the challenge of focusing on works that a museum could never own – they were after all destroyed, or missing, or even, in two cases, never completed – but that are nonetheless part of the narratives that such institutions, with their aim of presenting the different histories of modern and contemporary art, could and arguably should tell. The website, which lasted, rather fittingly, for just one year (July 2012 – June 2013) before becoming 'lost'

itself, was one response to the challenge; this book, with its expanded narratives about forty individual case studies is another.

Art history tends to be the history of what has survived. The business of examining, interpreting and appreciating the artworks that currently exist might appear sufficient for most people. But a glance into the vast realm of works that have not been preserved – and this volume covers only a tiny sample even within the limited field of twentieth-century art – reveals that loss has often had an influence on our understanding of that history. Furthermore, through our acceptance of transience as a valid and meaningful aspect of contemporary art, loss has developed into a central feature of art practice today, with consequences for the future history of our culture that we have perhaps yet to fully appreciate.

_ _ _ _

Introduction

The idea of lost art is familiar to us in relation to the art of distant times. Fires, earthquakes, wars and the ravages of climate have for millennia caused huge destruction and robbed us of the artistic production of entire societies. Looting, theft, iconoclasm, neglect and sheer bad luck have also taken their toll. Predictably, the further back in time one goes, the more the losses can be total, leaving irreparable gaps in the historical record. For example, we know of the achievements of the ancient Greek painter Apelles only through ancient texts: none of his paintings has survived. Similarly, the works of almost all ancient Greek sculptors – including those of Praxiteles, reputedly the first to carve a life-size model of a female nude – were lost within a few centuries and are known to history only through later Roman copies (and these have themselves been subject to destruction on a vast scale).

Moving nearer to our own times, proportionally more works have survived, preserved by a burgeoning art market and the growth of private and public collections. But they, too, have been subject to seemingly arbitrary forces of violence and neglect. Leonardo da Vinci's largest painting, *The Battle of Anghiari* 1505 (unfinished and covered over); Hans Holbein's iconic mural of Henry VIII and his family 1537 (destroyed in a fire in 1698); Caravaggio's *Nativity with St Francis and St Lawrence* 1609 (stolen in 1969, reportedly by the Sicilian mafia); William Hogarth's suite of six paintings called *A Harlot's Progress* 1731 (burnt in 1755); and Ingres's major undertaking *Apotheosis of Napoleon I* 1853 (destroyed during the insurrection of the Paris Commune 1871) – these are just a few of the more famous major works of art that have been lost in recent centuries. The total number of lost works, including those by minor or anonymous artists, is, quite simply, incalculable.

Loss, however, is a far less familiar concept in relation to art made in our own lifetime or that of our parents and grandparents. Many of us assume that modern and contemporary works are somehow immune to the disasters visited upon earlier art. Just as we expect children to outlive their parents, we tend to assume that most artworks will exist long after their makers have gone, and it feels surprising or quite simply 'wrong' at some level when this is not the case. The growth of great public museums around the world and the development of ever more sophisticated security systems encourage us to assume that artworks everywhere have become safer. At the same time, the increasingly public and lucrative nature of the art market and the proliferation of information sources (photographs, exhibition catalogues, newspapers and now the internet) make it seem less likely that works made relatively recently could ever simply go missing or disappear without trace. In other words, we tend to be particularly shocked by stories of the loss of modern and contemporary works.

In fact, as this book seeks to show, recent art is just as susceptible to loss as that of earlier centuries. Neither avant-garde daring nor the use of modern materials has proved a defence against the onslaughts of man-made and natural disasters. Fires may be fewer but they have been as devastating in modern times as they have been through history. War and its modern variant, acts of terrorism, have wreaked indiscriminate damage, destroying both artworks and the records of their existence. In any survey of lost works of art in the modern era, the Second World War in Europe stands out as a particularly dark period of cultural loss, involving both the destruction and the confused dispersal of hundreds of thousands of artworks, many of which are described to this day as 'missing, location unknown'. More recently, the attacks on the Twin Towers in New York in 2001 led to the destruction of several thousands of artworks, artefacts, photographs and archival items stored or displayed in the complex (the exact figure of destroyed artworks is not known but estimates put their combined value at $100 million).

Similarly, art in the twentieth century, as in earlier times, has been a target for ideologues seeking to impose their beliefs and values. The Nazis' vilification of modernist art in Germany in the 1930s, which saw thousands of artworks destroyed, artists prevented from working, and they and their supporters imprisoned or killed, may have been exceptional in its ruthlessness, scale and ideological underpinnings, but other authoritarian regimes in countries around the world, in recent as in distant times, have been similarly single-minded in their suppression of art that they considered objectionable. Changes of regimes can also lead to a quiet – or in the cases of the toppling of statues of past leaders a very public and newsworthy – culling of art favoured by previous governments.

Even in societies that pride themselves on their defence of freedom of expression, there are, and always have been, cases where limits – notably moral or political – are imposed and works are censored, removed from the public realm or even destroyed. These instances may be relatively infrequent but when they concern avant-garde art they typically generate an outpouring of protest from those who see artists' freedom to dissent from cultural and societal norms as a fundamental characteristic of a civilised society. But these cases can also be complicated, ethically as well as legally. The story of the removal of Richard Serra's massive sculpture *Tilted Arc* 1981 from outside a government building in New York illustrates the difficulties involved in reconciling the rights of the various parties in the dispute – the artist, the art community, the owners, the broader public and future generations – against a confused backdrop of personal and political conflicts. This bitterly fought case, in fact, helped pave the way in the United States towards legal recognition of artists' continuing 'moral rights' in works that are still in copyright and owned by others, offering grounds for defence against derogatory treatment or mutilation of listed artworks or works of 'recognised stature'. But it also posed the intriguing question of when it might be right not to preserve a work of art.

As objects of often considerable value, artworks have been subject to contract and property law, and historically – that is, up to the legal protection afforded artists' 'moral rights' in recent decades – it was generally accepted that, ultimately, owners could assert their right to do whatever they please with the works they owned. But as shown by the public protests surrounding the destruction of Diego Rivera's mural for the Rockefeller Center in 1933, or the general disquiet over Lady Churchill's later destruction of the official portrait of Winston Churchill by Graham Sutherland, the idea of treating art simply as property has long seemed inadequate. While fruitlessly protesting against the destruction of his mural by the Rockefeller family who had commissioned and paid for the work, Rivera spoke for many artists when he denied the relevance of property law in his case, which saw his patrons stop him from completing the mural and later destroying what he had done. It was a moral, rather than a legal, issue, he claimed, saying, 'They have violated two fundamental elementary rights, the right of the artist to create, to express himself, and the right to receive the judgement of the world, of posterity.'

Rivera pointed here to the power of art to give expression to the thoughts and feelings of an individual, and, later, to embody something important about whole cultures and the identity of groups of people. Major artworks can serve as 'memory-objects', forming connections between people, their experiences and values, their past and the future, in ways that many feel go beyond the rights of specific individuals, whatever the law may say. The world need not mourn all lost artworks, of course, but among the forty discussed in this book there are at least some that, if they had survived, might have represented a distinctive idea and expression of not just an individual but also of a society and a period that would have been valued by later generations and might have acted as a continuing source of inspiration for others. (In some cases, though, it was in part because they were lost shortly after they were made that several of the artworks studied here became famous and influential, albeit always at risk of being overlooked or completely forgotten at some point in the future.)

Artists themselves are often agents of loss. In the course of the creative process they frequently get rid of or erase preliminary work, which in hindsight might have been as important, or even more important, than works they chose to keep. In the early 1910s Georges Braque seems to have been the first to make cubist constructions, but seeing them just as experiments, he did not bother to keep them: only one photograph and some oblique references in letters remain as evidence of his innovation, which was adopted by his friend Pablo Picasso, who is now generally seen as the father of cubist sculpture. Similarly, Marcel Duchamp's *Fountain* – a shop-bought urinal exhibited as a work of art in 1917 – has become one of the most famous works of modern art but, at the time, neither the artist nor those around him thought it worth going out of their way to keep it. It was somehow mislaid or discarded almost immediately, and we know it today largely through a single photograph and later replicas.

Inadvertently, artists may also use materials that prove short-lived. In the interwar years the Russian constructivist sculptor Naum Gabo was cruelly deceived by a certain type of clear plastic that he thought had the longevity as well as the visual appeal of other industrially produced materials. More recently, artists using technologies that at the time seemed new and therefore exciting to use have had to come to terms with the fast pace of obsolescence in the late twentieth century: works that are only a few decades or even a few years old become defunct and therefore lost if parts cannot be replaced or old technologies be made to work. Paradoxically, perhaps, no field is more prone to rapid obsolescence than that of computer-based art.

Artists also frequently edit their own works, repainting and even destroying them, whether as part of the creative process or to shape their legacy. Francis Bacon would slash and break up paintings he considered failures, although he was reported to have regretted some of his decisions. Later artists used loss as the very subject of their work: a young Robert Rauschenberg famously erased a drawing by Willem de Kooning, and John Baldessari designated the cremation of his own early paintings a work of art.

In the wake of such challenging works, loss has become a well-established theme, stratagem and even a precondition of art-making in some quarters in the later twentieth century. This shift away from the production of durable objects was perhaps a logical extension of the questioning of the nature of art that can be traced back to the late nineteenth century. Do paintings have to depict uplifting subjects within a convincingly illusionistic space? The impressionists and post-impressionists said not. Does art, in fact, need to look like anything known? Generations of abstract artists have created art that does not depend upon resemblance for conveying meaning. Does it even need to lead to the making of actual objects, and do these need to be durable? Influenced, perhaps, by a sense of the fragility of life engendered by the Second World War and the Cold War, and reacting strongly against the commercialism of the art world and what they saw as the ossifying effects of art museums that tended then to collect only art that 'had stood the test of time', individuals in the middle and later years of the twentieth century felt no longer obliged to make durable works in order to define themselves as artists or to have a successful career.

Today art may or may not take material form. An artwork may, for example, be an action that has not been recorded or even witnessed by anyone. Performance and installation art place a new premium on the experience and involvement of the viewer, which of course can vary or change. The artwork can become, either wholly or in part, an event, one that can perhaps be repeated but does not exist as a functioning work between enactments (though it may continue to exist as a legal entity). The survival of knowledge about such a piece – if indeed this is an aim of the artist – depends on the adequacy and physical longevity of its documentation.

Works that have short lives can of course be extraordinarily powerful,

whether a bemusing half-hour performance by Jean Tinguely's machine *Homage to New York*, or Christo and Jeanne-Claude's breathtaking *Wrapped Reichstag*, which took nearly a quarter of a century to prepare and lasted a fortnight ('non-permanent art will be missed', the artists memorably said). Some artists allow their short-lived artworks to take on an expanded or second life through selling parts, associated works or documentation relating to the original piece. Others choose to focus entirely on the immediate impact their works make on the senses of viewers. In 1999 writer and curator Ralph Rugoff wrote memorably about a chocolate-covered wall by the British artist Anya Gallaccio:

> images cannot convey the complex and varied sensations that arise from encountering the actual work. They fail to capture what engages and interests us in that encounter – the emotional and sensory responses triggered by the work's material attributes, and our own active role unfolding and engineering her art's latent narratives. A picture of a brown wall is virtually meaningless compared to the personal confrontation which might very well end with one of us stroking and licking its chocolate-coated surface.

As Rugoff points out, documents cannot tell us all we would want to know about an artwork: we have to use our imaginations. But for many pieces that were famous in their time, it will only be through documents – including ones not selected by the artist (for example, press reports or viewers' photographs and accounts) – that they will stand a chance of being known in the future.

Given the public indifference and hostility that modern and contemporary art aroused over much of the twentieth century, many people might perhaps not regret the fact that large numbers of modern and contemporary works will not last or, in the absence of the works themselves, be understood or easily remembered by later generations. Artists themselves can be similarly sanguine about impermanence. Confronting her own mortality as a result of her brain tumour, artist Eva Hesse commented in the last few months of her life, 'Life doesn't last; art doesn't last. It doesn't matter.' This is perhaps an extreme view, but many artists feel that the world has enough objects already and do not see the need to add to their number or even to strive to leave a legacy. The 'here and now' is sufficient.

Regardless of whether a work has been lost accidentally or intentionally, however, people wanting to find out about it will look for evidence, sometimes in unlikely places, in order to begin to answer basic questions: what did it look like, what did it feel like to see it, how did it come about, what happened to it, and what impact on others, if any, did it have? And they must use imagination to begin to re-create the work in their minds and to understand its fate, all the while knowing that any such mental reconstructions will be partial and unsatisfactory. Without the anchoring element of a surviving object, lost art slips from the realm of art and aesthetic judgements to that of history and the various stories

that can be constructed on the basis of testimonies and surviving documents.

Nowadays, works that are not documented or recorded in some publicly shared manner may still evade discovery, but the task of researching lost works has been made immeasurably easier by the development of the internet and powerful search engines. These are tools that may offer the best chance for art-works lost in the modern era to be researched and to live as part of the historical record in the future. Whereas the work of researching personal and public papers was and can still be enormously time-consuming and require specialists to travel to sometimes distant libraries and archives, the trend for individuals and organisations to publish materials online allows not only information to be accessed more easily but also new connections between different types of information to be made. Visual materials – historical photographs and films in particular – are now more easily discovered than a few decades ago, while the internet also allows for the possibility of retrieving personal reminiscences and interrogating evidence rarely available to art historians working on earlier periods.

To date, however, very little attention has been paid to loss in the field of modern and contemporary art. Individuals and organisations involved in an unexpected loss often wish to draw a veil over things for personal, legal or financial reasons; and where major theft is concerned a blanket of silence quickly falls, sometimes never to be lifted, in the hope of not prejudicing negotiations for the work's return or dealings with insurance companies. With catastrophic events involving the loss of human life, the fate of cultural objects quickly pales into insignificance, and survivors become resigned to the loss of even cherished artworks. For their part, art museums tend to focus on the works they can display rather than present immaterial histories. With their strong institutional drive to preserve objects, they are also typically reluctant to draw attention to works lost within their own collections – although there would be no departments of conservation if there were not also an ever-present risk of degradation and loss.

Within the scholarly realm, art historians similarly tend to focus on what exists, not what has disappeared. This is in part because of the understandable difficulty of describing confidently what can no longer be seen and in discussing ideas for which the crucial piece of evidence – the work itself – is missing, and because the circumstances of the losses are often shrouded in some mystery. Somehow, too, the pathos associated with loss – the question of what might have been – feels not entirely compatible with the generally upbeat narratives of innovation, experiment and aesthetic achievement associated with conventional histories of modern and contemporary art, or with the priorities of the commercial sector that plays a significant, if typically little examined, role in framing what is of contemporary interest to both scholars and public.

But few would deny that the question of how works are lost, and what the consequences of loss are, is a subject worthy of art historical investigation. In what ways would art history be different, for example, if many thousands of modernist works had not been destroyed in the 1930s by the Nazi regime, or if

the Second World War had not caused such widespread devastation? Should the gaps in our understanding caused by these erasures be acknowledged or highlighted to a greater extent in our accounts of modern culture, and if so how? Or, to focus on a single work, would Picasso's *Guernica* 1937 have become quite the global icon of political protest against the savagery of war it is today if the equally large painting by his compatriot Joan Miró, *The Reaper*, made at the same time and also in response to the Spanish Civil War, had survived? At the very least, knowledge of Miró's mural-sized painting and the circumstances of its loss reframes our understanding of Picasso's work and the systems governing its care and reception.

Appealing to our desire to know and to imagine what can no longer be seen, stories of lost art help fill in gaps in the historical record and make us conscious of the place of all artworks within a broader context of ideas, practices and systems needed to generate and sustain them. The survival of artworks as objects, for example, requires not only processes that ensure careful handling, but also a widely shared belief in the value of art's preservation and in the importance of respecting the artist's intentions. This much is obvious, perhaps, but the hinterland of systems supporting the continued existence and record-ing of art – and in the case of lost art, the ways in which those systems have not operated – tends not to be recognised in conventional art history, with its focus on the extant object and the familiar but questionable assumption that meaning is derived from the artwork rather than from its context. Lost art, however, illus-trates the point that artworks should be seen rather as part of a broader contin-uum of thought and activity that can give meaning to the works even when they no longer exist physically (or, indeed, have never done so). As this book aims to show, not all works that are lost are forgotten, and even forgetting is part of art's broader histories.

DISCARDED

—————

STRICTLY SPEAKING, ART HISTORY TELLS US MORE ABOUT WHAT
INDIVIDUALS AND SOCIETIES HAVE BEEN ABLE, OR HAVE CHOSEN,
TO PRESERVE THAN ABOUT THE ART THAT WAS ACTUALLY MADE.
DELIBERATE HUMAN INTERVENTION, AS WELL AS ACCIDENT, HAS
OFTEN DECIMATED THE CULTURAL PRODUCTION OF ANY ONE PERIOD,
LEAVING A REDUCED HISTORICAL RECORD. THIS PROCESS OF LOSS
AND FORGETTING APPLIES AS MUCH TO MODERN AND CONTEMPORARY
ART AS TO THE ART OF ANCIENT TIMES, AND OFTEN BEGINS WITH
THE ARTIST.

—————

1—5

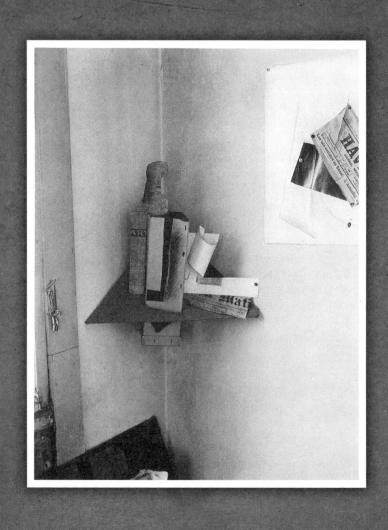

1

Waste Paper

Still Life 1914
Georges Braque 1882–1963

'What if?' is one of the many related questions associated with lost art. 'What if X had survived? What difference would have it made, and how can we ever know?' Sometimes what is lost might have radically changed the accepted chronologies and perspectives of art history. But it can be difficult to trace the impact of loss or even, in some cases, to establish with much certainty what exactly was lost. This is particularly so when, as was the case with Georges Braque, the artist in question is reticent and not inclined to draw attention to the gaps in the record – or even to recognise that the objects in question were significant.

Born in 1882, Georges Braque grew up in Normandy and trained first, like his father and grandfather, as a decorator before deciding to become an oil painter. His early works were impressionist and from 1905 fauvist, using bright, pure colours and undisguised brushstrokes. His way of painting was to change again, very dramatically, when he and the Spanish artist Pablo Picasso invented cubism in the years before the First World War. Key to the new style was a rejection of traditional perspective that had dominated western conceptions of art since the Middle Ages – or perhaps, more specifically, the way perspective was taught in schools and academies in the late nineteenth century. Even as late as 1954, Braque could speak to the art historian John Richardson with passion about this point. 'The whole Renaissance tradition is repugnant to me', he said.

> The hard-and-fast rules of perspective which it succeeded in imposing on art were a ghastly mistake which it has taken four centuries to redress; Cézanne and after him, Picasso and myself can take a lot of the credit for this. Scientific perspective is nothing but eye-fooling illusionism; it is simply a trick – a bad trick – which makes it impossible for artists to convey a full experience of space, since it forces the objects in a picture to disappear away from the beholder instead of bringing them within his reach, as painting should. Perspective is too mechanical to allow one to take full possession of things. It has its origins in a single viewpoint and never gets

away from it ... When we arrived at this conclusion, everything changed –
you have no idea how much.

Braque met Picasso in Paris in 1907 but their friendship did not blossom
until late 1908. In 1910–12 they began to collaborate very closely, discussing
pictorial problems on a daily basis and attempting to solve them in ways that
were uncharacteristic of their personalities and individual styles. For a period,
they did not sign the fronts of their canvases, wanting their works to be seen as
indistinguishable. Together, in the so-called analytic phase of cubism that lasted
from 1908 to 1912, they rendered their barely recognisable subjects – still-life
arrangements of objects or people – as schematic facets and planes that ex-
isted within a shallow pictorial space. By early 1913 all sense of atmosphere and
three-dimensional illusionism was eliminated from their paintings and, in the
phase known as synthetic cubism, Braque and Picasso worked with flat planes of
colour, identifying objects through highly simplified shapes and signs.

The story of the deep friendship between the two artists and of their
achievements in this period has become a cornerstone of the history of mod-
ern art. We know relatively little, however, about the nature of the exchanges
between the men beside some later reminiscences, brief references in letters and
the visual evidence of surviving works. It is for this reason that the loss of all of
Braque's paper constructions – a development he seems to have pioneered but
which was then taken up and made famous by Picasso – is so important histori-
cally: without knowing what Braque's constructions were like, or exactly when
they were made or how many there were, a significant part of the history of the
development of cubism, and, in particular of cubist sculpture and of Braque's
role in this, remains shadowy.

So what exactly is known about Braque's paper constructions? In a letter
from the summer of 1912 to his dealer Daniel-Henry Kahnweiler, Braque wrote:

> I am working well and taking advantage of my stay in the country to do
> things that cannot be done in Paris, such as paper sculpture, something
> that has given me much satisfaction.

Kahnweiler, who was a close confidant, later referred to Braque as having
begun to make these constructions in 1911; and Braque himself said the same to
the art historian John Richardson. In a letter of 1911, Braque wrote in an aside
that he was making 'mes papiers peint'. This would normally mean wallpaper,
but, as he did not make wallpaper, the phrase seems to allude to his creation
of painted paper constructions. The first such construction, Braque was later
reported to have said, was of a single object (a guitar or a violin) made with bits
of paper and cardboard, which were cut, folded and painted.

Furthermore, around 1911 Picasso began to use the nickname 'Wilbourg
Wright' more and more frequently for Braque, after the American brothers Or-

ville and Wilbur Wright, who designed and built the first successful fixed-wing aeroplane. Braque even took to signing his letters to Kahnweiler 'Wilbourg'. Linking this private joke to Braque's recent invention of paper constructions, art historian Alex Danchev writes, 'Braque's pioneering paper sculptures apparently reminded [Picasso] of the amazing and equally flimsy contraptions flown by the Wright brothers in their efforts to go further, faster, higher than anyone had been before without feathers, utilising as it seemed only a few spars and struts held together with a dab of glue.'

Beyond these brief references – and the inferences that have been drawn from them – there exists also a single photograph of one of Braque's later untitled paper constructions. This photograph shows a three-dimensional table-top scene set on a tilted triangular base, which is supported invisibly in a corner between two walls in Braque's Paris studio. Most easily recognised in this cubist still life is a bottle made of newsprint, presumably mounted onto card so that it stands upright and away from the wall. The lettering on the 'label' references Martini but punningly shows only the letters 'ART' – a self-referential joke making the claim that the object was indeed art in case anyone had any doubts. In front of the bottle is a hard-to-decipher three-dimensional vertical shape, which appears from the photograph to have sides and a back. Intriguingly, it seems to pass through the dark tabletop and end with a folded-over, and possibly stapled, bottom edge. To the right of the bottle is an L-shaped piece of white paper. One edge has been curled around imaginatively to create the flute of a lop-sided wine glass; an arc drawn on the horizontal part of the paper delineates the glass's base, while a very visible drawing pin fixes the extreme edge of the paper to the right-hand wall – puncturing any sense that the artist might have wanted to create a credible illusion of a glass. Behind the glass can be seen a piece of the newspaper *Le Matin*. Its date – 18 February 1914 – shows us that the work could only have been made between then and early August, when Braque enlisted in the French army.

It was a complex work, filled with cubist play with depth and flatness, solidity and transparency, and combining different levels of legibility. But Braque did not bother to preserve this or any other of his constructions. After a visit to Braque's studio in 1914, Kahnweiler recorded seeing a number of constructions – 'reliefs in wood, in paper, or in cardboard' – and so it seems that a significant body of work was lost, presumably thrown out at some stage by the artist. Nor did Braque make any effort to have them recorded for posterity in any way – the photograph discussed above is the sole known surviving image and it was published only in 1982 – and, somewhat unluckily for Braque, nobody else did either. Picasso, the more outgoing of the two and latterly more in the public eye, was more fortunate in this respect: some of his key paper constructions were captured in photographs of his studio that were reproduced in newspapers of the period.

Why was Braque so careless about works he evidently spent a good deal of time making? According to reported later conversations, it was because he did

not see himself as a sculptor and considered the constructions not as works of art but merely as tools to help him think through certain pictorial problems. It seems that he may have based some paintings on the ideas and compositions he had worked out in his paper and cardboard constructions. Furthermore, Braque was driven by the desire simply to paint; and unlike Picasso he did not feel compelled to hoard and document his works. Although the Spaniard did not manage to keep all his early paper constructions, he certainly retained some, storing them safely in boxes. When he donated *Still Life with Guitar* 1913 to the Museum of Modern Art in New York in 1973, it arrived in a clothing box that dated from 1913 and was presumably the same one in which he had first stored the sculpture. As Danchev notes, the fragile work had survived 'sixty years of upheavals and migrations, two world wars, two wives, innumerable mistresses, and passing fashions', protected within its box.

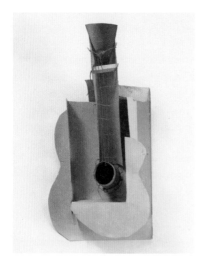

Pablo Picasso
Still Life with Guitar
Variant state, assembled
before 15 November 1913

Braque's making of three-dimensional constructions was a key step in the development of cubism. It was related to, and seems to have anticipated, the use of real elements in cubist paintings (famously, the collaged oil cloth printed to look like chair caning in Picasso's *Still Life with Chair Caning* 1912). It also predated Picasso's cardboard constructions. And yet the Frenchman's pioneering role was not fully credited or even known at the time. In 1913 four of Picasso's constructions made from wood, cardboard, paper and string were published, causing an outcry in the arts magazine *Les Soirées de Paris* (the works appeared to be neither paintings nor proper sculptures, and were rather flimsily made to boot). The newspaper illustrations and word of mouth, however, ensured that Picasso's radical and seemingly iconoclastic works became widely known; and artists from various countries, eager to learn about latest trends, visited Picasso in his studio to see them. Although it had been people's sense that the paper and card constructions were not really sculpture but something new that had made

them quickly famous, Picasso chose to rework one of his better-known constructions in more durable materials. Made of sheet metal and wire, *Guitar* 1914 (Museum of Modern Art, New York), for example, can be seen as a conscious attempt by the Spanish artist to ensure the longevity of his work. Braque's role in all this was overlooked and later more or less forgotten.

Circumstance also played a role here. Braque was severely wounded in the head in May 1915 and took several years to recover. His close friendship with Picasso could not be reconstituted, and in the meantime the latter had become increasingly famous, outshining his early artistic partner. Also, Braque was temperamentally disinclined to boast or to compete: what mattered to him in relation to Picasso was the friendship and collaborative spirit that had propelled their joint invention of cubism. Others, including on occasion Picasso himself, were inclined to present Braque as a less inventive artist, a mere foil to the fiery Spaniard's greater genius. Had some of his innovative constructions survived, or had more photographs of them existed, it seems safe to say that Braque's reputation and position in the history of the development of modern art (particularly in relation to the beginnings of cubist, and, by extension, later constructivist sculpture and even pop art) might well have been rebalanced in his favour.

However, Braque had first to value the works himself, and since he did not, it has proved hard for later historians and commentators to reclaim his lost status on his behalf or to fully acknowledge his role in the creation of a movement that profoundly altered the course of modern art.

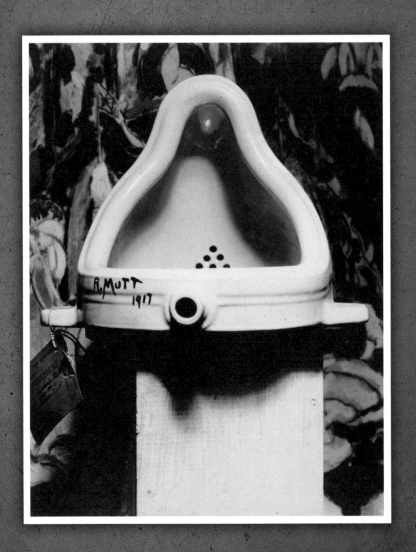

Discarded
~~Missing~~
~~Rejected~~
~~Attacked~~
~~Destroyed~~
~~Erased~~
~~Ephemeral~~
~~Transient~~
~~Unrealised~~
~~Stolen~~

2

Unique?

Fountain 1917
Marcel Duchamp 1887–1968

Many believe that Marcel Duchamp's *Fountain* 1917 is one of the most important works of modern art. An ordinary urinal, bought from a sanitary ware store and submitted to the inaugural exhibition of the Society of Independent Artists in New York in 1917, *Fountain* challenged traditional understanding of what a work of art was or could be. With this piece, Duchamp (though he was not immediately known as its author, for he signed it R. Mutt) appeared to many to assert that anything presented by an artist as a work of art was indeed art, whether or not he or she had actually made it. Duchamp's position was in fact more subtle than this – in titling and signing this object, and in submitting it for public display, he was testing the different characteristics of what was then thought to constitute an artwork – but the idea of a mass-produced item being used as a work of art had enormous impact on the history of twentieth-century art. Hitherto seen as inextricably linked to the actual making of something by an artist, an artwork became regarded as potentially divorced from the physical act of creation; and later generations of artists followed Duchamp's lead, exploiting the creative possibilities of using everyday and already made objects.

The artwork with which Duchamp so famously challenged the art establishment, however, seems to have been lost almost at once (amazingly, no one is certain how). Until he decided to authorise replicas in the 1950s and 1960s, *Fountain* was known chiefly through a single black and white photograph, taken immediately after the piece had been rejected by the Society of Independent Artists (the urinal still had the Society's label tied to it). In effect, the history of modern art was changed not so much by the artwork itself but by a photograph of it and the associated debates it engendered.

Duchamp had conceived of the idea of presenting mass-produced items as already made works of art (or 'readymades') shortly after he escaped the war in France and arrived in New York in 1915 (he had been declared medically unfit and had been exempted from military service). In the French capital he had collected objects – a bottle rack and a bicycle wheel mounted on a kitchen

stool – that he would later designate readymades. But it was only in the United States, when surrounded by a mass of sometimes unfamiliar consumer goods and rapidly teaching himself English, that he hit upon the new concept with its salacious pun on 'ready maid'.

His first readymade was a snow shovel, an everyday object that drew his attention because he had never seen one before in France. Transforming its status and function, Duchamp made it an artwork by treating it as an item that no longer had a practical use and in titling it. Enjoying linguistic games, he gave the work the perplexing title *In Advance of a Broken Arm*, a phrase that posed – and left unresolved – the questions of whose arm, why would it be broken and, above all, how could the break be known before it happened?

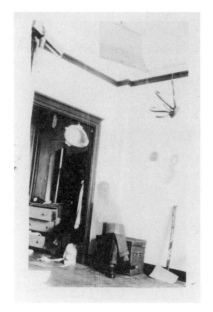

Quickly lost or discarded, most of Duchamp's early readymades are known only through photographs. One photograph of Duchamp in his studio, which was also his home, shows his determinedly unconventional attitude to these objects (as well as a disregard for tidiness). Rather than being placed on secure bases, the snow shovel and another readymade called simply *Hat Rack* were suspended from the ceiling, while *Fountain* was hung from its side wing from the top of a doorway. It was as if these were items in a crowded hardware store or garage rather than sculptures in an artist's studio. There is no record of Duchamp's friends remembering seeing the *Fountain* in his studio, hung like this or displayed in any other way, and so it would seem likely that the object was with Duchamp only briefly after its purchase and possibly not at all after it was submitted with its allusive title to the Society of Independent Artists in early April 1917.

Duchamp had been one of the prime movers behind the creation of this new grouping of artists. Based upon the Salon des Indépendants in Paris, the Society aimed to provide exhibition space for anyone who paid an initial fee of one dollar and annual dues of five dollars. A total of 2,500 paintings and sculptures by 1,200 artists, ranged in simple alphabetical order, were shown in the first exhibition at the Grand Central Palace. However, the Society's much publicised principle of total artistic freedom was immediately tested by Duchamp's covert submission. Shortly before the show opened on 10 April, an emergency meeting of the Society's directors was called and a heated argument about the aesthetic and moral qualities of the work took place. One director reportedly exclaimed, 'You mean to say, if a man sent in horse manure glued to a canvas that we would have to accept it?' Evidently, the majority felt the answer to this was 'no': a vote was taken and the directors refused to show *Fountain*. The day after the opening, the board of directors issued the following statement to the press: 'The *Fountain* may be a very useful object in its place, but its place is not an art exhibition and it is, by no definition, a work of art.'

Duchamp resigned as one of the directors of the Society of Independent Artists in protest at the rejection of R. Mutt's *Fountain*, as did his friend the collector Walter Arensberg (we do not know if Arensberg knew that Duchamp was behind the work or not). Duchamp was in no hurry to reveal that he was R. Mutt, and managed to keep this fact quiet for a few weeks. Shortly after the exhibition opened, the urinal, which had been stored in the exhibition space behind a partition out of the public's sight, was retrieved and taken to be photographed by Stieglitz, a leading photographer and creator of the 291 Gallery on Fifth Avenue, an important centre for modernist art and photography in New York.

For what was to become a famous and much-reproduced photograph, Stieglitz positioned *Fountain* in front of a colourful painting by the American painter Marsden Hartley, who had recently returned from living in Berlin. Painted in a style that showed Hartley's engagement with German expressionism, *The Warriors* 1913 showed massed ranks of the Kaiser's cavalry, in all their military finery, around a central helmet-shaped hill. Hartley was later to describe the work as an abstract picture of soldiers riding into the sun, 'a fact to take place not long after – for all of these went into the sun and never came back'. Stieglitz never commented upon the reasons why he chose this particular painting from his gallery stock to provide the background, but he may well have been struck by how the painting's central element, the hill, neatly echoed the shape of *Fountain*. The painting's masculine subject may also have seemed a fitting backdrop for a urinal (the pairing may also have been a subtle allusion to Hartley's homosexuality). There may have also been another reason for the choice. The United States had declared war on Germany only a few days before, at the beginning of April, aiming, in the words of President Wilson, to make the world 'safe for democracy'. As Duchamp scholar Francis Naumann has pointed out, Stieglitz may have been prompted by America's entry into the First World War to see a link

between the painting's image of warriors and the battle for artistic democracy within the Society of Independent Artists. With the object positioned slightly off centre on a wooden block, and with lighting that created a sense of a shrouded, possibly female, shadow figure within it, Stieglitz photographed *Fountain* in a way that created an absorbing image in its own right. Once the urinal was lost, it became the only record of what it looked like.

Duchamp's friends took his fight with the Society of Independent Artists to a broader public. The editorial of the second issue of the *Blind Man*, a magazine that Duchamp had founded with his friends Beatrice Wood and Henri-Pierre Roché, was devoted to 'The Richard Mutt Case', with a full page given to Stieglitz's photograph of the censored work. Later in life, Wood, who was one of the very few to know the true authorship of *Fountain*, claimed to have written the unsigned editorial but it can be assumed that Duchamp broadly agreed with the views expressed. Famously, the text includes this explanation:

> Whether Mr Mutt with his own hands made the fountain or not has no importance. He CHOSE it. He took an ordinary article of life, placed it so that its useful significance disappeared under the new title and point of view – created a new thought for that object.

Beneath this text, another close friend, Louise Norton, published a longer article that in its curious title, 'Buddha of the Bathroom', compared the outline of the *Fountain* to a seated Buddha. She, too, tackled head on the question of whether the work was art:

> To those who say that Mr. Mutt's exhibit may be Art, but is it the art of Mr. Mutt since a plumber made it? I reply simply that the *Fountain* was not made by a plumber but by the force of an imagination; and of imagination it has been said, 'All men are shocked by it and some overthrown by it' … Then again, there are those who anxiously ask, 'Is he serious or is he joking?' Perhaps he is both! Is it not possible?

Eventually, it became known in Duchamp's circles that he was R. Mutt, and that the name jokingly referred to the comic-strip characters Mutt and Jeff (as well as, perhaps, the idea of the work being authored in a mongrel, as opposed to pedigree, way). (Later Duchamp returned to this idea of having an artistic alias, presenting Rrose Sélavy – a pun in French on 'eros, that's life' – as the author of many of his artworks and writings, and having his friend Man Ray photograph him wearing women's makeup and clothes as this alter ego.) As for *Fountain*, there is no record of the piece after Stieglitz photographed it; and in all the interviews Duchamp later gave about this period, he never threw any new light onto *Fountain*'s fate, nor did he seem perturbed by its disappearance. It was subsequently assumed that it had been lost or discarded in some way: it was, after all, a mass-produced item.

In the early 1920s Duchamp had ostensibly retired from making art and focused instead on playing competitive chess (he was a member of the French national team in four chess Olympiads). Although he no longer produced artworks as conventionally understood, he remained active and well known within art circles in Paris and New York. His works were included in dada and surrealist exhibitions, and from time to time he was invited to organise exhibitions or contribute to various publications. Duchamp had been an important avant-garde painter before the First World War and was a key figure in the New York dada movement, but it was hard for anyone to have a clear sense of his achievements as he had yet to have a solo exhibition or a monograph devoted to his work, and many of his important early pieces had either been lost or were owned by a handful of private collectors in the United States. Rejecting the standard format of a book to commemorate his work, Duchamp set about creating 'portable museums' of his own works from the mid-1930s through to the early 1940s. Set first in leather attaché cases and later in editioned cloth-covered boxes, the 'museums' comprised photographic reproductions and miniature versions of sixty-nine of his key works, including a miniature hand-cast ceramic *Fountain*. This entirely novel format allowed Duchamp to define and preserve his legacy, offering if not a broad public then at least several hundred collectors an opportunity to gain an overview of his evolution as an artist, and it showed that he considered *Fountain* as an important work in his career.

However, those who wanted to promote interest in Duchamp's work still had to struggle with the fact that, however seminal he was to the history of modern art, he had not produced many works and that, consequently, there was little available to show or sell. Keen to promote dada and surrealist work in America, the New York gallery owner Sidney Janis asked Duchamp in 1950 if he would authorise another version of *Fountain*. Duchamp tried to find a suitable urinal but could not locate one that looked like the original. Janis eventually tracked down an old urinal in a Paris flea market and Duchamp duly signed it 'R. Mutt 1917'. Neither the urinal nor the signature were a particularly close match to the original, but this did not seem to matter to Duchamp or his circle: it was the idea of the readymade that counted at this point, though Janis took pains to find a version that looked aged. Duchamp later went on to authorise two other versions of *Fountain*, one for an auction to benefit a friend and another for a Swedish museum organising a retrospective exhibition of his works in 1963.

The idea of creating new versions of lost works quickly took root. A number of museum curators and gallerists became interested in the 1960s in making reconstructions and replicas of works by artists who had been active in the early years of modernism and which, for a variety of reasons, were no longer extant. Duchamp himself was involved in the making of a new edition of *Large Horse* 1914, an important cubist sculpture by his brother Raymond Duchamp-Villon, who had died in 1918. He also authorised the Milan-based gallery owner Arturo Schwarz to produce replicas of thirteen of the early readymades in an edition of

eight signed and numbered examples (like the edition of the Duchamp-Villon sculpture), with a further four pieces (one for Duchamp, one for Schwarz and two exhibition copies). For the replicas of *Fountain*, Schwarz did not attempt to find already manufactured urinals, as Janis had done, but instead undertook to have specially made clay versions painted a dense white to imitate the look of porcelain. The replica was based on technical specifications developed from Stieglitz's photograph. With this and replicas of the other readymades, great efforts were taken to re-create the objects in the right shapes and dimensions, though no attempt was otherwise made to suggest that they were anything other than brand new. Duchamp was not involved in the making of the pieces or the inscribing of the 'R. Mutt' signature on *Fountain*, but he signed and authorised the technical drawings, and signed the underneath of the objects and a small copper plate with the edition details that was then attached to each of the replicas.

The exhibition and sale of the replicas in Milan shocked many of Duchamp's admirers. He had long complained of the tendency of artists to repeat themselves, and for many he seemed to be doing just that in issuing editioned replicas of his early readymades. That the replicas were hand-crafted and not mass-produced everyday items also seemed, bizarrely, to miss the point of the readymades. Duchamp, however, had long been blurring the boundaries of the concepts of uniqueness, originality and reproducibility in his work, and the Schwarz replicas – all the more beguiling and collectable because of their close resemblance to the originals – can be seen as testing these ideas again. To have accepted the loss of the readymades as final, it could be argued, would have implied their uniqueness. But Duchamp felt that the essential characteristic of a readymade was 'its lack of uniqueness', and argued that a replica 'delivered the same message'.

Significantly, the replicas allowed museums around the world to build representative holdings of Duchamp's work, cementing his importance not just in the eyes of artists but also among a broader public. And this was one of Duchamp's goals in allowing his readymades to be replicated. For many people today, *Fountain* epitomises Duchamp's conceptual brilliance and wit in a period associated with the revolutionary dada movement in New York and Europe. But few remember when looking at one of the 1964 replicas that the original 1917 object – the object that defined a shift in modern understanding of the possibilities of art – disappeared almost as soon as it was presented as a work of art.

3

A Rival to Guernica?

The Reaper 1937
Joan Miró 1893–1983

Over five metres high, *The Reaper* was painted by Joan Miró as a mural for the Spanish pavilion at the 1937 World's Fair in Paris. One of his largest works, it showed a Catalan peasant holding a sickle, his face angry and contorted, railing at the heavens in protest against the plight of Spain, then being torn apart by a momentous civil war. It should have been one of the most important and iconic works of his career.

Nearly a year before, the Spanish Civil War had begun with a right-wing nationalist uprising led by General Franco against the centre-left Republican government that had come to power in 1931. It became a protracted and bitter conflict that divided families as well as the different regions of Spain along lines of religion and political ideology, with bloody purges of opponents both during and after the war as well as pitched battles and long campaigns of attrition. Other countries became involved, too, in defiance of a ruling by the League of Nations. The Soviet Union sold arms to the Republican government when few other countries would do so, while Germany, Italy and Portugal provided both military and logistical support to the nationalists, aiding General Franco on his path to eventual victory and the establishment of a long-lasting fascist dictatorship in Spain.

At the outbreak of the war, Miró moved with his family from his home in Catalonia, in northern Spain, to Paris. He had first come to the French capital in 1920, and within a few years had made a name for himself among the poets and painters of the surrealist group. By the mid-1930s he was recognised as one of the leading artists of his generation. He never lost touch with his homeland, however, and each summer he would return to his family farm, which was situated between the then small village of Mont-roig del Camp and the Mediterranean coast. When he fled Spain in the summer of 1936, he must have hoped that the conflict would be short-lived. There is no evidence that he ever considered taking up arms himself (he was then in his mid-forties), but, although he was never overtly political, his sympathies lay with the Republican cause, strong in Catalo-

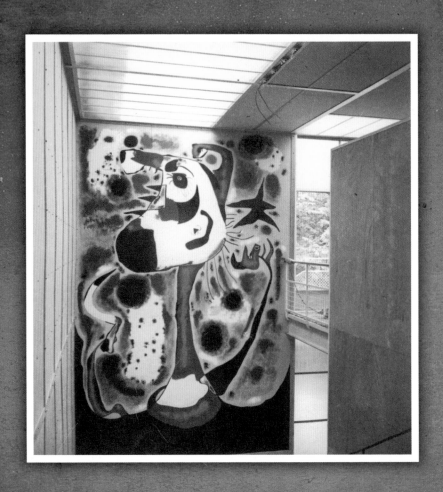

nia, and above all with those who had not sought the war. He later said about *The Reaper*, 'Of course I intended it as a protest ... The Catalan peasant is a symbol of the strong, the independent, the resistant. The sickle is not a communist symbol. It is the reaper's symbol, the tool of his work, and, when his freedom is threatened, his weapon.'

More than fifty countries were represented at the 1937 World's Fair in a series of buildings and specially constructed pavilions erected through the centre of the French capital. The fair's theme was the positive role that art could play in the development of new technology. But as each participant country built its pavilion, it became clear that national propaganda – not art and design – was its real focus. The fair was dominated by the spectacle of the German and Soviet pavilions squaring up to each other on either side of the Jardins du Trocadéro, a juxtaposition that for many symbolised the clash of fascist and communist ideologies and the increasing risk of a major European war.

The task of designing the Spanish pavilion on behalf of the beleaguered Republican government was given to the Catalan architect Josep Lluís Sert, working with Luis Lacasa Navarro. Sert's modernist building could hardly have provided a more striking contrast to its neighbour, the German pavilion designed by Hitler's favourite architect, Albert Speer. With its simple steel-girder structural framework and glass facade, the Spanish pavilion appeared to dissolve barriers between the exterior and the interior, suggesting the possibility of a democratic exchange of ideas and information. Its colours – tan and deep red – evoked the hues of rural Spain, while its interior provided an airy and unobtrusive backdrop for the visual propaganda the organisers wanted to include to show the suffering of the people and the fragile Republican government's struggle to survive.

Artworks and visual displays were key to the pavilion's aim of garnering international sympathy and support. A huge abstract concrete sculpture by Alberto Sánchez Pérez, romantically titled *The Spanish People Have a Path Which Leads to a Star*, greeted visitors at one corner of the building, along with changing photographic images of the war and news headlines on the walls. One banner proclaimed this message from the president of the Republic: 'We are fighting for the essential unity of Spain. We are fighting for the integrity of Spanish soil. We are fighting for the independence of our country and for the right of the Spanish people to determine their own destiny.'

Inside the pavilion, the open-plan ground floor was dominated by the pairing of Alexander Calder's fountain *Mercury Fountain* and Picasso's painting *Guernica*. The fountain sought to draw attention to mercury as one of Spain's most important natural resources, while Picasso's massive canvas was a dramatic response to the bombing of the Spanish town of Guernica on 26 April 1937 by German and Italian warplanes at Franco's behest. The utter destruction of the town centre and the mass killing of civilians (those who managed to flee were machine-gunned in the fields) caused alarm throughout Europe, not least

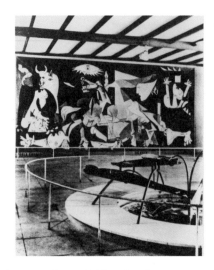

A view of Pablo Picasso's
Guernica 1937 inside
the Spanish pavilion,
with Alexander Calder's
Mercury Fountain 1937
in the foreground.

because the aerial bombardment was seen as a harbinger of tactics that would be used in future wars. Picasso had already accepted a commission from the Republican government to make a painting for the pavilion, but news of the attack led him to change his early plans. Over the next few weeks, he developed a range of archetypal figures, rendered in a modernist style, to convey a compressed narrative of anguish and pain. Eschewing colour, he used only blacks, whites and greys, alluding perhaps to the press reports and photographs through which he and the rest of the world had learned about the bombing. Curiously, his massive canvas did not attract much attention immediately, though some did criticise Picasso for not tackling the subject in a way that would be easily understood by the man on the street. But there was no doubting Picasso's sincerity in attempting to make art (rather than propaganda) from the wreckage of contemporary events, or his firm alliance with the Republican cause. As he worked on the mural, he was reported as saying:

> The Spanish struggle is the fight of reaction against the people, against freedom. My whole life as an artist has been nothing more than a continuous struggle against reaction and the death of art. How could anybody think for a moment that I could be in agreement with reaction and death? ... In the panel on which I am working, which I shall call *Guernica*, and in all my recent works of art, I clearly express my abhorrence of the military caste, which has sunk Spain in an ocean of pain and death.

From the ground floor, with its shop selling books promoting the Republican cause and large courtyard for displays of traditional Spanish music, theatre and crafts, a wide external ramp took the visitor directly to the second floor. Here was a display of contemporary Spanish art, including sculptures by Picasso, Alberto Sánchez Pérez, Emiliano Barral and Julio Gonzáles, together with a

series of photomontages by José Renau aimed at educating visitors about the regional crafts and industries of Spain, and contrasting these with the already manifested horrors of the war. The Basque region's display showed photographs of Guernica's destruction. From here the visitor was led down to a further display of photomontages on the first floor by means of a three-metre-wide staircase; it was on a wall in the stairwell that Miró's mural was located.

Although Miró had spent much of his adult life in the French capital, his move to Paris at the start of the civil war proved traumatic for him. From his arrival he was beset by depression and, living with his family in cramped conditions, he found it difficult to work. He returned to life-drawing classes in an attempt to regain his focus; he later talked about wanting at some level to control things through a return to realism. Nightmarish in its acidic colours and deep shadows, *Still Life with an Old Shoe* was his first major oil executed in Paris. Painted between January and May 1937 in a corner of a gallery run by a supportive owner (Miró did not have his own studio then), it was one of the strangest works he had ever produced. A cross between a landscape and still life, it showed a single lace-up shoe and items of a basic meal – some bread, an apple stabbed by a fork and a bottle – in colours suggestive of advanced decay and metamorphosis. However, the canvas did not address Spain's political situation explicitly: only many years later did Miró say to a friend, 'The fork attacks the apple as if it were a bayonet. The apple is Spain.'

Miró was deeply attached to the land – the image of a Catalan peasant wearing a *barettina*, or red beret, was a recurring subject in his work – but he had always shunned overt expressions of party politics, and it was perhaps only through the persuasion of Sert that he produced overtly pro-Republican works. In 1937 he designed a postage stamp called simply 'Aidez L'Espagne' or 'Help Spain', which was quickly produced as a small poster that could be bought in the Spanish pavilion. It showed a Catalan peasant wearing a *barettina* and raising his powerful fist, presumably against fascist aggressors. Beneath the image Miró wrote:

> In the current conflict I see massive forces on the fascist side, and on the other side are the people whose immense and creative resourcefulness will give Spain a vitality that will astonish the world.

A little later, in 1938, Miró wrote that he had 'never stopped thinking of how to get closer to the masses by means of painting', and this stamp-cum-poster, together with *The Reaper*, suggests a real determination to reach out to people. Interviewed in 1967, Sert claimed it was the Catalonian hymn of liberty *Els Segadors*, or *The Reapers*, that had provided the title for the mural in the Spanish pavilion.

The Reaper was bound up with Miró's identity as a Catalan but its message was arguably even more oblique than that of Picasso's *Guernica* in that it did not explicitly show acts of violence; one reviewer dismissed it as having 'no story or purpose other than the purely decorative'. But for the Miró scholar Jacques

Dupin, violence was implicit in the image of the lone reaper and in the way it was painted:

> it is integral with the act of painting and with the dramatic accentuation of the form which raises, denatures, and simplifies the face and all the other features of the figure. The lower part of the painting, black up to the height of the peasant's shoulders, brings to mind the horizon line – the range of mountains in the distance – so that the head and the figure as a whole seem not just to issue from the earth, but to be a frenzied incarnation of it ... The head with its savage eye, the double bludgeon-shaped promontory of the nose and the barettina, the heavy jutting jaw with its three aggressive fangs, is that of Miró's monsters. The energy of the formless is at work in this head, standing high against a stormy sky ... Some vast tremor is shaking the heavens, a cosmic anger to the scale of the human anger portrayed.

Miró painted *The Reaper* directly onto the insulation panels lining the pavilion walls over approximately two weeks in early June 1937 (like most pavilions, the Spanish display opened after the advertised May start of the fair). The finished mural – Miró's largest work to date – was visible from both the first and second floors, a focal point of the display of contemporary art in the middle of José Renau's photomontages. Although no colour photograph of *The Reaper* remains, in 1986 Catherine Blanton Freedberg gathered information about its striking colours from eyewitness accounts:

> The colours used in the figure itself were predominantly red, black and white: white in the ... face ... nose and the base of the neck, black in the chin, cheekbone, eye, ear and teeth as well as in the left arm ... upper torso and ... details of the cap, hands and sickle ... various shades of red in the cap, nose, cheek and neck as well as in the right arm ... while each of these colours was echoed in the painting's background, here additional colours were also used: spots of brilliant green, blue and yellow amidst somewhat amorphous areas of colour including white and the exposed buff of the Celotex support. The star in the upper right hand corner was painted an intense blue.

The fair closed on 25 November 1937, having attracted many millions of visitors. The French Senate turned down a proposed extension and the process of demolition began in February 1938. Under Sert's supervision, the Spanish pavilion was completely dismantled in less than a month. Miró donated his mural to the Republic; it was accordingly split into its six component panels and packed for shipping back to the Ministry of Fine Arts in Valencia. What happened next however, remains unclear. It is thought possible that the mural's poor condition – noted by Sert when it was packed – led the Ministry to destroy

it upon its arrival in Spain. Sert himself believed that the mural most probably fell victim to an assault on the train that transported it through Spain some time after March 1938. However, he also suggested, in a 1978 interview, that the mural might have been stored in the Spanish embassy in Paris and thrown out or destroyed during the war. Whatever the case, one of Miró's most important paintings is now known through only a few black and white photographs.

The significance of *The Reaper*'s loss is perhaps indicated by the huge fame and global significance achieved by Picasso's *Guernica* in the years since 1937. Picasso, too, had intended to give his painting to the Republic; his last-minute decision to allow the work to tour to Scandinavia, Britain and the United States saved it from *The Reaper*'s fate and initiated its rise to fame as an anti-war icon. With the approach of war in Europe, Picasso asked the Museum of Modern Art in New York to look after the painting and, while he always intended it to go one day to his home country, he did not allow it to do so while General Franco remained in charge of Spain. Franco outlived Picasso by a few years and the painting, which had long been shown in a special gallery in the New York museum, was not sent to the Spanish capital until 1981. A must-see item on any tourist's agenda, *Guernica* in the Museo Reina Sofia in Madrid now has a status similar to that of the *Mona Lisa* in the Louvre Museum in Paris.

A parenthetical note: a tapestry version of Picasso's mural, commissioned by the businessman, politician and art collector Nelson Rockefeller when Picasso refused to sell him the painting, was loaned in 1985 to the United Nations. Here it hung for many years at the entrance to the Security Council, but not without controversy. In 2003 United Nations officials covered over the tapestry when it otherwise would have formed part of the backdrop for a televised press conference with General Colin Powell, the US Secretary of State, following a speech appealing for international support for an American-led invasion of Iraq. It was in this address that Powell put forward evidence, subsequently shown to be grossly exaggerated and wrong, of the Middle Eastern country possessing 'weapons of mass destruction'. The story of the covering over of the tapestry was picked up at the time in the international press and, despite UN denials that the act had a political dimension, was interpreted by some as a sign that Picasso's image of women and children under bombardment remained a potent and troubling reminder of the horrors of war.

As a simultaneous yet very different response to the Spanish Civil War of the late 1930s, Miró's *The Reaper* can be seen today as a lost companion to Picasso's masterpiece, a work that, had it survived, might well have added another dimension to the history of anti-war protest. For Miró himself, however, the loss of this work had a personal dimension. On the artist's eighty-fifth birthday in 1978, Sert gave him a large-scale black and white photograph of the mural. According to the architect, interviewed that same year, Miró received the photograph 'as if it were a long lost child, and sat at length before it in silence and wonderment'.

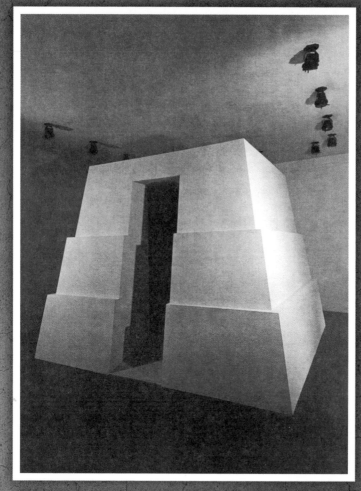

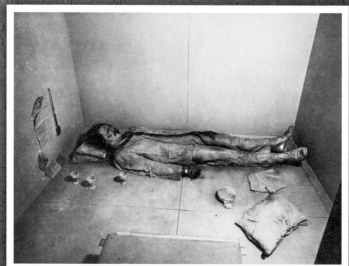

Discarded
~~Missing~~
~~Rejected~~
~~Attacked~~
~~Destroyed~~
~~Erased~~
~~Ephemeral~~
~~Transient~~
~~Unrealised~~
~~Stolen~~

4

Death of a Hippie

The Tomb 1967
Paul Thek 1933–1988

Many artists in the 1960s railed against aspects of the art market. They wanted to develop new practices and types of art that could not be easily traded or collected so as to avoid being caught up in the commercial system. But lacking the traditional indicators of cultural and financial value that the art market bestowed, some of their works became vulnerable to casual neglect – particularly if the artists were not in a position to look after them themselves. This was the case with a work that was seen as important at the time – and increasingly so since its final disappearance – Paul Thek's *The Tomb* 1967.

We know *The Tomb* now largely through two black and white photographs of the work showing it as it looked when installed at the Stable Gallery, New York, in September 1967, and through a lengthy description published in the magazine *Artforum*. The author, Robert Pincus-Witten, was conscious as he wrote that people might never again be able to see the work and took great pains to describe the various elements of the installation in detail in his review. Indeed, we would have very little idea of how the work was experienced without his thoughtful account:

> One enters a spacious, rosy-lit and incensed haze from which rises a large, three-tiered ziggurat ... Passing through the short entrance one arrives at a shallow parapet, like the interior of a glass phone booth, through which one peers into the dim, pink light of the burial site of the artist's wax simulacrum. The effigy is stretched out before us – the dead artist has been interred with unction. All is 'petal and American vermillion' pink – the light, the garments, the Tomb interior, the shoes. Thek's stringy blond locks have been casually brushed away from his forehead, revealing a dead mask, eyelids closed, and a dark, plagued tongue flopping upon a half parted mouth. Thek's long Genghis moustache, his lashes and lids have been painstakingly fitted, hair by hair, in to the wax mask. Absolute fetishism.

Perhaps Pincus-Witten had spoken with the artist, or at least, with his friends, because he observed that the work might represent 'a summation and an adieu'. Having shown himself dead, with the fingers of his right hand severed (a comment on the difficulties he felt he faced as an artist in America), Thek left New York just a few days after the show opened to start a new phase in his career in Europe.

But *The Tomb* was not forgotten. Seen as a memorable and important work, it was displayed in London in 1968, New York in 1969 and Minneapolis in 1970; and critics went on trying to define why the work was so unsettling. In London, Edward Lucie-Smith commented in 1968 that the piece 'was not an example of realism because it was too real, so much so that it almost seemed to refuse to be art'. In the same year, William Williamson said that Thek's work was 'about the presence of vivid and tenacious feelings and percepts which cannot be intellectualised, conceptualised, categorised'. And he added that *The Tomb* was a 'manifesto against that part of contemporary art which reduces art to abstract acts, to operations, and to an absence of hand'.

To some extent, the work can be seen as a wry reflection on some the dominant trends in art of the time. The tomb's ziggurat shape and the notice inside informing visitors about the structure's manufacture, dimensions and cost seemed like a deadpan joke about the geometric forms and factual language of contemporary minimalism, while the presentation of mortal remains within a tomb structure, with its evident echoes of ancient cultures, could hardly have been further from pop art's ironic engagement with consumerist culture or, as William Williamson noted, the 'abstract acts' of conceptual art.

Although very much part of the in crowd in Greenwich Village, and friends with writers such as Susan Sontag and artists Andy Warhol and Eva Hesse, Thek was deeply uncomfortable about what he saw as the art world's divorce from reality. Later he recalled, 'The world was falling apart, anyone could see it ... I'd go to a gallery and there would be a lot of fancy people looking at a lot of stuff that did not say anything about anything to anyone.' However, although he wanted to ground art in human experience, he sought principally to find ways of beautifying and transcending the real (the effigy was painted pink and seen through a sheet of yellow Perspex) and offering solace (the tomb was a place of reflection and engagement with the nature of the self).

Brought up a Roman Catholic, Thek was concerned with questions relating to spirituality and mortality throughout his life. A trip to the Capuchin catacombs in Palermo, Sicily, in 1963 had made a deep impact on him, helping him to look at death without repulsion or fear. Remembering the sight of the bodies in the catacombs, Thek said:

> their initial effect is so stunning that you fall back for a moment and then it's exhilarating. There are 8,000 corpses – not skeletons, corpses – decorating the walls, and the corridors are filled with windowed coffins.

I opened one and picked up what I thought was a piece of paper; it was a piece of dried thigh. I felt strangely relieved and free. It delighted me that bodies could be used to decorate a room, like flowers. We accept our thing-ness intellectually but the emotional acceptance of it can be a joy.

With this experience etched on his mind, he began after his return to New York to work on a series of coloured wax models of meat and limbs. He called these objects, which were often encased in Perspex, *Technological Reliquaries*. The title suggested a combination of modernity and mortality, referencing religious tradition in what for some would have seemed an improbable, and unholy, alliance of the contemporary art world and the Catholic Church. In *Meat Piece with Warhol Brillo Box* 1965, which was part of this series, Thek placed a wax imitation of a slab of raw meat inside an upended work by Warhol – a painted wooden copy of an everyday cardboard box printed with a design advertising Brillo pads. Uncomfortable truths about flesh and mortality were exposed as lying under a superficial veneer of smooth-surfaced consumerist culture. Two years later, in *The Tomb*, Thek was less interested in contrasting the spheres of organic life and culture (everything was painted a unifying 'petal pink'), but his continued preoccupation with cultural representations of mortality was unmistakeable.

The religious and art world allusions of *The Tomb* were quickly overshadowed, however, by the unexpected apparent topicality of the piece or, rather, of the effigy inside it. During the summer of 1967, 'the summer of love', as many as 100,000 people converged on the Haight-Ashbury neighbourhood of San Francisco. Flower power – a cultural and political rebellion involving street protests, psychedelic rock music, drugs, creative self-expression and sexual freedom – had arrived. Towards the end of the summer, a small group in San Francisco objected to the popularisation of the hippie movement and dilution of its ideas by the mass media. Attempting to halt the tide of press hype, they staged a demonstration through the streets of the city on 6 October 1967 called 'the death of the hippie', carrying a young man on a stretcher. This was some three weeks after the opening of *The Tomb* in New York, when Thek was already in Europe, having decided that he would never again make works for the art market. But Thek's recumbent effigy, with its long hair, moustache and psychedelic patterns on the disks on its cheeks, so resembled an archetypal hippie that the work became talked about, and retitled within a few months, as *The Death of a Hippie*. Thek disliked the new title ('Thek's Tomb + commercialized chic revolution don't mix', he wrote). But in the late 1960s *The Tomb* was increasingly seen to express the aspirations and fears of the counterculture generation, beset by growing numbers of casualties in the Vietnam War, tougher action by the state against the anti-war and free-speech movements, and political violence on the streets – and the name stuck.

Although the piece could hardly have been more resonant of the concerns of the period, no collector or museum bought *The Tomb/The Death of the Hippie* over the next few years, perhaps partly because of the fraught political atmosphere surrounding the hippie movement and anti-war protests. This left the work dependent upon the judgement and resources of Thek, and vulnerable to the vagaries and everyday mishaps of shipping and storage. Moving from country to country in Europe, Thek no longer made individual objects but rather focused on creating symbolic environments in museums, working collaboratively with a changing group of artists. He had the wax figure of the 'dead artist' brought over to Europe and used it in his new works, but left the large wooden tomb in the United States. After having had it stored for nearly two years in the cellar of a museum employee (although Thek had once indicated that it could be destroyed), Martin Friedman, director of the Walker Art Center, Minneapolis, wrote to the artist in 1972 explaining that he could no longer keep the tomb edifice and asking where it should be sent. Thek prevaricated. Perhaps he was fishing for an invitation to create a new installation at the museum using the pink tomb in a new work; or perhaps he did not want to take responsibility for deciding the fate of the structure: after all, he was engaged in making ephemeral installations that he described as 'works in progress'. Eventually, he named a former dealer to act as his agent. The dealer, however, replied to the director promptly and laconically, writing, 'I'm afraid it'll just have to go then → dump'. The museum complied.

The Tomb may have existed only for a few years as an entity, but the figure of the dead artist within it had a second life, and different meaning, within the complex environments that Thek was invited to create in various European museums in the 1970s. Perhaps ambivalent about the fame the 'hippie' had brought him, or perhaps uneasy at some level with the representation of himself as dead, Thek transformed the effigy. Inspired by Viking warriors in funeral boats, he showed the body in its shipping crate, resting on a pillow and covered by a blue blanket. On this were strewn tulip and onion bulbs symbolising pleasure (flowers) and pain (onions can induce tears) that sprouted during the course of the exhibitions. But visitors to his exhibitions might have been forgiven for missing the effigy entirely. Interviewed about one such installation, Thek said:

> The *Hippie* was simply placed in the choreography of the movement of the public through the space. One had to come through a twisting, almost-pink newspaper tunnel, and walk up some steps onto a wharf ... at the very end, just before you exit, is the *Hippie* as a Viking chieftain in a kind of boat. But you almost don't see it. There's no light on it; it's a total throwaway at that point.

Thek returned to New York in 1976. He found himself more or less forgotten in his home country, and felt he had stayed away too long. For a period he

struggled to support himself, taking odd jobs such as bagging groceries and working as a hospital janitor. Much of his artwork was too challenging for the commercial art market, though in reviewing Thek's recent small paintings in 1980, critic Richard Flood began by reminding his readers how Thek's *The Tomb* had been 'a sculptural *roman à clef* which summed up and buried an era' and how his 'narrative-realist stance – with its autobiographical context, and ritual implications – also proved a significant compass reading from '70s art'.

But Thek's increasingly erratic behaviour – sometimes forgetful, sometimes paranoid, particularly with those with whom he had practical dealings – alienated many of his erstwhile friends and supporters, and contributed to the destruction of the figure from *The Tomb*. Shipped back to the United States in 1982, the effigy was held by a storage company. When Thek discovered that the piece had not been insured, he instructed the company to destroy the work, which they refused to do without written directions. He then telephoned the company again and arranged for a delivery, but the work was sent back when it was found to be missing its hands. The records are unclear at this point but it seems likely that the shipping company must have thrown the work out sometime thereafter, not having received instructions from Thek or further payment for storing the crate.

Thek died of AIDS in 1988 and for some years was largely forgotten. Few museums, especially in the United States, owned his works, and little was published about him for many years. Yet *The Tomb* has been increasingly recognised as a key work of the 1960s and as an important point of reference for the work of later artists who focused on the body, sexuality and mortality.

There is of course an irony in mourning the loss of a work about death by an artist who was ambivalent about the commercial art world and its norms of preservation and display. In a sense, Thek's failure to look after the piece himself reflected his sense of transience as a positive and inescapable part of his art and of life in general. However, the loss of *The Tomb* also raises interesting questions about why this work and indeed the artist himself slipped out of the narrative of art history for so long. Was it because of the physical absence of this celebrated work, aesthetic discomfort with its waxwork realism, or ongoing antipathy to the countercultural values it expressed?

Thek's nomadic existence during the most productive phase of his career, his use of transient or unstable materials, his lack of an easily identified style, and presentation of his environments as 'works in progress', seem to have contributed to his neglect by critics and art historians. But in the view of American artist Mike Kelley, Thek's work had been overlooked primarily because it did not fit the established picture of 1960s art. 'Official art culture', he noted in 1992, 'knows that the best way to treat contradictory material is not to rail against it, but simply to pretend it didn't happen.' In his view, it touched upon too many raw nerves. Visually opulent and encapsulating America's fear about death, eroticism and gender confusion, *The Tomb* was for Kelley not only Thek's mas-

terwork but also 'a shrine to anti-Americanism' – albeit one now known largely through a couple of black and white press photographs and a critic's description of it in an art magazine.

– – – –

5

Corporate Power

Senster 1970

Edward Ihnatowicz 1926–1988

Edward Ihnatowicz was an artist whose interest in finding ways to emulate animal movement led him to become a British pioneer in robotic art. Dissatisfied with what he saw as the limitations of traditional art, he developed his enthusiasm for machinery to the point where, in the late 1960s, he was able to build the first computer-controlled sculptures that responded actively to sound and movement. For him, it was a logical extension of the age-old quest by artists to produce sculptures imbued with a sense of vitality.

His 1970 machine *Senster* marked the pinnacle of his achievements. However, its dependence upon collaboration with, and investment from, a major engineering corporation, and its location in a science theme park, also highlighted some of the compromises that Ihnatowicz later identified as having killed off this once promising sphere of artistic engagement. In 1986, long after *Senster* had been disassembled and rendered inoperable, he wrote: 'Artists have largely abandoned the field leaving it to the toy-robot manufacturers, Disneyland animators and Science-Fiction-Films special-effects departments. The early promise has not been fulfilled and the currency has been debased.' Although he and others had believed in the 1960s that technology and computing had become legitimate fields for artistic expression, twenty years later he felt that nothing much had in fact emerged from this moment of interchange. *Senster*, however, is remembered today as one of the most important works in the history of robotic and computer art, although it functioned for only four years.

Born in Poland in 1926, Ihnatowicz came to England as a refugee in 1943. After the war, he studied at the Ruskin School of Art in Oxford, where he began to experiment with electronics; but he felt obliged to abandon this interest in order to focus on traditional drawing and painting. He worked in a furniture-design company for more than ten years, before deciding to give up this career and return to making art. He rented a garage in Hackney, London, which became his studio. At first he worked in a traditional manner, making figurines and portrait busts in clay and plaster, and through his life he retained a passionate belief in

the value of good draughtsmanship and modelling skills. However, he struggled to find his way: 'inwardly I had no faith in the type of art I was trying to produce nor, for that matter, of any other being produced around me'. He turned increasingly to working with metal, learning in his back garden how to weld and even smelt metal, sometimes using car parts. However, his approach remained that of an artist and not an engineer: many of the machine parts used in his robotic sculptures, including *Senster*, were made first in clay or wood and then cast in metal and laboriously finished by hand to imbue the parts with an organic, rather than industrial, quality.

In the late 1960s he began to think of endowing his metal sculptures with imaginary functions and, above all, with movement – not repetitive mechanical movement (such as that found, he said, in the machines made by the Swiss artist Jean Tinguely) but fluid animal movement. He knew from his tinkering with cars that a hydraulic system could be made to move quite heavy objects: in order to learn how to control this movement, he had to become familiar with control engineering, which he then set out to master. In 1968 Ihnatowicz made his first cybernetic work. He called it *SAM*, short for Sound Activated Mobile, and later saw it as his first genuine piece of sculpture. The anthropomorphic robot consisted of a fibreglass, flowerlike head with built-in microphones, a long spinelike neck that could bend and twist in a smooth, natural motion, and a plinth for a body containing a circuit board. Sound registered by the microphones activated the flow of oil to the hydraulically operated pistons in the neck, so that the head turned to face or to follow the loudest sound.

SAM was included in a pioneering show held at the Institute of Contemporary Arts in London, called *Cybernetic Serendipity*, in 1968. It was the first exhibition to examine the role of cybernetics in contemporary culture, and included computer-generated images, music, poetry and choreography alongside robots and painting machines. Among other artworks were Bruce Lacey's robot *ROSA* and Nam June Paik's *Robot K-456*. *SAM* was a great hit at the ICA exhibition. Visitors, especially children, spent a long time in front of the sculpture trying to make the right level of noise (*SAM* was sensitive to low-level, sustained sounds rather than shouts) to gain a reaction. Influential critic and author of *Theory and Design in the First Machine Age* (1960), Reyner Banham wrote in a review:

> what is so startling about Sam is that it can snap round to attend to a noise as suddenly as a human being, can peer up or down as quickly as a cat hearing a mouse or a bird ... It's about the most beautiful fragment of sculpture I have seen in a decade – and the most disturbing. Beautiful because of the forms of the yokes [the hand-worked metal components in the machine's 'neck'], their finish, their articulation, their congruence in motion. Disturbing because the old atavism still shies at the sight of any patently man-made creation moving and responding in a manner that millennial tradition insists is the prerogative of the creations of the Almighty.

Ihnatowicz, in fact, had been aiming at re-creating the effect of an animal responding to its environment. Interested in photography and filmmaking, he once recorded a lioness in its cage in a zoo. The big cat briefly turned to look at the camera and then looked away, which led him to think about creating a sculpture that could do something similar in an art gallery, with the same feeling of a moment of contact with another seemingly sentient being.

SAM proved fragile: during the tour of the exhibition oil leaked onto its electrical parts and the machine ceased working. Ihnatowicz also felt its movements were a little too unpredictable and uncontrollable for the more elaborate and bigger structures he aspired to build. He contacted people in the field of powered prosthetics, and taught himself about fluidics and digital computers. Whereas most animal joints are quite complicated in that they can pivot in a number of directions, he learnt that crustaceans have simpler, hinged joints – a much easier model to replicate mechanically. As early drawings show, his plans for the new machine were inspired by a lobster's claw. The finished work was later dubbed *Senster* – part sensor, detecting both sound and motion, and part monster, resembling the long neck and head of a giraffe or dinosaur.

The giant electrical corporation Philips commissioned Ihnatowicz to realise his plans for a large-scale sculpture in Evoluon, a new exhibition space dedicated to science and technology in Eindhoven, The Netherlands. Ihnatowicz made a 1:4 model in his garage but to complete the work, moved to a basement laboratory in the Department of Mechanical Engineering at University College London. Insured for no less than £50,000 (at a time when an average house would cost only a few thousand pounds), *Senster* was installed in Evoluon in September 1970. Ihnatowicz and his assistants had designed and hand-built the electrical interface between the sculpture and computer, which was housed in the control cabinets kept to one side and behind the sculpture. The artist's son recalls that the Philips computer was the size of a small refrigerator and had only 8kB of memory. The huge hydraulic unit required to operate the machine smoothly was housed in a basement below, which meant that *Senster* was entirely, and seemingly miraculously, silent.

As with *SAM*, microphones in the head of *Senster* allowed it to track the source of sound, while radar units enabled it to respond to movement. The head could move within a second or two to anywhere within a total space of more than 1,000 cubic feet, with sophisticated electronic programs that allowed the head to slow down before coming to a stop, avoiding the appearance of jerky movement. Using punched paper, Ihnatowicz had programmed the computer to interpret the readings generated by ambient noise and movement according to past experiences and current contingencies. Like the smaller and less sophisticated *SAM*, *Senster* moved towards low-level sounds and slow movements but withdrew from loud shouts and sudden movements as if shying away with fright. If the sound levels became too loud, it raised its head up high as if indignant, ignoring the surrounding crowd until the noise subsided. Different behaviours

were programmed for different periods of the day. Initially, the machine was programmed to move, when activated, as if foraging for food.

Positioned near the entrance to Evoluon, *Senster* made a dramatic impression on all those who saw it. Visitors would spend hours in front of the machine, clapping or tapping the barrier in order to attract its attention and interacting with it as if it were a caged zoo animal. In response, it appeared to express an interest in the human beings around it. In the early morning, it would be found with its head down, seeming to listen to the faint noise of its own hydraulic pumps. Then if a girl walked by with noisy high heels, the head would follow her, looking at her legs. Ihnatowicz recalled that when he had just got it working, he cleared his throat, and the head came right up to him as if to ask, 'Are you all right?' Creating a behaviour-based robot on this scale was a huge and unprecedented undertaking at the time. Ihnatowicz was recognised as having taken an important step towards creating a machine that responded to its environment through computer-based data-processing, and Philips was congratulated in the press for its farsighted commission.

Ihnatowicz and a Philips engineer further refined the computer's program, but in 1972 Philips asked the artist to desensitise the machine, as its behaviour – and visitors' reactions – were creating too much of a stir. In December 1973 the company dismantled *Senster* (it was the legal owner) and only subsequently informed the artist, saying it was attracting 'unfavourable publicity'. Ihnatowicz replied that it had only begun to create a negative impression because it was not maintained correctly and its programming had been severely degraded in order not to create too much excitement and noise. The company subsequently got rid of records relating to *Senster* bar a few photographs. However, an employee of the firm Verburg-Holland BV (later Delmeco Fishing Technology BV), which was contracted to dismantle *Senster*, recognised the historic importance of the work and persuaded his company to retain the machine's body. Today it sits in the company's grounds in Colijnsplaat as an open-air sculpture. The electronic parts were given away to enthusiasts. It was a sorry end to what had been an extraordinarily innovative work, one that straddled the boundaries between art and technology and was a pioneering piece of robotic and computer-based art.

For Ihnatowicz, the experience of making *Senster*, and of discovering computer programming along the way, convinced him that computing could be a valid and important artistic medium. Artists, he felt, should embrace new discoveries in science and technology to enhance their personal understanding of the world, though he recognised a difference in approach: unlike scientists, artists took themselves as their only point of reference, and aimed only to demonstrate the workings of the world, not to explain them. However, he was not able to sustain an artistic trajectory in this field. Employed subsequently as a researcher in the Department of Mechanical Engineering at University College London, he had access to the necessary equipment and community of experts. But, as he acknowledged, his later works, though sculptural in conception, were

primarily pieces of technical equipment; and his ideas about the role of physical movement in perception were not scientifically grounded and were not taken up by colleagues. Ihnatowicz became interested instead in early computer painting and drawing programs, combining his traditional skills as an artist with his passion for new technology.

In the 1970s and 1980s, the cultural and economic structures governing the development of technology-based art made it difficult for such works of art – even when as pioneering and popular as *Senster* – to flourish and be preserved. They seemed too much like gadgets or pieces of property that could be disposed of once no longer useful rather than the realised expression of an artist's idea or vision. Combining early computer technology and mechanical engineering, *Senster* probably could have been preserved. But there were many other computer-based artworks from these pioneering years that inevitably became defunct when the equipment on which they depended stopped being manufactured and replacements could not be sourced, and many were thrown away.

Rapid obsolescence in the field of new media remains a problem. Artists today are creating highly complex digital artworks that many museums have difficulty in knowing how to preserve, let alone in having the equipment and processes in place to do so. 'Past generations captured who they were and what they did via museums and books', David Anderson of the School of Creative Technologies at the University of Portsmouth observed in 2011, 'but the pace of technological development in the digital age has now outstripped our capacity for preservation.' Some artists will not mind that they are creating works that are short-lived, but those whose role is to act as custodians of cultural records are concerned about the risk of losing evidence of a whole swathe of cultural endeavour. 'If we don't preserve the digital art made today', Anderson wrote, 'it could be like walking into a world-famous gallery and seeing nothing on the walls.' In this respect Ihnatowicz's *Senster* is just one example of a much bigger problem of ongoing artistic and cultural loss in this field of computer-related art.

————

MISSING

~~Discarded~~
Missing
~~Rejected~~
~~Attacked~~
~~Destroyed~~
~~Erased~~
~~Ephemeral~~
~~Transient~~
~~Unrealised~~
~~Stolen~~

ARTWORKS – EVEN VERY LARGE ONES – CAN GO MISSING WHEN PROPER RECORDS ARE NOT KEPT, OR WHEN THEY SLIP FROM PUBLIC VIEW FOR A PERIOD. IN SUCH CASES, THEY ARE DESCRIBED IN BOOKS AND CATALOGUES AS 'LOCATION UNKNOWN' OR 'MISSING, PRESUMED DESTROYED'.

WAR IS A PARTICULAR SOURCE OF CHAOS IN WHICH MANY THINGS GO MISSING OR ARE DESTROYED. THE SECOND WORLD WAR WAS A PERIOD OF ENORMOUS CULTURAL LOSS. MANY HUNDREDS OF THOUSANDS OF ARTWORKS MOVED WITHIN AND ACROSS NATIONAL BORDERS IN THE WAKE OF INVADING AND RETREATING ARMIES. BOMBING, LOOTING AND THE DESTRUCTION OF RECORDS ADDED TO THE TURMOIL. LATER, THE COLD WAR AND BREAKDOWN IN RELATIONSHIPS BETWEEN EAST AND WEST EUROPE HELD UP THE PROCESS OF CLARIFYING THE FATE OF MANY OF THE PIECES THAT HAD DISAPPEARED.

EVEN WITHOUT CONFLICTS AND MAJOR CATASTROPHES, IT IS OFTEN SURPRISINGLY DIFFICULT TO KEEP TRACK OF WORKS OF ART. ITEMS MAY DISAPPEAR IF THEY ARE SOLD TO SECRETIVE COLLECTORS. PIECES THAT BECOME UNFASHIONABLE ARE PARTICULARLY SUSCEPTIBLE TO BEING MISLAID. BUT WITH MISSING WORKS THERE IS ALWAYS THE CHANCE THAT THEY WILL COME TO LIGHT SOME DAY.

6–9

~~Discarded~~
Missing
~~Rejected~~
~~Attacked~~
~~Destroyed~~
~~Erased~~
~~Ephemeral~~
~~Transient~~
~~Unrealised~~
~~Stolen~~

6

Without a Trace

Peasant Funeral 1911
Kasimir Malevich 1879–1935

The mid-1920s proved a turning point in the career of the Russian artist Kasimir Malevich, an early pioneer of abstract art. Immediately after the Russian Revolution in 1917, the communist authorities had welcomed avant-garde experimentation, and in 1923 Malevich was appointed Director of the State Institute of Artistic Culture in Petrograd. But, with the rise of Joseph Stalin to power following the death of the revolutionary leader Vladimir Lenin in 1924, the cultural climate in the Soviet Union shifted. Sections within the government began to view with disfavour the abstraction with which Malevich was so prominently associated. In late 1926 he found himself dismissed from his post and the Institute was closed soon afterwards.

Amid these difficulties Malevich undertook a trip to Germany, taking with him seventy works, a large and representative selection of his career to date. The visit, with a programme of talks and exhibitions, cemented his reputation internationally as one of the most significant artists in Europe. But this success came with a price: it provoked his enemies within the state apparatus to summon him back to the Soviet Union. Suspecting his position was perilous, he took the precaution of leaving his artworks in the care of a friend in Berlin. Over the coming years Malevich was unable to leave the country, and found himself increasingly ostracised. He was eventually forced to stop making abstract paintings and returned to a form of figuration in order to be able to paint at all. He became ill with cancer and, denied permission to seek treatment abroad, died penniless in 1935. By then socialist realism was the only government-endorsed style of art in the Soviet Union, and Malevich's abstract works, condemned as anti-Soviet, had been removed from public view.

In the event, Malevich's decision to leave his artworks – a major part of his artistic legacy – in Berlin proved fortuitous. The advent of fascism in Germany, which was as intolerant of modernist art as Soviet Russia, threatened his legacy as did the fighting and bombing of the Second World War, but many, though not all, of the hidden artworks survived. Ironically, of the works left in Berlin, it was

largely the abstract works that survived, in part because supporters of modernist art, in Germany and elsewhere, did what they could to save them from the fascist regime. An early figurative painting called *Peasant Funeral*, however, was not so fortunate. Inconveniently large and painted in a style that would have seemed in the interwar years of only historical rather than current interest, the work disappeared without a trace.

Malevich was born in Kiev, the son of ethnic Poles. He grew up in the villages of the Ukraine, and was familiar with peasant styles of decoration. He studied drawing in Kiev and, after the death of his father, moved to Moscow in 1904 to further his career. Here he quickly experimented with imported modern painting styles: impressionism and fauvism from France, futurism from Italy. In 1910 he joined the avant-garde Knave of Diamonds group, and was influenced by the theories of fellow member Wassily Kandinsky. Like Kandinsky, Malevich tried to see whether certain combinations of colour and form could create a meaningful emotional response in viewers without resembling or evoking elements in everyday life.

Throughout these years of stylistic experimentation, Malevich was intensely preoccupied with themes of peasant life. As he had grown up among the sugar-beet plantations of the Ukraine, rural subjects had a personal resonance. But his choice of subject matter also showed his desire to follow in the footsteps of the great European modernists: artists such as Paul Gauguin had studied French peasants, believing their simple and rustic ways could somehow reveal some basic, more fundamental truth about the human condition and help rejuvenate stale traditions in art. In choosing to paint peasants in a quasi-'primitivist' style indebted to modern European artists in France and Germany, Malevich aimed then to create a bridge between the 'real Russia', symbolised for him as for so many intellectuals of the day by the peasantry, and the world of contemporary art.

Malevich's early sketches for *Peasant Funeral* depict workers gathered around an open grave. These appear to reference the famous vast nineteenth-century canvas by the French realist painter Gustave Courbet, *Burial at Ornans* 1849–50, which showed ordinary townspeople assembled for a funeral. In the final composition, however, Malevich shifted the focus of attention away from the grave to the procession of stocky peasant figures behind the pallbearers. The peasants are shown with bowed shoulders and huge hands, while their faces are rendered in a deliberately naïve style, echoing children's drawings and folk art.

Completed in 1911, *Peasant Funeral* was among the largest works Malevich ever painted at over two metres wide (whether he painted directly onto the canvas with oils or used gouache on sheets of paper mounted onto canvas remains uncertain). He showed the composition at an exhibition of the experimental Donkey's Tail group in Moscow in March 1912, and then sent it to Saint Petersburg for the annual *Union of Youth* show in December. Fortunately, a review illustrated the painting, giving us a reasonable black and white image of the work.

Another painting of this period offers us a sense of the bold colours Malevich would probably have used in the lost work. Painted in yellows, ochres and greens, with flashes of blue and orange, *Peasant Women in Church* 1911 was displayed alongside *Peasant Funeral* in the 1912 Donkey's Tail exhibition and excited press comment. Although influenced by fellow avant-garde artists Natalia Goncharova and Mikhail Larionov at this point, Malevich's use of colour appears to have been distinctive. One reviewer wrote about 'irresistibly made reds and yellows'; another declared simply, 'we are conquered by Malevich's colouring'.

For reasons that are not well understood, Malevich moved quickly and dramatically away from a style based on European fauvism and cubism in the years before the First World War. After 'alogism' – works presenting conflicts of logic – he went on to turn away from rationality altogether in 1913 with a series of canvases with two-dimensional geometric shapes. He wrote: 'we rejected reason so that another kind of reason could grow in us, which ... can be called beyond-reason'. The repudiation of European styles by Malevich and his contemporaries in favour of austere geometric forms – famously a black square on a white ground, and a white square on a white ground – became explicit in 1915 when they staged the *Last Futurist Exhibition 0.10* in Petrograd (as Saint Petersburg was called between 1914 and 1924). It was at this show that Malevich first named this style suprematism. However, his desire to be connected with the life of ordinary peasants did not wane: in 1915–16 he worked with other suprematist artists in a peasant or artisan cooperative.

A uniquely Russian avant-garde movement, Malevich's suprematism was heralded as a triumph by his contemporaries and, immediately after the Russian Revolution, by the communist state. In 1919 he enjoyed his first retrospective in Moscow. Titled *K.S. Malevich: His Way from Impressionism to Suprematism*, it presented Malevich's work as the latest stage in the development of European modernism. *Peasant Funeral* was among the 150 works chosen for this exhibition, placing it firmly within this evolution.

In the early 1920s Malevich had further retrospective exhibitions and published his aesthetic theories, including his manifesto of suprematism *The Non-Objective World*. European interest in Malevich's ideas grew and, prompted by an invitation from an artists' society in Germany, the State Institute of Artistic Culture in Petrograd, of which Malevich was director, agreed to organise an exhibition of its members' work in Berlin. Avant-garde or experimental art, however, was falling out of favour. In 1926 a Communist Party newspaper branded the Institute a place rife with 'counterrevolutionary sermonising and artistic debauchery', and the state refused to fund the proposed exhibition. Malevich found himself obliged to plan and pay for a trip to Germany himself.

Malevich left Russia on 8 March 1927 with a large bundle of his theoretical notes and diagrams and just over seventy of his paintings and works on paper. He journeyed first to Warsaw, where he was welcomed as a prodigal son. He gave lectures to Polish artists on the Institute's research and exhibited a selec-

tion of his paintings. He also visited the progressive Bauhaus arts school in Dessau, where the constructivist artist László Moholy-Nagy, who was a great admirer, arranged for the publication of some of his writings in German. In Berlin, the architect Hugo Häring introduced Malevich to key figures in the art world. The city had a large Russian émigré community and Häring, who had a Russian-born wife, was keen to promote Malevich's work. A member of the organising committee for the annual *Great Berlin Art Exhibition*, he was able to secure a special room for the works that Malevich had brought with him in the show. Only the second time a substantial body of the Russian artist's works had been seen in Germany, the display was, in effect, a mini-retrospective.

Malevich was thrilled with the positive reaction he received, writing to his Institute colleague Lev Yudin on 7 May 1927:

> As far as the level of interest at the demonstration of our works is concerned, I couldn't have asked for more ... the Germans gave me an out-of-this-world welcome ... How I wish you could see everything here, the consideration I am shown, and all of this in a foreign country. I do not think that any other artist has ever been accorded such hospitality.

Unfortunately, press reports of Malevich's activities in Germany only worsened his position in government circles in Russia. Ordered to return to Leningrad, he left Germany on 5 June 1927, asking Häring to take care of his works at the end of the exhibition: they were not to be sent to Russia but were to remain in Berlin until he could return. Malevich also entrusted a bundle of his theoretical writings to his host with the prescient written instruction that, 'in case of my death or permanent imprisonment', the package should be unpacked in twenty-five years and the texts translated and published.

Back in Leningrad, Malevich faced two weeks of interrogation from party officials and, though he was released, his reputation never recovered. The authorities refused to let him travel and his hopes of going back to Germany and showing his works in western countries were crushed. Opportunities to exhibit work in the Soviet Union became increasingly rare. In his remaining years, he returned to painting portraits and peasant scenes, attempting to reconcile his work with the state's demand for art that glorified the ordinary worker. Even this was unsuccessful and Malevich remained out of favour in his last years.

Knowing that the works in his care were all the more precious because of what was happening in the Soviet Union, Häring did his best to act in Malevich's best interests. Unfortunately, he did not keep proper records – presumably he thought he would be the custodian of the works for only a short time – and tracing what happened to them all has proved difficult. At the end of the Berlin exhibition, Häring allowed two works to be sold – a landscape and a suprematist piece – and at his own expense stored the remainder. At some point prior to 1930, Alexander Dorner, director of the Landesmuseum

in Hanover and a well-known supporter of modernist art, asked to borrow a group of Malevich's works from Häring. A large crate was shipped and a selection of works was included in the museum's 'Cabinet of Abstraction'. This was a gallery designed by the constructivist artist El Lissitzky especially for abstract art (it was destroyed by the Nazis in 1936). Dorner later lent three of the Malevich works he had borrowed from Häring to exhibitions of Russian art in Berlin and Vienna in 1930. However, *Peasant Funeral* was not among these, and it seems likely that the work had stayed in Berlin and was not among the works loaned to Dorner.

Another chance for the painting to surface in a public exhibition or official record came in 1935 when Alfred Barr, then director of the Museum of Modern Art in New York, visited Dorner in Hanover to select works for a groundbreaking exhibition he curated the following year, *Cubism and Abstract Art*. Barr borrowed a group of Malevich's suprematist works and five of his theoretical charts for the New York show. On the cover of the exhibition catalogue, Barr famously reproduced a flow chart he had designed showing the development of recent modern art, with suprematism identified as an offshoot of cubism and a forerunner of contemporary abstract art. The exhibition was hugely influential and helped underscore the importance of Malevich and suprematism on an international stage. However, *Peasant Funeral* was not among the works chosen, and Barr's records relating to his visit to Dorner make no reference to it.

At the closure of *Cubism and Abstract Art* in New York it was felt too dangerous to send Malevich's works back to Hanover – both for the works themselves and for the German museum's staff – and MoMA held on to them. As will be seen in other chapters, the German government attempted to purge the country of modernist art in the mid- and late 1930s, and Malevich's works, if returned, would have risked being confiscated and in all likelihood destroyed. In Hanover, Dorner removed all remaining Malevich works from display in his museum and returned the works he still had back to Häring before himself fleeing to the United States in 1937.

Häring left Berlin in 1944, taking the works with him to his home town of Biberach in southern Germany. In spring 1951 curators from Amsterdam's Stedelijk Museum, who were planning an exhibition of Malevich's work, traced Häring and found he still had a crate of the Russian artist's works in his possession. Comparing lists of works, the curators found that twenty-one pieces of the seventy that Malevich had brought to Berlin were missing and unaccounted for. Among these was *Peasant Funeral*.

Although the disappearance of *Peasant Funeral* was entangled in the ideological campaigns against modernist art in both Russia and Germany, it may have been the canvas's sheer size rather than its subject matter or unfashionable style that made it vulnerable to neglect and loss: most of the missing works among those entrusted to Häring were large, suggesting that they may have been packed separately, perhaps rolled up, in the Berlin storage depot he used. Unfortunately,

the depot was destroyed during the war. It now seems unlikely that *Peasant Funeral* will ever be found, although, for want of any evidence as to what happened to it after 1927, no one can be entirely sure.

————

Discarded
Missing
Rejected
Attacked
Destroyed
Erased
Ephemeral
Transient
Unrealised
Stolen

7

Lobster Legs

Kermesse 1912
Wyndham Lewis 1882–1957

Sometimes all that we have of works of art are written accounts. For example, the allegorical fresco of the Commune of Florence by the great fourteenth-century painter Giotto survives today only in a description by the writer Giorgio Vasari. A portrait of a young woman by Giotto's near contemporary, the Sienese master Simone Martini, is known only to us because it was the subject of a sonnet by Petrarch. Even in the modern age an apparently great work of art can both be lost physically and yet live on in our imaginations, even in changed and somewhat attenuated form, through descriptions or brief references.

No one knows, however, what Wyndham Lewis's painting *Kermesse* of 1912 looks like. There are no photographs of it; and if there were preliminary drawings, none has survived. The nearest we have to a direct visual record is a tiny drypoint print – it is the size of a cigarette box – made by Horace Brodzky in 1917. It shows a person standing in front of Lewis's huge canvas in a New York gallery. If we were to judge the painting by this, we would believe that *Kermesse* may have had a central figure, or part of one, but was otherwise a whirl of seemingly unconnected curving lines.

Luckily, however, some related works, chiefly small watercolours and even smaller printed designs, have survived. From these we know that Wyndham Lewis had adopted a way of painting that combined elements of continental avant-garde styles. From cubism Lewis borrowed the hatched planes and the carved, wedge-like volumes uniting figure and background found in Picasso's early cubist works. From futurism he took the theme of the dynamism of modern life, a sometimes violent and dehumanising energy expressed in machine-like images and arcing 'lines of force' linking the figure or object with the background. In the early 1910s, years in which Lewis was just coming to maturity as a painter, his style combined figurative elements rendered often in crudely simplified or geometricised shapes with a surrounding abstract patterning of jagged shapes and modulations of light and dark that might or might not refer to the scene depicted.

EDWARD WADSWORTH
British: Contemporary

381. COMBAT. An interesting definition, in strong colors, of masses by planes, depicting the vitality of a combat.

Height, 6 feet; length, 7 feet

Purchased from the artist

WYNDHAM LEWIS
British: Contemporary

382. KERMESSE [1912]. Cubistic rendering of three festive figures, the central figure in rich yellow, the others in varying shades of red and purple. Signed at lower left, WYNDHAM LEWIS, and dated 1912.

Height, 8 feet 9 inches; length, 8 feet 11 inches

Purchased from the artist

WYNDHAM LEWIS
British: Contemporary

383. PLAN OF WAR. A passionate attempt to express a profound emotion; fine arrangement of planes and lines, in strongly contrasted colors. Signed at lower right, WYNDHAM LEWIS.

Height, 8 feet 4½ inches; length, 4 feet 8½ inches

Purchased from the artist

[END OF THIRD SESSION]

To visualise the now lost *Kermesse* and to imagine what impact this nearly three-metre-square canvas had on contemporaries, we need to look to contemporary texts. Perhaps the most helpful starting point is the very last account we have of the work, the succinct description given in an auction catalogue of 1927. Here it was characterised tersely as a 'cubistic rendering of three festive figures, the central figure in rich yellow, the others in varying shades of red and purple'. How the cataloguer knew that the figures were 'festive' is uncertain, but a surviving related watercolour also called *Kermesse* shows a central couple locked in an embrace with figures either side holding glasses.

Wyndham Lewis
Kermesse
1912
Ink, watercolour and gouache
on paper
30 x 29

Accounts by those who saw Lewis's massive canvas in 1912 and 1913 are more subjective, with opinion divided, it seems, as to whether *Kermesse* was an important example of modernist art or simply mystifying. Writing in the *Nation* in June 1912, leading critic Roger Fry spoke of the piece's abstract design: its 'quantities and volumes have decisive relations to one another: long before one has begun to inquire what it represents, one has the impression of some plastic reality brought about by deliberately intentional colour oppositions. When we begin to look more closely, we find indeed that the rhythm of these elementary geometric forms is based upon the rhythm of the human figure. The rhythm is not merely agreeable and harmonious, but definitely evocative of a Dionysiac mood.' Others had fun at the painting's expense. A critic wrote in the *Observer* in October 1913, 'the dancers, it is true, look like some gigantic fantastic insects descended upon earth from some other planet'. Referring to the well-known science-fiction writer, the *Times* critic agreed: 'Mr Wyndham Lewis's "Kermesse" is an impressive design and looks as if it were an illustration to some new romance by Mr. Wells about forms of life on another planet.' The critic of the *New Age* chose a marine rather than extra-terrestrial theme for his analogies, and usefully provided some details about the imagery. Twice he went to see *Kermesse* by himself at the *Post-Impressionist and Futurist Exhibition* held at the Doré Gallery in London, he wrote, and each time he could only discern 'boiled lobster-legs'.

For a third time I returned to the Doré Gallery. This time I took good care to be accompanied by an expert, [the Spanish painter] Aureliano Beruete. He also saw nothing in the 'Kermesse' but the lobster-legs. But after some time Beruete said that perhaps at the centre of the picture there might be two figures kissing one another on the mouth. On the left a crustaceous shape, offering wine to another headless crustacean, which sat on something perhaps meant to be a chair. On the right another crustacean pouring out a jet of wine into his own crustaceous face. These shapes we could not see except by an effort of creative imagination. Once this effort relaxed – return of the lobster-legs.

There was no doubt, however, that many in the art world thought it an important work. The painter Augustus John declared himself 'greatly impressed' by the 'energy and grandeur of the conception'; and Walter Sickert later remembered it simply as 'magnificent'. The critic Frank Rutter recalled the painting as 'a whirling design of slightly cubist forms expressed in terms of cool but striking colour contrasts', adding, 'Here for the first time London saw by an English artist a painting altogether in sympathy with the later developments in Paris.'

Lewis himself clearly valued it. He seized whatever opportunities came his way to exhibit it in 1912–13, and, in 1916, when enlisted in the army, he wrote to his friend, the American poet Ezra Pound, calling *Kermesse* an 'important picture'. In the same letter, however, he revealed that he was still unhappy with it: 'even for a Wall painting it is too uncouth and its unfinished state would not recommend it to the very discriminating'. There is some evidence that he had already reworked the composition by 1913, possibly enriching the colours; his concern in 1916 to go on improving the work can perhaps be taken as a token of his faith in its importance as much as a desire to remedy its perceived failings.

What then was the significance of what Lewis felt was still a rather rough and ready, and even unfinished, canvas? Ultimately, it hinges on the very real possibility that it was the first thoroughgoing response to advanced continental trends, achieved on an unforgettable, mural-sized scale by one of England's boldest and most talented painters. It is important to remember that English art was then dominated by realism, whether expressed in the painterly portraits of Augustus John, the sober depictions of modern urban life of Walter Sickert or the colourful canvases of Spencer Gore and Harold Gilman. Post-impressionism had only recently been introduced, with dramatic effect on English artistic life, largely through an exhibition organised by Roger Fry in November 1910. Cubism was yet little known. Lewis, however, was a regular traveller to Paris and was familiar with the latest trends there, including cubism, and it is suspected he may also have known something of the Italian futurists who were based in the French capital. The futurist leader Filippo Tommaso Marinetti gave a lecture in London in 1910, and returned to introduce an exhibition of futurist art in March 1912. This exhibition kick-started a new form of cubo-futurist art in Britain that

led in 1914 to Lewis forming the Rebel Art Centre and to the establishment of the short-lived but important vorticist movement.

Futurism was also an element in the context and meaning of *Kermesse*. Later, Lewis was irritated by the arrogance of Marinetti and critical of the notion of amorphous flux that lay behind futurist understanding of the energies of modern life. But, initially, he felt galvanised by the sheer bravura and at times brutish force behind the new vision of the future. His images of hard-edged, dehumanised figures grimacing, staring at and variously confronting each other in the *Kermesse* watercolour, for example, expressed a response to the futurists' exaltation of 'movements of aggression, feverish sleeplessness, the double march, the perilous leap, the slap and the blow with the fist ... militarism, patriotism, the destructive gesture of the anarchists, the beautiful ideas which kill, and contempt for woman'.

But, in marked contrast to the futurists' urban bias, the masculine energies that Lewis sought to express in *Kermesse* were decidedly and distinctively those of pre-modern life. '*Kermesse*' was originally a Flemish word meaning a village fair or festival; and in a famous painting hung in the Louvre, Rubens had depicted a *kermesse* around 1630–5, with scenes of drunken revelry and bawdy behaviour. In 1908 Lewis had travelled around Brittany, then very much a traditional and underdeveloped region of France, and had observed Breton festivals at first hand; some of the works on paper relating to *Kermesse* show people in what could have been distinctive Breton hats. More than this, dance – long a favourite theme of artists from the 1880s to the First World War – was very much in the air at the time, often in the form of imports every bit as foreign and exotic as cubism or futurism. Art historian Lisa Tickner writes:

> Between about 1910 and 1914 there was an explosion of interest in all forms of dance – vernacular, theatrical and social. Folk dances were energetically collected, photographed and revived. Theatrical and ballet conventions were comprehensively overturned by Isadora Duncan and the Ballets Russes. On the dance floor, the previously daring 'do you reverse?' paled into insignificance beside the *risqué* new dances like the tango, the two-step and the Brazilian mazique.

Tickner goes on to suggest that Lewis's works of this period somehow convey something both of Brittany and of the flamenco dances associated with Spain, which Lewis had also visited.

Dance was also key to the intended purpose of *Kermesse*. Lewis had been commissioned to produce this large mural-like decoration, along with a range of designs for printed material such as programmes and letterheads, for a new theatre cabaret club in London. Established in a basement in a quiet road off Regent Street, The Cave of the Golden Calf was intended to be a free-thinking, high-spirited club for artists and writers, and was decorated by leading young

artists, including not only Lewis but also Spencer Gore, Charles Ginner and Jacob Epstein. According to its prospectus, issued in April 1912, the club promised to embrace 'on the one hand such art as we owe to the genius of the people, the dance, folk lore – on the other offering free development to the youngest and best of our contemporaries and – "Futurists"'. One month later, the club's statement of 'Aims and Programme' read:

> We want a place given up to gaiety, to a gaiety stimulating thought, rather than crushing it.
> We want a gaiety that does not have to count with midnight.
> We want surroundings, which after the reality of daily life, reveal the reality of the unreal ...
> We do not want to Continentalise, we only want to do away, to some degree, with the distinction that the word 'Continental' implies, and with the necessity of crossing the Channel to laugh freely, and to sit up after nursery hours.

Displayed in the entrance stairwell, Lewis's *Kermesse* signalled to visitors that the club would be a site of avant-garde experimentation and unbridled fun. However, it was no sooner hung for the opening of the club than Lewis unhung it to show it in a series of art exhibitions; and thus *Kermesse* began its transformation from wall decoration, displayed within the confines of a night club, to an easel painting, to be seen within art galleries and reviewed by critics as a work of art.

As has been seen, *Kermesse* attracted a fair share of praise as well as the predictable obloquy. However, it was not bought until 1916, when John Quinn, a major American collector, paid a much needed £70 for it and included it in an exhibition of vorticist work he organised in New York in 1917. Quinn died in 1924 and his collection was auctioned three years later. *Kermesse* was bought by an old friend of Lewis's, Captain Richard Wyndham, for a song. Wyndham was a wealthy Anglo-Irish peer and amateur painter, who had bought Lewis's work in the past and had even supported him with a stipend. Despite this, he found himself – or thought he found himself – viciously satirised by Lewis in *The Apes of God* 1930, a novel that ridiculed the wealthy patrons, critics, socialites and dilettantes who followed and aped true artistic genius. Richard Wyndham believed he was portrayed as the vacuous and morally suspect 'Dick Whittingdon', 'the authentic Ape, the world's prized Ape'.

> He was not only too old as he regretfully decided but far too clumsy and not very clever (as well as bald and rheumatic) to become an Oxford-voiced *Fairy-prince*. So Dick Whittingdon cast around for some recognised vice that might compensate for this social handicap. The pornographic literature of the camp and barracks (and for Dick the horizon of Letters was

more or less that) suggested a solution. So he is a noted *flagellant*. Whip in hand, Dick Whittingdon faces the world.

There was no going back after such disparaging comments and relations were severed. Wyndham lost little time in getting rid of two paintings by Lewis he owned, including, it is thought, *Kermesse*. Rather than selling the works through the art market where their fate would have been more assured, he placed a small classified advertisement in the *Times* in June 1930, advertising the works in terms simply of their size.

The implied insult to Lewis was duly noted and reported in the *Daily Express* in September 1930. Seizing the opportunity for paying Wyndham back, Lewis was quoted in the article as denying having based any of the characters in *The Apes of God* on Wyndham or anyone else. 'I don't think there is anything in the book in the least resembling Captain Richard Wyndham. Is it possible that he has chosen a figure in the book as being himself? If so, it is all imagination on his part.' The denial was not convincing. In the flyer he had printed that same month to draw attention to the case (and to add topical spice to a pamphlet he published called *Satire & Fiction*), Lewis described the wealthy Wyndham as suffering, like all members of his class, from chronic childishness, and poured scorn on his pretensions to be a painter.

No one knows what happened to *Kermesse*. Was it sold, or put into storage? Or did Wyndham, stung by Lewis's invective, decide to destroy the work himself? In any case, there has been no trace since 1930 of a painting that was perhaps the earliest and boldest statement of pre-war avant-gardism by one of England's most brilliant – if also combative and unpredictable – modern artists.

– – – –

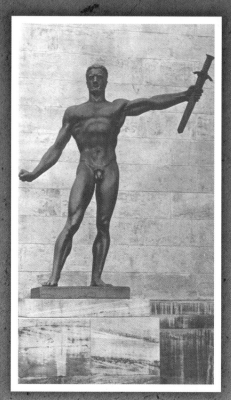

Discarded
Missing
Rejected
Attacked
Destroyed
Erased
Ephemeral
Transient
Unrealised
Stolen

8

Regime Change

Torch Bearer and *Sword Bearer* 1938
Arno Breker 1900–1991

In January 1938 the German Chancellor Adolf Hitler, dissatisfied with Berlin's eighteenth-century Chancellery, asked his chief architect Albert Speer to design a grand new complex of government buildings. In his memoirs Speer recalled his meeting with the German leader:

> 'I have an urgent assignment for you', he said solemnly ... 'I shall be hold-ing extremely important conferences in the near future. For these, I need grand halls and salons which will make an impression on people ... I am placing the whole of Voss Strasse at your disposal. The cost is immaterial. But it must be done very quickly ... Can you be done by January 10, 1939? I want to hold the next diplomatic reception in the new Chancellery.' I was dismissed.

Speer quickly selected artists to create a suite of decorative works for the New Reich Chancellery. Having already undertaken public commissions for the regime, Arno Breker was a natural choice. Born to a stonemason father in 1900, Breker studied in Wuppertal and Düsseldorf before moving to Paris in 1927 for three years. Here he was influenced by the great French sculptor Auguste Rodin and was in contact with many leading figures in the French art world. Awarded the Rome Prize by the Prussian Academy in 1932, Breker spent a year in Mus-solini's Italy. During this period, he and other prize-winners were visited by Joseph Goebbels, later Hitler's minister for propaganda. Breker later recalled Goebbels's encouragement to the young artist to return to Germany, 'where a great future awaited'. From this point onwards Breker, influenced by Italian clas-sical art, developed an overtly neoclassical style based on an idealised vision of the human figure.

Breker returned to Germany in 1934 and received his first public commis-sions the following year. However, it was with the Berlin Olympics of 1936 that he first came to the attention of the party elite. His sculptures for the Olympic

Park, *The Decathlete* and *The Champion*, were awarded silver medals in the sculpture competition organised by the International Olympic Committee. His oversized sculptures of male and female athletic figures were based on classical models but, emphasising muscularity and power, came to symbolise the Nazi regime's vision of a Germanic super race. In 1937 Breker joined the Nazi Party and was appointed to the judging panel of the *Great German Art* exhibition, an event designed to showcase art approved by the regime (Breker was to exhibit more than forty sculptures at these shows).

Given just a few days to produce ideas for a range of works to decorate the new Chancellery, Breker envisaged for the courtyard two larger-than-life male figures to stand either side of the building's entrance. Downplaying the political content and context for his statues, he later said, 'My figures were to make sweeping gestures away from the entrance and to have a relationship to the building. I could hardly install Adam and Eve there. In my view, the only sensible embellishment was to set a spiritual man on one side, symbolised by a flame, and on the other, the defender of the country, a man with a sword.' Soon after they were installed, however, Hitler renamed the statues *The Party* and *The Army*, identifying them with the two supposed cornerstones of the Reich's spirit and power. Breker's place as the Nazi Party's preferred artist was now secure. His works were promoted across the Reich – and beyond – as the embodiment of its cultural policy. In 1940, for example, Breker and Speer were chosen to accompany Hitler on his victory tour of Paris as representatives of National Socialist culture, and Breker was the only German artist to exhibit in occupied France, with a show at the Musée de l'Orangerie des Tuileries two years later when he was Vice-President of the Reich Chamber for the Visual Arts.

While modernist and Jewish artists were persecuted, imprisoned and in some cases murdered by the Nazi regime in Germany and in occupied countries, Arno Breker ran an extremely large and profitable studio during the war years. His personal wealth soared as commissions flooded in. The mass-production side of his workshop, the Arno Breker Works, made millions of reichsmarks per year. He also received lavish gifts from Hitler, being given a newly refurbished castle in the Brandenburg countryside for his fortieth birthday. In 1944, as the war entered its final and bloodiest stages, Breker was included on the list of 'God Gifted' artists drawn up by Goebbels, which ensured that he was exempted from military service as an indispensable contributor to German culture. That same year, the documentary *Arno Breker: Hard Times, Powerful Art* was produced by the film company of Leni Riefenstahl, another favourite of the regime. Inevitably, Breker was seen as a traitor by many of his fellow artists, particularly those who were persecuted by the Nazis.

As the war drew to a close, Breker and his wife fled to Bavaria, where they survived the German surrender. Although he and his work had been publicly endorsed by Hitler and other senior figures in the party, Breker, at his denazification hearing held in 1948, was judged to have been merely a 'fellow traveller'

of the Nazi regime. The board considered his famous New Reich Chancellery sculptures but found that he had created them in a spirit of apolitical classicism, arguing that Hitler, not the artist, was responsible for their political message when he renamed them *The Party* and *The Army*. Breker was ordered to pay only a small fine.

Notwithstanding his close personal and financial involvement with the regime's leadership, Breker for his part claimed that he had always focused entirely on his work and had not paid attention to government policies. He prided himself on having helped 'my persecuted friends' and having got a Jewish artist's model out of prison in Paris. In an interview of 1979 he claimed, 'Not a single word was ever spoken about the concentration camps. I lived like a pure fool in this period. I lived for my work alone.' To the end, he denied a political reading of his sculptures, writing in 1990:

> I have never intended to glorify any system of government through my artistic work ... if I glorify anything, it is beauty. The beauty of the human being, the beauty of the human body ... I have striven for the ideal ... no one who looks at my artistic work and judges it objectively can in good conscience suspect that it served to promote fascist ideology. The depiction of the human image in my way of thinking is a clear denial of everything inhuman.

Breker supported himself in the postwar years through working as an architect for a large company. He continued to produce idealised sculptures of the human figure for private clients, though not on the monumental scale of before. Outside of a small circle of supporters, however, he found himself ostracised by the art world for his political affiliations and condemned as an artist for having no original ideas of his own.

In recent times, as the shadow of the Nazi years has slipped away, some have attempted to review his work as he himself wished – as expressions of one man's vision of human beauty – without the taint of facist ideology. Few works of either his early Paris period or the Nazi years, however, have survived. The Allies destroyed most of his public work during or immediately after the war (and archives that might throw light upon his involvement with the regime were lost in the war or are otherwise not available to researchers). Breker complained in his late years that he had been 'totally deprived of the impact of my artistic achievement'. However, some would like the lack of evidence of Breker's activities to remain a brake on any attempt to rehabilitate his name.

Torch Bearer and *Sword Bearer* were among Breker's most important works, but what exactly happened to them remains a mystery. Although the New Reich Chancellery buildings were badly damaged by Allied bombing, the statues survived the war. Soviet occupying forces tore down what remained of the complex around 1946 and used its stone and marble to construct East Berlin

underground stations and the Soviet War Memorial that still stands in Berlin's Treptower Park. Photographs taken by Allied soldiers of the Chancellery court-yard, however, indicate that Breker's sculptures were removed sometime before the building was pulled down by Russian troops.

Ironically, Breker's sleek, monumental figures fitted with both fascist and communist ideologies. The Russian leader Stalin approved of Breker's work, of-fering the sculptor a commission in 1946. Breker refused, famously claiming 'one dictatorship is sufficient for me'. But many of his sculptures, including works from his Berlin studio and workshop, were taken by Soviet forces to Moscow after the end of the fighting as official spoils of war.

Questions surrounding the fate of much of the art looted from Germany in the aftermath of the conflict remain contentious and unresolved. In 1999 the Russian government passed a law claiming ownership of looted artworks, but in an effort to open dialogue German cultural institutions issued in 2007 a cata-logue of 180,000 items that many believe are stored in secret depositories in Russia and Poland. If this is the case, it remains possible that *Torch Bearer* and *Sword Bearer* still exist. Although there is nothing to indicate that the sculptures will ever come to light, these icons of German fascism are widely considered 'missing' rather than destroyed.

————

~~Discarded~~
Missing
~~Rejected~~
~~Attacked~~
~~Destroyed~~
~~Erased~~
~~Ephemeral~~
~~Transient~~
~~Unrealised~~
~~Stolen~~

9

Betrayal

The Wounded Table 1940
Frida Kahlo 1907–1954

Size in art matters – or, at least, is significant. When the twenty-five-year-old Picasso set about painting *Les Demoiselles d'Avignon* in 1907, he was little known outside a select circle; and the huge canvas was not exhibited publicly for nine years. But in choosing to attempt his largest canvas to date, just short of two-and-a-half metres tall and nearly as wide, he was making a statement. Not only was he attempting to reconfigure the style of some past and present masters – El Greco, Gauguin, Cézanne and Matisse – but he was also aiming to present the viewer with an imposing and unforgettably searing vision of life, stripped of traditional decorum and classical ideals. The Mexican painter Frida Kahlo likewise aspired to achieve something grand, even theatrical, when in 1939 she briefly set aside her usual quite small and domestic-sized canvases and tackled the nearly two-and-a-half-metre-wide panel that became *The Wounded Table*.

The context was the imminent approach of the *International Exhibition of Surrealism* that was to open in January 1940 in Mexico City. Kahlo had first met the leader of the French surrealists, André Breton, in 1938 when he came to Mexico and visited her and her husband, the famous muralist Diego Rivera, together with the exiled communist leader Leon Trotsky, who was then staying with them. Enchanted by her, Breton memorably described her art as 'a ribbon around a bomb' and claimed he saw 'pure surreality' in her work, though she had had no prior knowledge of the surrealist movement. Lured by the prospect of a solo exhibition, Kahlo travelled to Paris in January 1939, only to find Breton had arranged nothing. An alternative show was quickly planned, and the Louvre acquired a painting of hers from it; but she always remained disdainful of 'this bunch of cuckoo lunatic sons of bitches of surrealists' with their talk of poetry and the unconscious. However, the 1940 exhibition in Mexico City – the first major exhibition of the surrealist movement in her home country – was her big chance to impress.

She submitted two extraordinarily large paintings: *Two Fridas* 1939, which was finished some months before, and *The Wounded Table*, which Kahlo was

still working on just days before the exhibition opened. In a letter to her close friend and former lover Nickolas Muray in January 1940, she writes she was working 'like hell' to finish the painting. She also reveals that she was feeling 'lousy' ('Every day worse and worse'). After many bruising years of an on–off relationship, and affairs on both sides, her divorce with Rivera had been finalised on 6 November. At the same time, she had had more traction to help sort out the pain in her weak and damaged spine; a fungal infection in her hand made it painful for her to paint; and she had started to drink heavily. And yet she clearly was determined to create an impact in this exhibition. Although she genuinely preferred to work on small canvases, not least because she often needed to sit, or even lie in bed, while painting because of her ailments, it seems that she wanted to prove that she was capable of producing grand statements, of a scale that could at least rival that of her husband, who was famous for his massive mural paintings. (In fact, Rivera's submissions to this exhibition turned out to be smaller than Kahlo's works.)

All of Kahlo's works are about herself. This was her unique and defining trademark as an artist, expressed typically through an imagery that situated her 'self' amid the characters and events of her personal life, and also within the context of the contemporary drive towards reclaiming Mexico's indigenous culture (an impulse that played a determining role in the art and political beliefs of both Kahlo and Rivera). 'My subjects have always been my sensations, my moods and the profound reactions that life has produced within me', she wrote in October 1939. She went on to say that she aimed to crystallise, or 'objectify', these emotions in her repeated images of herself, 'as sincere and as real as I could make them for the expression of what I felt for myself and before myself'.

How, then, was Kahlo's intensely personal and introspective imagery to achieve a grand scale? For *The Wounded Table*, she chose two powerful pictorial traditions to frame, and give greater resonance to, her self-representation. The first was the metaphor of life as a performance on stage. In her wide painting, theatre curtains frame the scene, while a tipped-up stage and painted backdrop complete the viewer's sense of watching some sort of allegorical play. Kahlo's work was grounded in realism and close observation but it also embraced the theatrical possibilities of disguise, pretence and fantastical narratives. The second pictorial tradition was the Christian iconography surrounding Christ's Last Supper and his impending betrayal by one of his disciples, Judas. As in traditional depictions of the scene, Kahlo (who, like Christ at his death, was then thirty-three) placed herself at the centre of a table. Standing behind her with one arm around her shoulder is a large 'Judas figure'. In Mexican villages and towns on the Saturday before Easter, Judas figures made from bamboo and papier mâché, with sometimes the faces of hated politicians or notorious criminals, were hoisted above the gathered crowds and exploded, limb by limb, through fireworks attached to them. Kahlo had such a Judas figure in her home, dressed, as

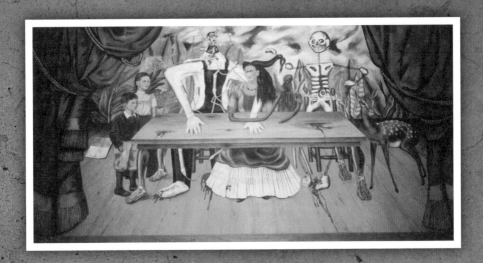

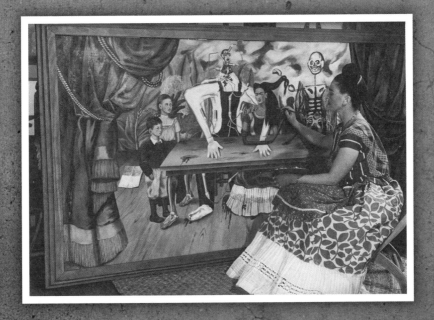

shown in the painting, in Rivera's overalls. Although the overalls may have been a domestic joke, the symbolism linking Rivera with Judas in the painting was obvious: notwithstanding their open marriage, Rivera's persistent philandering had been a source of pain for her.

To Kahlo's other side is a terracotta figurine, a grave good from the Nayarit region of Mexico. Kahlo's arm has become one with the figure and offers a cup to the inanimate object. The implication was that Kahlo was indissolubly linked with her Mexican identity – and accepted the obligation to make the sacrifices necessary to preserve it. The other elements expressed different aspects of Kahlo's thoughts about herself. Based on an actual life-size papier-mâché figure, the female skeleton seems to have symbolised both death and Kahlo herself. In the painting, it is shown with an injury to the pelvic area, in the same place that Kahlo herself was pierced by a metal railing in a horrific tram accident she suffered in 1925; it is strapped to a chair in a way that recalls the years that Kahlo was in traction or had to wear a back brace; and the right foot is missing toes just like Kahlo's own foot (she had some toes amputated in 1934, as a consequence of the polio she suffered from as a child). The deer was Kahlo's pet deer (she kept many animals in her home). Immersed in the folklore of indigenous Mexican peoples, Kahlo may have known that the Nahua people believed that different parts of the human anatomy were governed by various animal types, and that the right foot – Kahlo's damaged limb – was associated with deer. Finally, the children were faithful portraits of Kahlo's niece and nephew, Antonio and Isolda, children of her sister Cristina. Cristina had had an affair with Rivera some years previously, a betrayal that Kahlo had found devastating. The presence of the children may symbolise Kahlo's sadness at her inability to bear children or, perhaps more likely, may allude to this episode.

At the heart of this painting was the theme of betrayal. Kahlo may well have considered herself betrayed by fate (the bout of polio when a child and the tram accident when she was eighteen), by her body (she underwent a seemingly unending series of operations), and by those around her (her husband and her sister). At the centre of the painting is a table with human feet, dripping blood from its 'wounds'. There is a sense that the table – the subject of the work's title – can be seen as another representation of Kahlo or what Kahlo felt about herself. 'Sadness is portrayed in all my painting, but that is my condition', she once said. 'I can't be fixed.'

The Wounded Table was certainly not lost in the midst of the surrealist exhibition. Struck by the painting's macabre aspects, one critic urged visitors to look out for 'this marvel ... I am left frightened before a painting of somnambulist horror'. But its future was not secured either. Kahlo hoped to send *The Wounded Table* to an exhibition in a New York gallery, but this came to nothing and in June 1940 she wrote to Rivera, 'unfortunately I don't believe my work has interested anyone. There's no reason why they should be interested and much less that I should believe that they are.'

The painting appears to have hung in her home until 1946 when, it seems, she entrusted it to the Russian ambassador in Mexico, possibly with a view that it should be given to a museum in Moscow. Notes of an interview she gave to a reporter in 1949–50 confirm this but do not reveal any details. Both Kahlo and Rivera were committed communists and like a number of other artists in Mexico were keen to exhibit and give some of their works to communist countries around the world. In the 1950s, Kahlo became more and more fervent in her political beliefs and worshipped the Soviet leader Joseph Stalin. In July 1954, just a few days before she died, she took part in a demonstration against the CIA-sponsored coup against the democratically elected president of Guatemala, while in a wheelchair and against her doctor's orders.

The last trace we have of *The Wounded Table* is the catalogue of an exhibition of Mexican art held in Warsaw, Poland, in February 1955. The catalogue does not indicate who then owned the painting, but it does refer to a 'museum in Moscow' among the lenders. It is possible, though unproven, that this painting was then owned by a Soviet museum. However, all subsequent attempts to trace the work have failed. Given that betrayal was a major theme in the painting, it is perhaps ironic that Kahlo's faith in the people to whom she entrusted this major work should also have been betrayed. It was a painting that was intended to be hung in a public gallery and to be seen by many, but it has been lost for over half a century.

Things lost, however, may sometimes be found. Rivera was with Kahlo on the demonstration against American involvement in deposing the president of Guatemala in 1954 and in that year painted a large canvas ironically titled *Glorious Victory*, showing the director of the CIA shaking hands with the leader of the coup d'état, with workers slaughtered at their feet. The mural was shipped to Warsaw in 1956 for an exhibition that travelled around a number of eastern European countries. However, it went missing in Poland and only in 2000 did the Pushkin Museum in Moscow acknowledge that it had the canvas in its storerooms. After not having been seen in public for fifty years, it was loaned by the Russian museum to a Rivera exhibition in Mexico in 2007. The whereabouts of Kahlo's missing work are unknown, but the story of the unexpected recovery of Rivera's painting means that it remains possible that *The Wounded Table* might yet be located.

REJECTED

ART COLLECTORS GENERALLY HAVE EVERY REASON TO PRESERVE
WHAT THEY HAVE ACQUIRED AND PAID FOR. BUT WHAT IF THEY DO NOT
LIKE THE WORKS OR THEY CAUSE OFFENCE? CAN OWNERS DO AS THEY
CHOOSE WITH THEM? WHAT ABOUT THE RIGHTS OF THE ARTIST TO
EXPECT HIS OR HER WORK TO SURVIVE? OR THE RIGHTS OF SOCIETY AS
A WHOLE, AND OF FUTURE GENERATIONS, TO BE ABLE TO JUDGE FOR
THEMSELVES THE MERITS OF AN ARTWORK?

UNTIL THE RECENT RECOGNITION OF THE MORAL RIGHTS OF ARTISTS
IN THEIR WORKS, THE LAW HAS ALMOST INVARIABLY FAVOURED THE
RIGHTS OF PROPERTY OWNERS. BUT TO TREAT A WORK OF ART AS
MERELY A PIECE OF PROPERTY FAILS TO RECOGNISE ART'S BROADER
CULTURAL VALUE. FOR SOME, ARTWORKS PROPERLY DO NOT REALLY
BELONG TO ANYONE — OR RATHER, AS AN EMBODIMENT OF THOUGHT
AND CULTURE, THEY ULTIMATELY BELONG TO SOCIETY AS A WHOLE.

10–14

~~Discarded~~
~~Missing~~
Rejected
~~Attacked~~
~~Destroyed~~
~~Erased~~
~~Ephemeral~~
~~Transient~~
~~Unrealised~~
~~Stolen~~

10

A Thirty Years War

Sculptures for the British Medical Association Building 1908
Jacob Epstein 1880–1959

When installed on the facade of the new British Medical Association headquarters in the Strand in London in 1908, Jacob Epstein's eighteen nude statues were among the most hotly debated artworks in Britain. Condemned as obscene by some and praised as bracingly modern by others, the monumental sculptures established Epstein's reputation as one of the most gifted, albeit controversial, artists of the day – but at the expense of embroiling him in what he later described as 'a thirty years war'.

Born in New York in 1880, Epstein had studied in Paris before arriving in London to start his career in 1905. He was thrilled when approached by the architect Charles Holden with the offer to provide a series of statues to decorate the second floor of the new building he was designing, the headquarters of the British Medical Association, on the corner of London's Agar Street and the Strand. Holden was keen to incorporate sculpture into architecture but wanted a simpler, more modern approach than the somewhat clichéd grand style typical of Edwardian buildings. Introduced by a mutual friend, the artist Francis Dodd, Holden found in Epstein's work the clarity and energy he sought. And Epstein found in Holden an enlightened and sympathetic patron for what was his first public commission.

Having swiftly rejected the idea of representing famous medical men, Epstein set to work with relish on the agreed theme of 'The Ages of Man'. He was apparently warned from the outset not to produce anything too outrageous, but that did not weigh with him. He later said, 'Apart from my desire to decorate a beautiful building, I wished to create noble and heroic forms to embody in sculpture the great primal facts of man and woman.' Nudity was essential (though, in fact, he later added some drapery): 'I was determined to do a series of nude figures', Epstein later recalled, and he set about 'in symbolism ... to represent man and woman, in their various stages from birth to old age'. Paid £100 per figure, he quickly set to work to produce the eighteen sculptures, each measuring about two metres in height, needed to fit within the narrow niches set between the

second-floor windows of Holden's building. Over a period of fourteen months he worked with feverish intensity. 'I had been like a hound on a leash, and now I was suddenly set free.' Most of his sculptures were demonstrably related to the classical tradition of figurative sculpture, but Epstein was fascinated by collections of non-western art held in the British Museum, and in the postures of some of his sculptures can also be seen traces of his admiration for Hindu and Buddhist sculptures. He sketched from life and made clay models, which were then cast in plaster. The plasters provided a guide for Epstein and his two assistants to carve directly into the Portland stone of the building's facade.

In this preparatory phase Epstein widened his brief beyond the Ages of Man to produce eighteen figures with a vaguely medical or scientific character. The sculptures included, for example, *The Newborn* – an elderly woman presenting a newborn child; *Chemical Research* – a male figure engaged in examination of an argument; *Matter* – a male figure presenting a rock in which was inscribed the form of a foetus; and *Primal Energy* – a male figure breathing life into the atom. When the first set of plaster models was submitted to Holden for approval in the summer of 1907, the architect rejected only one. Titled simply *Nature*, this showed a walking naked woman holding a leaf: the figure's unapologetic nudity and references to the stylised poses of Asian art were perhaps too much for even this forward-looking Edwardian.

From the summer of 1907, Epstein and his assistants began the year-long process of carving the figures into the building's facade, bringing the plaster casts to site and taking them beneath a covered scaffold to carve while keeping the entire series from public view until its completion. In the summer of 1908 the plaster cast of one of the last figures to be carved – *Maternity* – was delivered to the site. Unfortunately, while waiting outside the scaffolding for its accompanying infant, this two-metre-tall female nude, inexplicably staring down at her own body, caught the attention of the British Medical Association's neighbours on Agar Street, the National Vigilance Association for the Repression of Criminal Vice and Public Immorality, an organisation that campaigned against prostitution and indecent publications.

Although the details of the carvings high up on the building were not easily visible from street level, the National Vigilance Association started a public campaign against the sculptures and their possible corrupting effects on young people. It lobbied the British Medical Association and sent letters of protest to key public figures and the press. London's *Evening Standard and St James' Gazette* called for the removal of the figures, 'a form of statuary which no careful father would wish his daughter ... to see'. Author of *The Sins of Society* 1906, Father Bernard Vaughan was quoted as saying, 'Let us not ... convert London into a Fiji Island, where there may be some excuse for want of drapery ... to the average man or woman ... these figures will be occasions ... for vulgarity and unwholesome talk, calculated to lead to practices of which there are more than enough in the purlieus of the Strand already.' The fuss had the opposite effect intended, and

for a period passengers in open-topped buses, Epstein recorded, would 'stand up in a mass and try to view the now famous Strand Statues'.

Epstein's 1907 plaster casts compared with the sculptures as photographed in situ in 2007. From left: *Youth*; *Maternity*; *Matter*.

Publicly expressing his personal dislike of the sculptures, the chairman of the British Medical Association forced Epstein to account for his work to a committee. Yet London's artistic community rallied in support. The artist Eric Gill declared the figures 'far from being indecent, to be almost ascetic in character'. Professor Charles Holmes of Oxford University, art historian and poet Laurence Binyon, artist Charles Ricketts and the editorial team of the *Times* newspaper all made public statements defending the works. The matter was decided in July 1908 when the British Medical Association consulted Sir Charles Holroyd, then director of the National Gallery. After Holroyd's evaluation of the sculptures as 'interesting ... dignified and reverent in treatment', they were allowed to remain in place.

Epstein's sculptures survived his critics but faced a more pernicious enemy. London was then one of the most polluted cities in the world owing to its millions of domestic and industrial coal fires. Fumes mixed with rainwater to form a weak acid, leading to the gradual erosion of the alkaline Portland limestone. The process was worsened by the many deeply carved areas in Epstein's sculptures, which allowed the rainwater to collect, and by a metal ledge running above the sculptures that leached black chemicals onto the stone. As early as 1914 the discoloration of the sculptures was clearly visible. In 1924 the British Medical Association sold the building to the High Commission of New Zealand, which produced a report on the sculptures noting that owing to 'exposure to the weather ... six of them are more or less eroded'. However, no action was taken at the time.

Epstein faced controversy with other public commissions. In 1925 his sculpture of writer W.H. Hudson's heroine *Rima*, for example, was termed the 'Hyde Park Atrocity' by the *Daily Mail*, and daubed with green paint, tar and

feathers in protest at its alleged obscenity. A letter campaign waged through the national newspapers saved the sculpture, with the playwright George Bernard Shaw and sculptor Frank Dobson among Epstein's supporters. Three years later, Epstein was commissioned by Holden to produce decorations for the London Transport headquarters, and his monumental sculptures *Day* and *Night* again met with public condemnation. Newspapers campaigned to have them removed and the managing director of London Underground offered his resignation until the furore died down when Epstein agreed to tone down the sexuality of the boy child shown with *Day* by shortening its penis. Epstein, however, did not receive another public commission for over a decade.

In 1935 the government of Southern Rhodesia acquired the former British Medical Association building, and the newly appointed High Commissioner quickly made plans for the sculptures' removal. While perhaps fitting for a medical establishment, he argued, they were by no means appropriate for government offices and had nothing to do with his country. The debate over the sculptures' propriety was reignited in the face of this threat. Epstein wrote to the *Observer* on 5 May 1935 that the sculptures were part of the building and any attempt to remove them would damage them: ownership, he said, 'does not give the right to remove and destroy or even the right to sell'. The art world rallied in Epstein's defence, though not without some dissent and rows. (Kenneth Clark, the current director of the National Gallery, headed a list of signatories of a letter to the *Times* saying that if the sculptures were removed or damaged, 'we find it difficult to believe that this generation will be acquitted by our successors of a charge of grave vandalism'. The president of the Royal Academy, however, refused to sign, something that caused the distinguished painter Walter Sickert to resign.) The Rhodesian High Commissioner was forced to back down temporarily.

In the summer of 1937 the coronation procession of King George VI passed down the Strand. The renamed Rhodesia House was decorated with bunting for the occasion; during the removal of these decorations part of one of Epstein's seriously eroded sculptures fell into the street, allegedly narrowly missing one pedestrian and injuring another. The High Commissioner now had a reason, or excuse, to act. A scaffold was immediately erected, and Holden was instructed to inspect each sculpture in the company of the police and a representative of the Rhodesian government. All protruding sections of the figures – including faces, shoulders and arms, and feet – were deemed hazardous and were knocked out or chiselled away.

Epstein was not allowed to inspect the sculptures, but Holden was permitted to supervise the taking of plaster casts of the sculptures, paid for by an unknown benefactor. Epstein was furious with the state of these rapidly made casts – 'complete travesties of the originals' – though having not been allowed on the scaffold he was perhaps not fully aware of how eroded they had become. In truth, the only other option would have been to have removed and replaced all the damaged parts, but it is thought that the sculptures were already in an ad-

vanced state of decay and that there was simply no money to fund this (certainly, none would have been forthcoming from the building's owners). Writing in 1958, Holden maintained that the precautionary knocking out of parts of the sculptures was not disastrous:

> Although some of the stones were disfigured in this process the general decorative character of the band of figures was not seriously destroyed, and they still convey something of Epstein's intention to portray the seven ages of man and have not lost their decorative value.

Epstein saw the matter quite differently. In his 1940 autobiography, he wrote that the greater part of every statue had been demolished. 'What is left ... is a portion of the torso here, a foreleg there, and an arm somewhere else. Not a single head remains. The mutilation was complete.' And yet these were important works, he felt: 'Perhaps this was the first time in London that a decoration was not purely "decorative"; the figures had some fundamentally human meaning, instead of being merely adjuncts to an architect's mouldings and cornices.'

Evidence today suggests that he was correct, and that what had been a grand public statement by one of the greatest modernist sculptors working in Britain before the First World War was lost, notionally on the dubious, and somewhat inglorious, grounds of 'health and safety'. 'The battle was lost', Epstein wrote in his autobiography. 'I had made my protests on aesthetic and spiritual grounds. Naturally, in a court of law I had no case, and so my earliest large work ended tragically.' As the chapters in this section indicate, for much of the twentieth century the rights of the owner of an artwork have generally prevailed over the wishes of the artist, but not without causing disquiet and regret.

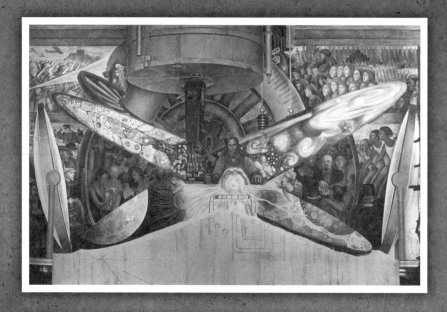

Discarded
Missing
Rejected
Attacked
Destroyed
Erased
Ephemeral
Transient
Unrealised
Stolen

11

Seeing Red

Man at the Crossroads Looking with Uncertainty but with Hope and
High Vision to the Choosing of a New and Better Future 1933
Diego Rivera 1886–1957

'It is not a legal question', he said. 'It is a moral question. They have violated two fundamental elementary rights, the right of the artist to create, to express himself, and the right to receive the judgement of the world, of posterity.' Talking to a reporter from the *New York Times* in May 1933, Diego Rivera summed up his rage at how he had been treated by the Rockefeller family and his belief – shared by many artists when the survival of their work is threatened by its legal owners – that artworks should not be treated like commodities. Individuals may own artworks, Rivera argued (like Jacob Epstein in the previous chapter and other artists before and since), but the vision expressed in the objects ultimately belonged to a culture and to future generations.

This argument alone might have generated press column inches and, had Rivera sought to pursue matters, a court case relating to a possible breach of contract. But there was also a political edge to the dispute, one that threatened to draw attention to fissures within western society at a time of significant tensions within the United States and, following Hitler's rise to power in Germany in January 1933, in the western world more generally. Underpinning the controversy – made particularly colourful by the spectacle of a charismatic artist at war with one of the richest family dynasties in the world – was a rivalry between two competing visions of the future of industrialised societies.

Brainchild of John D. Rockefeller Jr, the Rockefeller Center was a complex of fourteen high-rise buildings in the heart of Manhattan, New York. Financed by Rockefeller alone, this 'city within a city' was the largest private building project undertaken in modern times, and brought employment to forty thousand workers. By 1939, more than 125,000 people visited the art deco offices and entertainment venues in the Rockefeller Center each day; on its own, it would have been the fifty-first largest city in the country.

The Center aimed to bring together companies working at the forefront of modern communications. Radio, in particular, was quickly identified as a potent

new force, and the Radio Corporation of America (RCA) was an important early tenant of one of the buildings in the complex. (Its president was particularly forward looking, and in 1930 developed plans for television broadcasting studios in the Rockefeller Center, not only before construction had begun but also before the necessary technology existed.) The developers were clear that, 'as a monument of human skill and taste and imagination', the Center would become famous throughout the world – not just for its beauty and innovativeness, but also as 'the first clear expression in our economic life of a new social ideal, that is of human welfare and happiness as centring in the work that we do, and not in some incidental wage'. As planning documents show, this aspiration – framed at a time when everyone was becoming aware of the competition between capitalist, communist and, increasingly, fascist visions of the future – had a political resonance:

> If a whole population, such as Rockefeller will possess, can be lifted into a finer life in their working hours, then the economic democracy of America will have begun its answer to the Bolshevist challenge.

For the vast lobby in the RCA building of the complex the developers took as their theme a particularly all-encompassing subject:

> FRONTIERS OF TIME is a theme phrase which is appropriate for an enterprise indicating that here is the beginning of a new conception in the culture of America. Undoubtedly the age is ripe for such a conception. The geographical, the space frontiers of our Globe have virtually come to a close in our own day, but for the future of mankind, in the measures of time, greater frontiers are opening. Few indeed are the institutions that are not being replaced or reconstructed in society – the political, economic, religious, scientific, and perhaps of most importance the biological worlds are all undergoing transformation; and it is to discoveries along these frontiers that mankind must turn if society is to remain healthy and civilization grow strong.

Amid a huge programme of artistic commissions designed to express different aspects of this theme throughout the Center, the Mexican muralist Diego Rivera was one of three internationally famous artists initially approached to provide paintings for the lobby. Picasso and Matisse declined but Rivera, who then was living and working in North America, accepted, provided he was allowed to paint not on a canvas but directly onto the walls of the building.

Rivera was then very much in the public eye. Recently expelled from the Mexican Communist Party for his anti-Stalin views, he had come to the United States in 1930 to work on a mural in San Francisco at the invitation of an architect, and had stayed in the country with his wife, the artist Frida Kahlo, working

on various commissioned murals. In 1931 he had a retrospective exhibition at the Museum of Modern Art in New York that broke the previous attendance record. The *New York Sun* hailed him as 'the most talked about artist on this side of the Atlantic'. Significantly, the wife of John D. Rockefeller, Abby Aldrich Rockefeller, was one of the founders of the museum; unperturbed by Rivera's communist beliefs, she bought a sketchbook of the 1928 May Day parade in Moscow at the time of the retrospective.

Curiously, those on the political right and on the political left in this period could agree that the success of the economy and quality of life hinged upon the role of the modern industrial worker. To display sympathy with, and faith in, workers made enlightened capitalists look benign. Similarly, communists could point to the qualities and aspirations of workers as key to future social development, though blaming capitalists for oppressing workers and growing rich on the profits of the labour of others. In 1932 the president of the Ford Motor Company commissioned Rivera, notwithstanding the latter's known political beliefs, to create a series of murals for the Detroit Institute of Arts. Basing his imagery on what he saw around him in the city, and in particular on scenes in the Ford plant, Rivera provided murals of a complex iconography. Today the murals in Detroit are seen as among the best of his career, but when they were unveiled many people were shocked. Some disliked the representation of the workers of differing races labouring next to each others; others felt the nudes were less symbolic than pornographic in their earthy quality; and some Christians were offended by an updated nativity scene in which the three wise men were replaced by white-coated doctors administering vaccine to the baby Jesus.

The Detroit controversy should have given Rockefeller pause for thought, though by this point he had already commissioned Rivera. The Mexican, however, was seen as one of the most gifted artists of modern times, and his planned interpretation of the chosen theme for the New York mural appeared to fit the brief well enough. His early sketches – submitted to and approved by the developers – show that he responded positively to the Center's theme of 'Frontiers of Time', and, in particular, to the idea that new technologies of communication would transform society. On either side of the central emblematic figure of a male worker controlling machinery are large cinema and television screens. They show scenes of a May Day parade in Red Square, Moscow, workers' unrest in Depression America, and young girls exercising – sights that Rivera selected as emblematic of the forces at work in contemporary society. (The images remained in the final composition, though it was no longer so evident that they were projected or televised scenes.) Behind the central figure in Rivera's plans are two ellipses representing the lenses of a microscope and a telescope, suggesting that modern man was engaged in learning about, and mastering, all aspects of nature. The left- and right-hand panels show, respectively, lightning hitting the hand of Jupiter and being transformed into electricity, and the overcoming of tyranny (a crumbling statue of Caesar) together with the discovery by workers of

their rights to the products of their labour. Most strikingly, the sketches for the massive mural are crowded with anonymous people, a feature that satisfied both Rivera's desire to forefront ordinary workers in all his paintings and the vision of the site developers that the Center was to be for a broad public.

The devil, however, was in the detail. Rivera was not someone who would be content with vague symbolism, and as he worked on a commission he tended to incorporate portraits of real people (often those working with him) or use photographs of contemporaneous events. To capture the spirit of the city in the Detroit murals, for example, he spent time in the Ford factories, seeing industrial machinery at work. For the Rockefeller murals, he painted the portraits of project assistants and incorporated imagery taken from press photographs of a workers' demonstration in Wall Street. In other words, Rivera's compositions tended to evolve, and, indifferent to the sensitivities of those who commissioned him, he also sharpened their political messages as he worked.

Things began to go wrong when the press got wind of the 'communist activity' shown in the mural. On 24 April 1933, the *New York Telegram* wrote:

> Diego Rivera, great Mexican mural painter, over whose shaggy head many storms have broken, is completing on the walls of the RCA Building in Rockefeller Center a magnificent fresco that is likely to provoke the greatest sensation of his career.

> The painting is a forthright statement of the Communist viewpoint, unmistakable as such, and intended to be unmistakable, and it is being paid for by John D. Rockefeller, Jr., whose opposition to collectivist principles has been unwavering for a lifetime.

This 'opposition' was associated in the public mind with Rockefeller's involvement in a notorious suppression of a strike in 1913, which had left forty workers and thirteen women and children dead. A pivotal moment, it led to him withdrawing from business and focusing on a lifetime of philanthropy. The Rockefeller Center was his first public foray back into the world of business, and the use of Rivera – a self-professed champion of the working class – now threatened to rake up memories of class conflict that he had worked hard to bury. It did not matter that the Rockefellers personally admired Rivera as an artist, or that Rivera was quoted in the same article speaking about his efforts to create a beautiful and effective image in the setting of the new building: the political gulf between them was real and could barely be disguised by the veil of enlightened patronage.

In these circumstances it is hard to understand why in the next few days Rivera chose to add the face of Vladimir Lenin, leader of the Bolshevik Revolution and founder of the Communist Party, to the mural (let alone the Soviet

Photograph taken by Lucienne
Bloch of the head of Lenin in
Rivera's mural.
————

————
Photograph taken by Lucienne
Bloch of an assistant looking
at the Soviet emblem of the
hammer and sickle hidden in
the image of a star.
————

emblem of a hammer and sickle, disguised among a grouping of stars and spotted only by those working with him on the mural). It may have been devilment; it may have been a riposte to those in the Communist Party who accused him of being a capitalist lackey; it may have been an honest evolution of his ideas about how best to represent the idea of political leadership in a future society (Lenin is shown clasping the hands of workers of all races, watched by a pair of lovers). Or Rivera, acting as a revolutionary, may have judged it the right time to pin his true colours to the mast. Interviewed a couple of weeks later, Rivera talked about having come to America to advance the cause of the workers but having had to do so surreptitiously and slowly. 'Sometimes in times of war a man disguises himself as a tree. My paintings in this country have become increasingly and gradually clearer.'

Nelson Rockefeller, son of John and Abby and, like his mother, a trustee of the Museum of Modern Art, was in charge of the Center's art commissions, and while visiting the mural in progress spotted the inclusion of Lenin. On 4 May 1933, he wrote to Rivera, politely asking him to remove the portrait. 'The piece is beautifully painted but it seems to me that his portrait appearing in this mural might very easily seriously offend a great many people.' Rivera refused, though offered to add great American leaders such as Abraham Lincoln to counterbal-

ance Lenin. But he would not abandon his plan to present Lenin as a model of the 'leader of the future'.

In initial correspondence about the commission, Rivera had talked in general terms about representing 'harmony between men and with nature' through groupings of different generations and types of people in a rhythmic and balanced composition. The Center's rental manager Hugh Robertson therefore complained with some justice that it had been understood that the mural would be 'purely imaginative' and that Rivera had not given any indication that the mural would include 'any portrait of any subject matter of a controversial nature'. Matters quickly became ugly. On 8 May, Kahlo urged a young female assistant on the project called Lucienne Bloch to take photographs of the work as things were 'getting pretty serious' (if she had not done so, there would be almost no visual record of the mural; as it is, there is no photograph known of the right-hand panel, although this may have been because work on it had not started or was not sufficiently advanced).

The Rockefellers and the developers decided to end the dispute and to do so decisively. On the evening of 9 May, the building was filled with armed security guards, the telephone line was cut, and Rivera and his team were ordered out. Rivera was paid the remainder of his fee but was not allowed to re-enter the building to complete his work or to photograph it. A demonstration of art students and supporters of Rivera around the building, quickly organised by the project team, was broken up by mounted police a few hours later.

The decision to dismiss one of the world's most famous artists from one of the most prestigious architectural developments of the age predictably caused a storm of protest. Humiliated and angered, Rivera said his work had been 'assassinated' and compared what had happened to the mural – it was quickly covered over by paper by the site's owners – as akin to the Nazis in Germany burning the books of those whose opinions they despised and sought to eradicate. Rivera addressed various gatherings and spoke on the radio, while supporters wrote to the press, organised meetings, signed petitions and even picketed and shouted outside Rockefeller's home. A group of artists and writers petitioned Rockefeller directly to allow Rivera to continue work on the mural, writing, 'The completion of these murals by the artist seems to us of extreme importance for American art of the present and of the future.' But the Rockefeller family remained silent and stood firm; and the Center opened with the murals completely hidden under a covering of canvas.

The denouement of the saga came nearly a year later. Notwithstanding talk of finding a way to transfer the mural onto canvas and thus preserve it, the mural was destroyed in February 1934. It was chipped off and the surface replastered one night, with the excuse given that it had proved necessary to remodel that area of the building and to do so at a time that caused the least disturbance. This reignited the public debate about the rights and wrongs of the case. One thousand people, mainly artists and writers, gathered in New York to voice their

protest and there were complaints in the press about this drastic action. Many people might have agreed that Rivera's political opinions were out of place in the Rockefeller Center, but he was a popular artist who had been denied the opportunity to finish his work, and possibly create something of lasting value for everyone, simply because of his political beliefs.

The controversy ended Rivera's career as the mural painter of choice for America's capitalists. A commission to paint a mural for the Chicago World's Fair was cancelled. No other work was forthcoming, and Rivera found himself with no option but to return to Mexico. Happily for him, a commission in 1934 to paint a mural at the Palacio de Bellas Artes in Mexico City on an even grander scale allowed him to return to the theme, using the photographs taken by Lucienne Bloch. Seeking a modicum of revenge, Rivera included a portrait of Rockefeller on the left (negative) side of the composition, under the lens-shape showing nature become unhealthy, symbolised by diseased cells.

Given that Rivera was able to repeat the work, admittedly with minor variations and on a different scale, it could be asked what exactly was lost when his original mural was destroyed. Perhaps it was not so much the physical manifestation of the work itself but rather the possible conflation of two otherwise inimical utopian visions of society, one capitalist, the other communist, within the context of a forward-looking complex in the heart of Manhattan with all that that could have meant for the future. The story of Rivera's lost mural is, in part, the story of this lost context, this lost possibility.

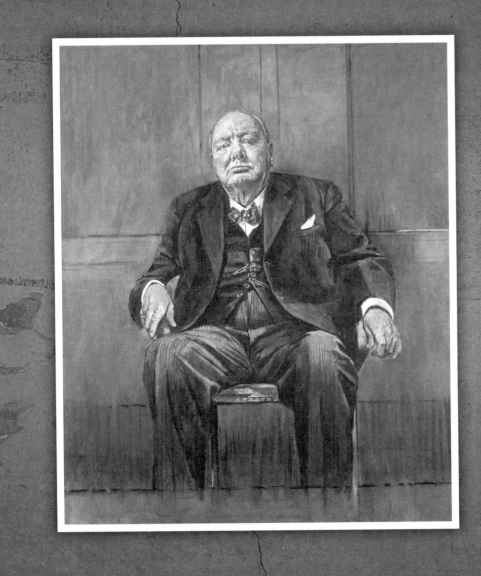

~~Discarded~~
~~Missing~~
Rejected
~~Attacked~~
~~Destroyed~~
~~Erased~~
~~Ephemeral~~
~~Transient~~
~~Unrealised~~
~~Stolen~~

12

An Unwanted Present

Portrait of Sir Winston Churchill 1954
Graham Sutherland 1903–1980

The question of what to do with an unwanted birthday present is something that most of us have wrestled with. Many people quietly resort to the use of a waste-paper bin, a cupboard or charity shop to solve the dilemma. But Winston Churchill, Britain's indomitable leader during the Second World War and world-famous statesman, faced a more difficult decision when, in his last years, he reflected on what to do with an important portrait of himself that he utterly loathed.

The public profile of the portrait – and the difficulty of disowning it – could hardly have been bigger. It was commissioned and paid for by members of parliament to mark his eightieth birthday. Churchill had had an extraordinary career in the House of Commons. He had been first elected as an MP in 1900, and held senior cabinet positions in a number of governments before becoming prime minister in 1940 and again, despite his age and growing health problems, in 1951. Members of both houses of parliament wanted to mark his long years of public service and hit upon the idea of commissioning a full-scale portrait that they would present to Churchill on his birthday in 1954 in a public ceremony.

Paid for not by the state but by private donations, the commissioning of the portrait was an unprecedented gesture, based on all-party respect and admiration for the serving prime minister. As Clement Atlee, leader of the Opposition, said at the grand presentation ceremony in which the portrait was unveiled, it was a 'tribute of esteem and affection to a most distinguished member of our parliamentary family'. Filmed by the BBC, Churchill responded to the historical significance of the event in his acceptance speech.

> This is to me the most memorable public occasion of my life. No one has ever received a similar mark of honour before. There has not been any-thing like it in British history ... I am now nearing the end of my journey. I hope I still have some services to render. However that may be and whatever may befall, I am sure I shall never forget the emotions of this day

or be able fully to express my gratitude to those colleagues and companions with whom I have lived my life for this wonderful honour they have done me.

But he had little to say about the portrait itself. He described the canvas evasively as 'a remarkable example of modern art'. Acknowledging that it was less than flattering, he managed to get a laugh from the packed audience in Westminster Hall by adding with perfect timing, 'it certainly combines force with candour. These are qualities which no active member of either House can do without or should fear to meet'. A performer, Churchill was putting a brave face on things but he was profoundly upset and shocked by the portrait: for many days he had been privately threatening not to come to the presentation ceremony.

Things had begun to go wrong from the very beginning. Born into the aristocracy and proud of the offices of state he had occupied, Churchill had hoped to be portrayed wearing the grand robes of the Order of the Garter. Instead, the parliamentarians who had commissioned the portrait specified that he be shown wearing his normal parliamentary clothes of black coat, waistcoat, striped trousers and spotted bow tie. It was an early sign of differing expectations about the portrait, and Churchill found himself obliged to concede the point.

The artist commissioned to undertake the portrait was Graham Sutherland, a leading British painter who had a reputation for being a modernist but who had also recently undertaken some portraits of leading political and literary figures. Sutherland aimed neither to flatter nor to denigrate but rather – and herein lay the danger for his sitters – to capture something of the truth of a person. He talked of himself being at the mercy of his sitters, whose moods and expressions dictated what the portrait would look like. But his willingness to present unflattering aspects, to capture people in informal, unconsidered poses, caused sitters some awkward moments, as he later acknowledged:

> I think it is true that only those totally without physical vanity, educated in painting or with exceptionally good manners can disguise their feelings of shock or even revulsion when they are confronted for the first time with a reasonably truthful painted portrait of themselves. Many people have the fixed idea that my portraits are cruel. I do not aim to make them so ... but I do *look* at the person whose characteristics I try to record.

Needing to complete the portrait before Churchill's birthday on 30 November, Sutherland went to his home Chartwell, near Westerham in Kent, for the first of the sittings in late August. During the sessions – there were less than ten in all – he drew pencil and charcoal sketches of Churchill, particularly his face and hands, and produced a small number of oil studies. The photographer

Elsbeth Juda was also asked to take photographs of Churchill in his portrait pose for the painter's use. Each day Sutherland would then return to his own studio where he kept the large canvas and try to capture different aspects of Churchill's face and expression based on his memory, his sketches and the photographs.

During the sittings the two men talked amicably about a range of topics: Churchill was an amateur painter and took a close interest in the work and in how he was being portrayed. However, Sutherland did not like showing him how things were developing and fobbed him off as politely as he could with drawings that he did not mind showing. Significantly, these did not give Churchill any sense of what the final portrait would look like.

Sutherland was slightly in awe of Churchill, and saw in the aged politician the great 'bull dog' who had saved Britain during the war. He was also very aware of the current discussions in both Conservative and Labour camps about whether Churchill should step down because of his age and poor health (that spring the *Daily Mirror* had called the prime minister 'the Giant in Decay'). Churchill was vexed about this, and during the sittings complained angrily about those who believed he had had his day. Sutherland later said,

> Repeatedly I was told: 'They (meaning his colleagues in the Government) want me out. But' – and this is a paraphrase of the actual conversation – 'I'm a rock'; and at that the face would set in furious lines and the hands clutch the arms of the chair.

It was no coincidence therefore that Sutherland chose a large squarish canvas for the portrait. Beyond echoing the pose of the famous 1920 sculpture of the great American President Abraham Lincoln in the Lincoln Memorial in Washington, D.C., Sutherland later explained, 'I wanted to paint him with a kind of four-square look – Churchill as a rock'. Perhaps, for all his later protestations, Sutherland did not just paint what he saw, but was influenced by this conception he had of the great man.

Intimations of trouble came when those who saw the portrait reported mixed feelings. Churchill's son Randolph thought his mother would not like it as it made Churchill look 'disenchanted'. Randolph's wife June thought it 'really quite alarmingly like him' but added in her letter to Sutherland, 'I wish he didn't have to look quite so cross, although I know he often does.' (Juda's photographs are evidence that Churchill could indeed look cross and disenchanted without necessarily meaning to, but that he also smiled winningly and at times was jovial during the sittings.)

Still Sutherland did not show the work to Churchill, despite having been asked to do so. On 20 November – only ten days before the official presentation – Churchill's wife saw the work and brought back a photograph to show Sir Winston. He was upset and angered, and, at the risk of upsetting the plans for the grand unveiling ceremony, sent a handwritten note to Sutherland by prime

ministerial limousine the next day, courteously but firmly rejecting the work. He wrote:

> Personally I am quite content that any impression of me by you should be on record. I feel however that there will be an acute difference of opinion about this portrait and that it will bring an element of controversy into a function that was intended to be a matter of general agreement between the Members of the House of Commons, where I have lived my life. Therefore I am of opinion that the painting, however masterly in execution, is not suitable as a Presentation from both Houses of Parliament. I hope therefore that a statement can be agreed between us which will be accepted by the Committee.

Churchill indicated that the ceremony could go ahead simply with the presentation of the book signed by contributors, though 'it is sad there will be no portrait'. Sutherland sent a note back expressing his regret but saying that he had painted honestly what he saw, a line he stuck to whenever discussing this portrait or portraiture in general. He later said: 'Churchill often showed me the greatest charm and could not have been kinder ... But I draw what I see; and 90 per cent of the time I was shown precisely what I recorded.'

So what did Churchill object to? From comments that have been recorded, it seems that the way his body had been shown sitting, somewhat slumped, in the chair struck him as offensive in its lack of dignity (he compared the position to that of sitting on a lavatory). The unflinching gaze and the lopsided mouth disappointingly suggested that the painter had seen little nobility or charm in his sitter, though the parliamentarians who had commissioned the work had done so as a token of their affection for him. Churchill was reputed to have said that the portrait made him look half-witted, but he may also have been privately anxious about the portrait revealing the stroke he had had the previous year, which he had so far successfully hidden from the general public. Although he always remained on civil terms with Sutherland, he also felt betrayed on a personal level, thinking that the painter, to whom he had displayed much politeness, should have shown him the work earlier, and that in not doing so, he had been pulling a fast one. Churchill may also have suspected that, as someone with contacts with the Labour Party, Sutherland may even have been politically motivated at some level in choosing to depict him as decrepit: the portrait seemed to echo the message of those who argued that he should step down. Finally, it was too painful for a proud man with an acute sense of his place in history to consider such an unflattering representation of him in his old age hanging permanently in the Palace of Westminster (it was intended to be installed there after Churchill's death). Over the next few days, however, the secretary to the committee that had commissioned the work and was organising the presentation persuaded Churchill that he simply could not decline the portrait without giving huge and lasting

offence to those who had contributed to its cost; reluctantly he agreed.

Reactions to the portrait when it was unveiled at the grand presentation ceremony and when press images were released were mixed. Those who admired Sutherland as a modern, uncompromising artist felt it was a great work. The *Spectator* critic said it would remain 'by far the best record of the Prime Minister which we shall bequeath to posterity'. While noting that the legs strangely faded out towards the bottom of the painting, the *Times* critic said it was a 'powerful and penetrating image'. Labour MP Henry Usborne noted that it might come to be regarded as the greatest portrait of the century, though most members had wanted to give not a great painting but one that Churchill himself would like. Others, however, were virulent in their dislike. Lord Hailsham said, 'If I had my way, I'd throw Graham Sutherland into the Thames. The portrait is a complete disgrace ... It is bad-mannered; it is a filthy colour.' Sutherland and his wife had to endure exposure to these very public criticisms, knowing that the subject and many of his friends hated the work. Interviewed on the radio three days after the presentation ceremony, Sutherland felt obliged to explain his predicament as a portraitist in relation to what was rapidly being seen as a watershed moment in the history of British portraiture: 'I want neither to flatter nor to denigrate. Least of all do I want to soil and mortify.'

Seen by people for only a few days, the canvas was despatched to Chartwell, where it was unpacked but never hung. Sir Winston and Lady Churchill refused to allow the work to be exhibited or indeed reproduced, and for two decades no one saw the work. His daughter Mary Soames believed that the experience had amounted to a profound culture shock for him: Sutherland had ignored the image of Churchill as a great figure, which was known throughout the world, and had shown the image of a man in decline in a manner that arguably displayed little respect for the sitter's past or personal feelings.

Churchill died in 1965; his wife Clementine, in 1977. Sutherland's requests to include it in exhibitions of his work were ignored, and in an interview given in 1975 he talked of his fear that Lady Churchill had destroyed the painting. His intuition was proved correct when her executors confirmed that this indeed was the case, explaining that she had been distressed to see how much the picture, which both she and Sir Winston disliked, preyed on her husband's mind. According to a later report, it seems that within a year of the work's arrival at Chartwell, Clementine had smashed the work to pieces in the cellar and had given the pieces to an employee to burn in an incinerator. In effect, Lady Churchill had acted like another person might do when given a present felt to be tasteless, ugly or useless. But this was a work of art not a mass-produced, replaceable object: by any standards, the portrait was a significant work of art by one of Britain's leading painters.

Sutherland was quick to denounce the brutal destruction as 'without question an act of vandalism'. Roy Strong, director of the Victoria and Albert Museum, noted that if the portrait was the property of the Churchill family,

they could 'of course' do as they wished with it. 'But an artist tears something out of himself when he paints a portrait and to burn it is like burning a chunk of Sutherland.' Letters to the press generally took the view that Lady Churchill did not have the right to destroy a work of art, even a disturbing and upsetting one, but should simply have put it in the attic and let posterity decide its fate, though there were many who admired her loyalty to her husband. The art critic and writer David Sylvester reflected the debate neatly:

> I do not think we have the right to feel we own the works of art we have, any more than the spouse we have. Therefore we should not kill them off just because we do not like them. Still, it is arguable that a portrait of one-self, or of someone near and dear, is a special case.

Debated hotly within the press, the case famously obliged the nation to ask whether it mattered that this particular portrait of Sir Winston no longer existed. The answer was a 'yes', albeit with some sympathy for the perpetrator of its destruction.

Discarded
Missing
Rejected
Attacked
Destroyed
Erased
Ephemeral
Transient
Unrealised
Stolen

13

Breaking the Rules?

Painting-Sculpture (Painting I and Painting II) 1971
Daniel Buren born 1938

Daniel Buren's *Painting-Sculpture* 1971 was made specifically for an exhibition of contemporary art at the Solomon R. Guggenheim Museum in New York. The work consisted of two parts: a twenty-metre-long, ten-metre-wide striped cloth, intended to hang vertically in the museum's central rotunda (*Painting I*), and a smaller horizontal banner of the same cloth, which was designed to be hung in the street outside the museum (*Painting II*). Drawing attention to the museum's role in providing a physical and conceptual framework for art, the piece aimed to highlight and link the internal and exterior spaces of the famous landmark building, as well as point to the wider aesthetic, social, political and economic factors determining how art is displayed.

 The only French artist to be invited to participate in the Sixth Guggenheim International group exhibition, Buren had been flattered to have been selected and cleared his plans with the organisers well in advance. However, when *Painting I* was installed the day before the opening of the show, some of the other artists in the group exhibition objected fiercely on the grounds that Buren's work obscured their own and had a disproportionate presence. The curators took the piece down that evening, without consulting Buren; *Painting II* was never installed. A major controversy ensued about what was seen by Buren and his supporters as an extraordinary act of censorship, one that revealed a great deal about the art world. Today, *Painting I* (known only through photographs taken when the work was briefly installed) and *Painting II* (never photographed) exist in storage, but have never been seen by the public.

 Buren first came to prominence in Paris in the mid-1960s with his use of a highly restricted visual vocabulary consisting, at first glance, simply of stripes. This depersonalised vocabulary might have been seen as referencing abstraction and minimalism, but Buren used the stripes as signage rather than image: his works signified an elimination of traditional artistic concerns and a critique of the conventions and ideological interests governing art and its display. Taking as his reference point the striped awnings commonly found in France, particularly

in government buildings, and their standard stripe width of c.8.7 centimetres, Buren sought to situate his art in relation to the buildings and spaces of everyday life, in part in order to test the boundaries of the notion of art itself. Although he used readymade materials (printed paper made to order, or commercially available striped canvas), he ensured that his canvas works qualified as paintings by adding a scarcely noticeable coat of white paint to the white stripe on the left- and right-hand sides of the works.

In 1969 Buren became widely known in Paris when he pasted striped posters over hundreds of billboards, and publicised where his works could be found in the left-wing journal *Les Lettres françaises*. In late 1970 he reprised his '*affichages sauvages*' (wild posters), and pasted striped posters around New York, announcing to the art world where his works were by using gallery mailing lists. Many of his pieces, however, were pasted over immediately or, if affixed to the sides of trucks, proved impossible to find. A photograph of a poster pasted on a building in Bleecker Street was used as the cover of *Art News* in April 1971. Ironically, the same issue included two articles, one reporting that, in the run-up to the Guggenheim International, Buren had been identified as the 'critics' choice' (hence his representation on the magazine's cover) and the other that his work had been removed from the exhibition before it opened.

Buren had been one of twenty-one artists who agreed to participate in the Guggenheim's sixth international exhibition. As the invitation letter from the director made clear, the exhibition did not aim to provide a neutral survey of contemporary art across the world but rather to reflect the selectors' preferences and judgement about 'certain significant departures today'. Over half the artists who accepted the invitation were American and included leading minimalist artists such as Carl Andre and Donald Judd, as well as land artist Walter de Maria and conceptual artists such as Joseph Kosuth and Lawrence Weiner. In effect, the show presented American minimalism of the mid-1960s as a forerunner of later trends both in the United States and around the world.

The invited artists were all tasked with making site-specific works that responded to the Guggenheim's celebrated helical building. Designed by Frank Lloyd Wright and opened in 1959, the Guggenheim was seen by many as itself a work of art. However, the building, with its unusual curved walls for the hanging of paintings and gentle spiral ramps, had not been without its critics. Prior to its opening, twenty-one artists, including Willem de Kooning and Robert Motherwell, had protested against the showing of their works in a space they felt to be inimical to the proper display of art. Buren was similarly critical of the way in which the building dominated and made peripheral the art shown within it (in his view the architecture was an artwork and the artworks within it were secondary). His plan was to hang a huge banner in the central space that would simultaneously draw attention to and overcome the building's tendency to overshadow the works on its walls, by focusing attention on the central (and typically art-free) rotunda space. The curators knew of his intentions and provided him

with architectural plans of the building, allowing Buren to determine the size of the banner he wanted to hang in the central space. Whatever misgivings they may have had (and curator Diane Waldman later insisted that she had expressed concerns to Buren about his work interfering with that of other participants and had not given him carte blanche), they did nothing to dissuade him from making his work in the weeks before the opening of the show.

Buren's blue-and-white-striped banner *Painting I* was hung the day before the show. Quickly, other artists, including Dan Flavin and Walter de Maria, who happened to be present at the time complained vehemently that the work blocked views of their pieces; at least one artist threatened to withdraw his work. That evening, Diane Waldman took Buren's work down without consulting him. Seeking to prevent a public escalation of the dispute, Waldman offered to continue to show the exterior banner (planned to be hung in 88th Street, between Fifth and Madison avenues) and to display *Painting I* by itself for one week after the closure of the group exhibition. But Buren ultimately refused these compromises, which he saw as attempts to 'buy his silence': *Painting-Sculpture* had been made in two parts for this particular group exhibition of site-specific works and any other presentation, he felt, would mutilate it.

Deeply shocked by the humiliating removal of his work on the eve of the opening of a major exhibition in one of America's most important museums, Buren polled the other artists in the show. Fourteen signed a petition saying that they believed Buren's work should remain. Carl Andre would have signed, too, but he was away. When Andre heard what had happened, he withdrew his own piece. Although fifteen out of the twenty-one artists did not want Buren's work to be withdrawn, the museum would not go back on its decision.

In the weeks and months that followed, recriminations flew, and the different factions quickly became polarised. Dan Flavin had sought the removal of Buren's work but, rather than being sympathetic to the French artist or simply content that his views had prevailed, he wrote a letter complaining to Buren about his conduct and denigrating his art in trenchant terms, describing it as 'intrusive-obstrusive drapery'. ('I have never before encountered such miserable nonsense as yours. When are you going to begin to act responsibly-responsively towards other nearby human beings, if not fellow artists in your obscure estimation', he complained before signing off, 'be assured that somehow, I simply don't want to spare the effort to dislike you.') Some months later Flavin wrote a letter in similar vein for publication in *Studio International* as the 'censoring' of Buren's work, and the role Flavin himself had played, continued to be debated in front of an international art world audience.

Arguably, Buren's *Painting-Sculpture* became more famous for not having been seen by the public than it would have been had it remained part of the exhibition. But to what extent did it impinge on other works in the exhibition, as its detractors claimed? Hanging in the central void of the Guggenheim, Buren's banner occupied the part of the building that normally dominated visitors'

experience of the museum. It challenged the architect's vision for the building (and implicitly made it evident that the other works in the exhibition had simply and, from a certain perspective, rather tamely, accepted the visual dominance of the building). Although always in view from all seven levels of the Guggenheim's spiral walkways, the banner did not actually interfere with the sight lines of most of the pieces in the exhibition, as had been asserted and was felt at the time. The majority of the works, with perhaps the exception of Flavin's large light installation that occupied the entire sixth level, did not need to be visible from across the rotunda to be viewed and appreciated. Some have argued that Buren's work did not so much hide the art on view as spotlight the real show: the visual effect of the building itself. Buren himself later wrote:

> One of the paradoxical things about the Guggenheim as a museum is that it actually conceals from view the works that are shown there. From the bottom nothing can be seen, except the proud shape of the museum itself ... [*Painting I*] irreversibly laid bare the building's secret function of subordinating everything to its architecture.

He claimed, too, that, for him, 'after the painting was taken away, the museum no longer appeared as a gigantic sculpture, unfurling its triumphant spiral, but as an enormous hole, senseless and uninhabited'.

Perhaps it was the sheer theatrical scale of the work that most annoyed and personally threatened Buren's detractors. They claimed that he had broken the tacit ground rules of group exhibitions, which required a degree of awareness of the expectations of each artist to have an autonomous space for his or her work. Flavin, in particular, seems to have interpreted the scale of the piece as indicative of an unseemly and unacceptable wish by the young French artist to upstage the others. While acknowledging that the attempt may not have been deliberate, the director of the Guggenheim, Thomas Messer, shared this view and said at the time that, 'if only to protect the balance of freedom among all participants, the tacitly existing rules had to be re-invoked'. Diane Waldman also later affirmed that the issue was simply one of 'incompatibility': 'there was simply no way of reconciling Buren's project with the other work in the exhibition'.

However, the notion that artworks need to exist in a neutral space of their own was precisely one of the elements of the functioning of the museum that Buren wanted to highlight with *Painting-Sculpture*. According to Buren, most contemporary art was made for a neutral museum-type space and derived its validation from the museum. In his eyes, such art was in essence dependent on, and subservient to, the prevailing ideology governing such institutions and culture in general.

The exclusion of Buren's *Painting-Sculpture* from the Sixth Guggenheim International was not taken up in the popular press. Most American art critics responded negatively to the avant-garde nature of the show and did not explore

the issues of curatorial responsibilities and independence underlying the museum's decision to remove the work of an invited artist. However, the bitterness of the controversy within artistic circles, combined with the negative press for the show as a whole, played a role in the Guggenheim's subsequent cancellation of the international exhibitions.

In the 1990s the Guggenheim commissioned a series of solo exhibitions by artists to address explicitly the striking architecture of its building, and in 2005 offered Buren the chance to create new work in response to the museum's famous spiral form. Buren considered whether he should reinstall *Painting-Sculpture* but felt that to do so after so much time had elapsed would 'result in censoring (by altering) its meaning a second time ... because of too much visibility and institutional endorsement'. Keeping the spiral ramps free of artworks, he instead built a huge mirrored tower – or rather, a corner of a tower – in the rotunda space. Almost a building within a building, *Around the Corner*, like the 1971 vertical banner, focused attention on the central void, and reflected the museum back to itself.

The two canvases of *Painting-Sculpture* survive today, folded up and preserved in storage. Buren has not entirely ruled out the possibility that the work might one day be shown in public: 'if they [the Guggenheim] wanted to show it again in the middle of a group show for example it's technically possible (if the context makes sense) to hang it up again exactly as it was in January 1971'. But, for him, it would be essential that the conditions of its original conception be met. For the moment, at least, this seems unlikely. In all probability, the story of this cause célèbre may prove more enduring than the work itself.

Discarded
~~Missing~~
Rejected
~~Attacked~~
~~Destroyed~~
~~Erased~~
~~Ephemeral~~
~~Transient~~
~~Unrealised~~
~~Stolen~~

14

Art on Trial

Tilted Arc 1981
Richard Serra born 1939

Richard Serra's *Tilted Arc* was a massive public sculpture installed outside government buildings in Federal Plaza, New York, in 1981. It was, in effect, a wall of steel – 12 feet high and 120 feet long (roughly 3.7 metres high and 36.6 metres long) – that traced a subtle arc over its length and leaned slightly to one side, one foot off its vertical axis. It had been commissioned by a government agency, and the designs had been scrutinised by a panel of experts, but the sculpture was disliked intensely by many – though not a majority – of those who worked in the offices in the plaza from the beginning. It became the cause of one of the most bitter legal disputes in the art world in the late twentieth century.

In the 1970s Federal Plaza was home to new but architecturally undistinguished government office buildings in which approximately ten thousand people worked. A panel of experts chose Serra, an artist known for his minimalist steel works, to create a permanent sculpture for the plaza as part of the 'Art-in-Architecture' initiative of the General Services Administration (GSA), the body responsible for new government buildings. This programme devoted 0.5 per cent of the cost of federal buildings to the creation of artworks by leading American artists. Led to understand that the work would be a permanent addition to the site, Serra, then an already established artist, spent two years planning *Tilted Arc*, during which he studied the routes people took to cross the plaza to ensure that the placement of the work caused minimal disruption to their use of the space.

Serra was honoured by the commission but never intended to create an artwork that would integrate with, or beautify, its surroundings. He understood the relationship of his artworks to their sites as one of criticism and transformation. 'It is necessary to work in opposition to the constraints of context', he said, 'so that the work cannot be read as an affirmation of questionable ideologies and political power.' *Tilted Arc* was not meant to relate sympathetically to the surrounding buildings or their uses, but to 'bring the viewer into the sculpture' and to make him 'aware of himself and of his move-

ment through the plaza'. Depending on a person's position, the arc would be an overpowering visual barrier or, seen from the ends, a gentle curve that on one side suggested enclosure and on the other expansion. Serra later wrote about site-specificity:

> The preliminary analysis of a given site takes into consideration not only formal but also social and political characteristics of the site. Site-specific works invariably manifest a value judgement about the large social and political context of which they are a part. Based on the interdependence of work and site, site-specific works address the content and context of their site critically. A new behavioural and perceptual orientation to a site demands a new critical adjustment to one's experience of the place ... It is the explicit intention of site-specific works to alter their context.

Unfortunately, nothing was done to prepare people for the arrival of the sculpture: contrary to its own policy, the GSA did not engage in a programme of public information and education about the commission or Serra's work in general before installing the sculpture. The reaction of the office workers to the piece was extremely negative: it was immediately seen as ugly, oppressive and a 'graffiti catcher'. Two petitions seeking the removal of the piece quickly gathered 1,300 signatures. A chief judge began a high-profile letter-writing campaign against what he called 'the rusted steel barrier' that he said destroyed the beauty of the plaza and its public utility. The controversy spilled into the pages of the *New York Times* when its art critic Grace Glueck described it as 'an awkward bullying piece that may conceivably be the ugliest outdoor work of art in the city'. Letters written to the newspaper's editor, published on 3 October 1981, show how divided opinion was by the different issues posed by the siting of the sculpture in the public space:

To the Editor:
Without question, Richard Serra's sculpture 'Tilted Arc' is one of the – if not the – most sensational public art works in all of New York City. Thank you for the beautiful large photograph of it on the front page of The Times (Sept. 23).

'Tilted Arc' has been hailed as a bold and masterful work by the curators of the Museum of Modern Art, the Guggenheim Museum and the Whitney Museum of American Art and by New York City's Commissioner of Cultural Affairs.

That petitions are circulating against the work is not at all surprising; initial public opinion was similarly against the work of the French Impressionists, Picasso and even Michelangelo. Happily, the major controversial works – such as Michelangelo's 'Last Judgment' – were not

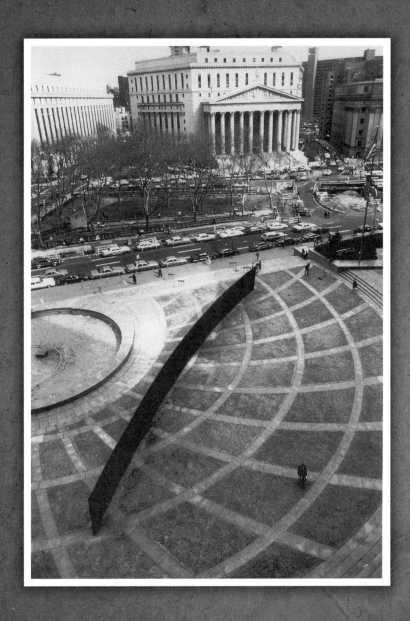

removed or destroyed. Let's hope that today's masterpieces will also be given the test and chance of time.

DONALD W. THALACKER
Director, Arts-in-Architecture Program,
General Services Administration, Washington

To the Editor:
When the feudal lords of old felt their power being undermined by the more creative new order of merchants and craftsmen, they tried to derive some sense of innate superiority by exaggerating sophisticated aspects of their social conduct *pour épater les bourgeois,* to shock the townspeople and thus expose their ignorance of the finer ways of life. It is ironical that today a government agency should try to achieve a posture of superiority over its fellow townspeople by shocking them with such expressions in art as the 'Tilted Arc,' endowed with a Federal grant of an unbelievable $175,000. As a lifelong student and teacher of the history of art and also a craftsman trying to carry on some of its traditions, I applaud the 1,300 workers at the site who refused to be mystified by such posturing and signed petitions for removal of the work.

LINCOLN ROTHSCHILD,
Dobbs Ferry, N.Y.

To the Editor:
Regarding the controversial sculpture 'Tilted Arc' by Richard Serra, installed at New York City's Federal Plaza, we feel that the General Services Administration and its Art-in-Architecture Program should be commended for providing an opportunity for the construction of an important and challenging work. With its architectural scale, 'Tilted Arc' provides a bold and powerful dialogue with the mammoth structure of the facing Government building.

The piece is a major example of environmental art which awakens a special awareness of the variety, scale and architectural system of the buildings in the surrounding area.

While the sculpture may run counter to many people's expectations of a decorative accompaniment to the building (news story Sept. 25), it is to be expected that good artists will challenge us when they introduce new forms and new ideas in their works to encompass and interpret contemporary experience.

ALICIA LEGG and DEBORAH WYE
New York, Sept. 29, 1981. The writers are, respectively, curator and
assistant curator of the Museum of Modern Art.

_ _ _ _

To the Editor:
The front page of the Sept. 23 Times was interrupted by a picture of
Richard Serra's 'Tilted Arc,' a steel sculpture installed in front of 26
Federal Plaza and described as being 12 feet high and 120 feet long.

The 'long' doesn't bother me; the 'high' does.

Twelve feet, as the city fathers must know, exceeds the height of
the tallest person. The Serra arc has completely hidden the Foley Square
panorama from the eyes of all who exit the Javits Federal Building.

After visiting a Federal agency, the view across the plaza when
leaving the building was refreshing – a kind of urban Rockies. Now New
York's Iron Curtain has intruded, and we are confronted with a rusted,
impenetrable screen. The arc has to be the worst matching of sculpture
and placement in the entire city.

If ladders or stilts cannot be supplied, at least a few periscopes
should be made available at the building entrance so some of us can
remember how it was.

RICHARD MADISON
New York

The GSA stood firm. The assistant regional administrator commented:
'There are approximately 10,000 employees in the building and if you have 1,300
signatures against it, there could possibly be 1,300 people who favored it. We
wouldn't consider removing the work; we see no need to.'

A few years later, however, the policy of the GSA towards the sculpture
changed with the appointment of a new Republican-appointed regional admin-
istrator, William Diamond, in 1984. Partly as a result of the Serra affair, the GSA
was beginning to adopt a policy of more extensive community involvement in
its commissions, and Diamond lent a sympathetic ear to the anti-Serra lobby,
though public criticism of the piece had in fact died down. In March 1985 Dia-
mond arranged for a three-day public hearing about the possibility of relocating
the work, and, though his own opinions were already known, appointed himself
head of a panel of adjudicators, which also included two other GSA employees.

At the public hearing, 180 people spoke, including the artist. Serra pointed
out that the commission had been for a site-specific sculpture, one that is 'con-
ceived and created in relation to the particular conditions of a specific site. To
remove *Tilted Arc* therefore is to destroy it.' He flatly denied that the sculpture
interfered with the social use of the plaza: in planning the work he had been

careful to leave open spaces for people and events, and noted that before there had been only a disused fountain (some of those leading the campaign against the sculpture had been the ones responsible for this non-functioning fountain, a point that got a laugh from listeners). Importantly, he claimed that the experience of art was itself a social function.

In all, 122 people, including many eminent figures from the art world, spoke in favour of retaining the piece, while only fifty-eight, mainly those working in the nearby offices, testified against it. Despite these figures (and the numbers of letters received in support of the sculpture were even more conclusive), and notwithstanding Serra's assertion that the sculpture could exist only as a work of art in the site for which he had created it, the panel voted to relocate *Tilted Arc*.

Serra proceeded to sue the GSA for $30 million. He claimed that he had been promised that the sculpture would be installed permanently, and also argued that the decision to move the work was counter to his moral rights as an artist and, censoring his work, denied him the right to free speech. For him, the proposed removal of his work was 'conduct akin to book burning'. The courts dismissed his arguments, ruling that his contract made the sculpture the property of the GSA, which therefore had the right to dispose of it in order to fulfil its obligations in relation to the public use of the plaza. The judgement also made the point that the American constitution guaranteed the right to free speech but 'not the freedom to continue speaking forever': if *Tilted Arc* lost its artistic value when moved, Serra was still free to express his artistic and political views in other ways. It also dismissed the claim that the regional administrator had prejudged the hearing as irrelevant to the legal issues. The case became famous internationally and marked a turning point in the history of public art commissions in the United States. For Serra, the outcome represented a victory of property rights over the moral rights of the artist. He wrote, 'If nothing else it affirms the government's commitment to private property over the interests of art or free expression.'

The sculpture was finally removed on 15 March 1989. The same day William Diamond issued a statement focusing on what he saw as the key issue in relation to public sculpture:

> There is a difference between private art and public art. In private art you have a choice whether you want to go to a museum and see a piece. In public art, paid for by the taxpayers, you do not have that choice. The people that live here and work here must see and face and go around and be confronted by this piece on a daily basis ... The piece appears to be menacing and overwhelming and has discouraged people from even going on the plaza ... We understand that it is very painful for him [Serra] to have his work of art removed but at the same time it is not the artist's right that counts, it is the public's right.

In response, Serra challenged whether Diamond and his supporters were speaking, as they claimed, on behalf of the majority of the public, a point he regularly returned to when criticised for the apparent elitism of his assertion of the supremacy of an artist's judgements over popular feelings and the right of a work of art to exist irrespective of any aesthetic or spatial infringements or offence it might cause.

The bitter and damaging controversy surrounding *Tilted Arc* led the GSA to review its guidelines for commissions, aiming to give local communities a stronger voice and to be more responsive to the uses and histories of project sites. Cut into three parts, *Tilted Arc* – or, rather, what remains of it – is stored in a warehouse, and the GSA has promised not to attempt to re-erect it elsewhere out of respect for Serra's views that the work could exist only in the site for which it was designed. The artist, however, regards the work as destroyed because removed from its intended site. He also noted that, in considering the work as movable, the GSA made the work 'exactly what it was intended not to be: a mobile, marketable product'.

Serra's reputation was not dented by the furore over *Tilted Arc*. He continued to produce similar monumental steel sculptures for museums and collectors around the world. But he understood the removal of *Tilted Arc* as an act of vandalism that reflected a broader shift in American politics in the late 1980s against liberalism and what was seen by its opponents as cultural elitism. 'My sculpture had been approved, commissioned, and installed under a Democratic administration. A Republican administration decided that it should be destroyed.' At the time of the removal of *Tilted Arc*, Serra made his views known in a series of polemical statements that served as titles for a series of drawings, including 'The United States Government destroys art'. However, the furore over this case helped pave the way towards an important change in the law in the United States with the passage of the Visual Artists Rights Act in 1990. This recognised an artist's continuing moral rights in a work, and permitted artists, under certain circumstances, to sue an owner of their work if he or she mutilated or destroyed it.

After *Tilted Arc* had been removed, William Diamond declared that a 'new art form – open space' would be exhibited in the plaza. A few benches and planters with trees were installed. Some years later when the plaza needed structural repair and renovation, a landscape architect was commissioned to enliven the space through a curling maze of bright green seating that offered workers the opportunity to meet and eat their lunches in the open air. The social function of the plaza had been foregrounded, but the argument put forward by Serra during the 1985 hearing that the experience of art was itself a social function had been lost with the removal of *Tilted Arc*.

- - - -

ATTACKED

~~Discarded~~
~~Missing~~
~~Rejected~~
Attacked
~~Destroyed~~
~~Erased~~
~~Ephemeral~~
~~Transient~~
~~Untimished~~
~~Sketch~~

ARTWORKS HAVE BEEN ATTACKED BY INDIVIDUALS, GROUPS AND GOVERNMENTS THROUGHOUT HISTORY FOR BOTH PERSONAL AND IDEOLOGICAL REASONS. IN THE TWENTIETH CENTURY THERE WERE A NUMBER OF AUTHORITARIAN REGIMES THAT USED COERCION TO CONTROL ARTISTS, IMPOSE A PARTICULAR CULTURAL VISION OR SUPPRESS DISSENTING VIEWS.

NAZI GERMANY WAS PARTICULARLY VIRULENT IN ITS ATTACKS ON MODERNIST ART, WHICH IT VILIFIED AS UNPATRIOTIC AND DEGENERATE. PRIVATE COLLECTIONS WERE CONFISCATED AND PUBLIC COLLECTIONS CENSORED; AND THOSE WHO SUPPORTED OR WERE ASSOCIATED WITH MODERNIST ART WERE DISMISSED FROM GOVERNMENT POSTS, IMPRISONED OR EVEN MURDERED. THOUSANDS OF MODERNIST ARTWORKS WERE DESTROYED OR WENT MISSING.

PARTLY IN CONSEQUENCE OF SUCH REPRESSION, FREEDOM IN RELATION TO THE VISUAL ARTS HAS COME TO BE SEEN IN THE WEST AS INTERTWINED WITH, AND ESSENTIAL TO, BROADER CIVIC AND POLITICAL FREEDOMS. BUT EVEN IN THE MOST LIBERAL SOCIETIES, FREEDOM OF EXPRESSION REMAINS CONSTRAINED BY MORAL AND LEGAL CODES. IT IS A TESTAMENT TO THE AFFECTIVE POWER AND CULTURAL STATUS OF ART THAT GOVERNMENTS AND INDIVIDUALS AROUND THE WORLD AND IN ALL PERIODS HAVE TAKEN SOMETIMES VIOLENT STEPS TO CONTROL, CENSOR AND EVEN DESTROY ARTWORKS.

15–17

15 Confiscated Egon Schiele, *Self-Seer* 1910
16 Degenerate Otto Freundlich, *Large Head (The New Man)* 1912
17 Horrors of War Otto Dix, *The Trench* 1920-3

~~Discarded~~
~~Missing~~
~~Rejected~~
Attacked
~~Destroyed~~
~~Erased~~
~~Ephemeral~~
~~Transient~~
~~Unrealised~~
~~Stolen~~

15

Confiscated

Self-Seer 1910
Egon Schiele 1890–1918

Egon Schiele's *Self-Seer* 1910 was the first in a year-long series of three double self-portraits and, although missing for more than seventy years, it remains much discussed by those interested in the work of the short-lived Austrian artist. For some, the lost canvas marks the moment when the young prodigy moved away from the influence of his mentor, the symbolist artist Gustav Klimt (1862–1918). For others, its psychological symbolism and pronounced homo-eroticism are among its most significant aspects.

Schiele's early career was defined by his relationship with Klimt, then the most famous painter associated with the Austrian Secession movement. Klimt had a reputation for encouraging young artists, and in 1907 Schiele, then only seventeen and with just two years' training under his belt, contacted the older artist and showed him his work. Supportive of the young man, Klimt introduced his protégé to artists, patrons and curators in Vienna, and in 1909 invited him to exhibit in the *Kunstschau*, the last major international exhibition in the city before the First World War. Schiele exhibited two portraits that, combining realism with areas of highly stylised geometric abstraction, showed Klimt's stylistic influence. Schiele remained indebted to Klimt throughout 1909 but, rather than using symbolic figures like his mentor, he began to focus instead on self-portraits. In *Self-Portrait with Spread Fingers* 1909, he combined naturalistic elements with decorative areas of gold leaf and flat colour, Klimt's trademark. But in this first self-portrait as a young adult he showed his face made-up with lipstick and rouge, suggesting a theatrical performance and possibly gender ambivalence. (Curiously, Klimt did not paint self-portraits, declaring that he was always much more interested in others, particularly women.)

In early 1910 Schiele departed sharply from the decorative aspects of Viennese Secessionist and symbolist painting. Barely twenty, the young painter began to emphasise the grotesque in his self-portraits, showing his face distorted, his skin discoloured and his body brutally curtailed. Strange truncations hint at some form of censoring, prompted by shame or fear of self-revelation.

This was powerful imagery in early twentieth-century Vienna. Capital of the Austro-Hungarian Empire, the city had both fabulous wealth and endemic licentiousness. In 1904 art historian Julius Meier-Graefe compared the city to 'a lad who has grown too quickly, tremendously tall but shockingly thin, weak of bone and precociously diseased'. In Viennese art and literature of the period, there was a striking fascination with abnormality, seen as a route to more intense experiences than permitted by everyday life, as well as an interest in the workings of the mind (it was, after all, the city in which Sigmund Freud developed his theory of psychoanalysis and the then-shocking proposition that humans were sexual beings from birth).

Klimt had long faced public criticism for the sexual elements of his imagery. The cycle of three large paintings he made between 1900 and 1907 for the ceiling of the Great Hall of the University of Vienna, for example, was roundly condemned by the university's faculty for its pornography and 'perverted excess' (the matter was even debated in the Austrian parliament). The paintings were never hung, while Klimt lost a teaching post and never accepted a state commission again.

However, Schiele went further. His self-portraits appeared to relish depravity; and in his private life he found himself in trouble with the authorities on a number of occasions for his sexually explicit drawings and watercolours. His use of young girls, including his sister, as nude models broke taboos, and in 1912, after a charge of rape and abduction was dropped, he was briefly imprisoned for displaying erotic drawings in a place (his studio) deemed accessible to children.

What was truly distinctive about the series of double self-portraits that Schiele painted in 1910–11, however, was not their eroticism but rather the psychological charge and ambiguity created by the inclusion of the second figure. If the first was a self-portrait of the artist, perhaps as seen in a mirror, then the second could be interpreted as a close friend or lover, a personification of death or some sort of 'other' self. Art historian Alessandra Comini felt in 1975 that these works, whether they had begun as an exploration of auto-eroticism or death, became 'in part a battle before the mirror, between the artist as creator of and vessel for his own image'. Similarly, Jane Kallir wrote in 1998:

> The title *Self-Seer* ... could refer to the artist's visionary capabilities, or to his introspective stance ... In several pictures from the series [the second figure] assumes the guise of a muse or spectre manipulating the artist like a puppet from behind ... now the spectator is a friend, now [an] ... incubus ... then it reappears as death incarnate. The double self-portraits thus hold manifold symbolic possibilities, leading Schiele to confront not only the creative spirit, but also the spirit of his father, and ultimately the spirit of death, which only immortal art could vanquish.

In the first of the series, completed in December 1910, a strangely de-sexed and naked Schiele is shown kneeling and partly enveloped in a dark garment. Behind him, and seemingly mimicking the position of his left hand with its fingers rigidly splayed, is a youthful twin figure. (It is difficult to say more about the painting because we know it only from a poor black and white photograph.) In another work in the series, *The Prophet* 1911, the two figures, one nude and the other clothed in black and seemingly blind, stand next to each other. *Self-Seer II (Death and the Man)* 1911, the final work of the group, shows two almost skeletal figures, one white and ghostlike embracing from behind a man seemingly transfixed by intense emotion. Mortality, or rather the generally hidden presence of death in life, was perhaps the theme of the series as a whole. Schiele had a strong sense of his creative powers, which he rejoiced in but which he also saw as inescapably linked with transience and disintegration. Using the term 'rich' metaphorically, he wrote obliquely in 1911, for example, 'I am so rich that I must give myself away'. The series of double portraits can thus be seen as a unique attempt by an artist at the height of his powers to explore a familiar theme in a new way, and as such the loss of the very first work in the series appears particularly significant.

To try to find a buyer for *Self-Seer*, Schiele used his network of supporters in Vienna. He had met the writer and collector Arthur Roessler in 1909, and when he then approached Roessler for help, the latter suggested the physician Dr Oskar Reichel as a purchaser. Reichel, who was later killed in the Holocaust, duly acquired the work and Schiele wrote to him in January 1911 to express his satisfaction with both the painting and its buyer:

> Without meaning to flatter you, I know of no greater Viennese art connoisseur than you. Therefore I have chosen you to receive this picture from my newest series – in time, you will be completely won over by it, as soon as you begin not to look at it, but to look *into* it. This is the picture of which G[ustav] Klimt remarked that he was happy to see such faces. It is certainly the best thing that has been painted in Vienna lately.

Schiele continued to promote *Self-Seer*. It was featured in Paris von Gütersloh's 1911 book *Egon Schiele: An Attempt at an Introduction*. In 1912 the artist convinced Reichel to allow the work to be transported to Munich and Cologne for display and possible resale. Willing to support the young artist, Reichel agreed, though the trip proved unsuccessful, and the painting was returned to him in January 1913.

Egon Schiele died in 1918, aged just twenty-eight, a victim of the Spanish flu epidemic that claimed more than twenty million lives across Europe and perhaps as many as fifty million worldwide (Klimt also died that year from the disease). Nonetheless, Schiele's fame continued to grow. In October 1928 the city's Neue Galerie and a local artists' association jointly staged an exhibition of

over two hundred works. It is not known when *Self-Seer* left Reichel's collection, but the catalogue for this exhibition listed it as among four works lent from the collection of 'Fritz Grünbaum, Vienna'.

Fritz Grünbaum was born in the Czech city of Brno, where his father ran an art dealership. Moving to Vienna aged eighteen, Grünbaum embarked on a career as a cabaret artist in 1903. Returning from service in the First World War, Grünbaum found considerable success in both Austria and Germany. His travels between Vienna and Berlin allowed him to build up an art collection that by the late 1920s numbered some four hundred pieces, including no less than eighty works by Schiele. With the arrival of the National Socialist government in Germany in January 1933, Grünbaum, like many cabaret artists, began to use his shows to voice his opposition to the regime. However, it very soon became clear that it was not safe for him to perform in Germany: in June 1934 the Nazi newspaper *Der Stürmer* dedicated an article to Grünbaum as an enemy of the Reich.

Formalising their longstanding hatred of 'degenerate' art, seen as unhealthy and unpatriotic, the German authorities began a programme of confiscations to remove such works from the country's public museums and galleries in the summer of 1937. With their exploration of the creative aspects of degeneracy, works by Schiele within Germany were soon the targets of such confiscations. In March 1938 Austria was annexed to the German Reich. Immediately, the new National Socialist authorities began the process of excluding Austria's Jewish community, and other opponents of their regime, from society. However, Schiele's works were viewed more with contempt than anger in Austria, and were not typically subject to confiscation campaigns or export embargos. Such was the prevalent hostility to modernism that those works that were seized from their owners for resale struggled to find new buyers. During the rapid Nazification of Austrian society, some important collectors were able to flee abroad with their artworks (the Nazis' campaign against 'degenerate' art ironically helped artists such as Schiele become better known in the United States and other Allied countries). But other collectors were not so lucky.

Attempting to flee to Czechoslovakia by train, Fritz Grünbaum and his wife Lily were arrested and returned to Vienna. Grünbaum hid for a while in Vienna but was betrayed to the authorities and was deported to the Dachau concentration camp in May 1938. In Vienna Lily 'authorised' the governmental confiscation of the couple's property (his power of attorney, signed in Dachau, gave her authority to do so and she would have had little choice). Although much publicity surrounded the notorious 1937 exhibition *Degenerate Art* and Nazi destruction of modernist art, the process of confiscation was orderly and considered. Vienna's Jewish collections contained thousands of highly valuable works, not to mention many 'Nazi-approved' pieces, and the authorities undertook a process of formal assessment, requiring Jewish owners to complete asset registrations detailing their works. Approved pieces were handed to Nazi officials or taken for the planned 'Führer Museum' in Linz, Hitler's hometown. The

rest, including many 'degenerate' works, were sold with the cooperation of deal-
ers and auction houses in the city. Grünbaum's collection was almost certainly
seized for sale rather than destroyed. A property assessment for Lily Grünbaum
dated 20 July 1938 provides the last record of *Self-Seer*; later documents refer to
the collection, but only in general terms. Following the confiscation of her apart-
ment in October 1938, Lily Grünbaum was registered at four different addresses
between 1938 and 1942. She was finally arrested on 5 October 1942 and deported
to the Maly Trostinec extermination camp near Minsk, where she was murdered
on 9 October. Her husband had already died. After a two-year period in the Bu-
chenwald camp, Grünbaum had been returned to Dachau in late 1940. Failing in
his attempt to commit suicide on New Year's Eve 1940, the sixty-year-old died of
tuberculosis on 14 January 1941.

The story of what happened to Schiele's *Self-Seer*, however, does not end
there. After Lily Grünbaum's deportation, her collection would have become
the property of the German Reich. In theory, the collection should have been
confiscated and sold through a sub-section of the Gestapo responsible for selling
off Jewish-owned luxury goods. But the Grünbaum collection does not figure in
any of the related records. In 1956, however, around forty Schiele works from the
collection appeared on the market via a dealership in Switzerland. According to
the dealership's owner, he had acquired the work from Mathilde Lukacs, sister
of Lily Grünbaum, who survived the war in Belgium. The sale attracted buyers
from across Europe and America, and included the 1911 oil *Dead City III*, which
had appeared alongside *Self-Seer* in Grünbaum's July 1938 property assessment.
Mathilde Lukacs died in 1979; it was never verified whether she had indeed
passed the works to the Swiss gallery or whether she had the right to do so.

In 1998 forty-four governments agreed to the Washington Conference
Principles on Nazi Confiscated Art. While encouraging research into potentially
stolen works, the principles paved the way for international legal recognition
of heirs' rights to reclaim works lost by their ancestors. As a result of the sheer

number of high value works it contained, and the uncertainty surrounding the 1956 Swiss sale, the Grünbaum collection has come to play a central role in determining the scope of these international laws. Can the sister-in-law of a collector be presumed to have had the right to sell that collector's work? Should normal limitation periods apply? If a work is transported from German-occupied Austria, sold in Switzerland and currently held by a gallery in New York, which country's law applies? Many of these questions remain to be resolved and may act as a brake on further disclosures of spoliated works.

Egon Schiele is now among the world's most high-priced artists. *Self-Seer* was well known when it was lost and, owing to its importance in Schiele's oeuvre, has not been forgotten today. Given the re-emergence in 1956 of works from the Grünbaum collection, it remains theoretically possible that *Self-Seer* still exists and may one day resurface. In the meantime, however, its fate remains a mystery.

Discarded
Missing
Rejected
Attacked
Destroyed
Erased
Ephemeral
Transient
Unrealised
Stolen

16

Degenerate

Large Head (The New Man) 1912
Otto Freundlich 1878–1943

Otto Freundlich's large sculpture *The New Man* 1912 became emblematic of German avant-garde art – and of the Nazis' determination to eradicate it – when it was illustrated on the catalogue cover of the infamous *Degenerate Art* exhibition in 1937.

The plaster had been acquired in 1930 by a museum with one of Germany's most extensive collections of twentieth-century art, but was withdrawn from public display three years later when the Nazis came to power. The Nazis condemned modernist styles of art as depraved symptoms of a sick society; and they particularly targeted Jewish artists such as Freundlich. To make their case, they brought together over six hundred modernist works, largely confiscated from German museums, in the *Degenerate Art* exhibition, which opened in Munich and toured a number of cities in Germany and Austria until 1941. What happened to the sculpture at the end of the exhibition is unknown, but government officials are assumed to have destroyed it along with many other works included in the exhibition.

Born to a Jewish family in Prussia, Freundlich had tried various careers before starting his training as an artist in 1907 aged twenty-nine. He moved to Paris the following year and rented a studio in the ramshackle building known as the Bateau Lavoir, where his neighbours included Pablo Picasso and Georges Braque. In his 1931 memoir, he fondly recalled the many artists and writers he met in these years, writing, 'It's too bad our conversations were not recorded. Today one can scarcely imagine the curiosity and audacity with which we thrashed out all the implications of our ideas … We all lived in a spirit of humility – lived purely for our art and for what it represented for us.' While living in Paris, Freundlich returned regularly to Germany, where he was in touch with leading avant-garde artists (he made *The New Man* on one such visit). However, Picasso remained his main inspiration. 'Picasso had thrown down his challenge to all traditions of art … Braque, Herbin, Juan Gris and I were called upon to play a pioneering role … we were witnessing a true dawn of modern painting.'

Picasso was among the first to incorporate aspects of tribal carvings in his paintings: in his famous canvas *Les Demoiselles d'Avignon* 1907, for example, the women are represented in angular forms, and two appear to be wearing African masks. Freundlich can be presumed to have seen this and similar paintings in Picasso's studio. In Germany, artists such as the Die Brücke group also looked to children's art and so-called primitive art or, as it was then often labelled, Negro art, seeking to shake off the burdens of western culture to express a new – and to their minds ultimately truer – vision of man. Freundlich's response to French cubism and German expressionism can be seen in *The New Man*, its title referencing the expressionists' desire for a new understanding of man's nature in the modern age. Suggestively, the figure's expression was one of sadness and, above all, anxiety.

Freundlich completed *The New Man* during a stay in Hamburg in the winter of 1912. Standing at nearly one and a half metres tall, it was an imposing work, one of the largest he produced: it suggests comparison with the carved stone heads found on Easter Island. A private collector in Hamburg quickly purchased it, but no photograph of the sculpture exists from these early years (we know it now only from photographs taken to represent the work – unsympathetically – in the *Degenerate Art* exhibition catalogue).

At the outbreak of the First World War, Freundlich returned to Germany where he was assigned to work in the health services. After the war, he joined the Berlin and Cologne dada movements and became a member of the November Group, a radical collective of artists that supported the short-lived socialist revolution in Germany and called for the integration of art and society. He cemented his credentials as a leading left-wing artist when he participated in the International Congress of Progressive Artists in Düsseldorf in 1922. Three years later, he returned to Paris.

In 1930 a local collector offered to donate *The New Man* to the Hamburg Museum of Arts and Crafts. The museum's director, Max Sauerlandt (1880–1934), was then building up an exceptionally strong collection of German modern expressionist art, despite controversy in the press regarding the use of public funds to acquire such works, and accepted the gift. However, when Hitler's Nazi Party came to power in January 1933, public and governmental discomfort regarding modernist art was transformed into a programme of vilification and censorship. Those deemed to oppose the new regime were removed from public posts. In order to practise, artists had to join the state-run Artists Society, membership of which was routinely refused to modernist or Jewish artists. In April 1933 Sauerlandt was dismissed and banned from entering his own museum, which ceased to show modernist works. Eventually, the regime confiscated 270 works of modern art, including Freundlich's *The New Man*, from the museum's collection.

In the summer of 1937 Hitler formalised his plan for the eradication of 'degenerate art' in Germany. Over a period of just three weeks, the director of

the Reich Chamber of Culture, Adolf Ziegler, began a programme of confiscation of more than sixteen thousand objects from public museums and collections across Germany. Early confiscations were taken to Munich to form half of a great double exhibition in the city. The newly built House of German Art displayed works approved by the regime in a grand style, while the former archaeological institute hosted the exhibition *Entartete Kunst* (*Degenerate Art*). Here the works were hung in chaotic and jarring groupings, with the (inflation-era) prices paid for these artworks from the public purse and sarcastic comments painted on the gallery walls. It proved a tremendously popular exhibition, attracting over two million visitors, and was shown in eleven cities in Germany and Austria over the next four years. Emblazoned on the cover of the guide, Freundlich's sculpture became the very public image of all that Nazism sought to obliterate from German culture. Inside the guide, the racial slant of the vilification of this and other modernist works was made clear. Together with a carved head by Richard Haizmann and a self-portrait painting by Ludwig Meidner, Freundlich's plaster was shown under the sneering heading 'Three samples of Jewish sculpture and painting'; the works were also reproduced at an angle to make it hard to see them as conventional artworks and to suggest a world gone crazy.

What happened to *The New Man* after the exhibition is unknown but it is assumed that the authorities destroyed it, probably after the end of the show's tour in 1941. Despite great efforts to establish what happened to the works in the *Degenerate Art* exhibition and, more generally, the thousands of artworks confiscated from German public collections, the fate of many remains unclear. Some were sold in Switzerland to raise money for the regime; others were acquired by collectors. Nazi officials took a number for their own use: Reichsmarschall Hermann Göring, one of Hitler's closest confidantes, took fourteen pieces, including a van Gogh and a Cézanne. In March 1939 the Berlin Fire Brigade burned many hundreds or thousands (no one is sure) of 'unsaleable' works. Many simply disappeared in the chaos and confusion of war.

During these years, Freundlich lived in Paris. He had returned to the French capital in the early 1930s and had tried unsuccessfully to become a French citizen. In 1933 he joined the Association des écrivains et artistes révolutionnaires in protest against the Nazi campaign against modernist art (he was particularly incensed by the closure of the Bauhaus school of art and dismissal of his friends, the artists Otto Dix and Paul Klee, from teaching positions.) Although respected within the artistic community in Paris, Freundlich experienced financial difficulties in the 1930s: a group of artist friends banded together in 1938 to launch a subscription to purchase a major work of his for the Musée du Jeu de Paume, concluding the appeal with these words:

> Otto Freundlich, this man with clear ideals, who supports his admirable
> life partner, is poor and on the verge of old age. He is such a dignified
> example of moral nobility that all those who still retain some belief in this

faith that alone justifies man's existence would like to collaborate
in spreading the art and the thoughts of Otto Freundlich.

When war broke out in 1939, Freundlich was arrested by the French au-
thorities as an enemy alien and sent to a series of internment camps in France,
though Picasso managed to vouch for his anti-Nazi beliefs and secure his release
in early 1940. When the German army occupied France, however, Freundlich, as
a known opponent of the Nazi regime and a Jew, had no choice but to flee. Be-
trayed to the authorities while hiding in a small French village, he was arrested
on 23 February 1943 and sent to the Majdanek concentration camp in Poland,
arriving there on 9 March. Aged sixty-four, he was murdered the day he arrived.

Given its fragility and notoriety, it seems highly unlikely that *The New
Man* will ever be found. However, another of Freundlich's works confiscated
from Hamburg Museum of Arts and Crafts and exhibited as 'degenerate' was
discovered in January 2010. Workers building an underground station in front
of Berlin's town hall found a buried cache of eleven sculptures, including a 1925
terracotta *Head* by Freundlich. Investigations suggest that in 1945 the sculptures
were in a building destroyed by Allied bombing. Why they were there remains
a mystery, but one theory is that lawyer Erhard Owerdieck, who was known
for his work assisting Jewish friends and colleagues, might have smuggled the
works from government hands and kept them in his apartment there. Broken
and incomplete, the rediscovered sculpture is a poignant reminder of Freun-
dlich's decimated artistic legacy and of Germany's modernist history, so nearly
obliterated by government-led iconoclasm.

17

Horrors of War

The Trench 1920–3
Otto Dix 1891–1969

That war is invariably brutal goes without saying, but how it should be remembered or represented has always proved much more controversial. Does the public have the right to expect to be shielded from the worst scenes of carnage? Do relatives of the dead have the right to have the deaths represented in terms framed by, if not political ideals, then at least consoling civic values? Or does truth, and the need to remember and perhaps to learn, count ultimately for more?

Otto Dix certainly believed in the need to remember. As a young man in 1914 he had willingly joined the German army and fought for four years in the trenches, mainly as a machine-gunner. Like many of his generation, he believed that war was neither evil nor unnatural but rather an expression of something fundamental in the human condition. He also did not wish to miss the excitement of an event that would sweep away what were widely regarded as outmoded ways of thinking and of seeing the world. Later in life he remembered being terrified when approaching the front line through trenches filled with corpses, mud and filth, but yet felt compelled, in his words, to experience 'the phenemona of war'.

> I ... had to see how someone next to me suddenly fell, and was gone, the bullet hitting him right in the middle. I had to experience all of that very precisely. I wanted to. In other words, I'm not a pacifist at all. Or maybe I was a curious person. I had to see it all for myself. I am such a realist, you know, that I have to see everything with my own eyes in order to confirm that that's the way it is.

During the war years Dix made many drawings of life in the trenches (a friend sent him drawing materials along with extra rations). His works were expressionist in style, and show him trying to capture the violent energy of war through anonymous figures. It was only a couple of years after the conflict that

he felt the desire to tackle the subject of the war experience, already fading within postwar society, and to do so in terms of the experience of recognisable individuals and telling, gruesome details. This may have been in part to exorcise his memories or even to reconnect with the thrill of war (almost fifty years later he wrote, 'The war was a horrible thing, but there was something tremendous about it, too.') He visited mortuaries and dissecting rooms to refresh his war-time memories, and brought a disconcerting sense of immediacy to the scene of smashed skulls, entrails and dismembered bodies mired in mud and agitated by the action of worms and maggots that filled *The Trench*, a monumental canvas over two metres tall and wide that took him three years to complete.

The imagery hit home. Responding to the work's unveiling in a museum in Cologne, a local critic described the painting in shocked detail:

In the cold, sallow, ghostly light of dawn ... a trench appears into which has just fallen a devastating bombardment ... the trench is filled up with hideously mutilated bodies and human fragments. From open skulls brains gush like thick red groats [hulled grain]; torn-up limbs, intestines, shreds of uniforms, artillery shells form a vile heap ... Half-decayed remains of the fallen, which were probably buried in the walls of the trench out of necessity, and were exposed by the exploding shells, mix with the fresh, blood-covered corpses. One soldier has been hurled out of the trench and lies above it, impaled on the stakes.

Although the painting drew on some famous medieval works of art, many critics struggled to see any redeeming feature in this catalogue of pain and physical degradation. The same critic who had recognised the power of the imagery in his description concluded that the painting offered nothing in terms of moral or artistic uplift; worse, in its anti-war message, it might weaken the people's 'inner war-readiness'. More decisively, a prominent Berlin-based critic pronounced that the German people did not want this gruesome reminder of the horrors of war, and claimed the painting made him want to 'throw up'. He campaigned for it to be withdrawn from public view.

Significantly, no critic doubted the veracity of the experience of the trenches represented in *The Trench*. Dix had drawn not only upon his own memories but also the documentary photographs of trench warfare that circulated freely – somehow immune from the controversy that surrounded artworks – in the postwar years, and these, in turn, had prepared his audience to accept the imagery as truthful. At the same time, writers had already begun to describe the conditions of the trenches in ways that closely echoed Dix's painting. English reporter Philip Gibbs wrote in his 1920 book *Realities of War*

> Bodies and bits of bodies and clots of blood and green metallic-looking slime made by explosive gases were floating on the surface of the water. Our men lived there and died there … Lice crawled over them in legions. Human flesh, rotting and stinking, mere pulp, was pasted into the mudbanks. If they dug … their shovels went into the softness of dead bodies who had been their comrades. Scraps of flesh, bloated legs, blackened hands, eyeless heads, came falling over them when the enemy trench-mortared their position.

But many found the immediacy and detail expected in documentary photography and reportage shocking and unacceptable when combined with the emotional force and cultural status of an oil painting. Although Dix was far from alone among artists of his generation in attempting to express the horrors of war artistically, he had done so in a way that appeared stripped of the visual civilities expected of art. The director of the Cologne museum who had bravely purchased the work was forced to resign and, despite letters of protest from leading artists in Germany, the canvas was returned to the artist in 1924.

Now that the painting had become an important symbol of the anti-war movement Dix's dealer Karl Nierendorf arranged for it to join the exhibition *Nie wieder Krieg!* (*No More War!*), which travelled to several cities in Germany. ('You are now a famous man and known all over Germany', Nierendorf wrote to the artist in August 1924.) Painted on cheap hessian with the poor-quality paints available immediately after the war, the painting became damaged during the extensive tour but was not forgotten. In 1927 a writer in the journal *Das Kunstblatt* published an article on *The Trench* in which he insightfully commented that

the painting owed some of its 'uncanny greatness' to Dix's unusual ambivalence towards war:

> The painter's obsession with the ideas of the horrors of war shifts them to a realm of monumentality in which it is completely unimportant whether one protests the monstrous event or merely, with shuddering, rapt devotion, allows it to wash over one. Dix's *The Trench* could just as easily be the object of supreme adoration of a fanatic worshipper of the god of war as it could be pacifist propaganda.

Having viewed the painting in an earlier trip to Germany, Alfred Barr, director of the Museum of Modern Art in New York, described *The Trench* in 1931 as 'perhaps the most famous picture painted in post-war Europe' and 'a masterpiece of unspeakable horror'.

> The very pigment seems to fester horridly, iridescently. Painted with the uncanny verisimilitude of wax works this staggering vision of decay in death lives even more through the spiny wriggling character of its design and the terrific loathing which Dix has concentrated in it. Looking back over the history of painting we cannot find its equal except in that other dreadful masterpiece, the Altarpiece of Isenheim [1506–15, by Matthias Grünewald].

By this point, however, *The Trench* was no longer to be seen. The canvas had been purchased by the Dresden art museum in 1928 and it promptly disappeared into storage. Officially, the museum needed to restore the painting, but it was later admitted that the administration had not dared exhibit the work. During the Nazi era, the museum staff claimed they had bought the work only in order to take it out of circulation.

Aware that *The Trench* was proving too controversial to show, and perhaps conscious that it was in a poor condition, Dix tackled the subject again in 1929–32, but this time echoing the style and format of medieval religious paintings. Employing fine glazes of tempera on smooth-as-glass gessoed wooden panels, Dix, now a full member of the Prussian Academy of Arts in Berlin, painted a massive memorial to the First World War in the form of a triptych, reworking the composition of *The Trench* in the central section. He later said that he returned to the theme because, already, people had seemingly forgotten the horror:

> many books in the Weimar Republic once more blatantly propagated a form of heroism and a concept of the hero that had long been taken to the point of absurdity in the trenches of the First World War. The people were already beginning to forget what unspeakable suffering the war had brought with it. It was this situation that led to the triptych.

He had hoped that the massive work would be installed in some form of a
bunker or underground passageway in the middle of a city so that people could
take a moment in their busy lives to enter and remember, if only for a few mo-
ments, the experience of war. Employing a conventional landscape setting, and
offering a logical narrative that could be read across the three panels (armies
go to war; war creates a terrible aftermath; a few survive), the triptych was a
masterful allegory but lacked the visceral immediacy of the earlier canvas. Pur-
chased by a museum in Dresden, it, too, went into storage, where it survived the
purges of the Nazi era.

Having come to power in January 1933, the Nazis moved quickly to remove
individuals identified as opponents of the regime and its values from official
positions. Dix was sacked that year from his post as professor at the Dresden
Academy, a post he had held since 1927, and for a period was banned from exhib-
iting work. He was informed:

> Apart from the fact that among your paintings there are those that grossly
> violate moral sense and thus endanger all moral reconstruction, you have
> painted pictures that are likely to detract from the will of the German
> people to defend itself. Accordingly you afford no assurances that you will
> always unreservedly stand up for the state.

The Nazis included Dix's *The Trench* as an example of the art they found
repellent and unworthy in an exhibition called *Reflections on Decadence in Art*
that opened in Dresden in late 1933 and toured German cities until 1936. A
photograph of the event shows crowds of people in front of *The Trench*, exhib-
ited as an example of contemptible art. Later it was one of eight paintings by Dix
taken from public collections and included in the *Degenerate Art* exhibition that
opened in Munich in 1937. As discussed in an earlier chapter, the works in the
show were reviled as expressions of those who were mentally ill, perverse or
unpatriotic. The catalogue text next to the illustrations of *The Trench* and
another major work by Dix, *War Cripples*, appeared to have Dix as the intended
subject of its slander and abuse:

> Here, 'art' enters the service of Marxist draft-dodging propaganda ... That
> not just Jews but 'artists' of German blood could produce such botched
> and contemptible works, in which they gratuitously *reaffirmed* our en-
> emies *war atrocity propaganda* – already unmasked at the time as a tissue
> of lies – will forever remain a *blot on the history of German culture*.

The implication was clear: the sooner the blot was removed the better.

It used to be thought that *The Trench* was one of the several hundreds or
thousands of paintings that were burned in the grounds of the fire station in
Berlin in 1939. This art-burning echoed the episodes of mass book-burning that

took place in 1933, but unlike the latter there were no surviving records or visual documents, and it is impossible to know for sure what works were destroyed then. However, it seems that *The Trench* somehow escaped this fate and survived, at least for a little while longer. The Nazi authorities traded in some proscribed and confiscated artworks, selling them to a small number of trusted art dealers, who in turn often sold the pieces abroad. A bill of sale for $200, dated 22 January 1940, found in the records of one such dealer, Bernhard Boehmer, shows that *The Trench* was sold under the title *The War* (it had gained this alternative title some time in the 1920s). What happened to the large canvas thereafter remains a mystery.

For his part, Dix stayed in Germany but lived a life of 'inner emigration' on Lake Constance near the Swiss border. Eschewing imagery that risked getting him into trouble with the authorities, he painted 'safe' landscapes and works with Christian and allegorical themes. Even so, following an attempt on the life of the Nazi leader Adolf Hitler in 1939, he was rounded up and interrogated by the SS for two weeks: his name had been on an SS document listing 553 'leading men' of the Weimar period. But his war record apparently counted in his favour and he was released. Ironically, Dix's war experiences had propelled him along a path that led to his public vilification and the destruction of many of his works, but may also have helped save him.

However, fate dictated that, willingly or otherwise, he had to return to war. In the last months of the Second World War he was drafted, aged fifty-four, into the German militia and sent to the western front. Again, he survived, and, after a year spent in a French prisoner-of-war camp, he returned to Germany in 1946. There he set about rebuilding his career, painting religious allegories or scenes of postwar suffering until his death in 1969.

DESTROYED

ARTWORKS ARE AS VULNERABLE TO CATACLYSMIC EVENTS – SUCH
AS WARS, ACTS OF TERRORISM AND FIRES – AS ANY OTHER FORM
OF MATERIAL OBJECT. WHEN SUCH EVENTS INVOLVE HUGE LOSSES
OF LIFE, THE DESTRUCTION OF ART SEEMS ALMOST TOO TRIVIAL
TO MENTION. BUT, PARADOXICALLY, LOST ARTWORKS ARE PERHAPS
MORE LIKELY TO BE REMEMBERED IN THE LONG TERM, IF ONLY AS A
FOOTNOTE IN ART HISTORY, THAN THE MANY PEOPLE KILLED.

PERHAPS THIS IS BECAUSE WE FIND IT EASIER TO RESPOND TO,
AND RECORD, THE LOSS OF SINGLE ITEMS THAN THE ULTIMATELY
UNQUANTIFIABLE LOSSES REPRESENTED BY A MASS OF VICTIMS.
IT MAY ALSO BE BECAUSE WE TEND TO EXEMPT WORKS OF ART
FROM THE CYCLE OF LIFE AND DEATH AFFECTING HUMAN BEINGS
AND ARE DISTURBED BY EVIDENCE OF ART'S VULNERABILITY TO
DESTRUCTIVE EVENTS.

18–21

~~Discarded~~
~~Missing~~
~~Rejected~~
~~Attacked~~
Destroyed
~~Erased~~
~~Ephemeral~~
~~Transient~~
~~Unrealised~~
~~Stolen~~

18

Moving House

Merzbau c.1923–37
Kurt Schwitters 1887–1948

From 1919 the Hanover artist Kurt Schwitters made collages using waste materials, including bus tickets and old newsprint, in creative protest against the harsh realities of life in Germany in the aftermath of the country's defeat in the First World War. He named his new way of working 'Merz', and applied this personal brand name not just to his collages but also eventually to his sculptures, sound poems and installations: he even published a periodical called *Merz* for nearly a decade. Around 1923 Schwitters began transforming his studio in the apartment block where he and his parents lived into a structure that was part sculpture and part environment. He called it *Merzbau* (Merz building), and over a period of fourteen years expanded the structure so that it eventually covered eight rooms. Although few people saw it, this unique construction has assumed something of a mythic status in the history of modern art – perhaps in part because it was so short-lived.

The site of the *Merzbau* – Waldhausenstrasse 5, Hanover – was Schwitters's home for more than thirty years. His family built the house in 1901 when Kurt was fourteen, and took an apartment on the ground floor. With the outbreak of the First World War, Schwitters was exempted from military service owing to his epilepsy. In 1915 he married Helma Fischer and the couple moved into an apartment on the second floor of Waldhausenstrasse 5. His parents converted their ground-floor dining room into a studio for him, and Schwitters began his career painting figurative oils and exhibiting with local artists' societies. As the war progressed, his paintings became darker and more expressionist, although he had no direct contact with avant-garde groupings.

In June 1917 conscription was extended to include those previously exempted. Schwitters was briefly enlisted in a regiment before being declared unfit and sent to an ironworks to work as a draughtsman. The experience hastened his move away from traditional figuration: he later said that in the factory he discovered a 'love for the wheel' and saw that 'machines are abstractions of the human spirit'. Schwitters exhibited two abstract works at Der Sturm, then the

leading gallery dealing in modernist art in Germany, in June 1918, and through this came into contact with the Berlin dada group.

Founded in Zürich during the war, the dada movement sought to reject the conventions and beliefs of a society that had allowed the war to break out (and included traditional art and museums among its targets). There were many centres of dada activity, each with their own distinctive character, across Europe and in New York. The dada group in Berlin – notably, Richard Huelsenbeck, Raoul Hausmann and Hannah Höch – became known for their use of collage to make satirical works with a sharp political edge. Schwitters, by contrast, aimed in his collages to create works of visual appeal and beauty, albeit using new and improbable materials. Although he was never more than loosely associated with the group, his embrace of the fragmentary and the nonsensical meant that, for a period at least, he was very much in tune with the dada rebels. In June 1919 he had a solo exhibition at Der Sturm, and that autumn published, with a well-orchestrated publicity campaign, a nonsensical love poem called 'An Anne Blume' (To Anna Flower). Debated and parodied in newspapers and magazines, the poem made him famous almost overnight.

Looking back at his development of Merz works, Schwitters wrote in 1930 that the experience of war and its terrible aftermath in a defeated and broken Germany had been critical:

> In the war things were in terrible turmoil. What I had learned at the academy was of no use to me ... I took what I found, for we were a poor country ... everything was destroyed anyway and new things had to be made from the fragments.

Finding meaning and beauty in what had been discarded became for Schwitters a metaphor for the process of rebuilding German society in the years following the nation's military defeat and subsequent political turmoil. Alluding to the failed leftist revolution in Germany of 1918–19, he said his change of approach 'was like a revolution within me, not as it was, but as it should have been'. Merz was key. The name – cut from an advertisement for the Hanover Kommerz und Privatbank and used in his first *Merzbild* or Merz picture – stood for an arena that was associated with, but distinct from, the prosaic world of 'commerce'. With this nonsense word used as a label for his art, poetry, performance and installations, Schwitters found a way of thinking about his work as functioning in a parallel realm, removed from the constraints and logic of capitalist society and yet not fully divorced from it.

While making artworks that, even if made with detritus, were both recognisably pictures and saleable commodities, Schwitters began in his studio and home to create something quite new – an environment and living space that was itself a work of art and, it would seem, an aesthetic escape from everyday reality. He began to cover surfaces with not just his own artwork but also newsprint

and images, and construct columns of assembled objects. Visitors to the studio recalled the sense of carefully arranged clutter in the studio. Dada artist Richard Huelsenbeck, who visited Schwitters in 1919, remembered:

> This tower or tree or house had apertures, concavities and hollows in which Schwitters kept souvenirs, photos … the room was a mixture of hopeless disarray and meticulous accuracy. You could see incipient collages, wooden sculptures, pictures of stone and plaster. Books, whose pages rustled in time to our steps, were lying about. Materials of all kinds, rags, limestone, cufflinks, logs of all sizes, newspaper clippings.

Although Schwitters did not speak publicly about his studio constructions until 1931, it seems that they began to merge together as an environment around 1923, forming the start of the *Merzbau*.

Things changed in March 1927 when Schwitters's parents reclaimed their dining room. His studio was moved to a room at the back of the house, and with this blank canvas the artist began working on a new, unified, environmental construction. Clad with angular shapes, the walls and ceilings soon resembled those of a geometricised cave or forest. By 1930 the largely white structure filled the space, and Schwitters started referring to it as the *Cathedral of Erotic Misery*, though he said this was 'only a name … it does not fit the contents or only very slightly'.

The *Cathedral* was constantly changing and expanding. Areas were dedicated to members of the Schwitters family, well-known figures, and to contemporary news stories: in one area he incorporated a pencil stolen from the desk of architect Mies van der Rohe; in another, a pair of socks belonging to artist László Moholy-Nagy. Schwitters asked fellow artists to make contributions to the *Cathedral*: the dealer Herwarth Walden (owner of the Der Sturm gallery) and Hannah Höch had their own sections, as did Hans Arp and El Lissitzky. Schwitters's structure seemed to oppose every element of traditional artistic production: there was no single creator; it involved the use of scrap and detritus; and it was an immovable structure that could never be sold or displayed. Yet these aspects only served to increase the standing of the work and of Schwitters himself in avant-garde circles.

When the Nazis assumed power in January 1933, Schwitters realised that *Merz* and his studio construction would be classified as 'degenerate' by the authorities. Immediately all references to the *Cathedral of Erotic Misery* stopped; the first use of the more neutral term *Merzbau* was seen in a letter of April 1933. Significantly, he had the *Merzbau* professionally photographed by Wilhelm Redemann (these photographs are now our only visual guide to what the space looked like). Schwitters was right to be concerned. In September 1933 his works were included in a Dresden exhibition focusing on artistic 'decay'; in December he was named in a newspaper article titled 'The Betrayal of Art'. Schwitters's

epilepsy also made him a target: the condition was listed as one of the hereditary conditions the regime sought to eliminate, and the artist knew a public seizure would be grounds enough for arrest or worse. Although he continued to work on the *Merzbau*, Schwitters's public performances and exhibitions dwindled. He began to spend increasing periods on the Norwegian island of Hjertøya, where the family had holidayed since the late 1920s. Around 1933 Schwitters rented a studio on the island, which soon became its own small-scale *Merz* installation, its interior covered with collage.

Despite his difficulties in Germany, Schwitters became increasingly known abroad, particularly in countries where abstraction was belatedly beginning to take root and there was a new interest in understanding its origins and history. Having heard about the *Merzbau*, Alfred Barr, director of New York's Museum of Modern Art, visited Schwitters's home with his wife Margaret in 1935. In the 1980s, Margaret Barr wrote about the visit, using notes taken at the time: 'It is like a cave; the stalactites and stalagmites of wood junk and stray rubbish picked from the streets are joined together to fill the whole room from floor to ceiling and walls to wall, [we] are silenced. The effect is mesmerising.' Barr was clearly impressed, choosing to show five of Schwitters's collage works in the 1936 exhibition *Cubism and Abstract Art*, and six photographs of the *Merzbau* in *Fantastic Art, Dada, Surrealism* in 1936–7.

The position of modernist artists in Germany, however, continued to worsen through the 1930s. As friends and colleagues were forced into exile, Schwitters made plans to move his family permanently to Norway. His son Ernst was sent ahead in December 1936, and Schwitters followed in January 1937. His wife Helma remained behind to care for the couple's elderly parents, writing in March 1937, 'I can't leave three old people alone or they will be too lonely ... so for the time being I'm not going to Norway but just to visit my two now and then.' Schwitters later described the *Merzbau* as he left it in 1937, 'eight spaces were Merzed in the house. Practically my *Merzbau* was not an individual space ... sections of the *Merzbau* were distributed over the whole house, from one room to the next, on the balcony, in two spaces in the cellar, on the second floor, on the earth [outside]'.

Schwitters was represented by four works in the 1937 *Degenerate Art* exhibition. While other artists were derided by reason of their abstraction, their communist sympathies or their Judaism, Schwitters's work was classified simply as 'Complete Insanity' (his methods and materials were likened, in effect, to those used in the art of the mentally ill, a subject then much studied by clinicians and by avant-garde artists, though the reference here to insanity was intended as an insult). Among the works included in the show was his first 1919 *Merzbild*, known today through black and white photographs as it was destroyed by the Nazis when the exhibition ended.

Living in exile in Norway, Schwitters rented a house in the town of Lysaker, near Oslo, and almost immediately began work on a new version of the

Merzbau, which he named Haus am Bakken (House on the Slope). The house burnt down in 1951 and there are no surviving photographs, but, according to Ernst Schwitters, it was designed largely to echo the forms of the Hanover *Merzbau*. The only records of its layout are a series of drawings Ernst made and submitted to the Oslo planning department in 1938.

Schwitters had thought himself safe, but in April 1940 Germany invaded Norway, and he and his son made the dangerous sea crossing to the Lofoten Islands, at that time under British control. They eventually arrived in Edinburgh in June 1940. Unfortunately for them, the British government had just begun to implement a policy of arresting and interning enemy aliens, a policy that extended to refugees. As a result, father and son were transported to the Isle of Man, where they spent the next year at the Hutchinson internment camp. Here Schwitters found himself among a large group of émigré artists, writers and intellectuals. The highly educated inmates set about organising exhibitions, lectures and performances. Although he made some small-scale abstract collages, Schwitters produced mainly realist portraits for the camp's exhibitions.

Released in 1941, Schwitters set up home in London for a few years. Finding his abstract work unpopular and choosing to maintain a distance from the many émigré groups in the city, Schwitters was quite isolated. In 1943 he discovered that the Waldhausenstrasse house, including the *Merzbau*, had been completely destroyed by an Allied air raid. He was devastated at the loss of what he called his 'life's work' and 'a new domain in art', and wrote, 'For what did I actually live? I don't know.' The same year, he found out his wife Helma, whom he had not seen since 1939, had died of cancer in Hanover. In 1944 Schwitters had his first and only solo exhibition in London during the war. Herbert Read, a well-known defender of modern art in Britain, wrote the catalogue essay (and earned the gratitude of the artist in a small collage called *Homage to Herbert Read*), but the show did little to bolster Schwitters's reputation in Britain.

Unable to build his career in London, Schwitters moved to the Lake District with his new British partner, Edith Thomas, in 1945. Although he settled into rural life, painting landscapes and portrait commissions for the locals, he became preoccupied once again with making a new *Merz* construction. In 1946 he wrote to contacts in the United States, urgently requesting funding to help for the reconstruction of the *Merzbau*: 'it was the work of my life ... I worked twenty years on it ... I fight for it in desperation, like an animal for its child.' His request for funds reached staff of the Museum of Modern Art in New York, who – during a prolonged correspondence involving no fewer than twenty-two letters and several food packages – made a grant for $3,000 in 1947. At this point it was clear that there was no hope of saving anything from the bombed building in Hanover and that he would not be able to return to Norway to complete the second construction because, still a German citizen, he would not have been able to return to Britain. In the summer of that year, Schwitters began work on a third version of the *Merzbau*, this time titled *Merzbarn*, in a farm outbuilding at his home in Elterwater.

In a letter to Ernst, Schwitters described the *Merzbarn* as 'even less dada-istic' than the Haus am Bakken and, indeed, the photographs of what was completed show a very different type of work. By October 1947 Schwitters estimated that around ten per cent of the *Merzbarn* was finished, and that it would need at least two or three years to complete. But he fell seriously ill in the winter of late 1947 and died in Kendal hospital in January 1948. The final instalment of the MoMA grant paid for his funeral expenses.

With the loss of the original *Merzbau* during the war, and the destruction of Haus am Bakken by fire in 1951, we are now left to imagine Schwitters's visionary environment from a handful of early black and white photographs and remnants of two later versions: the one completed wall of the Lake District *Merzbarn*, now preserved in Newcastle's Hatton Gallery, and the dilapidated remains of the Hjertøya studio. Although testament to his deep-seated need to create and, as necessary, recreate, a Merz environment for himself, Schwitters's later constructions, however, were inevitably different in character and lacked the complexity and intensity of his first work sited in his childhood home. Subsequent reconstructions of the Hanover *Merzbau* – made in the 1980s largely on the basis of an analysis of three photographs of the main room taken by Redemann in 1933 as well as the recollections of Ernst Schwitters and others – seem equally problematic: the replicas show only a small part of the installation, and as Schwitters constantly moved and changed things, they can offer only an approximate experience of the original spaces. The incomplete state of our knowledge today of the lost *Merzbau* in Hanover, however, is perhaps appropriate for a work that had originally sought meaning in the fragments of Germany's destruction through war and its aftermath.

– – – –

Discarded
~~Missing~~
~~Rejected~~
~~Attacked~~
Destroyed
~~Erased~~
~~Ephemeral~~
~~Transient~~
~~Unrealised~~
~~Stolen~~

19

Bombed

Composition I 1910
Wassily Kandinsky 1866–1944

The loss of a major work of art may be tragic, but sometimes the story of that loss calls attention to tragedy of a far greater scale. The challenge of understanding the impact of the loss of a single artwork in the narrative of an artist's output and legacy, however difficult this may be, is nothing compared with the difficulties involved in addressing the gaps in the narratives of families and entire societies caused by widespread human loss.

The story of Wassily Kandinsky's *Composition I* 1910 – a grand, ambitious and colourful canvas that was the first of an important series of paintings – is enmeshed with the broader tragedies of the Second World War. Known now only through a black and white photograph taken in 1912, it was destroyed by a British air raid on the industrial city of Braunschweig in the Ruhr Valley on the night of 14 October 1944. The many men, women and children who were killed in the raid were remembered by surviving relatives and friends for a generation, perhaps two, but today such memories are largely gone and are even harder to retrieve than the story of the destruction of this major work by one of the pioneers of abstract art.

Ironically, perhaps, given the work's subsequent history, Kandinsky believed that paintings such as *Composition I* were harbingers of a new spiritual awakening for modern man. In his book *On the Spiritual in Art* 1911, he claimed that vanguard artists and other visionaries were leading mankind up through 'the spiritual pyramid that will one day reach to heaven'. Focusing not so much on subject matter but simply on colour and form, artists, he wrote, needed to respond to their own inner feelings and impulses. In so doing, they would touch the souls of others and engage them in the upward progress of humanity.

Kandinsky's sense of the artist as a prophet was deeply coloured by his reading of theosophy and other mystical texts. But his belief in the power of the visual language of art also came from his own acute sensitivity to colour and form, and his ability to be inspired by his 'inner world'. Two events, as he later recalled, had had a decisive impact on his thinking. In 1896 he saw an exhibition

of the now famous series of paintings of haystacks by the French impressionist artist Claude Monet and had been profoundly struck by their ability to elicit a deep emotional response in viewers *before* they recognised what the paintings depicted. The 'unsuspected power of the palette', he commented in *Reminiscences* 1913, 'surpassed my wildest dreams'. In the same period a stirring performance of Wagner's opera *Lohengrin* led him to think about how painting could begin to emulate the emotional and spiritual force of powerful music. Listening to the opera, he wrote, 'I saw all my colours in my mind; they stood before my eyes. Wild, almost crazy lines were sketched in front of me.' Spurred on by these events, Kandinsky, who had trained as a lawyer and had just been offered a teaching post in Moscow University, decided to leave Russia for Munich to train as a painter.

In fact, the traditional training Kandinsky received in the German city seems to have had little impact on him but from there he travelled widely in Europe. He was quick to assimilate the bright colours and loose handling of paint characteristic of the fauvist artists in Paris, and soon he became an inspirational figure among young artists in Germany who wanted to break away from nineteenth-century realism. However, he was also passionately interested in Russian folk art, and his paintings reflected the religious themes and fairy tales associated with this naïve genre. His scenes of mounted riders galloping across a countryside dotted with castles and sometimes accompanied by angels, combined still-recognisable motifs with a high-octane colourful vision that seemingly had no need for traditional perspective or modelling, and resisted precise interpretation.

From c.1909 to the outbreak of the First World War, Kandinsky progressively cut loose the moorings that tied his imagery to recognisable motifs and he became a pioneer of abstract art. Or, at least, this is how his achievements are typically discussed within art history. However, his canvases of these years show a balance of representational and abstract elements, with both typically being present in his works in different degrees. Some pictures looked abstract but closer examination showed that even these incorporated recognisable motifs and were inspired by recurring narratives.

In *On the Spiritual in Art*, Kandinsky explained that he called his paintings that were rooted in experience of nature 'impressions'. 'Improvisations', by contrast, arose from unconscious memories and thoughts. 'Compositions' were more ambitious and ultimately more important works. They were based upon images that came to him spontaneously and upon expressions of feelings that were then painstakingly and 'almost pedantically' examined and developed into visually strong arrangements of shapes, colours and lines, often over a very long period of time ('Here, reason, the conscious, the deliberate, and the purposeful play a preponderant role'). In short, what mattered to Kandinsky was the visual and emotional force of the imagery, not the extent to which it did or did not look entirely abstract.

Kandinsky painted seven *Compositions* between 1910 and 1914, and only a further three after the First World War. For him, this category of work seems thus to have been particularly tied to this pre-war period. The first three paintings in the series fell victim to Allied bombing during the Second World War, but attention focuses here on the very first of the series as arguably being uniquely important in understanding Kandinsky's development. At 1.4 metres wide, *Composition I* would certainly have been striking, and was later remembered by one witness as having radiant and joyful colours. (Kandinsky's lettering on a preliminary pencil study shows that he initially intended the three riders to be white and the horses grey and pink, though it was not uncommon for his compositions to become more colourful when painted.) Some motifs are relatively clear. In the foreground are three seated figures, while in the middle distance are the three riders, one to the left and two to the right. Behind them are onion-domed churches and houses clinging precariously to the sides of seemingly impossibly vertical hills in a manner that echoes children's drawings. But the meaning of these and the other harder-to-decipher elements in the painting remains mysterious.

According to a note in the artist's records, *Composition I* was completed in January 1910. Its subsequent exhibition history suggests that Kandinsky saw the work as important. It was sent immediately for exhibition in London and was then shipped to Odessa, where it was shown at the 2nd International Art Exhibition at the Salon Izdebsky in December 1910. The painting appeared – with an illustration in the catalogue – in the 1912 *Kandinsky Collective Exhibition* at Der Sturm gallery in Berlin, an important centre for early expressionist and abstract art in Germany. It then came back to Kandinsky, now one of the leading figures in the artist group called Der Blaue Reiter (possibly named after one of Kandinsky's paintings). Hans (also known as Jean) Arp exhibited with this Munich group in 1912 and quickly became friends with Kandinsky. According to a note in the latter's papers, Arp acquired *Composition I*, and he is thought to have taken the canvas with him when he fled to neutral Switzerland during the First World War.

Arp did not forget Kandinsky while in Switzerland. He had parts of the Russian artist's illustrated book of sound poems *Klänge* (1912), read out by members of the Cabaret Voltaire in Zürich, home to the dada movement during the war. Later in life he was reported to have allowed no one else beside himself and his wife to handle his copy of the book, about which he later wrote appreciatively:

Kandinsky has undertaken the rarest spiritual experiments in his poems. Out of 'pure existence' he has conjured beauties never previously heard in this world. In these poems, sequences of words and sentences surface in a way that has never happened before ... In these poems we experience the cycle, the waxing and waning, the transformation of this world. Kandinsky's poems reveal the emptiness of appearances and of reason.

Records indicate that *Composition I* then passed to Otto Ralfs, a German businessman and collector. He developed an interest in modern art following a visit in 1923 to the Bauhaus art school, where Kandinsky taught. Within a year he had staged his first exhibition of modern art in Braunschweig's Landesmuseum, showing works by Kandinsky, Paul Klee, Lyonel Feininger and Alexei Jawlensky, who were then practically unknown in the city. By 1925 Ralfs had established a Society of Friends of the New Art in Braunschweig, together with a Klee Society, which aimed to promote the Swiss artist's works to German collectors. Ralfs and his wife Käte welcomed artists from across Germany to their home. Entries in the couple's guestbooks show that they received not only Kandinsky but also Arp, Klee, Nolde and Schwitters. It was during this period that Ralfs acquired *Composition I* from Arp.

When Hitler became chancellor of Germany in January 1933, Ralfs ceased to promote the cause of modern art. The movements he had tried to support were now branded 'degenerate' by the authorities; his contacts in the museum world were forced from their positions; and his artist friends were driven abroad. At their meeting of 6 July 1933, the Society of Friends of the New Art voted to disband. There were no entries in Ralfs's guestbooks between 1933 and 1945.

Ralfs was not Jewish and his private collection was therefore not a priority target for Nazi confiscation. But it would certainly have attracted unwelcome attention. The situation worsened when many of the artists in his collection appeared in the Nazi-organised *Degenerate Art* exhibition in 1937. In this notorious show, Kandinsky earned the dubious honour of an entire wall daubed with decorations intended to mock his compositions. A programme of confiscations of modern works from museum collections and forced sales of items in Jewish collections made ownership of modern art risky, even for Ralfs. As the 1930s progressed, he managed to sell some works abroad but at the outbreak of war in September 1939 his collection still numbered between two and three hundred pieces, including *Composition I*.

As a major industrial centre – home to munitions factories, major rail interchanges, research institutions and the German Research Centre for Aviation – Braunschweig was a target for air raids from the beginning of the Second World War. But the raid carried out by the British RAF as part of Operation Hurricane on the night of 14 October 1944 was unprecedented in its devastation. The use of explosive and then incendiary bombs caused – as had been fully intended – a massive firestorm, and left fires burning in the city for two and a half days. Owing to the city's frequent air-raid drills, the death toll was much lower than might have been expected (it is estimated at around one thousand, with nearly a hundred killed in one bunker at the height of the firestorm through lack of oxygen). But ninety per cent of the city's medieval city centre was destroyed, together with Ralfs's home and art collection. This included not only *Composition I*, but also works by Otto Dix, Alexei Jawlensky,

Paul Klee, Oskar Kokoschka, László Moholy-Nagy, Edvard Munch, Emil Nolde and Max Pechstein.

Kandinsky died not long after the raid, in December 1944. Forced to leave his teaching post in the Bauhaus, he spent his last years in Paris, knowing that significant portions of his life's work had already been destroyed in Germany. Ralfs, however, survived the war, and was able to open a gallery dedicated to modern art, which he ran until his death in 1955.

– – – –

~~Discarded~~
~~Missing~~
~~Rejected~~
~~Attacked~~
Destroyed
~~Erased~~
~~Ephemeral~~
~~Transient~~
~~Unrealised~~
~~Stolen~~

20

Nine Eleven

Bent Propeller 1970
Alexander Calder 1898–1976

The devastating terrorist attacks on the World Trade Center in New York on 11 September 2001 killed nearly three thousand people and dramatically affected the United States' relationships with the rest of the world. The shock caused by the event was profound, and in the immediate aftermath inevitably little attention focused on the art that was lost with the collapse of the buildings. The attacks on the Twin Towers and the accompanying damage to the surrounding edifices in the World Trade Center complex, however, also destroyed large numbers of artworks housed in and around the skyscrapers in this vibrant business area. The exact figure of destroyed works is not known – records were lost along with the works in the corporate offices, private storage vaults and artist studios within the complex – but insurance estimates put the combined value as high as $100 million. A spokesman for the Art Loss Register in London described it as 'probably the largest single art loss in history'.

Among the many pieces destroyed, one public work in particular became symbolic of the cultural loss suffered in the attacks, and of the efforts to mitigate the damage in the weeks that followed: Alexander Calder's *Bent Propeller* 1970. Commissioned for the World Trade Center Plaza while the buildings were still being constructed, the seven-metre-high steel sculpture was broken and crushed under the debris. But its distinctive red colour offered hope that its pieces could be identified among the building rubble.

Calder became famous for his invention in the early 1930s of the 'mobile' (a coinage of fellow artist Marcel Duchamp), a suspended sculpture with parts moved by a motor or, more commonly, by currents of air. His delicately balanced mobiles were abstract, but for Calder they signified important aspects of the workings of the physical universe. In 1932 he wrote about art being made from 'volumes, motion, spaces bounded by the great space, the universe', and about 'abstractions' that were 'like nothing in life except in their manner of reacting'. He also made self-supporting sculptures or 'stabiles', which did not move but created the impression of movement through their dynamic shapes.

A popular and successful artist, Calder exhibited frequently in the United States and became seen as one of the fathers of American modern art. However, he always retained close friendships with artists he had met in Paris before the war; and from the 1950s he lived near Tours in France. Focusing increasingly on making large public sculptures in his later years, he worked with the local foundry at Biémont, which took his maquettes and under his supervision transformed them into large steel constructions, with skilled boilermen undertaking the riveting.

In the late 1960s Calder was commissioned to create a large public sculpture for the Civic Center in Grand Rapids, Michigan. Painted in Calder's favourite red, *La Grande vitesse* (or 'grand rapid') was the first public sculpture funded by the Art for Public Places programme of the National Endowment for the Arts. In 1969 Calder was commissioned by the Port Authority of New Jersey to make a stabile for the World Trade Center, then in the course of construction. Reviewing the range of artists commissioned to make works for the new site, curator Dorothy Miller interestingly referred back to the Rockefeller Center project of the early 1930s and, implicitly, to the debacle over the censorship of Diego Rivera's mural showing the face of Lenin:

> From its initial plan to its present realization, the fine arts program of the Port Authority has set a splendid example for the inclusion of the arts in a great public building program. In the thirties, New York's Rockefeller Center performed a similar function, incorporating painting and sculp-ture in the design of its complex of buildings. However, in the half century since the building of the Rockefeller Center, knowledge and acceptance of contemporary art have grown so tremendously that the Port Authority has been able to include in its art collection some of the most advanced art of our time, a goal not readily attainable in the earlier period.

Although not someone followed by younger artists, Calder still counted then as a modernist figure, one whose large, colourful sculptures complemented modern architecture and could be counted on to appeal to a public.

Calder quickly conceived of creating the sculpture from three sheets of metal, curved gracefully like bird wings, or, as he suggested, a bent propeller. The final work was sometimes known as the *World Trade Center Stabile*, but the artist himself called it *Bent Propeller* and this is the name by which it became known. Like many of his public sculptures it was painted in a distinctive bright red colour. In 1962 Calder said, 'I love red so much that I almost want to paint everything red.'

The World Trade Center was not one building but a complex of seven. WTC1 and WTC2 were the giant Twin Towers, around which were grouped five smaller buildings. Calder's sculpture was first located near the entrance to WTC1 (the North Tower), before being transferred in 1979 to the north-east

corner of the World Trade Center Plaza on Vesey Street and Church Street. It was later moved to the footbridge between WTC6 and the main entrance to WTC7. It might have escaped the terrorist attacks on the Twin Towers, but WTC7 collapsed several hours after the towers as a result of fire damage, and the sculpture was buried under thousands of tons of debris.

In the aftermath of the attacks, some New Yorkers began to visit the site regularly to provide support for the rescue workers. One of these was Victoria Leacock, a friend of Alexander Rower, grandson of Alexander Calder and head of the Calder Foundation. Rower asked Leacock for help in attempting to recover the stabile and they made up flyers to hand out to the workers, reading – with patriotic emphasis – 'Please Help Recover and Preserve Famous AMERICAN SCULPTURE'.

By this point there was no hope of finding more survivors, and workers clearing the site tried to support efforts to locate parts of Calder's sculpture in the shared hope that enough would be recovered to allow it to be restored. 'I was there when they pulled some of the parts out of the ash', Rower was later reported as saying. 'This was October 11. The steel was still red hot, which was shocking to me. The heat, the intensity of that devastation was so incredible.' But it was difficult for the workers to identify the parts. One day later Leacock visited the site and discovered a mechanical grab cutting up a damaged section of the sculpture. Most of the paint had been scorched off in the fire, and the metal had buckled under the weight of collapsing masonry, but the row of rivet holes identified the twisted metal sheet as part of Calder's sculpture. The dumps used to house and sort debris were searched and, in all, about forty per cent of the sculpture was recovered. However, this was simply not enough to restore the work, as Calder's grandson had hoped, and the surviving pieces are now kept by the Calder Foundation in storage. In 2008 one fragment was included as testimony to the destruction wrought by the terrorist attack in an exhibition dedicated to 9/11 held in Caen, France. Although the sculpture cannot be repaired, its damaged parts may yet have an afterlife as a memorial, as there is a deeply felt need to preserve and value artefacts that survived, and bear witness to, the terrorist attacks.

Another public sculpture installed in the World Trade Plaza in the same period as the Calder stabile has had a happier fate. Nearly eight metres high, Fritz Koenig's revolving sculpture *The Sphere* 1971 was intended to symbolise world peace through trade. While Calder's steel sculpture was mangled beyond recognition, *The Sphere*, though located between the Twin Towers, miraculously survived relatively unscathed. Initially, the artist was opposed to any attempt to reinstall the punctured and dented sculpture, saying it was a 'beautiful corpse'. But six months later Koenig supervised the setting up of the work as a memorial in Battery Park, near the original site. 'It was a sculpture, now it's a monument', he commented. 'It now has a different beauty, one I could never imagine. It has its own life — different from the one I gave to it.'

————

Discarded
Missing
Rejected
Attacked
Destroyed
Erased
Ephemeral
Transient
Unrealised
Stolen

21

Burnt Memories

Everyone I Have Ever Slept With 1963–1995 1995
Tracey Emin born 1963

In 1995 Tracey Emin, then a little known artist in her early thirties, stitched some text and the names of everyone she had ever slept with onto a tent. Playing on the interpretation of the word 'slept', she included the names of not only lovers but also friends and members of her family (including her twin brother). The work proved a turning point in her career. Displayed in a number of exhibitions of the work of young British artists, and later bought by the advertising executive and art collector Charles Saatchi, the work quickly became seen as an iconic example of 1990s 'Brit Art'. The use of a tent gave the piece its popular identity and it became known simply as 'Tracey Emin's tent' and is still remembered as such. Along with hundreds of other artworks, however, it was destroyed in a fire that swept a warehouse in east London in 2004, only nine years after it had been made.

Emin first made a textile-based work two years before the tent or, to give it its full title, *Everyone I Have Ever Slept With 1963–1995*. *Hotel International* 1993, an embroidered quilt, was named after the seaside hotel her father had run and in which she had grown up. It included many confessional details of her youth, spelt out in capital letters or handwritten on smaller bits of fabric. The combination of sewing (conventionally, a feminine practice) with texts representing seemingly raw and uncensored memories marked Emin's work out as both original and challenging.

From the beginning Emin presented herself and the story of her life as part of her art. For the first day of the Gramercy International Contemporary Art Exhibition, held in the Gramercy Park Hotel in New York in 2004, Emin stayed in a bed covered with the Hotel International quilt, which was for sale, though this was something of an involuntary performance. She later confessed, 'I'd never been to New York before and I couldn't understand the jet-lag thing so I stayed up all night at a party. When the Gramercy opened, I was too exhausted to get out of bed, so people just came and met me.' Demonstrating a willingness to court and exploit publicity, as well as to engage directly

and openly with a broad public, she briefly became one of the most popular 'exhibits' on show.

Everyone I Have Ever Slept With 1963–1995 was first displayed in a group exhibition called *Minky Manky*. Held in the South London Gallery in 1995, the show aimed to deal with 'fundamental questions of existence' and investigate the artist as 'an expressing subject'. Although people had to crawl into the igloo tent in order to read the texts, the work proved an unexpected highlight of the show. One reviewer wrote:

> One of the few pieces that actually looks like it has come from a life that is not wholly concerned with being a professional artist is Tracey Emin's *Everybody I've Ever Slept With 1963–1995* (1995). This piece, perhaps Emin's most resolved work to date, comprises a tent whose interior is plastered with the names of all those the artist has slept with – in every sense – and is far less voyeuristic than earlier, more directly autobiographical work. The object itself and, more evocatively, its peculiar musty smell, bring out a thousand childhood and adolescent memories of travel, holidays, private spaces and intense experience in a way that allows the viewer's own memory to mingle with the artist's rather than be overwhelmed by it.

Two of the most poignant names in the Tent were 'FOETUS I' and 'FOETUS II', referring to Emin's two abortions.

In December 1995, Emin, though still little known outside the art world, established the Tracey Emin Museum, in a former minicab office on Waterloo Road in south London. She opened the Museum – a combined exhibition space, studio and shop – two afternoons a week, and would talk about her work with visitors. For curator Patrick Elliott, 'This was a peculiarly direct and unnerving way of experiencing art, and it marked Emin out as a new and completely unique voice in British art.'

Emin had been inspired to make *Everyone I Have Ever Slept With 1963–1995* partly by a Tibetan tent she had seen in an exhibition. Within Tibetan culture, nomadic Buddhists use tents as a place for solitude and meditative thought. Emin wanted her tent to be similarly a portable shelter and a place of meditation, with the tent's themes of sleep and sex suggesting a mystical understanding of life. When the tent was included in the Minneapolis exhibition *Brilliant! New Art from London*, she specified that it be installed in a quiet place. But her instructions were disregarded and the tent was sited next to a loud video work. Then, as later, people saw the tent primarily as confessional rather than contemplative. For Emin, however, the piece was about intimacy broadly understood, and the tent had a memorial function: she said that making it was like 'carving out gravestones'.

The inclusion of *Everyone I Have Ever Slept With 1963–1995* in the 1997 exhibition *Sensation* at the Royal Academy, London, helped make Emin a house-

hold name in Britain and lodged the piece in the national psyche. Featuring 110 works from the collection of self-confessed 'artoholic' Charles Saatchi, the exhibition was one of the most controversial shows ever held at the Royal Academy. However, it proved an enormous popular success, with over a quarter of a million visitors and extensive media coverage. The exhibition toured to Berlin and New York, reinforcing Emin's celebrity and the fame of her tent.

In the early hours of 24 May 2004, however, a devastating fire destroyed a warehouse in which the London-based art-handling company Momart stored most of the art in its care. It is thought that burglars attempting to steal electrical equipment from an adjacent unit started the blaze. The fire spread quickly and within hours the whole complex was alight. Fifteen pumps were called to the scene and water was poured on the site for two days. Over a hundred works in the Saatchi collection, including *Everyone I Have Ever Slept With 1963–1995*, were lost, as well as several hundred other pieces by leading British artists.

Some British journalists seized on the opportunity to express satisfaction at the destruction of works by artists they saw as overhyped and overpriced. Countering the sense of shock, even trauma, experienced in art circles over this overnight destruction of so many artworks, some suggested that the 'Brit Art' artists could easily remake their works. To underscore this point, the *Daily Mail* commissioned a woman to remake Emin's tent, as if this could be a substitute for the artist's lost work. The article headline read: 'Bad news, Mr Saatchi: Tracey Emin's £40,000 tent has gone up in flames. But the good news is the Mail has made you another (and it'll only cost you £67.50!)'.

Approximately one hundred artists lost works in the Momart warehouse fire. Some said they could attempt to remake their works; most, including Emin, felt this would be impossible. She later said:

> It's a seminal thing. It was that moment and that time in my life. It's me sitting in my flat in Waterloo sewing all the names on. It took me six months to make. It just fitted inside my living room, which was 10ft by 12ft, and the TV just fitted inside the tent. I couldn't remake that time in my life any more than I could remake the piece.

For the families of deceased artists, the loss of works was particularly painful. Fifty paintings by Patrick Heron (1920–99), including several major canvases, were destroyed. Four months after the fire, his daughter Katherine spoke about the emotional and personal aspects of the loss of so much of her father's artistic legacy. Although lost works can take on a second life through documentation and memory, she said that the fire had left a gaping hole in the record of her father's life:

> Even at the worst stage of people burning books, actually, somewhere, the manuscript or the idea or the story stayed, and even if you lost the score

of a piece of music, or if you lost a choreography, they can be recreated, because they exist by being reproduced. The thing about something like a painting or a sculpture or any other artefact-based art form is, once it's gone, it has gone. It's so absolutely final. The first thing is, I think: Thank God nobody died. People always come first. But the second thought is that, actually, the whole life of somebody like my father was about his art, every single thing was focused on his art, and if a substantial amount of his work is destroyed, it's like denying his existence, a denial of life.

DISSATISFIED WITH WHAT THEY HAVE DONE OR LACKING THE MONEY TO BUY NEW MATERIALS, ARTISTS HAVE OFTEN REMADE OR PAINTED OVER THEIR WORKS. SOME HAVE REVISED THEIR INITIAL IDEAS TO THE POINT WHERE THEIR ORIGINAL COMPOSITIONS WERE EFFECTIVELY DESTROYED.

ERASURE, HOWEVER, CAN BE CREATIVE AS WELL AS DESTRUCTIVE IN ITS IMPACT AND LEGACY. TRACES OF PAST WORKS, OR EVEN THE KNOWLEDGE OF THE EXISTENCE OF HIDDEN UNDERPAINTING, CAN ACT AS A SPRINGBOARD FOR NEW CREATIONS. AND MANY ARTISTS HAVE USED THE LOSS OF ARTWORKS AS THE SUBJECT OF NEW WORKS.

22–25

Discarded
Missing
Rejected
Attacked
Destroyed
Erased
Ephemeral
Transient
Unrealised
Stolen

22

Fig Leaf

Hot Eyes 1921
Francis Picabia 1879–1953

Hot Eyes, or in French *Les Yeux chauds,* created a controversy in the press when it was first exhibited at the Salon d'Automne, Paris, in November 1921. It was painted by Francis Picabia, one of the most charismatic and unpredictable of the group of artists and writers that made up the Paris dada movement in the early 1920s. With its hard-to-understand title and baffling combination of words and imagery, visitors to the Salon judged it a dadaist provocation, all the more so when it was revealed by a newspaper that the painting was based on a diagram of an air turbine. Nearly two metres high and painted in a graphic style, *Hot Eyes* was a striking and, owing to the press controversy, well-known work. But within a few months, Picabia chose to paint over it entirely. Today, the original composition – a circular shape, a hand and some phrases – is known only through a poor-quality black and white photograph in a newspaper and some tell-tale traces in the surface of the repainted work.

The story of *Hot Eyes* is bound up in Picabia's short-lived involvement with the Salon d'Automne. Founded in 1903 in opposition to the more conservative Paris Salon, the Salon d'Automne was an annual exhibition of new art held at the Grand Palais in Paris. It provided an occasion at which artists, whether or not they also had dealers, could show and sell their latest works. The Salon d'Automne had a reputation for being generally supportive of new art. Although bitterly opposed to many of the conventions and traditions surrounding art and the art market, Picabia was invited, somewhat surprisingly, to join the 1921 Salon's hanging committee. And through his position on the committee that year he was able to rescue the works of the dada group from a stairwell and ensure that they were shown in a more prominent position near the exhibition entrance.

When preparing *Hot Eyes* for inclusion in the 1921 Salon, Picabia wrote 'Remerciements au Salon d'Automne' or 'Thanks to the Salon d'Automne' on the left of the huge canvas as an obviously humorous (and hollow) nod towards ingratiating himself with the Salon committee. Equally, his inscription 'Hommage à Frantz Jourdain' on the 'eye/disc' in *Hot Eyes* may have been a joke

about the well-known beliefs of the founder and president of the Salon in the importance of good design to educate the 'eye' of the masses. Or, it may just have been another piece of over-the-top flattery and signal that obsequiousness was a necessary characteristic of artists' relationships with the Salon.

To heighten expectations about the appearance of his new work, Picabia published a self-promoting leaflet that managed to repeat his name several times in different sized fonts and often underlined. It also included a list of wildly discrepant terms for himself: he was an imbecile, an idiot and a pickpocket, but also a Spaniard, rich, poor, 'the only complete artist' and – this was repeated twice – a 'funny guy'. Down the sides of the leaflet were two sentences that together capture the alternatively dark and mercurial aspects of Picabia's personal philosophy:

Men covered in crosses [war decorations] make you think of cemeteries.

If you want clean ideas, change them as often as your shirts.

Somehow – surely Picabia was to blame – a wild rumour circulated that Picabia intended to hang an 'explosive picture' in the Salon. The patient Jourdain was obliged to make a statement to the press: 'All the paintings have been carefully inspected and none has been found suspicious. The visitors, therefore, may attend the opening of our Salon with the fullest assurance of safety.'

Alongside *Hot Eyes*, Picabia submitted to the Salon d'Automne a second canvas, *The Cacodylic Eye* 1921, but one that could scarcely be called a painting. He had had a bout of opthalmic shingles that had been treated with sodium cacodylate (hence the title). During his recuperation, he painted a large eye near the centre of an otherwise bare canvas and invited friends and visitors to his studio to sign the work. In this painted equivalent of a Facebook page, some left affectionate and wry comments; others affixed small photographic portraits. A compendium of Picabia's circle, the work was complete when nothing further could be squeezed on. In submitting this patently multi-authored work to the Salon d'Automne, Picabia was testing the limits of what then could be considered a work of art. The reference to a sick or 'cacodylic eye' and to 'hot eyes' in the titles of the two works can be seen as suggesting that the visual sense was being discomforted, at the very least, by contemporary art in general and his paintings in particular.

But this discomfort was nothing compared with the controversy stirred by a press relevation (again, who could have been the source?) about *Hot Eyes*. On 9 November 1921, *Le Matin* carried on its front page a story about the origin of the imagery. Comparison of the painting and a diagram of a turbine engine in a popular science magazine made it clear that Picabia had borrowed the essentials of the composition and even a phrase (*'action du vent'*, wind action), adding only the image of a hand and the other phrases. In fact, Picabia rarely, if ever, painted

from life. Instead, he took inspiration from, and sometimes directly copied, re-productions in books and magazines, but this was revealed only for the first time in the row over this work. The gist of *Le Matin*'s article was that Picabia, for all his dadaist bravura, was nothing but an unoriginal copyist. Picabia – who in bor-rowing the imagery had totally transformed its meaning – responded with heavy sarcasm the next day: 'I congratulate the newspaper *Le Matin* not only for hav-ing discovered the secrets, but for understanding them.' He added with shovel-loads of irony: 'Picabia copies an engineer's sketch instead of copying apples. To copy apples, that is comprehensible to everyone. To copy a turbine, that's idiotic.' Although he admitted this act of appropriation, Picabia kept remarkably silent throughout his career about the fact that he routinely borrowed imagery from printed sources. The full extent of his borrowing – based on a highly original disregard for originality – was discovered only after his death.

Francis Picabia
The Fig-Leaf
1922

Perhaps Picabia had not enjoyed the controversy; or perhaps he delighted in the prospect of resubmitting the same work in a different guise to the Salon d'Automne. Whatever the reason, Picabia covered *Hot Eyes* with an entirely new composition, some time between the end of the exhibition in December 1921 and May 1922. Over the previous decade, he had produced abstract or machine-related imagery and dada compositions, but now, surprisingly, he created an almost classically rendered masked figure in black, wearing a green fig leaf, known in French as a 'feuille du vigne'. Paint analysis shows that, strangely, he painted this figure first, and then painted the white background, bringing the white up to the black contours.

The target of this second composition was no longer the Salon d'Automne, but a new trend in contemporary art favouring neoclassicism and 'correct' draw-ing as expressions of a French tradition in art. Artists formerly known for avant-

garde styles, such as Pablo Picasso and Fernand Léger, were leading this fashion and finding favour among rich clients. Picabia mocked this tendency with *The Fig-Leaf*, basing the pose of the figure on that of the Oedipus in the well-known 1808 painting *Oedipus and the Sphinx* by the great neoclassical painter Ingres, and adding the words 'DESSIN FRANÇAIS' (French drawing) to highlight the nationalistic undertones in the renewed attention to the quality of line associated with French artists such as Ingres. Censorship and prudery were also favourite targets of Picabia, and the eponymous fig leaf not only drew attention to the presence of male genitals artfully hidden from view in the nineteenth-century painting, but also suggested that such art was itself something of a polite fiction covering up unpalatable realities. However, if Picabia was hoping to create a second storm with this new painting, he was quickly disappointed. *The Fig-Leaf* was shown in the 1922 Salon d'Automne but in what one critic described as the highest, dirtiest, most obscure vault of the hallway, where it failed to attract much comment.

Picabia went on to paint over many canvases, but *Hot Eyes* was one of the first to be lost to his habit of erasing past efforts and starting afresh. It also appears to have been one of the earliest pictures painted not with artist's oils but household paint. Recent analysis of *The Fig-Leaf* – in particular, cracks in its surface – by Tate conservator Annette King has shown that the background colour of *Hot Eyes* was close to a pale baby blue, while the hand was a hot pink colour, discoveries that bring us a little closer to the lost work. These colours, and the use of house paint, would have given the painting a disconcertingly brash quality. In 1926 his close friend and fellow dada artist Marcel Duchamp wrote that Picabia 'loves the new, and his canvases ... have this aspect of fresh paint, which keeps the intensity of the first moment'. Picabia's love of the new was central both to the creation of *Hot Eyes* and to its almost immediate loss under an even more topical composition, now preserved in Tate's collection.

23

Cut Up

Study for Man with Microphones 1946
Francis Bacon 1909–1992

Sometimes artists are not the best judges of their own work, although there is no one else who is better qualified – at least, ethically – to decide whether a work should be destroyed because it is not good enough to form part of the artist's oeuvre.

Francis Bacon's *Study for Man with Microphones* was completed in 1946 and exhibited twice that year. Luckily, one of the exhibition catalogues included a black and white photograph, which is the only known image of the work in its original form. At some point in the next fifteen years, the Irish-born British painter radically reworked the composition, retitling the piece *Gorilla with Microphones*. Bacon found it difficult to stop working on his paintings, even when finished, and routinely destroyed works he was dissatisfied with. After his death in 1992, his London studio was discovered to contain almost one hundred slashed or destroyed canvases alongside thousands of books, photographs and other reference materials. *Gorilla with Microphones* was among the badly mutilated works. Tantalisingly, Bacon once described his destroyed works as among his best.

Looking back over his career in 1971, Bacon claimed that his aim as an artist had been to paint 'a History of Europe in my lifetime'. *Figure in a Landscape* 1945 was the first work in his earliest series on this theme. Completed in the closing months of the Second World War, and based on a photograph of a friend called Eric Hall sitting in Hyde Park in London, the painting shows a generic male figure, wearing a smart flannel suit and sitting casually astride a backwards-facing chair. But, disturbingly, much of the body is missing; his open mouth – a motif that obsessed the artist – lunges towards a railing, upon which are mounted devices suggestive of both a statesman's microphone and a soldier's machine gun. In a second work, *Figure Study II* 1945–6, Bacon focused again on the figure of the public orator. Here the man's open mouth is clearly recognisable, while his self-importance – ludicrous given his ugliness and near nakedness – is emphasised by the umbrella and raised stagelike

setting. The gaping mouth, umbrella and potted plants in this painting were elements carried over into *Study for Man with Microphones*.

Bacon was fascinated with the theme of the speech-making politician: his studio was filled with press photographs of Hitler and his henchmen Hermann Göring and Joseph Goebbels, whose speeches before and during the war had created an indelible memory in the minds of Bacon's generation. In *Study for Man with Microphones* the male figure is clearly a public orator, caught seemingly mid-sentence. His white shirt and dark suit were standard dress for British politicians, while the black umbrella was associated with Neville Chamberlain, the pre-war British prime minister (in some cartoons he was even represented as an umbrella). The seated pose of the figure may also have reflected Bacon's growing obsession with the masterful and chilling portrait of Pope Innocent X painted by Spanish artist Diego Velázquez in 1650, which led later to a famous series of paintings depicting 'screaming Popes'.

Following on from *Study for Man with Microphones*, and further developing its imagery of the speaking politician, Bacon's first great series culminated in *Painting* of 1946. Showing a seated man, his face half-shaded by an open black umbrella, with a splayed cow's carcass behind him, the painting suggested a hatred of anonymous authority figures. This work sold quickly, and with the proceeds Bacon left London to live for a period in Monte Carlo. (There he made almost no work, and instead enjoyed the night life and gambled prodigiously.) The picture's resale in 1948 to New York's Museum of Modern Art made it the first of Bacon's works to enter a museum, and it remains to this day one of his best-known pieces.

Study for Man with Microphones, however, did not enjoy a similar reception. Unsold after its exhibitions in 1946, the painting was returned to the artist and remained in his studio until 1962, when it was exhibited at the Galleria d'Arte Galatea in Milan. However, the work was now dramatically altered. Although the microphones remained, the man seated under an umbrella had been replaced with the truncated torso of a nude; its back turned to the viewer, its head and face distorted. In the 1962 catalogue, the work also had a new title: *Gorilla with Microphones*.

Exactly when Bacon repainted the canvas is uncertain. In his 1964 catalogue raisonné of Bacon's works, Ronald Alley placed the revisions at around 1947–8 as the changes appear similar to works from that period. The new imagery seemed to reflect Bacon's revived interest in the male nude, which peaked around 1949, when he discovered the anatomical images of the nineteenth-century photographer Eadweard Muybridge. Even with the new title, however, the link with political satire remained: there was an established tradition, in particular among the British press, of associating powerful political figures with monkeys or gorillas.

Yet Bacon was not happy with the changes he had made. Two years after the Milan exhibition, the work was listed in Alley's 1964 catalogue as 'abandoned',

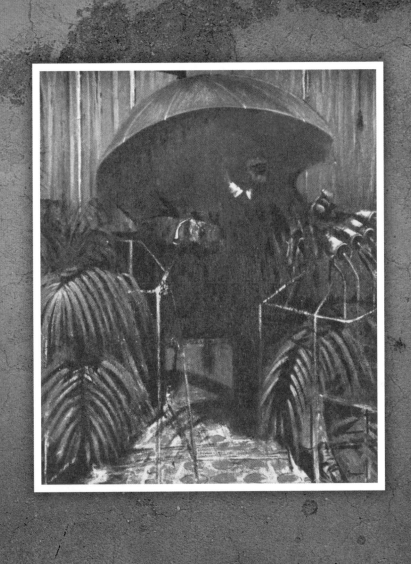

though crucially it was not classified among the destroyed works. After Bacon's death, his studio at 7 Reece Mews, South Kensington – where he had worked for over thirty years – was found to be full of ruined canvases. Portraits with faces cut out were piled on the floor. Larger lacerated works were stacked against the windows and walls. In some cases the damage had evidently been inflicted even while the paint was still wet. In others, the fracturing of the dry paint showed they had been cut long after completion. This was the case with *Gorilla with Microphones*, which had two large sections cut away from the centre of the canvas. The missing portions were found in the same room.

Although Bacon never spoke about the reworking and eventual destruction of this painting, he had long confessed that he had difficulty in resisting tinkering with a work if it remained in his studio. In 1962 he said, 'I think I tend to destroy the better paintings ... I try and take them further, and they lose all their qualities.' He also admitted in the same interview that once the process of reworking had started on a painting, it was almost doomed to fail, as even the slightest trace of paint on a canvas affected his ability to achieve the 'accidental' effect he saw as key to his greatest works: 'How can I re-create an accident? It's almost an impossible thing to do ... One tone, one piece of paint, that moves one thing into another completely changes the implications of the image.'

While Bacon jealously retained the great majority of his rejected paintings in his studio, he seems at times to have thrown or given a few away. Some were rescued, or scavenged, from a skip outside his London studio; others were retained by people who provided the artist with practical assistance. Several works that survived in such ways have been sold for significant sums at auction.

In 2013 it was reported that one or more rejected unfinished paintings had ended up in an art supplies shop in Cambridge that Bacon once used. The owner, it seems, had given the canvas or canvases away to a local amateur painter named Lewis Todd for him to re-use (Bacon liked to work on the unprimed reverse of canvases, and so the front of a rejected painting remained unspoilt). The only condition was that Todd should cut the material up into small sections to ensure that Bacon's rejected painting was destroyed, as he had wished. After Todd's death in 2006, his family found on the undersides of a handful of his paintings unmistakeable elements of one or more compositions by the Irish-born artist. There was now great market and scholarly interest in even rejected scraps of Bacon's works, and after scientific analysis and testing, the painting on the reverse of Todd's compositions was authenticated by Bacon's estate. Turned over and seen together, Todd's canvases suggested that some or all of them may derive from a 'screaming Pope' painting, a hitherto unidentified part of the series for which Bacon became famous in the early 1950s. Even more tantalisingly, it was evident that key parts of the original composition were missing. 'Someone, somewhere might even have a painting by Todd with a pope's head on the back of it', said auctioneer Chris Ewbank, who specialised in finding discarded paintings by Bacon. 'Anyone who owns a painting by Todd should take it off the wall

and check the back of the canvas. Those seemingly random daubs of paint could indicate a work of far greater significance.'

————
Pieces of one or more
destroyed paintings by
Francis Bacon, mounted on
stretchers.
————

Bacon's heir donated the contents of the artist's studio, including the hundred or so slashed paintings, to the city gallery in Dublin, where Bacon had been born. The gallery arranged for these materials to be meticulously catalogued before re-creating the studio, in exact detail, in the Irish capital (the curator claimed, 'If Bacon woke up from the dead, he could go straight back to work in the room'). Today the reworked and mutilated remains of *Study for Man with Microphones* are a tangible reminder that many artists destroy works as part of a sometimes tortuous creative practice – and, of course, that their decisions to reject or rework their original compositions may be regrettable.

————

ERASED de KOONING DRAWING
ROBERT RAUSCHENBERG
1953

Discarded
Missing
Rejected
Attacked
Destroyed
Erased
Ephemeral
Transient
Unrealised
Stolen

24

Drawing Away

Untitled c.1950s
Willem de Kooning 1904–1997

'It has always been rather difficult for anyone to dislike Rauschenberg personally. His exuberance, energy, and high spirits are infectious, and his spontaneous enthusiasm for work by other artists, even when it is very different from his own, is especially winning.' These words by Calvin Tomkins in an article in the *New Yorker* in 1964 expressed a widely held view that the young American painter was both gregarious and entertaining. Certainly, his affability was such that rather uniquely he easily moved between the different (and generally fractious) groupings that made up the American art scene then. 'Abstract Expressionists who welcomed his company got around the aesthetic problem posed by his work by writing him down as essentially non-serious', Tomkins noted.

In autumn 1953 Rauschenberg, then twenty-eight, was very serious about his idea for a work that would involve erasing a drawing by one of the most respected artists associated with abstract expressionism. He told Tomkins:

> I had been working for some time at erasing, with the idea that I wanted to create a work of art by that method ... Not just by deleting certain lines, you understand, but by erasing the whole thing. If it was my own work being erased, then the erasing would only be half the process, and I wanted it to be the whole. Anyway, I realised that it had to be something by someone who everybody agreed was great, and the most logical person for that was de Kooning.

Nearly fifty, Willem de Kooning was then one of the better-known artists working in New York, at least among fellow artists. He had studied fine art in Rotterdam in The Netherlands before coming to New York immediately before the Second World War, and during the 1940s he became increasingly seen as one of the leaders of the abstract expressionist group of painters that included such figures as Arshile Gorky, Mark Rothko and Jackson Pollock. Although artists and critics in New York held de Kooning in the highest esteem as a painter and

draughtsman, he had struggled to support himself. All this was to change radically in 1953. In March, *ARTnews* published an article by Thomas Hess, 'De Kooning Paints a Picture', chronicling and romanticising the artist's struggle to complete *Woman I*, a disturbing depiction of woman as a grinning, grotesque creature, over a period of more than three years. A few weeks later, de Kooning showed this painting, as well as six other large oil paintings and sixteen drawings on the same theme, at the Sidney Janis Gallery in New York. The Hess article and the Janis exhibition brought him much needed public recognition and commercial success.

Photograph taken by Robert
Rauschenberg of de Kooning's
studio in 1952, showing
Woman II in development.

With de Kooning's star rising, Rauschenberg approached the older artist with his request. In fact, Rauschenberg had known de Kooning for a couple of years and rather idolised him: a year previously he had sneaked a visit to the Dutch artist's studio, photographed *Woman II* in progress and stole a drawing from a wastebasket. Aiming to do things correctly for the intended work, however, Rauschenberg went to de Kooning's studio armed with a bottle of whisky, and settled down to explain what he had in mind:

I remember that the idea of destruction kept coming into the conversation, and I kept trying to show that it wouldn't *be* destruction, although there was always the chance that if it didn't work out there would be a terrible waste. At first, he didn't like the notion much, but he understood, and after a while he agreed. He took out a portfolio of drawings and began thumbing through it. He pulled out one drawing, looked at it and said, 'No, I'm not going to make it easy for you. It has to be something that I'd miss.' Then he took out another portfolio, and looked through that, and finally gave me a drawing, and I took it home.

At this point in his career Rauschenberg was seeking to test the limits and definition of art. With a series of plain, all-white canvases called *White Paintings*, Rauschenberg had pared painting down to an absolute minimum: a plain, thin layer of rolled-on paint with no colour, image, trace of the artist's brush or personal expression. The *White Paintings* were displayed at the Stable Gallery in autumn 1953, about the same time Rauschenberg approached de Kooning for a drawing. For Rauschenberg, the *Erased de Kooning Drawing* was an extension of the *White Paintings*: the idea of the erasure of a drawing paralleled the preparation and exhibition of his recent monochrome canvases. He later said that the *White Paintings* were an attempt to 'see how far ... you could push an object and yet it still mean something'. *Erased de Kooning Drawing* asked whether a drawing could mean something if utterly effaced by a third party.

The act of erasure was not easy. Not easy psychologically (many others have said they would baulk at the task) and not easy physically. Rauschenberg said it required several weeks of work and many different types of eraser to rub out the crayon, ink, charcoal and pencil of the original drawing. The effort, however, was part of the process of imbuing the final object with meaning: 'in the end it really worked. I *liked* the result. I felt it was a legitimate work of art, created by the technique of erasing.' The question had been answered: as far as he was concerned, erasure could create a new work of art, and he never felt the need to repeat the trial.

Rauschenberg did not exhibit *Erased de Kooning Drawing* until 1963, but news spread through the New York art world by word of mouth and the artist often showed the work to visitors to his studio. In 1957 art critic Leo Steinberg telephoned Rauschenberg to inquire about *Erased de Kooning Drawing*. Steinberg had never seen the work, but was intrigued by the concept and wanted an explanation. (When Steinberg asked whether his understanding would be enhanced by seeing the artwork in person, Rauschenberg responded, 'Probably not'.) The work became much talked about in art circles, in part because of consternation about the loss of a potentially significant (and commercially valuable) artwork by a painter widely acknowledged as an accomplished draughtsman. To some, it seemed a shocking act of vandalism. Others were more acutely aware of the implied erasure of the achievements of one generation by the conceptual prac-

tice of younger artists such as Rauschenberg himself, and were either dismayed or impressed by the efficacy of the gesture.

Part of the appeal of Rauschenberg's work was of course the mystery surrounding the lost drawing by de Kooning: after all, not knowing is a powerful inducement to attempt to know. Some ghostly shadows of lines are all that are visible to the eye, with a neat, official looking inscription in the cream-coloured mount surrounding the drawing, with details of title, authorship and date penned by Rauschenberg's friend, the artist Jasper Johns, set into a recessed window (note the mount with its inscription is considered to be part of the work). Until recently, there was no way of visualising what de Kooning's original drawing looked like (there were no photographs of the work). In 2009, however, the San Francisco Museum of Art created an infrared digital partial reconstruction of the lost image. This reveals that the drawing had several different elements: quasi-abstract mammiferous creatures at the centre and top, and a schematic female figure, with eyes and teeth, breasts and haunches, at the bottom left. And, if further proof that Rauschenberg did indeed use a genuine de Kooning drawing was needed, the backboard that had been applied to support the paper has been removed, revealing a drawing of a single figure in de Kooning's characteristic style – though it, too, is in effect 'lost' by being on the back of the work that Rauschenberg appropriated and made his own.

Robert Rauschenberg
Erased de Kooning Drawing
1953

For Rauschenberg, the loss involved in erasing de Kooning's drawing was neither destructive nor tragic; if anything, the creation of a new work was a cause for celebration. And the element of material and aesthetic loss embodied in this new work was ultimately less important than the vindication of the idea that erasure – the simple act of rubbing out a drawing by someone else – could in certain contexts create a meaningful work of art.

Discarded
Missing
Rejected
Attacked
Destroyed
Erased
Ephemeral
Transient
Unrealised
Stolen

25

The Death of Painting

Cremation Project 1970
John Baldessari born 1931

It is not uncommon for artists to excise particular works and, occasionally, whole phases in their production from their published oeuvre. They might keep the works hidden or dispose of them privately; they can also refuse permission for photographs of them to be reproduced. But the American conceptual artist John Baldessari went a step further and made something positive out of the decision to get rid of a whole phase of his career. In the summer of 1970, all paintings in the artist's possession dating from the thirteen years 1953–66 – from his graduation from art school to when he began to work as a conceptual artist – were incinerated at a crematorium in San Diego. He made the process public and part of his new oeuvre, calling it first *Cremation Piece* and then the more encompassing term, *Cremation Project*, when he added a series of documentary photographs. In a letter to a critic he wrote shortly afterwards, 'I really think it is my best piece to date'.

Baldessari began his career in his home town of National City near San Diego, California, painting and exhibiting while working as a high-school art teacher. He soon formed part of a group of artists in southern California who rejected the still dominant ethos of New York-based abstract expressionism. A world away from the chaotic gestural traces of Jackson Pollock, or the brooding monolithic paintings of Barnett Newman, works such as the punning *God Nose* 1965 suggested a more light-hearted and critical approach to art. (This particular canvas belonged to the artist's sister and escaped the *Cremation Project*. In all, about ninety paintings made in the period May 1953 to March 1966 survived because they were owned by others.) According to the artist, 'hundreds' of paintings that were still in his possession were burned. But what they were remains a mystery: the artist took the precaution of making slides of most of them but the exact number of works destroyed is unknown.

Baldessari began to use photography in his paintings from 1966. As he said in 1981:

> I stopped trying to be an artist as I understood it and just attempted to talk to people in a language they understood ... but rather than ... aspire to the conditions of a photograph, why not just use the photograph or a text? I thought I would do all that on canvas so that the canvas would be an art signal.

The resulting *National City* paintings, depicting the artist's home town, were the subject of his first solo exhibition in Los Angeles, and, because based on a conceptual approach, were excluded from the *Cremation Project*.

As the 1960s progressed, Baldessari continued to move away from the idea of the great artist, as glorified in the New York art scene. In 1969 he detached himself entirely from the physical process of creation with a series of works called *Commissioned Paintings*. Critiquing the idea that conceptual art 'pointed' to or signalled things rather than depicted them, Baldessari took a series of photographs of a hand pointing at everyday objects and commissioned local amateur artists to paint the images, together with a clear – but ironic – statement of their authorship in lettering on the canvas. Such paintings were also excluded from the 1970 *Cremation Project* because they dated from a later period and were already conceptual in character.

An old movie theatre, Baldessari's large studio was filled with artworks he had made over the years (he had sold very few). He later said he felt that he was drowning in his paintings and at the same time becoming more and more doubtful about the idea that painting alone was art. For the 1969 exhibition *Konzeption–Conception* in Germany, he sent a series of notes including one titled, 'The world has too much art – I have made too many objects – what to do?' One of his answers to the question was:

> Burn all my paintings, etc., done in the past few years. Have them cremated in a mortuary. Pay all fees, receive all documents. Have event recorded at County Recorder's. Send out announcements? Or should it be a private affair? Keep ashes in urn.

The idea of getting rid of old paintings had a practical aspect: Baldessari had just been hired to teach at California Institute of the Arts and would soon be relocating, with his wife and two young children, from National City to Los Angeles in order to be closer to his new job and to the larger Los Angeles art community. To transport and keep paintings that no longer seemed relevant to him was unappealing. After a one-day studio exhibition and sale in December 1969, Baldessari decided to create an artwork out of his desire to make a fresh start. He found a crematorium owner in San Diego who was prepared to incinerate his artworks, and he and a small number of friends physically broke up the canvases or took them off their supports so that they could be transported to the crematorium and there loaded into a

furnace. The process was documented for the artist by David Wing as part
of *Cremation Project*.

The project was both highly emotional for the artist, involving as it did
getting rid of thirteen years' worth of his production as a painter, and conceptual
in that it asked the difficult question of whether it mattered if artworks no longer
existed materially. As Baldessari explained in 2005, 'A lot of that [*Cremation
Project*] was coming out of ideas such as where does art reside? Is it physically
there in that painting? Is it in my head? Could it be a trace memory? Could it
be a photo? What is necessary for it? Can you just talk about it? And so on.' At
every stage, the process of the paintings' cremation was made to parallel the
cremation of a human body. The paintings' ashes were decanted into the boxes
usually used for human remains, filling nine adult-sized containers and a smaller
one that would typically be used for the ashes of a child or an amputated limb.
Baldessari kept a portion of the ashes in an urn made to resemble a book with
leather-lined covers. The inscribed plaque on the book's cover, 'John Baldessari
May 1953–March 1966', signalled the American's view that this action repre-
sented the death both of his early paintings and of himself as a 'traditional artist'.
And after the incineration, Baldessari used his local newspaper to announce
the demise of his paintings, just as friends and relatives might publish news of a
death. (Interviewed in 1973, Baldessari admitted he had needed to publicise his
action in order to prevent him from returning to painting as a 'safe' technique:
'I had to advertise it. It's sort of like when you're dieting, you're supposed to ...
tell people you're dieting, so that if you don't diet, then they say, "Well, I thought
you were dieting." So if anybody caught me painting, they'd say "I thought you
stopped painting".')

More than simply a death, the cremation of Baldessari's early works also
marked a beginning for the artist, a stage in a cycle following which new pieces
could be created. Suggesting such a renewal, some ashes were baked into biscuits,

although the artist has said that he only knew of one person who actually ate one. The paintings' ashes were also used in some of Baldessari's subsequent works. For *A Potential Print* 1970, a footprint was made in ashes sprinkled in a corner and a photograph taken. As the accompanying text explained, the footprint – a play on the making of an artistic print – referenced an old superstition about predicting death. The incinerated remains of a 'body' of work, the ashes entered Baldassari's conceptual practice both as raw material and as a set of associations with scope for punning jokes about art itself.

As Baldessari's fame and influence grew, he was repeatedly questioned about the meaning of *Cremation Project*. In 2009 he recalled with some embarrassment that at the time he had felt it fitting that the incinerated paintings, which were made of minerals and natural materials, should return to the earth: his paintings were just one point on a cycle of 'endless return'. Works that escaped the furnace have since been included in later retrospectives, suggesting a greater acceptance by Baldessari of those early works and – conceivably – perhaps even a sense of regret at their loss. Many artists edit their work, getting rid of or refashioning artworks they do not wish to be known or remembered by. But Baldessari went one further in creating an artwork from a clinical erasure of a substantial chapter of his past, and in embedding the remains of his old works in new works.

Cremation Project marked a decisive turning point in Baldessari's career, and, with its pronouncement of the death of painting made literal through the trappings of a cremation, it became a landmark in the history of conceptual art. Underscoring the human dimension of Baldessari's action, however, artist David Salle pointed to the trauma of the loss and the excitement of a fresh start involved in the project when he observed:

> I don't think we can underestimate the trauma at the heart of the repudiation; the yawning abyss of failure (for what else is it except an admission that these works that I had thought were me are not me), which was also the exhilarating breaking down of a previously locked door.

————

EPHEMERAL

MATERIALS USED TO MAKE ARTWORKS HAVE A PARTICULAR LIFESPAN
AND ARE SUBJECT TO PROCESSES OF DEGRADATION. SOME MATERIALS
HAVE WHAT CONSERVATORS REFER TO AS 'INHERENT VICE' – A HIDDEN
FLAW THAT MAKES THEM DETERIORATE IRRETRIEVABLY. ARTWORKS
MADE WITH THESE MATERIALS END UP CHANGING AND MAY EVEN
BECOME UNRECOGNISABLE AND UNEXHIBITABLE.

MANY MODERN ARTISTS LIKE TO USE NEW OR UNCONVENTIONAL
MATERIALS, THOUGH THEY MAY HAVE NO IDEA HOW LONG THESE WILL
LAST. THEY MAY BE WILLING TO ACCEPT THE RISKS AT THE TIME, BUT
IT CAN LATER BE A SOURCE OF REGRET, FOR THEM AND FOR OTHERS,
WHEN THEIR WORKS PROVE SHORT-LIVED.

26-28

Discarded
Missing
Rejected
Attacked
Destroyed
Erased
Ephemeral
Transient
Unrealised
Stolen

26

Material Decay

Construction in Space: Two Cones 1936, replica 1968
Naum Gabo 1890–1977

Some artists do not care about the durability of their works. They choose to use materials that will not last and happily accept that their works will never acquire a patina of age and accreted meaning. The Russian constructivist sculptor Naum Gabo, however, wanted to make permanent works and had every reason to believe that the new materials he used in his interwar constructions would last, if not for ever, then at least for a very long time.

Born Naum Neemia Pevsner in Russia in 1890, he adopted the surname Gabo in 1915 to distinguish himself from his brother, Antoine Pevsner, also a sculptor. Before this, he had studied medicine and then the natural sciences at Munich University, while also attending art history lectures by the Swiss critic Heinrich Wölfflin, a highly influential exponent of an approach to art that focused on style and form rather than content. In 1912 Gabo transferred to an engineering school in Munich, where he met the Russian abstract artist Wassily Kandinsky. Deciding to become an artist himself, he spent time in Paris and then Norway, where, in 1915, he made his first constructed sculptures.

He returned to Russia shortly after the October Revolution of 1917, and quickly became a leading figure among avant-garde artists, teaching at Moscow's Vkhutemas (Higher Art and Technical Studios) alongside Kandinsky and Vladimir Tatlin. In 1920, he set out his new thinking in the *Realistic Manifesto*, which he posted on hoardings around Moscow. The text condemned cubism and futurism as having failed to deliver a convincingly new approach to art, suitable for post-revolutionary life and culture. Art could not be built on empty abstractions but on 'life and its laws', which for him, drawing on his scientific and engineering background, meant the principles of space and time. 'The plumb line in our hand, eyes as precise as a ruler, in a spirit as taut as a compass, we construct our works as the universe constructs its own, as the engineer constructs his bridge, as the mathematician his formulae of the orbits.' In short, he wanted to bring the 'constructive thinking of the engineer into art'.

It was thus natural that he believed that artists should make use of the new industrial materials that the modern age provided. Made from metal, glass and increasingly plastic, his 'constructions in space' echoed the forms and surface qualities of scientific models and contemporary machinery. In the mid-1920s, new plastics became much widely available, and Gabo, then living in Berlin, seized upon cellulose acetate for its transparency, translucency and malleability.

From his earliest days as an artist Gabo explored ideas for sculptures through small models, often using paper or card. He would then make progressively bigger models before creating the final full-scale works. Sometimes a model might be reworked and become the source for more than one sculpture. This seems to be the case for a tiny plastic model now in Tate's archive. It apparently served as a prototype for *Construction in Space: Soaring* 1930, a work owned by Leeds Museums and Galleries, before the artist altered it as he developed what was to become *Construction in Space: Two Cones*.

At the heart of the conception of both works is the shape of two cones. In *Soaring*, the cones sit either side of a vertical shape made of stereometric triangular shapes, and black struts soar upwards and behind the piece like wings. In the interwar years Gabo was interested in aeroplane designs, and this piece suggests his fascination with flight, both mechanical and animal. Six years later Gabo reworked the idea in *Construction in Space: Two Cones*, twisting the black wing forms forwards and around to suggest a more organic and apparently grounded structure. Whether his shapes were rectilinear or curved, however, Gabo believed that they related to deeper aspects of nature and of man's spirit. 'Shapes act, shapes influence our psyche, shapes are events and Beings', he wrote. 'Our perception of shapes is tied up with our perception of existence itself.'

Gabo made the second work while living in London. A Jewish left-wing intellectual, he left Berlin in 1932 just before the Nazis came to power, and travelled to Paris. The loss of his home and despair at the political situation in Europe weighed heavily on him: convinced that his art was becoming increasingly irrelevant to a society descending into chaos and political reaction, he tried to commit suicide on at least one occasion. Art, however, remained a source of consolation. When he moved to Britain in March 1936, buoyed by the thought of the small but growing community of abstract and constructivist artists in London, he brought with him the tiny model from which he created the larger work. (Made from cellulose nitrate rather than cellulose acetate, the model's transparent plastic has yellowed but otherwise remains in good condition.)

Combining flamboyant curves and geometric shapes, *Construction in Space: Two Cones* was first displayed in an exhibition of Gabo's constructions at the London Gallery in January 1938. One of the more important pieces in the show, it was reproduced on the cover of the invitation. The exhibition as a whole was favourably reviewed, though critics struggled a little with the aesthetic justification of these abstract sculptures. The *Sunday Times* critic, for example, wrote

that Gabo's pieces 'show by their complexity and precision how mathematics and aesthetics can be fused, as in a Bach Invention, into a synthetic whole'. *Construction in Space: Two Cones* was bought by the major American collector A.E. Gallatin for the Museum of Living Art in New York, and then given to the Philadelphia Museum of Art in 1952. As was then apparent, the piece was an important work, marking a transition from the machine-related constructions of the 1920s to the later sculptures made with continuous and rhythmically curving planes. For these, Gabo essentially took the form of the two cones and developed it into a series of variations of spiral shapes and, famously, what he termed 'spheric themes', sometimes incised with lines to help articulate the idea of movement through space. He was to make many examples of the 'spheric theme' motif, which he had developed from the idea of two interlinked and twisted circles and, before that, two cones.

In 1960 conservators at the Philadelphia Museum of Art noticed condensation droplets on *Construction in Space: Two Cones*, the first signs that the sculpture had begun to deteriorate. Cracks developed in some parts of the construction and the plastic base and central element were fractured. Repairs were made but the piece continued to deteriorate. In 1968 the museum carefully sent the work to Gabo, who was then living in Middlebury, Connecticut, for an assessment. He felt that repair was impossible and, refusing then to accept that there might be a problem with the material itself, blamed the deterioration on the fact that the museum had kept the piece in an airtight case. He offered to make a replica using the same material but refused the museum's request to use Plexiglas, a more stable plastic.

Gabo returned the sculpture to the museum but only after he had created templates of the various elements of the piece. He then used these templates to make a replica, employing the same materials; he had old stock of sheets of cellulose acetate and presumably wanted to prove there was nothing inherently wrong with it. In 1977 he presented the replica to the Tate Gallery in London.

All plastic degrades eventually but different kinds of plastic degrade at different rates depending on their composition and environmental factors. Developed in 1904, cellulose acetate is made by treating wood or cotton fibres with acetic acid. Pure cellulose acetate is easily broken but when plasticised with a liquid solvent becomes flexible. However, the solvent evaporates slowly, resulting in brittleness, shrinkage and a loss of surface transparency. Cellulose derivatives also tend to oxidise when exposed to light. The acidic by-products of this oxidation react with water in the air, breaking the chemical bonds holding the cellulose acetate together and releasing acetic acid (the source of the telltale vinegar smell found when cellulose acetate begins to deteriorate). This acid may increase the rate of the deterioration but is not the cause of the material's buckling and warping. When the acetate sheets are made, the material is extruded, dried and pressed. This locks in stresses related to the differential drying of different parts of the sheet. Once much of the plasticising solvent has gone,

the forces locked into the acetate reassert themselves: sheets warp and shrink. When the degradation has been triggered, it cannot be stopped.

Signs of deterioration in Tate's sculpture were first noticed in 1980: the work gave off a strong vinegar smell and shortly thereafter sweatlike beads of moisture appeared on its surfaces. By 1982 much of the adhesive holding the pieces of plastic together had failed under the stress of the pieces warping. Five years later, the base was distorted and two corners were broken off. The black base of the sculpture was split and distorted. Sections had begun to separate into their component layers. Research suggested that the deterioration of Tate's version of *Construction in Space: Two Cones* was caused by the 'inherent vice', or flaw, in the materials, with the environmental history of the work providing an additional catalyst. Significantly, however, not all of Gabo's cellulose acetate works were in poor condition or are today. The chemical and physical structure of the acetate used in different sculptures seems to have varied, while the different environmental conditions experienced by the works appears also to have played a role in determining the variable longevity of the pieces.

Knowing that the deterioration of this particular piece was going to proceed apace, Tate conservators commissioned the making of a holographic representation of the work in 1987. The aim was to capture something of the three-dimensional quality of the sculpture, seen from different angles, to try to retain something of the experience of viewing the piece in the round for future generations. They have also attempted to document fully existing cellulose acetate sculptures in the collection before they begin to warp and collapse, and have made a small number of new replicas.

Today the hologram of *Construction in Space: Two Cones* hangs on a wall in Tate's sculpture conservation studio, a spectral reminder of – but no substitute for – an artwork that is no longer available to be viewed or experienced in all its spatial complexity. The original work and its replica are just broken shards and distorted fragments, and with the accord of the artist's estate are now classed unexhibitable, at least as artworks by Gabo.

– – – –

~~Discarded~~
~~Missing~~
~~Rejected~~
~~Attacked~~
~~Destroyed~~
~~Erased~~
Ephemeral
~~Transient~~
~~Unrealised~~
~~Stolen~~

27

Life Doesn't Last; Art Doesn't Last

Sans III 1969
Eva Hesse 1936–1970

Eva Hesse created *Sans III* in 1969 at a time when she was beginning to win critical acclaim both in New York (her home city following her family's escape from Nazi Germany) and internationally. Invited to participate in a group exhibition that opened in Bern and travelled to Krefeld and London, she made *Sans III* as a new variant on the theme of linked box shapes she had explored in two earlier sculptures, *Sans I* 1967–8 and *Sans II* 1968, which were unavailable for the touring show. This was just a year before she died, aged thirty-four.

Hesse had shown *Sans I* and *Sans II* in her first (and only) solo exhibition. It opened at the Fischbach Gallery, New York, in November 1968 and was called *Chain Polymers*, a punning reference to the molecular construction of latex and fibreglass and to her use of linked and repeated elements or 'chains'. To make *Sans I*, she cast forty-eight rectangular units in latex over a simple plaster model, and then glued the boxes together in a double-row chain with more latex. The idea of making sculptures from repeated boxlike forms referenced the early 1960s minimalist works of such artists as Donald Judd, Robert Morris and Sol LeWitt. But Hesse rejected the emphasis on a grid structure and the impersonal and industrial found in minimalist works. Instead, she explored qualities of flexibility, instability and expressivity, for which latex proved a perfect, if highly unusual, medium.

To make the much larger *Sans II*, Hesse used more durable fibreglass and polyester resin, rather than latex. The process of fabrication, however, was essentially similar: repeated casts were taken of the same module and then linked together in a long chain. Hung horizontally on the wall, the double-row piece occupied 35 feet of the 39 feet available in the Fischbach Gallery. A reviewer noted about this work:

Here again Miss Hesse divides, subdivides and aligns as if she is a hard-core serialist, but then the creased and rippling viscous contours, and the light-catching lumpiness of the surfaces or 'structural' walls undermine that ostensible methodology.

With such works she was recognised as one of a new generation of what became known as post-minimalist sculptors, though one who distinctively explored qualities of fragility and the hand-made. The critic concluded:

> Incorporating the conceptual with a wryly objective slant on that conceptualness in terms of her materials, and the processes she uses to shape them, Miss Hesse adds a distinct new accent to the current scene in sculpture.

Completed in January 1969, *Sans III* consisted of a chain of forty-nine linked latex boxes that hung vertically and extended onto the floor. At some point Hesse made a related drawing showing a single vertical row of boxes. Next to it she wrote, 'rubber skeleton of squares. no inside'. *'Sans'* in French means 'without', a word that in English can suggest either a lack or being outside. In the context of the *Sans* sculptures, 'without' can be interpreted as referring to the hollowness of the units ('no inside'), or the idea of the work being 'a rubber skeleton' surrounding, or being outside, a vital core. In her titles, Hesse was drawn to use words that expressed ambiguous relationships; other titles included *Aught*, *Repetition* and *Contingent*. For the catalogue of her 1968 solo exhibition, she commented that that she sought out words that resisted straightforward interpretation, and that it was the non-logical aspects of her sculptures that interested her:

> The formal principles [of my work] are understandable and understood.
> It is the unknown quantity from which and where I want to go.
> As a thing, an object, it accedes to its non-logical self.
> It is something, it is nothing.

In 1968 Harald Szeemann, the director of the Kunsthalle Bern, invited Hesse to show works in what proved to be a ground-breaking exhibition, *Live in Your Head: When Attitudes Become Form. Works–Concepts–Processes–Situations–Information*. Szeemann wanted to reflect what he saw as an emerging tendency among contemporary artists to focus on the processes of making art rather than forms. The notion was central to the practice of Hesse, who talked about not keeping to preconceived ideas but rather finding out the potential of a piece through developing it. 'As you work, the piece itself can define or redefine the next step, or the next step combined with some vague idea.' The inclusion of *Sans III* in Szeemann's touring show helped establish Hesse's

reputation internationally as one of the most interesting and distinctive artists of her generation.

Hesse had begun to use latex (a material generally employed and then discarded by artists in casting works) as a medium for her sculptural work in 1967. At first she simply made latex casts (as with *Sans I*, for example) but soon experimented with its colour and translucency by adding pigments and fillers. Trained as a painter rather than a sculptor, she was attracted to the idea that in its liquid form latex could be applied in layers like paint, and she chose to make *Sans III* by brushing coats of the material around plaster moulds. Each coat took at least thirty minutes to dry and so the process of making the forty-nine units was fairly time-consuming. The huge cheesecloth sheets attached to long poles of *Expanded Expansion*, completed in February 1969, also required layers of latex to be painted on the soft material.

Hesse was aware that latex would not last indefinitely. A naturally elastic material tapped from trees, it is subject to continuous but unpredictable degradation. Change can be initiated by temperature, light, oxygen or ozone, physical stress and contact with metals, but the course and speed of the deterioration are variable. Depending on whether the molecular bonds making up the polymer chains are broken apart or link together, deteriorated latex can become powdery, brittle, resinous or sticky, or even liquid. Hesse felt her immediate need to use the material, however, was more important than concerns about how her sculptures would change over the years. She was working in a period in which the idea of the artwork as a precious and permanent object was being challenged by many of her contemporaries and although she wanted her sculptures to last, she also had no deep-seated objection to their deteriorating over time. Confronting her own mortality as a result of her brain tumour, she said resignedly shortly before she died, 'Life doesn't last; art doesn't last. It doesn't matter.'

A year after her death in May 1970, *Sans III*, then part of the artist's estate, was included in a Hesse exhibition at the Visual Arts Gallery in New York. It is thought that the work thereafter remained in storage until 1997 when it was discovered that the chain had broken and the boxes had crumpled. Darkened and brittle, the work was beyond repair (it not only had changed in appearance but it also could no longer hold its own weight when hung from a wall).

In 2002 the future of Hesse's latex works in general was the subject of a symposium involving art historians, conservators and those who had known and worked with Hesse herself. Acknowledging that the translucency and elasticity of the latex had been lost, commentators were divided as to whether deteriorated pieces should continue to be displayed or whether new versions could legitimately be made following Hesse's methods and procedures as study pieces. A complicating factor was ambiguity surrounding Hesse's understanding of her art as process (rather than a final object with a fixed appearance). She accepted change as a factor in her work and knew that the latex she used would change in appearance over time, but would she have wished her works to be seen when

severely deteriorated? It is now generally felt that Hesse's *Sans III* should not be exhibited, although there are some who believe that this decision does not respect the Hesse's own acceptance of the role that the latex would play in determining the future life of her works. In 2012 the American artist and critic Jonathon Keats, for example, argued: 'Hesse's work concerned her materials, her interactions with them, and theirs with her. Those interactions are still reverberating physically and chemically. The materials with which she collaborated have become her executors. They deserve our respect.'

In fact, several of Hesse's latex works remain in reasonable condition or have been treated so that they remain displayable. One such work is *Test Piece S-93*. Hesse made it to try out an idea in latex for a metal version of *Repetition Nineteen* 1968, a sculpture comprising nineteen bucket-like forms, each one slightly different from the next and placed directly on the floor. By 1997 the test piece had sagged and partially collapsed; its surface was cracked and darkened; and the rubber tubing had broken into several pieces. Conservator Martin Langer, however, was able to fill the cracks, restore surface losses and replace the tubing, making the piece robust enough to be transported. Although far removed from the translucent upright form it once was, the object still conveys much of Hesse's original concept and was included in an exhibition of 'studio-works', experimental items left in Hesse's studio or given away to friends, in 2009. Critics expressed admiration for the emotional freight still conveyed by these objects, as well as a nostalgia for what has been lost both through Hesse's untimely death and the inherent fragility of many of her major works. *Test Piece S-93* may not have been as Hesse had intended but, unlike *Sans III*, it is intact and offers at least a sense of what she intended and how she worked.

In 2013 the Hesse estate sanctioned the making of an exhibition copy of *Sans III* for a restaging of the exhibition *Live in Your Head: When Attitudes Become Form* for which it had been made. The process, the conservators involved said, offered valuable insights into Hesse's working methods. Although a lost original can never be replaced, the creation of exhibition copies of sculptures, authorised by artists' estates, can meet the educational and, to some extent, the aesthetic needs of future generations. But issues relating to how the value of a decayed artwork is assessed, who decides when a piece no longer can be considered an artwork, and what criteria are used in the decision-making process remain today largely unresolved.

––––

28

Moths

Felt Suit 1970
Joseph Beuys 1921–1986

An important function of museums – part of their raison d'être – is to protect and preserve the objects in their collections. Teams of conservators, art handlers and registrars work to achieve this goal on a daily basis, following established codes and procedures and developing new ways of securing the future life of objects in their care. But even the best-laid plans can be tested by the unforeseen or by a bit of bad luck.

Joseph Beuys's *Felt Suit* was produced in an edition of one hundred in 1970. The charismatic German artist wore the original suit in an anti-war performance in Düsseldorf in 1970. He authorised the making of an edition shortly afterwards as a means of reaching a broader audience. It became one of Beuys's best-known 'multiples', and in 1981 Tate bought number 45 in the edition.

Felt was a signature material for Beuys. According to the story he told about his experience as a pilot during the Second World War, he had been shot down over Crimea and was nursed back to health by Tartar tribesmen who covered his body with animal fat and felt as insulation against the cold. The account was later shown to be untrue, but the myth provided a powerful allegory to help explain the symbolic value of felt in his work. For Beuys, felt generally signified the need for human beings to conserve warmth – seen as both a type of energy and a spiritual quality – against forces that diminished and drained vitality and creativity. In one of his more famous early sculptures, *Infiltration Homogen for Grand Piano* 1966, for example, a piano was concealed by a tailored covering made of grey felt, with a red cross. Here the felt suggested the need to protect – and the danger of muffling – the piano's potential for communication, its quality of 'warmth'. Blurring the boundary between art and artist, Beuys habitually wore a grey felt hat, incorporating his signature art material into his everyday appearance.

Appointed professor in the Monumental Sculpture Department of the Düsseldorf Art Academy in 1961, Beuys became an important figure within the loose-knit artists' group Fluxus in the 1960s. He promoted what he called a

revolutionary form of 'living art' that aspired to make an active intervention into society. He was soon drawn to performance, or 'actions', as a means of achieving this social engagement, and as the sole performer, he himself became integral to his art and its meaning.

In 1970 the American artist Terry Fox asked for Beuys's help in finding a venue for an action in Düsseldorf to protest against the Vietnam War. Beuys suggested the Academy's basement, a former coal cellar with bare brick walls. The day before the planned action, Beuys proposed that they collaborate. Fox recalled: 'He showed me a mouse, that had lived for a month under his bed. He had fed the mouse with pieces of bread. The previous night, the mouse had died. He suggested we do the action together ... he suggested a kind of funeral for the mouse.' At 7pm on 24 November 1970 Fox and Beuys began their action *Isolation Unit*. On the basis of statements by the artists and spectators, art historian Uwe Schneede later reconstructed the following sequence of events:

> Using a gasoline fuel he had renamed 'Napalm', Fox painted a cross on the cellar floor and set it alight. Moving to a small bowl of soap and water he began washing himself, the sound of the circular motions of the soap amplified by loudspeakers, captured on a two reel tape recorder. On the other side of the room, Beuys – dressed in his oversized grey felt suit – held the dead mouse in the palm of his hand and proceeded to show it to the spectators, before placing it on the turning spools of the tape recorder. As Fox used two iron pipes to smash the glass from an old window frame, Beuys began to eat a halved passion fruit, as one witness recalled, 'with his face, with his whole body ... he ate like an animal'. Fox began to strike his iron pipes against the floor; in time with this striking, Beuys spat the seeds of the fruit into a small silver bowl placed on the floor before him, the ringing of the silver bowl chiming against the dull thud of the pipes.

When the fruit was consumed, the action came to an end. In all, it lasted around an hour.

With the aggressive striking of iron and glass and reference to napalm, the inflammable liquid used by the American military in Vietnam, the anti-war message of Terry Fox's *Isolation Unit* was clear. Beuys was also opposed to the war – he refused to travel to the United States until the end of the war in 1974 – but his contribution broadened Fox's message. Focusing on the small scale and the personal (the single dead mouse, the consumption of the fruit with its tiny seeds), Beuys made a more general statement about death and survival. It was perhaps a desire to avoid too specific a political statement that saw Beuys shortly afterwards rename his contribution *Action the dead mouse*, distancing himself from Fox's concept.

During *Action the dead mouse* Beuys wore not only his usual felt hat but also a felt suit based on one of his own but with lengthened sleeves and legs. He

later stressed that the felt in the suit should be seen as an extension of its use in his sculptures. 'The felt suit was an attempt to express two principles that were very important for my actions', he said. 'On the one hand, it's a house, a cave that isolates a person from everybody else. On the other, it is a symbol of the isolation of human beings in our era. Felt plays the part of an insulator.'

Shortly after the performance, Beuys's dealer René Block produced the edition of one hundred suits based on the one the artist had worn. The suit had no buttonholes and, as Beuys acknowledged, would have been difficult to wear. 'The suit is meant to be an object which one is precisely not supposed to wear. One can wear it, but in a relatively short time it'll lose its shape because felt is not a material which holds a form. Felt isn't woven. It's pressed together usually from hare or rabbit hair. It's precisely that, and it isn't suited for button-holes and the like.'

Although he was well aware that the material was fragile, he did not have particular views as to how the work should be displayed. In 1970 he said, 'I don't care. You can nail the suit to the wall. You can also hang it on a hanger, ad libitum! But you can also wear it or throw it into a chest.' The museums and galleries that acquired examples typically chose to hang them on clothes hangers high on a wall. When Tate purchased its suit in 1981 (it was described in an internal memo as 'a must – a classic, archetypal Beuys image') conservators flagged the piece as an 'unusually vulnerable item', and arranged for it be stored with chemical pesticide in a specially made storage bag.

Unpacked in order to be shown in a gallery display, the suit was discovered to be infested with moths in February 1989. How this had happened was unclear: dormant eggs may have been in the suit at the time of purchase, or a moth may have laid eggs in the suit when it had been on display (museums are not immune to moths). More frequent monitoring of vulnerable materials in artworks at Tate was instigated, but there was nothing that could be done for the suit. A conservation report noted:

> The infestation was severe ... the shoulders were the most severely damaged ... the felt in the body of the suit was copiously penetrated with small holes ... the felt has been weakened to such an extent that it could no longer support its own weight without tearing.

Conservators concluded that any repair of the suit would not only be prohibitively expensive, but would fundamentally alter its colour and texture. However, the museum was reluctant to discard the signature piece, and after fumigation it was kept in storage.

The story of the loss of Tate's felt suit became widely known, in part because it showed that even a great national museum can have as much trouble with the humble clothes moth as everyone else. In 1995 it inspired Canadian artist Jana Sterbak to create *Absorption: Work in Progress*, a nearly two-metre-

high photograph showing her appear to hug a giant white structure representing a moth chrysalis. An accompanying text explains that, as an artist who was well known for her dresslike sculptures, she had become 'bothered' by Beuys's felt suits and in an act of revenge or homage had envisaged herself as a moth devouring these precedents:

> In 1970, nine years before my first wearable pieces, Joseph Beuys created the first of his felt suits. I became aware of this in 1986 and its existence has bothered me ever since ... At the beginning of the nineties I conceived of a solution: the absorption of the suit.
>
> To this end I have metamorphosed myself into a moth, and proceeded systematically to eat, one after another, the 100 suits Beuys sold to private and public collections around the world. In some cases my activity was temporarily disrupted by misguided conservation efforts ...
>
> Nevertheless, it would not be immodest or inaccurate to state that I have already put more than one suit out of its exhibition condition. My work is not easy, but it's not without reward, and, what is most important, it continues.

Planning to show *Absorption* at Tate, Sterbak had wanted to include Beuys's moth-damaged suit alongside her new work. However, Beuys's estate ruled that the deteriorated suit should never be publicly shown. Tate deaccessioned the work from its collection and another example was found to be exhibited with Sterbak's piece.

In 2005, reviewing the status of the suit's remnants, still stored by the museum, conservator Rachel Barker and art historian Alison Bracker wrote: 'Seemingly, as a work of art, the piece is defunct physically and conceptually. Nevertheless, Tate staff remain disinclined to declare it altogether dead.' At the time the decision to keep the suit's remnants was influenced by the hope that a way might be found to restore the piece in the future. It perhaps also reflected the museum's instinctive desire to protect and preserve what was left of a valued artwork. However, Tate's purchase in 1998 of another suit from the edition as a replacement made the already distant prospect of the original suit having a future function seem even more remote. But despite its apparent redundancy, the suit is still routinely monitored to ensure that there is no further degradation, though it is not made available for the public to see.

Beuys regarded the conservation of materials as a flawed enterprise in that all matter is destined to turn into dust, but also believed that an artwork had an indestructible 'spiritual substance'. He might have appreciated these attempts to preserve the remnants of the artwork, and with them the story of its destruction, if only as a salutary warning about the fragile status of objects even within the seemingly safe confines of a modern museum.

TRANSIENT

~~Discarded~~
~~Missing~~
~~Rejected~~
~~Attacked~~
~~Destroyed~~
~~Erased~~
~~Ephemeral~~
Transient
~~Unrealized~~
~~Stolen~~

SOME MODERN ARTISTS MADE ARTWORKS THAT WERE NEVER INTENDED TO ENDURE OR BE COLLECTED BY MUSEUMS. TODAY THESE OFTEN THEATRICAL OR PERFORMATIVE WORKS LIVE ON IN PEOPLE'S MEMORIES AND IN THE HISTORY OF ART THROUGH EYEWITNESS ACCOUNTS, PHOTOGRAPHS, FILMS OR REMNANTS. THEY CAN ALSO BE REVIVED, IN SOME SENSE, WHEN REINTERPRETED BY LATER ARTISTS.

HOWEVER, NOT ALL ART NEEDS TO SURVIVE IN MATERIAL TERMS IN ORDER TO BE REMEMBERED: SOME ARTWORKS MAKE A DEEP IMPRESSION PRECISELY BECAUSE THEY ARE SHORT-LIVED.

29–35

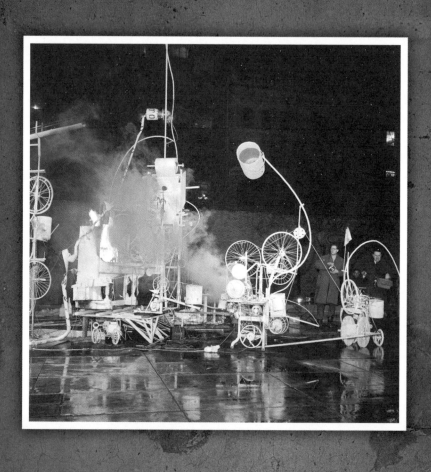

29

Like a Falling Star

Homage to New York 1960
Jean Tinguely 1925–1991

On the evening of 17 March 1960, Jean Tinguely presented a new type of artwork to an invited audience in the sculpture garden of the Museum of Modern Art, New York. It was a vast conglomeration of objects and mechanical parts found largely in scrapyards, which were engineered to perform a series of movements leading to the slow disintegration of the piece. It was the Swiss artist's first auto-destructive sculpture.

The evening proved a memorable occasion, though most of the construction malfunctioned. To assist the machine's planned 'suicide', Tinguely had to take an axe to it in the final stages, and the machine's performance was eventually cut short by the intervention of the fire brigade. Lasting only twenty-seven minutes, the event is known now only through black and white film and a small number of photographs. Later most of the artwork was thrown away, as planned, though several parts were retained as mementos of what some saw as an exciting new art form. Despite – or perhaps because of – its short life, *Homage to New York* became Tinguely's best-known work. A collaborator on the project described it as a spectacle full of 'beautiful humour, poetry and confusion'. Today, notwithstanding the fact that there are very few people alive who can remember the event, it remains for many an almost archetypal example of 'lost art'. For the artist himself it was a turning point and affirmation of his hopes for a new form of art:

> What was important for me was that afterward there would be nothing, except what remained in the minds of a few people, continuing to exist in the form of an idea. This was for me very liberating … It wasn't the idea of a machine committing suicide that fascinated me primarily; it was the freedom that belonged to its ephemeral aspect – ephemeral like life, you understand. It was the opposite of the cathedrals, the opposite of the sky-scrapers around us, the opposite of the museum idea, the opposite of the petrification in a fixed work of art.

In 1953 Tinguely left his native Switzerland for Paris, aged twenty-eight. There he quickly began to explore his interests in the new art forms of kinetic art and sound art, producing by 1959 some twenty machines of various sizes that made thousands of unique drawings on rolls of paper. This was no experiment in engineering: these 'meta-matic' sculptures provided him, he said, with the opportunity to be 'poetic' and to make machines that were 'joyous' because 'free' and unpredictable. For him, these machines 'demonstrated that a work of art is not something finished or final, but something that makes its own life within the bounds of its potentialities; the work of art itself has creative powers'. Tinguely's mechanised sculptures created a storm in Paris (the elderly dada poet Tristan Tzara declared he had finally witnessed the end of painting). The young Swiss artist hoped to create the same impact in New York, when he was invited in January 1960 to show recent works at an exhibition at the Staempfli Gallery.

During his voyage to New York in early 1960, Tinguely had the idea of creating a large, self-destroying machine to be shown at the Museum of Modern Art. Critical of the way museums tended to preserve or ossify works of art, he wanted to create something transient within the museum's grounds:

> I wanted something ephemeral, that would pass like a falling star and, most importantly, that would be impossible for museums to reabsorb. I didn't want it to be 'museumised'. The work had to pass by, make people dream and talk, and that would be all, the next day nothing would be left.

At first, the museum was not keen to offer Tinguely space. One curator told him that its role was to 'preserve and conserve, and not destroy art'. However, with the support of curator Peter Selz, Tinguely eventually obtained permission to stage the work's 'suicide' in the sculpture garden as a temporary exhibition.

He enlisted the help of a Swedish electrical engineer and scientist Billy Klüver, who had an interest in marrying art and technology. Klüver helped Tinguely source materials and equipment in surplus stores and from the dumps of New York to create the massive machine that, amid breezes, fire and smoke, and a cacophony of musical sounds and the percussive clanking of the machinery, was intended to tip over and eventually collapse. Remembering this period of building the machine, Klüver later wrote: 'It is against the background of the anarchy and chaos of the Newark city dump that I see the growth of his machine.'

Also involved was the young artist Robert Rauschenberg (he later went on to collaborate with Tinguely on other projects and with Klüver in an organisation called Experiments in Art and Technology, or EAT). Tinguely had asked many American artists to join him in the project, but only the ever-game Rauschenberg responded. On the day of the performance, the young American brought a 'money-thrower' machine, made using an old metal toaster and some springs, which took many hours to connect to the sculpture and then went off

in a big flash, sending silver dollars into the crowd. Later he talked about feeling privileged to have been part of the team that helped build *Homage*: 'There were so many different aspects of life involved in the big piece. It was as real, as interesting, as complicated, as vulnerable, and as gay as life itself.'

Homage to New York had begun with two small drawing machines, but over the space of three weeks it grew to be a structure that was some seven metres long and eight metres high. The completed piece included about eighty bicycle and pram wheels, parts of old motors, a bathtub, a weather balloon, a piano, oil cans, saws, an address-label machine, an American flag, a radio and a fire extinguisher, and bottles of chemical smoke and smells. Painted a unifying white, making it visible against the night sky, the structure was equipped with about a hundred different operations, all started by preset time-delay releases, so that, in theory at least, the machine would function automatically and ultimately collapse and so 'commit suicide'.

The museum's press release for the event gives more details about what was meant to happen (but mostly did not):

> As the various sections are set in motion, key parts of the structure will be sawed, hammered or melted so that after 30 minutes the entire machine will collapse to the ground.
>
> During its brief noisy life cycle, a meteorological trial balloon will be inflated and burst, colored smoke will be discharged, paintings will be made and destroyed, bottles will be moved across a horizontal metal trough and crash to the ground. A text of words will be shown on a revolving roll of paper and a text of meaningless symbols on another. The piano controlled by a rheostat will be played at 5 speeds by mechanical arms while a radio will be tuned to local news. The percussion noises made by metal parts hitting each other will be augmented by a sound track playing two voices: the artist explaining his work with another high shrill voice constantly correcting and improving his explanation.

Although Tinguely was relatively little known in New York, there was an atmosphere of great excitement surrounding the unveiling of the first auto-destructive artwork. Tinguely was seen as part of a new generation of neo-dadaists: two artists associated with the first flowering of the dada movement, Richard Huelsenbeck and Marcel Duchamp, wrote texts for the brochure accompanying the event, along with the art writer Dore Ashton, the Swedish museum director Pontus Hultén, and the Museum of Modern Art's distinguished director of collections Alfred Barr and Peter Selz.

In front of an increasingly impatient audience (it was a cold and wet evening), the performance of the mechanised sculpture started an hour later than planned, at 7.30pm. Almost immediately, things did not go to plan. A fuse blew; one of the drawing machines started sending the paper in the wrong direction;

only a few of the piano keys were hit and the piano was quickly set alight by a bucket of petrol; the radio started on cue but could not be heard above the din of the motors and clanking drums; a small chariot that had been set alight headed into bystanders, rather than the museum's pond; the fan sent smoke into the faces of the audience, obscuring its view; the extinguisher did not go off; the label maker started to work but quickly fell over; the stink bottles did not break; and the structure only sagged rather than collapse entirely as planned. However, for Tinguely, such accidents were both inevitable and welcome: the mechanised sculpture was meant to have an unpredictable life of its own. It was not something that could succeed or fail: it was a spectacle.

Reactions of those present were mixed but many enjoyed the event, made all the more unusual by the presence of a photographer and cameramen. People booed and hissed when firemen ended the performance by hosing down the fire (they were instructed to do so by Tinguely himself, suddenly nervous that the fire extinguisher in the construction might explode). After the performance, Selz commented: 'I had no idea how beautiful it was going to be. You had a real feeling of tragedy that that white machine couldn't be preserved somehow.' Press response was similarly mixed, with some predictably calling the event a damp squib. The *New York Times* critic, however, suggested that the piece's destructive aspect reflected the mood of the times:

> the significance of the event lies not in the fact that it was, over all, a fiasco, but in the intention of Mr. Tinguely and the Museum of Modern Art in staging it in the first place.
>
> In conceiving and carrying out (as far as he was able) what must seem to most people only a preposterous and wasteful stunt, Mr. Tinguely was, rather, a kind of philosopher, even if one of nihilism, and the leading one of a current generation of artists descended from the Dadaists of World War I times ... [Dada]'s recent revival, in force, is without much question a reflection of a similar despair in our own moment.

After the performance, members of the audience helped themselves to parts of the work (and in doing so broke the stink bottles, creating a stench that lasted two days). Tinguely later willingly signed scrap items, notably the pieces of paper that the two drawing machines spewed out during the performance, for those who wanted souvenirs. The next day the remains of the work were cleared away. However, the little chariot that had signally failed to 'commit suicide' by plunging into the pond in the sculpture garden survived and was given by Tinguely to the Museum of Modern Art. Other surviving parts include the car with horn, which is now in the collection of the Tinguely Museum in Basel.

Tinguely returned to Paris immediately after the performance. Encouraged by his sense of the success of *Homage to New York* – and, significantly, having learned how to use electrical welding equipment – Tinguely went on to

create a great many mechanical works that combined pathos, humour and theatricality. However, the spectacle and excitement of *Homage to New York* lived on vividly in people's memories and through their written accounts and photographs, special in part because it was the first to happen within the confines of a museum. Perhaps its double-edged message about New York also lodged in people's minds. Tinguely spoke about the city in terms of 'all those monster buildings, all that magnificent accumulation of human power and vitality, all that uneasiness, as though everyone were living on the edge of a precipice', against which he contrasted the joyous and playful irrationality of *Homage*, a machine 'conceived, like Chinese fireworks, in total anarchy and freedom'. Selz claimed that the setting of New York was crucial to the concept and resonance of the work:

> In New York Tinguely finds a maximum concentration of life and energy, a virility which accelerates its own dissolution. He believes that the idea of a self-constructing and self-destroying mechanised sculpture would never have occurred to him in the ancient ambience of the Mediterranean coast. Its dynamic energy as well as its final self-destruction – are they not artistic equivalents for our own culture?

For many, Tinguely's wayward machine provided a fitting commentary on modernity as seen on the cusp of the 1950s and 1960s. Of Tinguely's 'anti-machines', Pontus Hultén wrote, 'This kind of art accepts changes, destruction, construction and chance, that rule anyway. These machines are pure rhythm, jazz-machines.'

Although it functioned for only twenty-seven minutes and was thrown out the next day, *Homage to New York* became seen as a milestone in the history of twentieth-century art and took on legendary status. It also challenged conventional understanding about the relationship between art and time. Tinguely's accomplice in making *Homage*, Klüver later reflected:

> The art of the museum is related to a past time that we cannot see and feel again. The artist has already left his canvas behind. This art then becomes part of our inherited language, and thus had a relation to our world different from the reality of the immediate now. [Ephemeral art], on the other hand, creates a direct connection between the creative act of the artist and the receptive act of the audience, between the construction and the destruction. It forces us out of the inherited image and into contact with ever-changing reality.

At the very least, the fun involved in this artwork-as-event marked it out as something different from what was experienced in the normal round of museum openings and private views: one woman spectator was recorded on film as say-

ing, 'It felt like being in the twenties again. Very amusing and very nice.'

Over half a century later, British artist Michael Landy wanted to pay homage to Jean Tinguely and this very first auto-destructive work. Landy had long felt inspired by the Swiss artist's inventive repurposing of junk to make art and to comment upon man's relationship to technology and consumerism, but of all Tinguely's work it was *Homage to New York* that most haunted his imagination. In 2007 he advertised for anyone with any surviving fragments of the piece to get in touch with his New York gallery, but no one at all contacted him, suggesting that there were not many more physical remnants of the work to be discovered. He was not permitted by the Tinguely estate to re-create the work as he would have liked, but he made 160 drawings and a documentary about *Homage to New York* based on his close study of the records and talking with those who remembered the performance. Like a falling star, Tinguely's *Homage to New York* may have disappeared almost as soon as it was created but – owing to the vivid impression it made on people at the time and the survival of documentation and some elements – it has not been forgotten.

~~Discarded~~
~~Missing~~
~~Rejected~~
~~Attacked~~
~~Destroyed~~
~~Erased~~
~~Ephemeral~~
Transient
~~Unrealised~~
~~Stolen~~

30

Decline and Fall

Partially Buried Woodshed 1970
Robert Smithson 1938–1973

Robert Smithson made *Partially Buried Woodshed* in the grounds of Kent State University, Ohio, in January 1970. The American conceptual artist had been invited to the university for a one-week residency and, while there, created this work with the help of students. As its title indicates, the artwork consisted of an old wood-shed that was partially buried on one side by twenty truckloads of earth, piled around and onto the structure until its central roof beam cracked. Smithson intended the shed to break up slowly under the weight of the earth, and vegetation to grow over the mound; and he wanted the university to take appropriate care of the artwork and the surrounding site until this process had run its course. However, the artwork's anticipated demise was hastened through a number of circumstances, and although it is considered one of Smithson's most important earthworks, as well as the first in America, nothing remained of it after only fourteen years.

Born in New Jersey, Smithson came to prominence in the mid-1960s as a minimalist artist, but in the latter part of the decade he increasingly began to work with natural materials and the landscape. Time and the force of entropy – the gradual dissolution and decay of matter into a state of inert uniformity – were his major preoccupations. In *Asphalt Rundown*, made in October 1969, he poured a truckload of asphalt down the side of an abandoned quarry outside Rome, the first of his 'flow works'. The second was a 'glue pouring' undertaken in Canada in December 1969. According to his wife, the artist Nancy Holt, these works were 'entropy made visible'.

Fascinated by ruins and the idea of habitations and culture being buried by natural eruptions and debris, Smithson saw geological change as a metaphor for the workings of the mind:

> One's mind and the earth are in a constant state of erosion, mental rivers wear away abstract banks, brain waves undermine cliffs of thought, ideas decompose into stones of unknowing ... Slump, debris, slides, avalanches all take place within the cracking limits of the brain.

A few months after completing *Asphalt Rundown*, Smithson went to Kent State University, Ohio. He wanted to create a 'mud pouring', but freezing weather – it was one of the coldest winters on record – made it impossible. Deterred by the extreme conditions, Smithson was ready to give up on the idea of creating an outdoor artwork but the art students pressed him to think of a feasible project. When he floated the idea of burying a building, they quickly obtained permission from the university authorities for him to use an old farm outhouse in an out-of-the-way part of the campus. Smithson made a number of sketches of what he wanted, and had a local contractor dump twenty loads of earth around one side and on top of the woodshed, creating a spiral pathway up the newly created mound. The work was declared complete when the central beam holding up the roof cracked. From that point onwards it was only a matter of time until the structure collapsed entirely.

At the end of the project Robert Smithson formally documented his 'gift' of the work to Kent State University. Cleverly, he attributed a significant monetary value to the piece – a useful brake on any bureaucratic impulse to get rid of the work at some later date – and also stipulated how it was to be looked after:

> an area of 45' should surround the art. Nothing should be altered in this area. Scattered wood and earth should remain in place. Everything in the shed is part of the art and should not be removed. The entire work of art is subject to weathering and should be considered part of the work. The value of this work is $10,000.00. The work should be considered permanent and be maintained by the Art Dept. according to the above specifications.

In conversation at the time, he said that he hoped the piece would not only go on to decay but also would acquire 'its own history'.

A few months later, in April 1970, Smithson went on to create his most famous work. Built from mud, salt crystals and basalt rocks, *Spiral Jetty* forms a massive coil – 460 metres long and 5 metres wide – jutting out of the shore of the Great Salt Lake, Utah. (Constructed when the water level was extremely low, the spiral can be walked upon, or indeed, seen, only when the lake levels are low: for three decades after its construction it was fully submerged, and in more recent years it has once again come close to being hidden from view as the water levels have risen.) The spiral form may have been a development of the spiral pathway up the mound in *Partially Buried Woodshed*.

Partially Buried Woodshed might have continued on its slow path of collapse without much further publicity but for a tragic incident on the campus of Kent State University. On 30 April 1970, President Nixon, who had been elected on the promise of reducing America's involvement in the Vietnam war, announced on national television and radio that American troops would attack Viet Cong bases in Cambodia, a country that had been ostensibly neutral throughout the conflict. Many were shocked at this sudden escalation and

expansion of the war, and on Friday 1 May protests occurred across university campuses, where anti-war sentiment ran high. At a rally in Kent State University, a copy of the American constitution was buried to symbolise its 'murder' (Congress had not authorised this extension of the war) and another rally was called for Monday 4 May. In the meantime, there were various disturbances and clashes between protestors and local police in the town over the weekend. A state of emergency was called, the National Guard was deployed in the university, and further rallies were banned. Two thousand students turned up on the campus on Monday, some not knowing that the authorities had banned the planned rally, others to protest against the presence of armed soldiers on the campus. At a certain point, a group of National Guard soldiers fired indiscriminately at the unarmed students. Sixty-seven bullets were discharged in thirteen seconds, killing four and wounding nine. The soldiers later said that they feared for their lives but exactly why they fired remains contested. Reproduced in the national and international media, a photograph of a young girl kneeling down beside a dead student on the ground became a potent image of the event that, in effect, brought the Vietnam War to America. The Kent State shootings, as they became known, sparked a round of student strikes and demonstrations, both violent and non-violent, across the nation, and dramatically helped shift public opinion against the continuation of the war in Vietnam.

Shortly after this tragic and traumatic event, the words 'MAY 4 KENT 70' were painted onto the woodshed in bold white letters. Suddenly, the work became an unofficial memorial, much visited by students; and a photograph of the work was used in an anti-war poster. Some began to see Smithson's artwork as expressive of a malaise within American political society, the cracking of the roof beam by the overwhelming force of gravity serving as a metaphor for the breaking of the political system. Nancy Holt, the artist's wife, later said:

> Obviously, the students, or whoever did that early graffiti ... recognised the parallel. Piling the earth until the central beam cracked, as though the whole government, the whole country were cracking. Really, we had a revolution then. It was the end of one society and the beginning of the next.

Smithson died in a plane crash in July 1973, aged just thirty-five. He had pioneered the concept of earth sculpture but had left only five outdoor earthworks, including *Partially Buried Woodshed*. However, the continued existence of *Partially Buried Woodshed* came under threat. Smithson's request that the piece be left as it was had been ignored from the beginning: the contents of the woodshed were quickly stolen, and graffiti were regularly daubed in the inside. Then, in 1975, someone set it alight using a soda can filled with kerosene, and half of the shed burned to the ground. Paradoxically, while it was becoming more and more of an eyesore, at least in the eyes of the university authorities, it was becoming increasingly famous in art circles, with artists and journalists,

from the United States and abroad, coming specifically to see the work. Writing to the university, the artist's wife reinforced this point about the site's growing importance despite the changes it had suffered:

> It is a seminal work which has influenced much other art during the last five years. The fact that it has changed with the slow natural aging of weather and the rapid natural aging of fire is quite consistent with Robert Smithson's esthetic philosophy.

The question of what to do with the site, however, became a topic of local controversy. Planning to redevelop the area and to create a new major public entrance near to the woodshed, the university found the work and its unofficial memorialisation of the shooting embarrassing, and would have had the shed removed if it were not for the spirited resistance of Smithson's supporters. After much public debate about the value of the work and the university's responsibilities to Smithson, a compromise was reached: the shed was allowed to remain but all loose timbers were removed and a screen of fast-growing conifers was planted to obscure it from view.

In 1982 the central beam finally broke entirely, and the work, with the graffiti still intact, moved closer to collapse. From time to time groundsmen cleared up and took away loose timbers. At some point, someone – it is not known who or by whose order – cleared the site completely, removing all the remaining timber and leaving only the concrete foundation of two of the shed's walls. This was not noticed until February 1984.

Smithson's work was gone, or at least the physical remains of it; and it was no longer a feature of the landscape or an element in students' experience of being at the university. Some argue that the idea of the piece survives intact and independently of the original materials, which were always intended to change over time anyway. Others suggest that what happened to the work was only an artificially quickened example of a process of entropic return to an even uniformity that Smithson believed was the destiny of all matter. Somehow the piece continues to exist as a concept that is still attached to the particular site through people's memories. Mindful of the past presence of *Partially Buried Woodshed* and of its place in the history of the institution, Kent State University has not sought to develop or pave over the area. And, moved by the story of the lost work, a number of artists, including Tacita Dean, Sam Durant and Mike Nelson, have made new artworks in homage to the *Partially Buried Woodshed* and to keep its memory alive.

Discarded
~~Missing~~
~~Rejected~~
~~Attacked~~
~~Destroyed~~
~~Erased~~
~~Ephemeral~~
Transient
~~Unrealised~~
~~Stolen~~

31

Berlin Wall

Berlin Wall Mural 1986
Keith Haring 1958–1990

Between 1949 and 1961 approximately 3.5 million people, or twenty per cent of the population, escaped from East Germany to the West. Most slipped through the border controls in Berlin, then a divided city controlled by four occupying powers (the United States, Britain, France and Soviet Union). Concerned at the rising numbers of defectors and the effects on the economy and the image of the communist regime, the East German government erected in 1961 first a barbed-wire fence and then a concrete wall with watchtowers and anti-vehicle trenches. Called by the East German authorities the 'Anti-Fascist Protection Rampart' (with the implication that West Germany had not been fully de-Nazified and risked spreading fascism to the East), and described occasionally by the West Berlin city government as the 'Wall of Shame' (because of its prevention of movement, and consequent separation, of friends and families), the Berlin Wall became a potent symbol of the Iron Curtain separating east and west Europe. Some East Germans continued to try to escape over the wall but generally failed: well over one hundred people (estimates differ) were killed in the attempt from 1961 to 1989.

Checkpoint Charlie – or, officially, Checkpoint C – was one of the more visible controlled border crossings between East and West Berlin. It was the principal route for East Germans to leave their country in the 1950s and the sole crossing point for foreigners and members of the Allied forces. With a café offering a view into East Berlin to one side, the crossing featured in a number of classic spy films and books, and it became something of a tourist attraction in its own right for visitors to West Berlin. As the years passed, artists and graffitists painted on the western side of the wall, by the crossing and elsewhere, notwithstanding the dangers of antagonising the East German soldiers guarding it (the wall stood a couple of metres inside the East German border). Such acts of defiance and expression of personal freedom became seen in the west as a sign of West Berlin's cultural vibrancy as well as an informal protest against the wall and all it symbolised.

Building on this reputation, the director of the Checkpoint Charlie Museum invited the young American artist Keith Haring to paint a mural on a section of the wall in 1986. Aware of the historical importance of the wall, Haring, who was visiting Europe at the time, welcomed the opportunity to work on a grand scale. For him, the work was very much a political gesture, an attempt to 'destroy the wall through painting it', and amid much publicity he completed his mural, nearly 100 metres long, in a day.

Haring had initially studied graphic design in Pittsburgh but quickly switched to fine art, enrolling at the School of Visual Art, New York, in 1978. He became immersed in the alternative artistic culture developing in the streets and clubs of Manhattan, outside of galleries and museums. Inspired by the energy of the teenage graffitists, he painted alongside them for a while, developing the distinctive tag of a 'radiant baby'. As a teenager, Haring had encountered members of the Jesus Movement, a grassroots network of Christian groups, which later influenced his imagery (the baby is suggestive of the infant Jesus) and shaped his desire to reach out to a mass audience. He believed art should be direct and engage people of all types and walks of life, and willingly embraced popular political causes. For example, in 1982 he designed a poster for an anti-nuclear war rally in his trademark black and white linear style, showing the baby in a mushroom cloud surrounded by three angels.

This was a period in which Haring became well known in New York through making technically illegal chalk drawings on the black paper panels used to cover empty advertising hoardings in the subway. Producing as many as twenty or thirty drawings a day while on the way to and from college, he made the corridors of the subway system his personal gallery. With their stock cartoon-like characters, his drawings became a distinctive feature of the experience of travellers. 'The number of people passing one of these drawings in a week was phenomenal', Haring recollected. 'Even if the drawing remained up for only one day, enough people saw it to make it easily worth my effort.'

Although his work was similar to graffiti in some respects, people recognised that his chalk drawings showed a breadth of vision and an artistry, reflecting both the influence of contemporary figures such as Andy Warhol and a complex mixture of Aboriginal and African art and eastern calligraphy. Haring was arrested no less than five times for his efforts, but former curator of twentieth-century art at the Metropolitan Museum of Art and Commissioner of Cultural Affairs for New York City, Henry Geldzahler celebrated Haring's subway drawings in 1984:

> a new presence has been seen and felt in New York City's streets and subways. Radiant Babies, Barking Dogs, and Zapping Spacecraft, drawn simply and with great authority, have entered the minds and memories of thousands of New Yorkers. Our instant familiarity with this new pantheon of characters coincides with our rapid recognition that a sympathetic

sensibility is at work in our midst. This call to attention, stronger than that exerted by the colossal glut of advertising or official signage, sets the work of Keith Haring apart from other graffiti writers. The man responsible for this cheer never signs his work. Keith Haring's gift to the public is generous and heartfelt – a celebration of the spirit that is not and cannot be measured in dollars.

By the mid-1980s Haring was exhibiting in leading galleries in New York and in museums abroad. The prices of his canvases soared and he abandoned his subway drawings, in part because people began to collect them. He opened his own artist's store in Manhattan called Pop Shop, selling affordable T-shirts and other items imprinted with his familiar designs. He became something of a celebrity himself when he drew on the body of Grace Jones and on the leather jacket of Madonna. But, though he mixed with celebrities, he still aimed to reach the poor and people not interested in art – and he became famous partly because of his ability to bridge the two worlds. In June 1986 he discovered a wall in a more or less abandoned handball court, which when painted looked from the freeway like a billboard. He did not ask permission but brought his ladders and paints and within a day created a mural with the simple anti-drugs message 'Crack is Wack'.

It was while on a trip to Europe later that same year that Haring was invited to paint on the Berlin Wall. He agreed quickly and planned to use the colours of the East and West German flags (black, red and yellow), symbolising the bringing together of the two peoples. He asked the staff of the Checkpoint Charlie Museum to cover the wall with layers of white and then yellow paint prior to his arrival. The staff worked through the night before he was scheduled to arrive (if they had started earlier the blank space would have attracted graffitists) but, contrary to what Haring had asked, they used only one coat of yellow. This meant that the underlying painting showed through in places. To his chagrin, the team painted over a recent work by the French artists Thierry Noir and Christophe Bouchet showing repeated images of the Statue of Liberty. When the artists protested to him in person, Haring could only apologise.

Haring worked without sketches or assistants, inventing the positions of the interlinked figures over the length of the hundred metres as he painted. Only when the East German guards were satisfied that he was not defaming East Germany was he relatively safe to continue working, despite having technically crossed into East Germany without authorisation and undertaking a forbidden act. Interviewed later, Haring recalled:

I went to Berlin for about 3 days when I went to do the wall, and unfortunately, as is often the case, it was very cold and almost rainy most of the time I was there. The rain sort of let up around 10 or 11 o'clock in the morning so I started painting. When I started to paint, the East Germans

were peering over the wall all the time. At first they were curious because they saw all the people, sort of milling around on the western side and the press and things, so they didn't know exactly *what* I was going to do. But eventually after they came out a few times and realised that what I was painting was not really derogatory or insulting them in any way, they just decided to let me alone and stayed behind the wall the rest of the time.

With his portable radio blaring rock music, Haring completed the mural in somewhere between four and six hours (accounts vary).

The museum staff worked hard to publicise the mural, ensuring that Haring's painting of the wall was not just a national but also an international news event across Europe (including East Germany) and the United States. Haring played his part in promoting the work, giving interviews and holding a press conference during the day in which he explained the politics of his seemingly apolitical painting: 'In some ways, although it's a political act, it has to transcend politics and be a message to people. It's about unity, no matter in the face of whatever struggle or oppression, there still has to be a power of the people.' Knowing from the outset that it would not be permanent, Haring always felt that the mural was going to be both an artistic expression and 'a media gesture'. 'For me the Berlin Wall was probably one of the most successful media events that I ever did. The whole reason almost for doing the wall was more for the idea of doing it and almost as a gesture more than it was to actually paint a wall.'

Like all graffiti and street art, Haring's mural was vulnerable to erasure. That night or early the next day, someone painted large sections of the mural grey, perhaps in political protest against the upbeat message of the American's work. Quickly, other artists and graffitists painted on the hundred-metre section that Haring had used, and within months there was very little left to see. Paradoxically, it was not censorship by the East German authorities that Haring needed to have feared but other artists. (Disappointed at the swift effacement of the American's work, the director of the Checkpoint Charlie Museum said, 'I think Haring was so successful that other artists could not forgive him.')

Three years later, on 9 November 1989 the East German government succumbed to mounting public pressure and announced that East Berliners would be able to travel freely to the West. That evening people on both sides of the wall picked up sledgehammers and started to bring the wall down in what was a momentous step that led to the reunification of Germany.

Nothing now remains of Haring's mural beyond people's memories and photographs. But the artist was not distressed by the impermanence of this and other works. He was reassured not so much by the thought that it was the idea that counted but by the belief that photographs provided adequate records. In 1987 he wrote in his diary:

If it is not regarded as 'sacred' and 'valuable', then I can paint without inhibition, and experience the interaction of lines and shapes. I can paint spontaneously without worrying if it looks 'good'; and I can let my movement and my instant reaction/response control the piece, control my energy (if there is any control at all) ... It is temporary and its permanency is unimportant. Its existence is already established. It can be made permanent by the camera.

In the case of the graffiti works of Thierry Noir, however, not all were lost. Some surviving sections of the Berlin Wall with his signed paintings were sold, nominally for charity, at an auction in 1990 (Noir fought a ten-year court case to secure some payment for the sale of his work). Today a small fragment of another of his paintings is incorporated into the pavement around a new building complex in Berlin, a token reminder of one artist's response to the sadness and desperation that had been symbolised by the wall for nearly three decades.

Discarded
Missing
Rejected
Attacked
Destroyed
Erased
Ephemeral
Transient
Unrealised
Stolen

32

A House Divided

House 1993
Rachel Whiteread born 1963

Rachel Whiteread's *House* was never intended to last. A concrete cast of the inside of a Victorian terraced house, it was built in 1993 in the east end of London as a temporary project, one that was due to exist for only three months. Its transient nature neatly complemented the work's emotive theme – the passing of the memories and experiences that are associated with, and sometimes physically embedded in, the fabric of our homes. But over the course of its brief existence *House* became highly contested, with prominent figures campaigning for the work to be given a stay of execution, at least for a time, and others refusing to be swayed. For a while, all the arguments that could ever be applied to a public artwork were focused on *House*. Was it art? Was it any good? Could it be a permanent piece? Did it give aesthetic pleasure, or in any way change the lives of those who saw it? Did local people want it? Who would decide its fate?

Rachel Whiteread was still a young and relatively little-known artist at the time. She had come to prominence in 1990, only a few years after graduating from art school, when she exhibited *Ghost* at the Chisenhale Gallery in east London. This was a large white plaster cast of the space inside a room in an old Victorian house. Showing the reversed imprints of the fireplace, window and architectural mouldings of this traditional and, to a British public, familiar type of interior, the sculpture established Whiteread as an important younger artist, one who alluded to the simple shapes and stripped-down ethos of minimalism and who, through the casting of domestic spaces, had found a new way of evoking the pathos of traces of human presence and experience.

Having cast a room, she began to think about how it might be possible to cast a whole house. Working with Artangel, a commissioning and producing organisation that supported challenging temporary art projects, Whiteread spent two years attempting to secure a short-term lease on a suitable house already earmarked for demolition. For her it was important for the building to be free-standing so that the finished artwork should be visible from all angles. It was also crucial that it should be an example of the relatively humble, turn-

of-the-century construction that had long been a familiar feature of the London cityscape. Such houses had a commonly understood history: they had not only been homes to several generations but, surviving the Second World War and successive waves of modernisation, they had also witnessed major transformations in the ways people lived and worked over the course of the twentieth century.

Whiteread's vision for *House* encompassed what she saw as a need to respond to the threat posed to such old houses by still ongoing campaigns of modernisation. When interviewed about the project, she acknowledged that it had a socio-political dimension and talked about the 'ludicrous policy of knocking down homes like this and building badly designed tower blocks which themselves have to be knocked down after 20 years'. *House* was situated next to an old Roman road that still dictated the ground plan of the area after two thousand years, and within sight of churches of different faiths, some 1880s terraced housing, as well as 1960s tower blocks and 1980s high rises. In the distance were the dominating new skyscrapers of Canary Wharf, London's second financial centre after the City itself. *House* accordingly drew attention to the history of redevelopment within the east end. Its location just a few feet from where the first V2 rocket had landed in the Second World War gave added poignancy to the original building's fate.

The site chosen was in Grove Road in Bow, a relatively deprived area of east London. The local council had decided to pull down the entire street to create a park as part of an ambitious plan to produce a green corridor through the borough. In early 1993 the opposition of one resident – Sid Gale, an ex-docker and war veteran who had lived in the house all his life – had held up the demolition, and as a result 193 Grove Road, and the two buildings either side of it, had temporarily escaped the council's bulldozers. Understanding that Mr Gale would move out shortly, the council voted by a narrow margin to allow Artangel to lease the structure for a peppercorn rent for a few months. It was agreed that the project would finish by 31 October 1993, and that the site would be made into parkland by the end of November (the costs of removing the last three houses would thus fall to the project rather than the council). As things turned out, Mr Gale moved out two months later than planned, and the project was behind from the beginning.

Whiteread's video diary shows how the inside of the building was transformed during the project. New foundations for the house-within-a-house were laid; windows were boarded up and extraneous sinks and cupboards were removed; cracks were filled and the walls coated in a debonding agent to create a new continuous surface. Then locrete – a special material applied to the cliffs of Dover to protect the chalk, but here coloured with pigment added by Whiteread to achieve a particular shade of pale grey – was sprayed onto all the walls to a depth of about five centimetres to create the outer shell of *House*. This was followed over the course of several weeks by a second, thicker application of concrete onto a steel mesh, to a depth of about twenty-five centimetres. The dis-

tinguishing features of the different periods of the house's existence – its original staircase with wooden stair rail, its pre-war electrical systems, its colourful wall-papers of different vintages – were obliterated as the interior became a feature-less grey mausoleum.

This technically difficult phase of work complete, the builders exited through the roof and sealed the hollow structure. The final task was to pull away the Victorian structure to reveal *House*, a highly modified version of the interior space of a real house (without an attic or roof) but one that powerfully evoked the reality of a home now destroyed for ever.

Whether intrigued by its inside-outness or moved by its embodiment of lost history, people were curious about *House*. Over its eleven-week existence, many thousands came to see it (creating traffic jams to the annoyance of local residents). Numerous art critics acclaimed it as a powerful work. 'I do not recall seeing a more ambitious piece of public sculpture in London than Rachel Whiteread's *House*', wrote the *Sunday Times* art critic. *House* 'stands monumental and poignant like a great white mausoleum for the collective memory of a dying way of life', according to a writer in the *New Stateman*. For Andrew Graham-Dixon writing in the *Independent*, it was the most extraordinary public sculpture to have been created by an English artist in the twentieth century and was all the more powerful for using the familiar and humble form of an ordinary home:

> Looking at *House* is temporally as well as spatially distorting. It is like looking at an object from the present that has suddenly been pitched far into the future or far into the past. An English terraced house has been remade as an archaeological find, and what an oddly simple thing it turns out to be. Just a squat arrangement of spaces to inhabit, a stack of caves honeycombed together. *House* contains the traces of late 20th-century living habits and technology, which survive in odd details like the impressed patterns of a fossil caught in its surface: the zigzags of a wooden staircase running up one of its walls, the indented relics of plug sockets ... *House* is a sculpture that memorialises, in its transfiguration of an ordinary person's home, the ordinary lives of ordinary people (ordinariness, it suggests, is one thing we all have in common) ... It is both a relic and a prompt to the imagination (Who lived here? What did they do? What did they feel?) as well as a sculpture that is charged with a deep sense of loss ... *House* is about the past and it is also about the unrecoverability of the past.

For television news and the tabloid press, *House* offered a field day, with added spice coming from the local council's reaffirmed decision to pull the monumental sculpture down in the face of Whiteread's nomination for the prestigious Turner Prize for her recent work. The views of local residents, both pro- and anti-, were reported gleefully. Sid Gale, the former occupant and pithy critic of the open-air sculpture, became a local celebrity. For some, *House* was a

waste of money, pointless, unwanted and ugly. For the chair of the council, who had been absent when the council had first agreed to the project, the concrete megalith was not a work of art but a 'monstrosity' that needed to be got rid of as soon as possible, whatever the art world might think: 'We have enough concrete in Bow already, and what we need is not more of it, but trees and grass. These we will have.'

The desire to preserve art has always been powerful, however, and those in favour of the piece found it difficult to countenance demolishing a work that seemed so significant artistically and had touched the imaginations of so many. On utilitarian grounds, some urged in leader columns and letters to the press that the council should rethink its plans, given the unexpected fame and cultural capital that *House* had brought the borough. Some pointed out that the Eiffel Tower had originally been intended to be temporary and argued that allowing it to remain had not done Paris any harm. A petition calling for *House* to stay collected over 3,500 signatures on the site in twelve hours (a rival petition urging its demolition collected 800 signatures over a number of weeks). In late November a formal motion was submitted to the council claiming that 'it would be an act of intolerance and philistinism to destroy [the] sculpture in Grove Road, Bow, before more people have had the opportunity to see it', and calling upon the council 'to consult local people about whether or not it should be destroyed'. Bemused by the attention the work received and of finding herself described as the 'most famous artist in Britain', Whiteread wanted *House* to remain, at least a while longer. 'I think it needs to be seen, and that takes time', she said in an interview. 'I don't feel that I've seen the work myself yet – I'm too close, too involved with it. A part of me would like it to remain for the time it takes to become invisible ... Ideally I'd like it to remain until the crowds stop flocking, and it's just there.'

All to no avail. On the same day that Whiteread was presented with the Turner Prize at the Tate Gallery, she learned that the Bow Neighbourhood Committee had rejected the request to extend the life of *House*, even temporarily. Despite continued pressure from various quarters, the sculpture was pulled down on 11 January 1994, and the site grassed over.

Reflecting later on the unprecedented media controversy that had engulfed the work, James Lingwood, co-director of Artangel, noted that what was so unusual (and difficult to deal with) was the fact that there was no consensus among any of the groups involved.

Local against national, the art world against the real world, grass roots realities against disconnected dilettantes ... Such binary oppositions could neither explain nor contain the multiple shades of opinion and sentiment which *House* engendered.

There were passionately different responses, of course. But the differences of opinion were always located *within* any identifiable com-

munity or constituency, and not *between* them. There was no consensus amongst the inhabitants of the block of houses opposite, on the street or in the neighbourhood, nor in the letter pages of local and national newspapers. There was no consensus among the local councillors. Even the fateful decision not to grant an extension to *House* was taken only on the casting vote of the Chairman after the councillors were equally divided. There was no consensus even within the Gale family whom the Council had moved out of the home which eventually became *House*. *House* did not seek to manufacture some confectionary consensus, as many public works of art are compelled to do. Indeed it laid bare the limits of language and expectation which afflict the contentious arena of public art.

The status of 'art' does not guarantee a work's survival, but who or what should decide its destruction, and on what grounds, remain for some, as the case of *House* shows, complex and potentially irresolvable questions, determined in practice more by circumstances than by consensus.

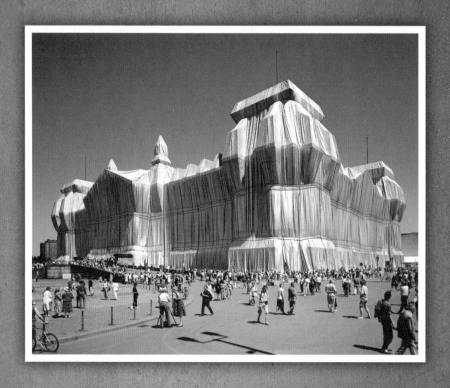

33

Wrapped/Unwrapped

Wrapped Reichstag, Berlin 1971–95 1971-95
Christo (born 1935) and Jeanne-Claude (1935–2009)

For two weeks in the summer of 1995, Berlin's Reichstag building – historically the seat of the German parliament and a famous site in Germany's history – was covered with 100,000 square metres of fabric, held in place by steel framing and over fifteen kilometres of blue rope. It was an astonishing feat and, by all accounts, an amazing sight. The artists Christo and Jeanne-Claude had conceived the project in 1971. Situated in the heart of the divided city of Berlin, during the Cold War the Reichstag was under the jurisdiction of both East and West Berlin authorities. It was scarcely used, but such was the tension between the two governments, and the political sensitivity of the site, that the project to wrap the building was rejected three times. It was only following the reunification of Germany and before the reinstatement of the Reichstag as the seat of the national parliament that the project was accepted, nearly a quarter of a century after it had been first proposed. It lasted only a fortnight but the conceptual audacity and visual impact of *Wrapped Reichstag* made it one of Christo and Jeanne-Claude's most famous works.

Born in Bulgaria, Christo Javacheff fled the Soviet bloc in 1957, and artistic and political freedom remained a strong guiding principle throughout his life. He met Jeanne-Claude Denat de Guillebon in Paris the following year, and the couple were soon living and working together. Early projects were attributed solely to Christo but later their partnership was acknowledged in joint attribution. Alongside his activities as a painter, Christo began to make objects, covering familiar items such as barrels, paint cans, cars and furniture with fabric and string. This wrapping made everyday objects seem mysterious, and stimulated a sense of curiosity and surprise in the viewer.

In the early 1960s Christo and Jeanne-Claude began to create temporary public works. On the evening of 27 June 1962, for example, the couple filled rue Visconti in Paris's Latin Quarter with eighty-nine oil drums, blocking the street for eight hours. The impermanent structure echoed the barriers erected by police elsewhere in Paris to contain protesters against the Algerian War.

Its subtitle *The Iron Curtain* – a phrase used to denote the physical and ideological division between east and west Europe after the Second World War – underlined the political message of the work, a message made all the more pertinent by the construction of the Berlin Wall, separating the east and west sections of the city, one year before.

Christo and Jeanne-Claude envisaged covering an entire building in the early 1960s (and even noted that it should be a public site, like a parliament). But it was not until 1968 that they achieved the first of such projects, wrapping the Kunsthalle Bern as part of the museum's fiftieth birthday celebrations. Visitors could still enter the building through a slit in the translucent polyethylene in front of the main entrance, but because of the costs of maintaining proper security (insurance companies refused to underwrite the Kunsthalle and its valuable collection during the period the building was covered), the museum was unwrapped after only one week. The artists went on to wrap Chicago's Museum of Contemporary Art in 1969, but from the 1960s onwards they focused on making increasingly grand and dramatic interventions in natural landscapes, including wrapping a stretch of coastline and hanging a curtain across a valley.

The idea of wrapping the Reichstag came from Michael Cullen, an American journalist based in Berlin, who wrote to Christo and Jeanne-Claude in 1971 with this suggestion. Attracted by the artistic and symbolic potential of the project, they agreed to try to undertake what would be their third and final wrapped building, and set about raising the necessary money through selling drawings, plans and scale models (as a point of principle, they did not accept commercial sponsorship or government subsidies). The first exhibition of their preparatory work on the project was held in a commercial gallery in London in 1977, while they began their long campaign to persuade the German authorities to permit the wrap to take place.

The Reichstag had been constructed in 1894 to house the German parliament, though such were the tensions surrounding this formalisation of democracy that it had taken the German kaisers two decades to allow the planned pro-democracy inscription 'Dem Deutschen Volke' (To/For the German People). In the interwar period, the building had been seriously damaged in an arson attack in February 1933. Exactly who was responsible remains uncertain, but the Nazis, who had recently come to power, blamed Berlin's communists and used the fire to crack down on the far left and cement their hold on power. Hitler chose not to rebuild or use the Reichstag, preferring to keep the building in its damaged state as a symbol of the threat posed by communism. The building was not restored until the early 1960s. By then, the seat of the West German government had moved to Bonn and the building was used only occasionally as an exhibition venue or concert hall.

The process of getting permission to wrap a building of such historical and political importance was complex. Although the Reichstag was within the British sector of occupied Berlin, its eastern facade lay within Soviet-controlled

air space. There were also both city and national authorities, East and West, to consult. As Christo explained in 1986:

> The president of the Bundestag [national parliament] in Bonn is the only
> one who can give the final permission because the Reichstag is mostly in
> West Berlin ... but because the Reichstag is located in the British military
> sector, the West German government is obliged to ask the point of view
> of the British who automatically pull together the French and the Ameri-
> cans to discuss ... being also in divided Berlin, the British, Americans,
> and French are obliged to inform, or discuss the east facade of the build-
> ing with the Soviet army headquarters in East Berlin, and of course, the
> Soviets will be obliged on their part to discuss the matter with the East
> German government, whose capital is East Berlin.

Permission to wrap the Reichstag was refused in 1977 and again in 1981. Yet there was continued support for the project, not least from the former chancellor of West Germany, Willi Brandt. ('He climbed the stairway to my studio on the fifth floor in the early 80s in a moment when we were in despair, we almost gave up the project or resigned. Brandt tried to help us and explained that the project was so important that we should not give up.') In 1984 the artists made detailed scaled models of the *Wrapped Reichstag* with American engineer Vahé Aprahamian. Nonetheless, in 1987, a third application for permission was refused.

Attitudes towards Christo and Jeanne-Claude's project finally changed with the fall of the Berlin Wall in November 1989 and the subsequent reunifica-tion of Germany. In 1991 Berlin was chosen as the capital city and plans were set in motion for the German parliament to return to the Reichstag. The president of the German parliament, Rita Süssmuth, made it clear she would support the *Wrapped Reichstag* project, and, with her backing, the artists made a fourth application for official permission in 1994. On 25 February 1994 the German parliament in Bonn debated the *Wrapped Reichstag* project for seventy minutes in a session attended by 525 members, an unusually high turnout, and watched on television by millions. In his speech to the house, politician Konrad Weiss argued:

> The wrapping of the Reichstag, my colleagues, enables us to see in another
> light and newly, perceptually experience this central and ambivalent place
> in German history ... The wrapping of the Reichstag will remind us of the
> limits of our perceptions and how uncertain our knowledge is. That is
> the vision: the stone of the Reichstag will be concealed from our view for
> a time. What remains is the form under soft, draping material, the trans-
> formed, alienated contours. Christo's drawings can only hint at what we
> will really see. But it will be new and it will be transient. It will be a cut

into the history of this building and, in contrast to the fire of over half a century ago, it will be a peaceful, a productive turning point. The soft material which drapes the Reichstag will remind us of the flames that lashed from these walls and how vulnerable and endangered democracy is.

Despite objections from Chancellor Helmut Kohl, who believed the wrapping would trivialise the building, the proposal was passed with 292 in favour and 223 against.

From April to June 1995, workers installed over 200,000 kilograms of steel frames around the building, allowing the 100,000 square metres of fabric with an aluminium surface to hang in folds from the towers, statues and stone decorations. German manufacturers produced everything from the aluminised polypropylene material to the weights and bright blue ropes used to keep it in place, while a workforce of over a thousand people assisted Christo and Jeanne-Claude with the design, installation and monitoring of the completed *Wrapped Reichstag*. The project cost US $15,000,000.

Commenting on the piece, the artists' official website draws together the building's historical significance and their aesthetic concerns in the process of wrapping it:

The Reichstag stands up in an open, strangely metaphysical area. The building has experienced its own continuous changes and perturbations: built in 1894, burned in 1933, almost destroyed in 1945, it was restored in the sixties, but the Reichstag always remained the symbol of Democracy.

Throughout the history of art, the use of fabric has been a fascination for artists. From the most ancient times to the present, fabric forming folds, pleats and draperies is a significant part of paintings, frescoes, reliefs and sculptures made of wood, stone and bronze. The use of fabric on the Reichstag follows the classical tradition. Fabric, like clothing or skin, is fragile; it translates the unique quality of impermanence.

For a period of two weeks, the richness of the silvery fabric, shaped by the blue ropes, created a sumptuous flow of vertical folds highlighting the features and proportions of the imposing structure, revealing the essence of the Reichstag.

In interviews at the time Christo emphasised his and Jeanne-Claude's hands-on involvement in the design and construction. 'We chose the Reichstag fabric to give this very thick force, almost Medieval, Gothic ... angular pleats.' The work was to be understood not as a conceptual artwork but as sculpture with conscious echoes of past art forms. Every detail was carefully planned but, as the artists acknowledged, the visual complexity and full impact of the work could be entirely known only after its construction:

We do prototypes, we do a variety of research in advance, but we cannot do secretly the Reichstag for ourselves and hide it from the public. No, we only discover the colours, the volume, the movement of the fabric, the dynamics of the material with the wind, the incredible contrast of the fabric when the project is realised and this is the marvelously exciting part.

Completed on 24 June 1995, the *Wrapped Reichstag* was an immediate success with the public, with millions of visitors flocking to the site. Around 250,000 fabric samples were handed out by paid uniformed monitors as free souvenirs. The German government asked the artists to extend the project, but Christo and Jeanne-Claude refused, stating that the temporary nature of the work was important because it challenged people's belief in the immortality of art: 'non-permanent art will be missed', they said.

For commentators in Germany and around the world, the wrapping and unwrapping of the Reichstag focused attention on the country's changing status. Though conceived in an earlier era, the artwork became an easily grasped symbol for the emergence of a newly reunified Germany – in part because it demonstrated the triumph of the dogged perseverance of the two artists in the face of almost insurmountable odds. In the *New York Times*, Paul Goldberger described the project as 'at once a work of art, a cultural event, a political happening and an ambitious piece of business'. He went on to observe:

> The wrapped Reichstag makes lightness and softness ... into characteristics of the greatest monumental power ... If the architecture of the Reichstag represents a kind of Prussian hardness – Germany as it was – the wrapped version can almost be seen as an ideal symbol of the new Germany.

On 7 July 1995 the building was unwrapped and the materials were sent to be recycled. The artists' efforts over twenty-four years, together with the many years of work by the small team supporting the project, had culminated in a spectacle lasting a mere two weeks. In an interview Christo declared: 'I and Jeanne-Claude would like our projects to challenge and question people's notion of art. The temporal character of the project challenges the immortality of art. Is art forever?' He went on to compare the temporary nature of the wrapped Reichstag to the tents used by nomadic tribesmen, quickly erected and equally quickly removed, and to the transience of life itself. 'It is a kind of naiveté and arrogance', he commented, 'to think that this thing stays forever, for eternity. All these projects have this strong dimension of missing, of self-effacement ... they will go away, like our childhood, our life. They create a tremendous intensity when they are there for a few days.'

Discarded
Missing
Rejected
Attacked
Destroyed
Erased
Ephemeral
Transient
Unrealised
Stolen

34

Melting

In the 1990s British artist Anya Gallaccio became known for creating artworks that made evident the processes of change and that were themselves impermanent. So central was transience to her practice that in 1999 curator Ralph Rugoff noted:

> after over a decade of creating installations, Gallaccio has virtually nothing to show for it. Her many installations and evanescent sculptures have ended up not in the permanent collections of museums and art connoisseurs but in the skip. Only a few traces and snapshots remain as proof that she has produced anything at all, and these are inadequate as evidence. So, in the end, her work lives on only in the idiosyncratic museum of our memories.

intensities and surfaces was a striking and characteristic example of Gallaccio's exploration of the transient. Sited in the boiler room of a nineteenth-century water-pumping station in east London and made simply from slabs of ice stacked around an inner core of rock salt, the sculpture melted over a period of three months in spring 1996. Its block-like form referenced the grid structures associated with American minimalist artists such as Donald Judd and Carl Andre; but into an artistic vocabulary associated with permanence and industrial precision, Gallaccio introduced evanescence and the idea of cycles of transformation, associated more with European art, in particular the tradition of Arte povera and its use of natural and everyday materials. Central to the meaning and impact of *intensities and surfaces*, however, were the translucency of the ice and the play of reflections in the water, together with the historical character of the installation site.

Built in 1892 by the London Hydraulic Power Company, the Wapping Pumping Station had sent pressurised water through a network of cast-iron pipes to power the cranes and hoists of London's docks in the early years of the

twentieth century. At first the pump house was steam driven and then fully converted to electricity in the 1950s. When it closed in 1977, it was said to be the last of its kind in the world. Interested in making the disused building a theatre and exhibition space, the Women's Playhouse Trust first commissioned Gallaccio to make an installation in the space in 1990. She installed twenty-four whistling kettles in the chimney of the disused building and called the piece *prestige*, after the manufacturer of the kettles and an ironic reference perhaps, too, to the decline in status of many of Britain's industries. Visitors' awareness of the kettles' whistling – caused by the escape of air pumped into them – changed as they approached the site, with the sound levels rising from a nagging background noise to a piercing shriek as if caused by pain or loss (a curator described it as 'a wailing chorus that suggested rage and hysterical mourning'). Gallaccio later revealed that the piece remained associated in her mind with her brother, who had helped her with the installation but died just two days before the private view. She continued: 'I think that sense of longing and loss was always in my work, in a clumsy sort of way – that idea of an object that you can't possess, something that's quite intangible – but that was the first piece that clearly articulated it.'

Six years later, the Women's Playhouse Trust asked Gallaccio to make a second work in the derelict building pending its efforts to secure ownership. This was to be *intensities and surfaces*, for which Gallaccio enlisted the help of friends and assistants. She later recalled:

> The ice piece at Wapping was made in one day. One of the slabs cracked when we were installing it and I left it broken. I try to accept the inconsistencies of the processes and materials that I use. We took the scaffolding down the day of the opening, so that was the first time I saw the object in the space. I had three hours to get my head round the idea that this was my piece of work.

Over the period of the exhibition, the ice blocks of *intensities and surfaces* melted not only because of the ambient temperature but also because hidden at the work's core was a block of rock salt. The salt helped corrode the structure in unpredictable ways, creating dramatic changes and shapes reminiscent of weathered rocks. 'It was like having a cancer or a heart – one destroys and the other makes things live – inside this elegant, formal block', the artist said. The pristine beauty of the original block of ice was soon lost, and instead the work offered a play of changing reflections in the widening pool of water of the boiler room's floor.

The decay of once conventionally beautiful materials was a hallmark of a number of Gallaccio's works in the 1990s. As Rugoff noted in 1999, this was a risky gambit: 'In a media-driven culture which continually bombards us with perfect images and images of perfection, physical reality frequently seems underwhelming, and many of us may initially respond to such work with disap-

pointment and peevishly blame the artist.' In its latter stages, *intensities and surfaces* changed beyond recognition, in places absorbing dirt from the floor. The title of the work seemed to imply that what mattered was not the original shape of the block of ice but rather the dramatic processes of its mutation, or what Rugoff called the 'quietly outrageous metamorphoses in process under our noses and under our feet'.

Today, a few images remain to tell us what the work looked like, but significantly Gallaccio refused herself to make and sell photographs of her pieces: they were at best partial records, she felt, of what was essentially an encounter. Photographs, Rugoff has written, 'fail to capture what engages and interests us in that encounter – the emotional and sensory responses triggered by the work's material attributes, and our own active role unfolding and engineering her art's latent narratives'. Gallaccio herself insisted that her works were always about an emotional response to the art's physical presence and that the important thing was to see and to be physically with the works. She also revealed that she had a deep-seated aversion to the commodification of art: 'My work is very much tied to me and I've always had a terror of feeling possessed.'

In the 1990s Gallaccio presented the processes of transformation through decay in a number of works involving different types of flowers, a risky strategy for a woman artist, perhaps, but she was determined to attempt to make 'serious' works of art with them. For *preserve 'beauty'* in 1991, she created a window display in a London gallery of a type of red gerbera known as 'Beauty', hanging eight hundred flowers between a glass panel and the gallery's window. Initially a very striking and cheerful sight, the work rapidly changed, as the flowers dried and then rotted and putrefied. As mould grew, the gridlike form – associated within the history of modern art with minimalism and concepts of perfection – was turned into a site of uncontrolled natural processes. But the subject of the works was not just the flowers: the glass was an important element, too. Made from sand and seashells, the glass had within it traces of its past life in its physical properties; and while normally used to preserve artworks, in these pieces the glass panels hastened the flowers' decay.

In this period Gallaccio was not at all concerned with leaving a legacy. 'To me that really doesn't matter', she said in 1996. 'I want acknowledgement now. I am not interested in making some huge monument to myself to prove I was on the planet.' She later modified her practice, however, allowing her flower pieces that had been site-specific and had required her involvement in their installation simply to be remade by their owners following instructions she provided, whenever wanted. The subject of her art was still the 'changing state of things and concern with the fleeting nature of possession', but with the concept of easy repeatability she had found a way of allowing these flower pieces, presented as single or grouped panels, to enact repeated loss and absence.

In the late 1900s and 2000s Gallaccio continued to work with impermanent and organic materials, and made site-specific works in both natural and

formal settings. But she also now embraced permanent materials, using ceramics and casting organic forms in bronze. In 2011 she said, 'My interest in making bronzes came in part from a realization of the limitations of always making things that literally "disappear".' But she added, 'To me, however, the bronzes are no more reassuring as objects than my more ephemeral works.' Her casts of trees, pinecones or humble broad bean pods signaled transience, notwithstanding the fact that they were made of bronze. Ultimately, what was at stake was not the materials nor the ostensible subjects of her works but rather the concept of ephemerality that, paradoxically, she found did not need to be expressed or represented in short-lived materials.

————

Discarded
Missing
Rejected
Attacked
Destroyed
Erased
Ephemeral
Transient
Unrealised
Stolen

35

Dispossessed

Break Down 2001
Michael Landy born 1963

'Consumerism has permeated all kinds of different areas, especially in the last twenty years, from politics to religion, sport, all areas of culture', British artist Michael Landy said in advance of his two-week project, *Break Down* 2001. Staged in a recently closed department store in Oxford Street, London's busiest shopping area, his installation aimed to ask, 'what is it that makes consumerism the strongest ideology of our time?'

Landy spent three years developing and planning *Break Down*, which involved the systematic disintegration and disposal of all his possessions. Complex items were dismantled, and everything was sorted and then shredded or granulated. Loss is typically associated with sadness, but Landy willingly embraced the destruction of his 'self-defining belongings'. At the end, he was left with little more than the clothes he was wearing – and some debts. (Initially, he had planned to sell granulated items as new artworks to help finance the project, but he came to feel that the logic of the project, and his own views on consumerism, dictated that there should be no surviving products or reminders of his past.)

Landy became well known in Britain through *Break Down*, but it was not his first work to focus on the mechanisms of consumerism and capitalism. In 1992, during a recession in the UK economy, he staged a mock closing-down sale in his dealer's gallery. Shopping trolleys, filled with junk found on the streets, crowded the floor; signs advertised a 'meltdown madness sale' at 'rock bottom prices'; and a continuous voiceover by Landy promised 'bargains, bargains, bargains!' At a time when many shops were closing and had similar signs in their windows, Landy's *Closing Down Sale* drew attention to the obvious, but rarely discussed, parallels between an art gallery and other commercial enterprises. The garish signs pointedly suggested that art, despite its traditional claims to represent a disinterested and autonomous sphere of creativity and thought, was similar to any other type of saleable product within the current economic system. (Signs that Landy had made for this project and kept were later destroyed in *Break Down*.)

In planning his project, Landy researched the literature on anti-consumerism, material reclamation, recycling and sustainability. Initially, he was going to call the work 'Michael Landy's Lifestyle', seeing it as an attack on the idea of 'lifestyle' – which, he believed, was purveyed by corporate enterprises as a marketing ploy and accepted with little question by most consumers, who uncritically identified themselves with the particular brands and items they bought. Over time, however, the project came to focus also on the wastefulness involved in the making of consumer goods and the fact that they were not being designed in ways that made it easy to recycle their constituent parts. In 1999 Landy created *The Consuming Paradox*, a collage over two metres wide, made with images, articles and even books that had influenced him, including *Damaged Nature, Auto-Destructive Art* (1996) by the pioneer of auto-destructive art Gustav Metzger.

Landy conceived *Break Down* as a project that would mimic the impersonal processes involved in factory production. With a friend, he began to create a catalogue or list of all his belongings, with short descriptions and identifying numbers and letter coding. 'A' stood for artworks, 'C' for clothing, 'E' for electrical, 'L' for leisure, and so forth. Everything – down to his cold medication and individual photographs – was itemised and in this way presented as lacking personal and individual value. Landy intially thought about including only the consumer goods that he owned, but finally felt that everything, including the most personal mementos and even artworks by other artists in his possession, had to go for the project to be successful. He wanted to reject – and be seen to reject – consumerism and an attendant attachment to objects, even though, ironically, this would leave him needing to purchase certain items again after the project's end. When *Break Down* was finished, the list of 7,227 items was published as a public record of what Landy had 'broken down' and destroyed.

Artangel, which commissioned and produced the project, secured the empty premises of a recently closed department store on Oxford Street for the duration of *Break Down*. (Ironically, the site had the same sort of signs advertising 'Everything Must Go', as Landy had used in *Closing Down Sale* a decade before.) Landy chose all the equipment used in the project, and also designed the uniforms worn by the team. He and twelve assistants worked for two weeks, methodically sorting and dismantling his possessions into their constituents in four bays, each focused on different tasks (general dismantling; shredding and granulating; motor vehicle dismantling; and electrical and reading material dismantling). The artist stood on a raised platform from which he could monitor the whole process, which saw his personal possessions become as impersonal as shop goods as they circulated on conveyor belts from bay to bay.

In this project Landy destroyed items that many would find hard to live without, including his credit cards, passport and birth certificate. He said he never had doubts about destroying such objects: harder, and more significant to him, was the act of getting rid of his own art and belongings that had a sentimental meaning to him. The destruction of such personal items in the name of

making art struck a chord with the public. Landy commented:

> Most people could just about give up the flat screen television and the
> DVD and the digital camera, but when it came to the love letters and the
> photographs, that was more difficult ... that's what drew people in really,
> that really hit people in the bottom of their stomach.

The last object to be destroyed was a sheepskin coat that had belonged
to Landy's father.

> I think the sheepskin coat was there on the conveyor belt from the first
> day and it just kept travelling round and round. A few of the things I had
> more attachment to I destroyed last ... The sheepskin coat was something
> that my Mum had bought for my Dad, but then he had a mining accident
> and couldn't wear it any more, so it was stored away in a cupboard. Over
> those two weeks the coat became my Dad in a way. My Dad is still alive but
> somehow it became him. It was the last object that we destroyed from all
> the 7,227. Just before that we'd destroyed my BMW speakers, my record
> collection – so for the first time it was quiet, sombre – though there were
> thousands of people in the store that last day. All that was left was my
> Dad's sheepskin coat ... One of the operatives, Barry, shredded it and then
> there was nothing left.

Landy's project aroused great interest among the public, who were in-
trigued or appalled, but not, as he had imagined, angered, by his destruction of
his possessions. During the fortnight of its staging, *Break Down* attracted over
50,000 curious visitors from among the shoppers on Oxford Street. For his part,
Landy learned to change his ways and acquire and retain less, but because it had
been such an extreme project he found it difficult to move forward artistically.
It took him a year or so before he went back to making art, and when he did,
he began with a series of simple drawings of weeds, plants that can survive on
almost nothing.

Nearly a decade later, Landy returned to the theme of getting rid of things
– this time focusing specifically on art – with *Art Bin*. In early 2010 he exhib-
ited a huge container inside the South London Gallery and for six weeks people
could climb to the platform at the edge of the bin and throw in artworks –
chiefly their own – that they considered failures. Many pieces broke with the
impact of their fall. Fellow artists, including Tracey Emin, Damien Hirst and
Gillian Wearing, contributed works, as did art students (some disposed of their
entire degree show) and members of the public. As the container filled up, it
became, in Landy's words, a 'monument to creative failure', though some critics
questioned whether some used the opportunity to promote their own works
through the attendant publicity rather than as a cathartic letting-go of failed

works. Sited in a gallery, the project was also intended to point to the capacity of art institutions to make and break artists' careers, and to ask who has the power to apportion value to art. As with *Break Down*, the items in the bin were subsequently sent to landfill. Beyond documentation and memories, nothing now remains of either project.

UNREALISED

A WORK THAT IS DESTROYED OR MISLAID REPRESENTS THE DISAPPEARANCE OF A TANGIBLE PART OF THE ART HISTORICAL RECORD. BUT WHERE AN ARTWORK IS MISSING BECAUSE IT WAS ENVISAGED BUT NOT MADE, OR STARTED BUT NOT COMPLETED, SHOULD IT BE CONSIDERED AS LOST AND DOES THIS KIND OF LOSS MATTER?

JUST AS THE DESTRUCTION OF WORKS OF ART REMINDS US THAT ART IS NOT IMMORTAL, SO THE FAILURE TO COMPLETE A PIECE UNDERLINES THE DIFFICULTIES SOMETIMES INVOLVED IN THE CREATIVE PROCESS. UNREALISED WORKS MAY ALSO BECOME SYMBOLS OF UNFULFILLED ASPIRATIONS. PARADOXICALLY, THE ROMANTIC ASPECT OF FRUSTRATED HOPES AND AMBITIONS MAY BE MORE ALLURING AND LIVE LONGER IN THE IMAGINATION THAN A REALISED WORK.

36-37

36 Monumental Dream Vladimir Tatlin, *Monument to the Third International* 1920
37 Capsized Bas Jan Ader, *In Search of the Miraculous* 1973-5

Discarded
Missing
Rejected
Attacked
Destroyed
Erased
Ephemeral
Transient
Unrealised
Stolen

36

Monumental Dream

Monument to the Third International 1920
Vladimir Tatlin 1885–1953

Vladimir Tatlin became famous for a work that was not built (and could never have been). He started to make plans for a monument to celebrate the 1917 Russian Revolution around the beginning of 1919. In March of that year, however, communist parties from across the world met in Moscow to unite under a single organisation, the Communist International (abbreviated to Comintern and also known as the Third International), and this changed his thinking. Rededicating his project to this historic meeting and the global vision it embodied, Tatlin unveiled a model for his proposed monument – a vast spiralling tower that would straddle the banks of the River Neva – in November 1920. He went on to make two further models during the 1920s but never produced detailed proposals for the tower's construction, not least because chronic shortages of materials made the project unrealisable at the time. But his plans for celebrating a new world order cemented his place as a major figure in the Russian avant-garde, and in its sheer ambition and use of modern materials (iron, steel and glass, as opposed to stone or marble), Tatlin's concept was to have an enormous impact on modern architecture. A concept rather than a reality, the tower has since become a world-famous symbol of utopian thinking.

Born in a part of Russia now in the Ukraine, Tatlin moved to Moscow in 1911, where as a young artist he was able to observe the fast-paced evolution of the European avant-garde thanks to international exhibitions and the availability of foreign publications. In 1914 he travelled to Paris and gained first-hand knowledge of the latest developments in art, meeting Picasso in his studio and viewing the latter's cubist constructions. The visit sparked Tatlin's growing interest in abstract three-dimensional works, and led to a series of pieces termed 'painterly reliefs' that explored the boundaries between two- and three-dimensional representation. Tatlin wanted to change art and the art world. Writing to a Moscow newspaper in December 1914, he claimed: 'it has been my constant aspiration ... to find a way out of the present most unhappy artistic reality and into new conditions of artistic life'. He began to develop his constructions into fully

free-standing or hanging works, rejecting the physical limitations of wall-hung paintings and plinth-based sculptures. Strung from taught ropes and wires, his 'counter-reliefs' suggested to some people aeroplanes in flight.

Tatlin's experimental views found favour with the new communist regime. He was appointed head of the Moscow office of Izo-Narkompros, the branch of the Soviet Ministry of Education concerned with the fine arts, and found himself responsible for reform of art education and the protection of Russia's artistic past. In April 1918 – barely a few months after the start of the Revolution – the Ministry of Education began implementing the new 'Plan for Monumental Propaganda', removing Tsarist monuments from Russia's cities and replacing them with works honouring communism. Tatlin was in charge of the plan in Moscow, yet the resulting works – largely lifelike sculptures honouring historical figures – were something of a disappointment to the artist. Writing to his superiors in October 1918, he argued that artists should work, 'not only on monuments to prominent figures but also on monuments to the Russian Revolution, monuments to a relationship between the state and art which has not existed until now'. Tatlin embarked on his own monument to the Revolution that winter.

In March 1919 – the same month as the founding of the Third International – Nikolai Punin, head of the Ministry of Education in Petrograd (as Saint Petersburg was then called), wrote an article about Tatlin's planned monument for the state's art journal. Although no specifics were given, there is a clear sense from Punin's text that Tatlin's new project would be both politically and artistically revolutionary:

> The ideal monument must respond to the widespread call for ... one unified form which is at the same time architectural, sculptural and painterly ... [Tatlin] is tired of creating busts and statues of heroes ... all the elements of the monument should be modern technical apparatuses promoting agitation and propaganda ... the monument should be a place of the intense movement.

Tatlin worked together with a 'Creative Collective' of young artists on his planned monument. In both its form and its method of production he wanted the monument to emphasise the relationship between art and society, and between the achievements of the individual and the influence of the masses. In his 1919 text 'The Initiative of the Individual in the Creativity of the Collective' he wrote, 'invention is always the working out of impulses and desires of the collective and not of the individual'. An element within Tatlin's sense of collectivity was the project's references to labour and industry: an assistant recorded that Tatlin found in the cranes and girders along the River Neva in Petrograd 'an inexhaustible source of inspiration ... a poetry of metal'. Tatlin and his team worked on plans for the monument throughout 1919–20, first in Moscow, and then in Petrograd after Tatlin was appointed teacher at the city's Free Art Stu-

dios. Here Tatlin also founded his own studio, the 'Studio of Volume, Material and Construction'. Just as workers had risen against the government in 1917, so artists, he believed, needed to rebel against the naturalistic art of previous generations. He described this shift in his collective's 1920 statement 'The Work Ahead of Us': 'What happened in '17 in a social sense has been carried out in our craft ... distrusting the eye, we place it under the control of touch.'

For his revolutionary project Tatlin envisaged a tower of four hundred metres (a third higher than the Eiffel Tower and, if realised, the tallest building on earth) erected on both banks of the River Neva. Inside the spiralling structure were to be four suspended chambers, linked by lifts and offering functional spaces that rotated around the building's central axis at different speeds (in Tatlin's plans, 'revolution' was understood as both political revolt and physical rotation). At the base would be a giant cube for lectures and conferences that rotated once a year. Above, a pyramid housing Party offices would revolve once a month. Further up, a cylinder housing a restaurant and an information-and-broadcasting centre would revolve daily, while at the top would be a hemisphere housing radio equipment. For Punin, one of Tatlin's supporters within the state hierarchy, Tatlin's spiral structure, seen from the side, was like 'a muscle tensed with a hammer', a dynamic symbol of a liberated humanity moving away from 'all animal, earthy and grovelling interests'.

Beyond such political messages, the planned monument also had religious undertones, its huge scale evoking the Russian tradition of building great churches to commemorate historical events. Tatlin was well travelled and familiar with a range of religious architecture. By echoing the shapes of famous mosques in Egypt and Iraq (for example, the Al-Malwiya Mosque at Samarra in Iraq), Tatlin hoped his communist tower could become another great non-Christian temple. He wrote of his planned tower in 1919:

> The temple represents the Earth, which returns its dead, and Heaven ...
> which is being populated by resurrected generations ... a sturdy structure
> could be created – a Temple of the Worlds – which would exist without
> props or supports, and which would move in an infinite space. Such a
> temple would emancipate all the world from bondage.

The design also recalled late-medieval representations of the Tower of Babel. According to the biblical story, the Tower of Babel was built as a challenge to God's power at a time when the earth was united by a single language. God's response, according to the Book of Genesis, was to 'confound the language of all the earth', creating incomprehension and distrust between men to curb their power. The spiral shape of Tatlin's tower echoed the image of the Tower of Babel found in a well-known engraving of 1679 by the German scholar Athanasius Kircher, with the intention of symbolising the Third International's aspiration to reunite mankind under communism. Tatlin's design also referred to a strik-

ing symbol of progressiveness, the Eiffel Tower in Paris. Constructed in 1889 to mark the centenary of the French Revolution, the Tower symbolised for many not only France but also modernity itself. With its iron structure, Tatlin's tower not only alluded to its French counterpart but also – as the artist Robert Delaunay famously did in his pre-war paintings of the iconic building – dramatised its shape and visual impact. Lunging sideways, Tatlin's tower provided both usable space and a sensation of vast spirals that appeared to continue indefinitely in a way that spoke of the soaring ambition of the modern age.

Over five metres tall and constructed from wood, cardboard, wire and paper, the first model for the impossible building was itself spectacular. It was displayed in Tatlin's studio in the former Mosaic Studio of the Free Art School in Petrograd from November to December 1920. Then it was dismantled and moved to Moscow to be displayed for two months at the Eighth Soviet Congress. Russia was then in the midst of a civil war in which many European states had taken sides: the eyes of the world were on the capital. When the Soviet leader Vladimir Lenin used the Eighth Congress to outline his plans for agricultural reform and the electrification of Russia, Tatlin's Tower became seen by many as a symbol of the optimism and modernity of the regime. His work was also acclaimed by those who believed that art should be socially useful.

Even in these early days, however, there was a sense that the monument was somehow detached from reality. Tatlin provided no detailed plans for how the tower was to be constructed. Though they praised its design, many of Tatlin's colleagues questioned its appropriateness at a time of chronic shortages of materials. Others objected on aesthetic or utilitarian grounds. Anatoly Lunacharsky, overall head of the Ministry of Education, described the 'iron monster' of the Eiffel Tower as 'a thing of beauty compared with Tatlin's slanting building', while Leon Trotsky, a leading figure in the government, wrote of the tower's moving chambers in 1924: 'I cannot avoid asking: for what purpose?'

As the 1920s progressed, Tatlin's tower remained unrealised, yet it continued to stand as a symbol for the Soviet regime. In 1925 Tatlin constructed a second, simplified model for the Russian pavilion at the Paris International Exhibition of Decorative and Visual Arts. Standing alongside a bust of Lenin, the model formed the focal point of the pavilion. Back in Leningrad (as Petrograd had been renamed after Lenin's death in 1924), Tatlin worked on a third model of the monument, for use in the city's Workers' Day celebrations on 1 May 1925. This model was larger and more complex than the Paris version, yet less dynamic than the original plans; its slant was reduced and its base made oval to fit onto the processional cart. There were still no plans for the tower's realisation, and it was becoming increasingly clear that the symbolic value of the idea was overtaking a desire for an actual monument.

Tatlin's *Monument to the Third International* was never built, and all three of the artist's original models were lost. Tatlin's avant-garde idealism fell from favour in the Soviet regime in the late 1920s. During the Stalin years he was criti-

cised for his 'formalist errors' as an artist; and although he was never officially condemned by the Communist Party, his death from food poisoning in 1953 went unremarked.

With the resurgence of interest in Marxism in the west following the social and political upheavals of 1968, however, fresh attention was paid in Europe and the United States to the artistic achievements of the Russian Revolution. For some, Tatlin's tower assumed an almost mythical status as a symbol of utopian aspiration, while the fact that so little was known about it beyond a few photographs and descriptions meant that it was open to many interpretations. Writer Brian Dillon described Tatlin's unrealised tower in 2009 as, 'a monument of the mind: half ruin and half construction site, the receiver and transmitter of confused messages regarding modernity, communism and the utopian dreams of the century gone by'.

To try to represent this unrealised work, some museums and galleries in Europe and America have built reconstructions of Tatlin's models; and filmmakers have attempted to use modern technology to visualise how the tower might have looked. Although it is difficult for modern audiences, familiar with the achievements of architecture today, to imagine the sense of excitement and sheer audacity of Tatlin's tower, such reconstructions help underline the idealism and cultural freedom that lay at the origins of the Soviet regime. They also serve as a reminder of the yawning gulf that can often exist in art as well as society between theory and practice.

————

Bas Jan Ader
"In Search of the Miraculous"

Discarded
Missing
Rejected
Attacked
Destroyed
Erased
Ephemeral
Transient
Unrealised
Stolen

37

Capsized

In Search of the Miraculous was a three-part performance and installation project conducted over two years by Bas Jan Ader, a Dutch-born conceptual artist who lived in Los Angeles. The work's first part was a walk that Ader undertook through Los Angeles one night in 1973, which was documented in a series of photographs. The second part was an exhibition of the photographs together with images and sounds of a student choir singing sea shanties, which was held in April 1975. For this event, Ader designed an invitation card showing what looks like a ghostlike figure leaning over the side of a boat in rough seas in anticipation of the solo voyage from America to England that he planned to undertake a few months later. The third element was intended to be an exhibition in Groningen, Holland (near where Ader grew up), which would restage the Los Angeles show and include new photographs and documentation of the voyage. Armed with a movie camera and tape recorder, but without a maritime VHF radio, Ader set sail from Massachusetts on 9 July 1975. He never reached his destination.

Bas Jan Ader was born in 1942, the son of a Calvinist minister, in Holland. His parents were in the Resistance and helped hide Jews and British pilots from the Nazis. When Ader was two, his father was arrested and shot. Ader, who settled in California in 1963, spoke little about the meaning of his artworks – mainly short films and photographs – but his preoccupation with tipping points in life, both physical and spiritual, may have been influenced by, or a creative response to, these traumatic events in his childhood. In 1970–1 Ader produced a number of short films showing him falling in one way or another – tumbling off the roof of a house, cycling into a canal or dropping from the branch of a tree. Like other conceptual and performance artists of his generation, he used his own body as an object to be manipulated. But his exploration of failure and preparedness to express vulnerability within his practice suggested a willing submission to circumstances beyond his control. 'I do not make body sculpture, body art or body works', he once said. 'When I fall off the roof of my house or into a canal, it was because gravity made itself master over me.' Writing in 1994, James Roberts

and Collier Schorr noted the distinctive role played by comedy and pathos in his work, 'Ader fills the requirements of 70s conceptualism by repeating in lieu of explaining, but he also manages, through the slightest variations in expression, to implant a plot that is not universal, but personal.'

Ader was particularly fascinated by the idea of the miraculous escape. In a 1972 performance, for example, he read aloud from the *Reader's Digest* the true story of a boat captain and a boy who accidentally sailed over the Niagara Falls:

> Honeycutt grabbed Roger's arm, fighting to hold the boy's head out of the water. But the furious currents tore them apart. The rapids wrenched Roger down, spun him around. Then all at once he was free, thrust out over the edge of the falls, dropping through space.

In the story the captain died, but the boy miraculously survived. Ader similarly sought to pit himself against nature to see if he would survive in his 1975 voyage across the Atlantic. Where some have questioned whether Ader was driven to seek death in some way, the ostensible subject of his works was always survival against the odds.

Bas Jan Ader
*In Search of the Miraculous
(One Night in Los Angeles)*
1973

In Search of the Miraculous began with a walk by Ader, holding a powerful flashlight, through Los Angeles one night. His wife, Mary Sue Ader, photographed the walk, which started at dusk in the Hollywood Hills and ended at dawn looking out to the Pacific Ocean. The work posited a naïve faith that the miraculous existed and could potentially be found through determined looking in the environs of a modern American city. The failure to find the miraculous in

any literal sense was of course beside the point: the quest was what mattered. Ader was clear that he intended the search to be understood in a spiritual, as well as physical, sense: he named the work, and the bigger project of which it was the first part, after a 1949 book by P.D. Ouspensky, which discussed esoteric teachings about self-development and the cosmos. Ader created a photographic series from the shots and added to each in white ink a line from the 1957 hit *Searchin'* by The Coasters, a Los Angeles-based rhythm-and-blues group:

> Yes, I've been searchin'
> I've been searchin'
> Oh yeh, searchin' every which way
> Oh yeh, searchin'
> I'm searchin'
> Searchin' every which way ...

The words provided, as it were, an implied soundtrack for the work, framing the viewers' affective response to the images.

Ader exhibited the night-walk photographs in April 1975 at the Claire S. Copley Gallery, Los Angeles. He had already mapped out in his mind the three-part nature of the project, and at the opening had his students sing sea shanties (he was then teaching at the University of California) in anticipation of his Atlantic voyage. The recording of the songs, together with photographs of the performance and the sheet music, formed part of the second element of *In Search of the Miraculous*.

Bas Jan Ader getting ready
to set sail, 9 July 1975

A keen sailor, Ader set sail from Cape Cod, Massachusetts, in July 1975 and hoped to reach Falmouth in England in just over sixty days. This would have set a world record for such an extremely small boat (only 12½ feet or 3.8 metres). Ader had long been thinking of making a single-handed crossing and planned the trip carefully. He made the boat ocean-ready with stronger rigging and took enough food and water for 180 days, as well as fishing equipment, a movie camera, tape recorder, and books on navigation and philosophy. His father had cycled from Holland to Palestine at the same age (thirty-three), with many injuries and near-death experiences, and Ader perhaps wanted a similar adventure to memorialise his father.

To commemorate Ader's solo voyage, the Amsterdam gallery Art & Project published a pamphlet. The document included a photograph of Ader on his small boat, called *Ocean Wave*, and the music for the song 'A Life on the Ocean Wave', with its declamation of a love of adventure in its first verse:

A life on the ocean wave,
A-home on the rolling deep!
Where the scater'd waters rave,
And the winds their revels keep.
Like an eagle caged I pine
On this dull, unchanging shore.
Oh give me the flashing brine,
The spray and the tempest's roar.

Ader should have arrived in England in early September, and then gone on to Groninger Museum, Holland. Initially, Ader's wife, Mary Sue, and his brother, Eric, also assumed that the journey was simply taking much longer than expected: they had accepted Ader's own confident assertions that he could manage the trip without much question. Mary Sue later said, 'He was so convinced he was going to make it, and make it in fast time, that he insisted, even though we were desperate for money, and had a teaching contract in California, that I go to Holland to be there as late into September as I could.' She had to return to America but still thought he would eventually arrive. On 17 October the museum director wrote to Ader's wife about the show: 'We didn't hear anything from Bas Jan but we have confidence.' As the weeks passed, however, it became clear that something had gone wrong; eventually it was accepted that he had died at sea.

Nine months after Ader had set sail, a Spanish trawler from La Coruña found the capsized hull of *Ocean Wave* off the Irish coast. The amount of fouling on the boat suggested that it had been drifting around in this position for about six months. Ader's body was never found, and the boat itself was later stolen. No one knows exactly how Ader died. Mary Sue Ader was interviewed shortly after Ader's boat was discovered. She confirmed that the third part of *In Search of the Miraculous* would have consisted of documentation about the voyage, a

reperformance of the shanties (in Dutch or English), and photographs of a new night-walk undertaken in Amsterdam. And she discounted suggestions that he had intended to die or had gone missing deliberately, stressing how he had convinced everyone else, including experienced sailors, that the voyage would go well despite the boat's tiny size.

Ader left only a small body of work and was not well known at the time of his death. He might have been forgotten. Those in his circle were deeply shocked and there was an initial reluctance among some to talk about his work; and supporters later struggled to promote it given that he had produced relatively little in his short life. But his insistence on foregrounding pathos and melodrama within a conceptual practice – intensified by the mystery of his disappearance at sea 'in search of the miraculous' – continues to resonate as not only distinctive but also, in some ways, a critique of the work of his contemporaries.

His final work was not completed, and he himself was lost in the process of trying to make it, but this loss did not undermine the effectiveness of the work itself. As the art writers Roberts and Schorr commented:

> While Ader's vanishing reads like a fable, it stands as a conclusion to a project that revolved around the risk of death. The concept behind the Search was the undertaking of a physical exercise, free from the safety of land, in order to access a spiritual meeting that could deliver the romance of survival in its purest sense. The fact that Ader failed to complete the journey has little bearing on the success of a project that never hinged on making it across the Atlantic, but on trying to make it.

————

STOLEN

ART THEFT IS BIG BUSINESS, REPORTEDLY WORTH BILLIONS OF POUNDS EACH YEAR. IT CAN BE SEEN AS A SOPHISTICATED, VICTIMLESS CRIME, BUT IT IS GENERALLY UNDERTAKEN BY ORGANISED GANGS WHO USE THE STOLEN PAINTINGS OR SCULPTURES AS COLLATERAL IN UNDERWORLD DEALINGS THAT IN TURN ARE LINKED TO EXTORTION AND VIOLENCE.

THIEVES CAN BE CARELESS WITH THE WORKS THEY STEAL BUT THEY USUALLY HAVE EVERY INCENTIVE TO LOOK AFTER THEM. OWNERS THEREFORE GENERALLY HAVE GOOD REASONS TO HOPE THAT THE AUTHORITIES WILL EVENTUALLY RECOVER STOLEN ARTEFACTS, EVEN IF THE TRAIL GOES COLD.

38–40

Discarded
Missing
Rejected
Attacked
Destroyed
Erased
Ephemeral
Transient
Unrealised
Stolen

38

Off the Wall

Francis Bacon 1952
Lucian Freud 1922–2011

When famous artworks are stolen, there may be an initial flurry of press reports, but a blanket of official silence quickly descends, as the police undertake their enquiries and, more often than not, owners await a ransom demand or contact from an intermediary. Typically, it may be several months or even several years before those holding a stolen artwork make any attempt to contact its owners.

In May 1988 a very small painting on copper by Lucian Freud – one of the finest of his early period – was stolen in broad daylight from an exhibition of the German-born British artist held in Berlin. Visitors and the museum guard patrolling the exhibition area saw nothing unusual; and there was no clue as to who took the work from the gallery wall. A month later a man contacted the artist, offering to act as an intermediary, but he did not get back in touch. Nothing of substance has been heard since about the likely whereabouts of the painting.

Lucian Freud met Francis Bacon in London in 1945, and the two artists quickly became friends. Born in 1909, Bacon was thirteen years older and Freud admired Bacon's freedom and daring in his handling of paint. Freud later recalled:

> He talked a great deal about the paint itself carrying the form, and imbuing the paint with this sort of life. He talked about packing a lot of things into one single brushstroke, which amused and excited me and I realised it was a million miles away from anything I could ever do.

In the later 1940s and early 1950s Freud painted in a meticulous realist style that owed much to northern Renaissance art and, in particular, to the smooth surfaces and detached manner of the French nineteenth-century master Ingres. Freud's friendship with Bacon, however, helped crystallise his growing discontent with this way of working, leading to his adopting a much freer handling of paint and producing larger scale works in the late 1950s.

Freud painted his friend Bacon only twice. The stolen portrait of 1952 took some three months to complete. In this period, Freud worked seated with his canvas – or on this occasion, copper plate – on his knees rather than on an easel; he worked so closely to Bacon, who was also sitting, that their knees touched. The intensity of Freud's gaze – and, with his downcast eyes, Bacon's calm resistance to it – made the portrait one of the most famous, and memorable, of his early career.

In 1988, before the painting was stolen, the art critic Robert Hughes wrote of the work:

A small picture, about the size of a shorthand notepad, and one whose extreme compression makes it even more compact in memory; one remembers it as a miniature. The thought of 'miniature', with its Gothic overtones, was affirmed by the surface: tight, exact, meticulous and (most eccentrically, when seen in the late fifties, a time of urgent gestures on burlap) painted on a sheet of copper. There seemed to be something Flemish about the even light, the pallor of the flesh, and the uniform cast of the artist's attention. But there, on the edge of familiarity, its likeness to the modes of older portraiture stopped. What a strange, ophidian modernity this small image had, and still retains! One did not need to know it was the head of a living artist to sense that Freud had caught a kind of visual truth, at once sharply focused and evasively inward, that rarely showed itself in painting before the twentieth century.

In 'normal' portraiture, a tacit agreement between painter and subject allows the sitter to mask himself and project this mask – of success, of dignity, of beauty, of role – upon the world. But here the face with its lowered, almond-shaped eyes and eyelids precisely contoured as a beetle's wing-cases is caught in a moment between reflection and self-projection. It is as naked as a hand ... Bacon's pear-shaped face has the silent intensity of a grenade in the millisecond before it goes off.

Freud tackled a second portrait of Bacon in 1956–7, using his now freer style of painting. But this work remained unfinished when Bacon temporarily left London. By contrast, Bacon painted Freud on a number of occasions down to the 1970s. The earliest known work was a large full figure study, which began as a portrait of the writer Kafka and which Bacon only minimally adapted. Unlike Freud, Bacon did not rely on sittings and instead worked largely from photographs. As was his style, he obscured and distorted his friend's features in the later portraits.

In 1987–8 the British Council organised a major exhibition of Freud's work, the first outside Britain. The retrospective toured to Washington, Paris, London and Berlin, and one of its acknowledged highlights was the small portrait of Francis Bacon that had been bought directly from Freud by the Tate Gallery in 1952.

The painting was stolen from the Neue Nationalgalerie, Berlin, on 27 May 1988. A visitor reported the work missing, and the gallery quickly called in the police, who sealed the building before questioning and searching visitors. The thief must have used a tool to remove the screws of the mirror-plates securing the frame to the wall (the painting was not wrenched from its fittings). Some speculated that he or she might have had an accomplice to act as a lookout. However, the ease and speed with which the work went missing was a source of both mystery and deep embarrassment to the Berlin museum, pointing to a hitherto unsuspected lapse in standards of guarding. A small reward was offered; ports and airports were notified; a couple of fruitless tip-offs were pursued. But the authorities were left in the dark about what had happened to the work. Paradoxically, a painting stolen opportunistically can prove harder to locate than one taken by a criminal gang to be used as collateral in underworld dealings.

The theft of the work left a gap in Tate's holdings of early Freud works. The museum declined to accept the insurance money for the stolen painting, hoping that it would eventually be returned – and because there were no equivalent pieces available with which to replace this exceptional work. The loss also weighed heavily with Freud himself. After the theft, he refused to allow the painting to be reproduced in colour. This was partly because he was not pleased with the quality of the existing colour reproduction and partly 'as a kind of mourning'. Reproducing the work only in black and white was, for him, a 'rather jokey equivalent to a black arm band'. It has been reported that Robert Hughes suggested to Freud that he could view the theft as proof that someone loved his work, a compliment in other words. Freud demurred, saying, 'I don't think so. I think somebody out there really loves Francis.'

Freud's friendship with Bacon had waned and later soured as the two men aged, but he remained sorry not to be able to count on this portrait to tell the story of his development as an artist. In 2001, prior to another major retrospective, he designed a WANTED poster to attract the attention of people in Berlin who might know where the work was, offering a reward of up to 300,000 DM. He thought that a high-profile campaign might lead to new information and the painting's recovery: under the German statute of limitations, a crime could not be prosecuted after twelve years, and the artist hoped that the lapse of time since the theft would allow a deal to be struck and the painting to be returned to the public realm. In a statement to the press Freud asked politely, 'Would the person who holds the painting kindly consider allowing me to show it in my exhibition next June?' Despite this appeal, nothing was heard about the painting's whereabouts, and to date its location and fate remain as mysterious as when it was stolen in 1988.

Discarded
Missing
Rejected
Attacked
Destroyed
Erased
Ephemeral
Transient
Unrealised
Stolen

39

Scrapped?

Reclining Figure 1969–70
Henry Moore 1898–1986

In most cases it is clear why a work of art is lost. It can be wilfully destroyed or accidentally mislaid. It may never have been intended to endure; or the materials used may have proved ephemeral. But sometimes the loss can be the result of a cause or a motive that is more difficult to discern or understand. When a work of art is stolen it is usually obvious that the thieves knew what they were taking and why: to use as collateral in criminal activities, to resell on a black market and make major financial gain, or, occasionally, to grace the home of a private collector. However, in the case of Henry Moore's *Reclining Figure* 1969–70, which was stolen one night in 2005, it remains a mystery whether those who perpetrated the crime understood exactly what they were taking and its real value.

The subject of the reclining figure was one of the most important in Henry Moore's work. 'From the very beginning', he once said, 'the reclining figure has been my main theme. The first one I made was around 1924, and probably more than half of my sculptures since then have been reclining figures.' For Moore it was a liberating theme because so familiar: 'within the subject that you've done a dozen times before, you are free to invent a completely new form-idea'.

Moore kept a collection of small bones and stones that appealed to him, and used these as starting points for his large-scale bronze sculptures. He would add some plaster to a piece of bone or stone, subtly transforming its shape, and then create a mould of it from which he would make a plaster positive. To this he might add another bone or stone, or a broken off piece of plaster, to develop the idea of the sculpture, and then create a further mould and a plaster positive, leading to a finished maquette.

The plaster maquette for *Reclining Figure* was only fifteen centimetres long. Although an edition of small bronzes was cast from it, its main purpose was to serve as a model for a scaled-up polystyrene (with some plaster) version from which to make an edition of the large bronzes, each 3.6 metres long and weighing 2.1 tons. Maquettes allowed Moore to envisage the correct size for the final versions of his large-scale sculptures and to plan how best to locate

them in particular settings. In 1972, when planning a major retrospective of his work in an old fortress with spectacular views over Florence, he photographed the maquette against a colour photograph of the view over the Italian city from the spot where he envisaged siting the full-scale bronze to study how it would look. This exhibition was a particular challenge for Moore both aesthetically and logistically: Florence was famed for its great Renaissance art and installing two hundred sculptures in a sixteenth-century hillside fort posed technical problems. But Moore was determined to plan the installation himself and used maquettes and photographs to help him do so from his home in England.

The exhibition proved one of the pinnacles of his career. He had been delighted to have the opportunity to stage a major retrospective of his work in Florence, a city associated with sculptors of the stature of Donatello and Michelangelo. In an open letter addressed to the mayor of the city, Moore wrote about his long-standing love of the city. 'I feel it is my artistic home', he said. 'No better site for showing sculpture in the open-air, in relationship to architecture, + to a town, could be found anywhere in the world, than the Forte di Belvedere, with its impressive environs + its wonderful panoramic views of the city.' The full-scale bronze example of the *Reclining Figure* was one of the highlights of the exhibition that attracted nearly 400,000 visitors. Later Moore said that the exhibition had encouraged him to work on a large scale.

Reclining Figure had been cast in an edition of six, plus an artist's copy, in 1969 and early 1970 (other works in the edition are now owned by private collectors, a foundation in South Africa and museums in Denmark, Israel and Japan). In 1977 the artist created The Henry Moore Foundation, sited in his own home and studio in the Hertfordshire countryside, and the artist's copy became part of the Foundation's collection. The huge sculpture was stolen after its return to the Foundation, having being lent to an exhibition. The theft was swift and seemingly professional. CCTV footage revealed that a four-wheel-drive vehicle entered the Foundation's yard at 10.08 pm on 15 December 2005. A waiting lorry with a crane followed and quickly drove away with the sculpture. The theft was discovered the next morning and the police were called, but they had few leads to go on. On Saturday 17 December, a press conference was held, and newspapers and television gave extensive coverage to the crime, announcing the offer of a substantial reward. Spokesmen for the Foundation expressed their deep sense of shock at the loss and also their surprise that such a large and heavy sculpture could have been taken so quickly and apparently without trace. Detective Sergeant Vernon Rapley, head of the Metropolitan Police Arts and Antiques Unit, commented, 'For many years these objects have been considered unstealable because they are so large and heavy, because they are on public display and because they were seen as unsaleable. They weren't considered a risk. Now it seems they are. The people perpetrating these crimes appear to have no appreciation of, or respect for, the objects they are stealing.'

Others spoke about their fear that the bronze sculpture, worth £3 million at the time, might have been taken simply for its scrap value, which was less than £3,000. Scrap-metal prices had been soaring, fuelled by the building boom in the Far East, and it was suspected this may have been the trigger for a recent spate of thefts of large-scale bronze sculptures and plaques. Between 17 and 21 December the police and staff from The Henry Moore Foundation visited a number of scrapyards and telephoned scores of scrap merchants in a concerted effort to locate the sculpture. Helicopters were used to survey areas where the artwork may have been dumped or stored. The lorry used for the theft was found on 18 December, abandoned on a housing estate in Coopersdale, near Epping. It was later revealed that it had been stolen only an hour before the theft in Roydon, Essex. The car, which had also been stolen, was found burnt out in nearby Hoddesdon. The two stolen vehicles were worth far more than the scrap value of the sculpture but police continued to suspect that the artwork had been taken for its metal and not for resale or to order by a collector.

A few years later, in May 2009, the police announced that they were confident on the basis of new intelligence that *Reclining Figure* had indeed been broken into parts and processed as scrap metal the night of the theft. Others, however, were not so sure, partly because the operation had been so professionally executed, and continued to have doubts. Mark Dalrymple, a leading loss adjuster, for example, said in 2006, 'There's a misconception that the Henry Moore stolen in 2005 was taken to be melted down for scrap. I do not believe that is true. There were three or four men involved. They stole a four-wheel drive and took a truck with a grab. It was taken because it was worth £3m. Whether or not they find a buyer is another matter, but they knew what they were doing.' Although the police believe they have solved the mystery of the Moore theft and that the sculpture no longer exists, the questions about who the thieves were, what exactly they did with the sculpture, and whether they had ever planned to realise something close to the piece's value as a work of art remain unanswered.

Even when lost or destroyed, an artwork can continue to exert influence as an image, memory or story. The reputation of Henry Moore and the general incredulity that such a well-known and large sculpture could disappear without trace led to the theft being reported internationally. In Germany the idea that the work had been melted down for its scrap value inspired Fritz Balthaus to create in 2009 a sculpture made from the equivalent weight of bronze of the stolen work. Called *Pure Moore*, the sculpture took the form of 221 ingots arranged roughly in the shape of Moore's *Reclining Figure*. Balthaus had the ingots cast at the Noack foundry in Berlin where the original sculpture had been cast, and installed the piece, with a certain irony, in the grounds of the Federal Criminal Police Office in the German capital.

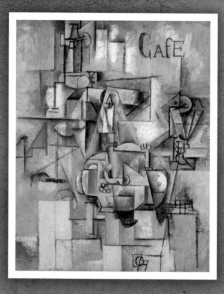

~~Discarded~~
~~Missing~~
~~Rejected~~
~~Attacked~~
~~Destroyed~~
~~Erased~~
~~Ephemeral~~
~~Transient~~
~~Unrealised~~
Stolen

40

Unsellable?

Five Paintings Stolen from the
Musée d'Art Moderne de la Ville de Paris

Pastoral 1906
Henri Matisse 1869–1954

The Olive Tree near L'Estaque 1906
Georges Braque 1882–1963

Pigeon with Peas 1911
Pablo Picasso 1881–1973

Woman with a Fan 1919
Amedeo Modigliani 1884–1920

Still Life with Candlestick 1922
Fernand Léger 1881–1955

Art theft and the trafficking of stolen works of art is a major criminal business, perhaps the largest in terms of financial value after the illegal trade in arms and drugs. The FBI currently values criminal income from art theft at $6–8 billion a year. The Art Loss Register – a private company that documents and helps trace stolen or lost artworks, antiques and collectables – has over 300,000 items listed in its database and adds a further 10,000 each year.

The theft of artworks is commonplace, but it becomes a news item, and lodged in the public's memory, when the works are by major artists or when they are taken from museums. The loss in these cases is shared and public, and interest may be piqued by the enormous value of the artworks and by details of exactly how they were taken – particularly if there are echoes of well-known films.

On 20 May 2010 five paintings by five different modern masters were stolen from the Musée d'Art Moderne de la Ville de Paris. The group ranges in date from 1906 to 1922, and represents a roll-call of some of the most famous names in early modernism. A classic fauvist piece, *Pastoral* 1906 by Henri Matisse is a freely worked scene of naked figures in a hilly landscape of ochre, blue

and lavender. Another fauvist painting, Georges Braque's *The Olive Tree near L'Estaque* 1906 is a landscape dominated by non-naturalistic reds, oranges and yellows. More sombre with its typical cubist palette of greys and ochres is Pablo Picasso's *Pigeon with Peas* 1911, a modest still life executed in a key period in the development of cubism. Larger, at a metre high, is Amedeo Modigliani's *Woman with a Fan* 1919. Acknowledged as the finer of the two Modigliani paintings owned by the museum, this figure study shows Lunia Czechowska, a close friend and patron of the artist. Modigliani painted her no fewer than ten times (in her memoirs she recalled, 'As a sitter you had the impression that your soul was being dissected, and you had the strange feeling that you were unable to hide your innermost feelings'). Modigliani's works command high prices, and this work has been valued at £15.2 million. The fifth stolen work is Fernand Léger's *Still Life with Candlestick* 1922, an interior scene rendered in highly stylised but still legible shapes.

The museum's CCTV footage revealed that the theft was carried out by just one man, though he may have had accomplices waiting outside the museum. Masked and wearing black, he cut through a padlock securing a grille and smashed a window to enter the museum in the early hours of the morning. He selected the five works, which were in different galleries, and made his getaway in no more than fifteen minutes. Three guards were on duty at the time but did not notice anything unusual. The incident came to light only at 6.50am when a guard patrolling the grounds spotted the broken window. The works' empty frames were later found discarded outside the museum.

The museum had only just had its security improved while closed for renovations, but the electronic system had had a fault since March and was in fact not working when the theft occurred. CCTV cameras inside the museum captured the image of the burglar but the quality was so poor that the footage could not help identify him, even though he once looked directly at a camera. The thief stole works from separate rooms, taking paintings by Picasso, Braque and Léger from one and crossing two other rooms to reach the gallery where the Modigliani and Matisse canvases were on display. The care with which the thief chose these particular works among the several hundred on display raised suspicions that he may have been stealing to order by one or more unscrupulous private collectors somewhere in the world – though in fact art thefts are rarely undertaken to order.

The Paris museum remained shut for the day, as police attempted to gather evidence. They quickly revealed, however, that they had little to go on; and their alerting of airports and ports yielded nothing. The city and museum authorities speculated about why the theft had been carried out (the works were too famous to be sold legitimately) and how it had been achieved so easily, though they conceded that the building's security systems had been inadequate. Director of a nearby art museum, Pierre Cornette de Saint-Cyr, addressed those responsible for the theft directly in his comments to the press: 'These five paintings

A forensic police team
examines the empty frames
outside the museum.

are unsellable, so thieves, sirs, you are imbeciles. Now return them.' As a prime purpose of a museum is to collect and preserve objects for future generations, the theft struck at the central function of the museum. Deputy Culture Secretary for the City of Paris, Christophe Girard, described the theft as a 'serious crime against the heritage of humanity'. Amid concern that inside information about the temporary shortcomings in the museum's security systems may have reached the criminal world, others were directly critical of the museum authorities: Tom Cremers, founder of the Museum Security Network, commented: 'Security is a core business for museums, and it is not acceptable that a core business should be out of order for several months.'

Although barely a decade into the new century, press at the time were quick to call it the 'art heist of the century'. Valued at 100 million euros (though this may be conservative), the paintings are still missing and there is no public information about what happened to them or where they might be now. The trail seems to have gone cold. Negotiations to secure the return of stolen paintings may take years, or even decades, to conclude. But the expectation must be that these paintings will be returned one day, through one channel or another, to the museum and to the public that owns the works.

Research Resources

Bas Jan Ader, *In Search of the Miraculous* 1973-5

Bas Jan Ader: Please Don't Leave Me, exh. cat., Museum Boijmans Van Beuningen, Rotterdam 2006.

Christophe Cherix (ed.), *In & Out of Amsterdam: Travels in Conceptual Art 1960-1976*, exh. cat., Museum of Modern Art, New York 2009.

Jan Verwoert, *Bas Jan Ader: In Search of the Miraculous*, London 2006.

'Bas Jan Ader, In Search of the Miraculous', Patrick Painter Inc., 2010, http://vimeo.com/11764389

http://www.basjanader.com

————

Francis Bacon, *Study for Man with Microphones* 1946

Ronald Alley, *Francis Bacon Catalogue Raisonné and Documentation*, London 1964.

Andrew Brighton, *Francis Bacon*, London and Princeton 2001.

Margarita Cappock, *Francis Bacon's Studio*, London 2005.

Martin Harrison, *In Camera: Francis Bacon - Photography, Film and the Practice of Painting*, London 2005.

Martin Harrison, 'Francis Bacon: Lost and Found', *Apollo*, 1 March 2005, pp.90-7.

David Sylvester (ed.), *Interviews with Francis Bacon 1962-1979*, London 1980.

————

John Baldessari, *Cremation Project* 1970

Coosje van Bruggen, *John Baldessari*, New York 1990.

Jessica Morgan and John Baldessari, 'Somebody to Talk To', *Tate Etc*, no.17, Autumn 2009.

Jessica Morgan and Leslie Jones (eds.), *John Baldessari: Pure Beauty*, exh. cat., Tate Modern, London 2009.

————

Joseph Beuys, *Felt Suit* 1970

Rachel Barker and Alison Bracker, 'Beuys is Dead: Long Live Beuys! Characterising Volition, Longevity, and Decision-Making in the Work of Joseph Beuys', *Tate Papers*, Autumn 2005, http://www.tate.org.uk/research/tateresearch/tatepapers/05autumn/barker.htm

Eugen Blume and Catherine Nichols (eds.), *Beuys. Die Revolution sind wir*, Berlin 2008.

Zdenek Felix (ed.), *Terry Fox: Metaphorical Instruments*, Essen 1982.

Ute Klophaus, *Sein und Bleiben: Photographie zu Joseph Beuys*, Bonn 1986.

Stuart Morgan and Frances Morris (eds.), *Rites of Passage: Art for the End of the Century*, London 1995.

Mark Rosenthal, *Joseph Beuys: Actions, Vitrines, Environments*, London 2004.

Joan Rothfuss et al., *Joseph Beuys: Mapping the Legacy*, New York 2001.

Jörg Schellmann and Bern Klüser, *Joseph Beuys: Multiples*, Munich 1980.

Uwe M. Schneede, *Joseph Beuys, Die Aktionen: Kommentiertes Werkverzeichnis mit fotografischen Dokumentation*, Stuttgart 1994.

Caroline Tisdall, *Joseph Beuys*, New York 1979.

————

Georges Braque, *Still Life* 1914

Douglas Cooper, *The Cubist Epoch*, London 1971.

Pierre Daix, *Picasso: Life and Art*, trans. Olivia Emmet, New York 1993.

Alex Danchev, *Georges Braque: A Life*, London 2005.

John Golding, *Cubism: A History and an Analysis 1907-1914*, London 1988.

Pepe Karmel, *Picasso and the Invention of Cubism*, New Haven and London 2003.

Pepe Karmel, 'Beyond the "Guitar": Painting, Drawing and Construction 1912-1914' in John Golding and Elizabeth Cowling (eds.), *Picasso: Sculptor/Painter*, exh. cat., Tate Gallery, London 1994, pp.189-97.

Isabelle Monod-Fontaine with E.A. Carmean Jr (eds.), *Braque: The Papiers Collés*, exh. cat., National Gallery of Art, Washington 1982.

John Richardson, *A Life of Picasso, Volume II: 1907-1917*, London 1996.

William Rubin, *Picasso and Braque: Pioneering Cubism*, exh. cat., Museum of Modern Art, New York 1989.

Bernard Zurcher, *Georges Braque: Life and Work*, New York 1988.

————

Arno Breker, *Torch Bearer* and *Sword Bearer* 1938

Arno Breker: The Collected Writings, foreword by B. John Zavrel, trans. Benjamin Webb, New York 1990.

Peter Chametzky, 'Sculpture and Crime: Arno Breker', in Peter Chametzky, *Objects as History in Twentieth-Century German Art: Beckmann to*

Beuys, Berkeley, Los Angeles and London 2010.

Jacques Damase (ed.), *Arno Breker: 60 Ans de Sculpture*, Paris 1981.

Ronald Hirlé, *Arno Breker – Sculpteur – Dessinateur – Architecte*, Paris 2010.

Steven Lehrer, *The Reich Chancellery and Führerbunker Complex: An Illustrated History of the Seat of the Nazi Regime*, Jefferson and London 2006.

Jonathan Petropoulos, *The Faustian Bargain: The Art World in Nazi Germany*, London and New York 2000.

Volker G. Probst, *Der Bildhauer Arno Breker: Eine Untersuchung*, Bonn and Paris 1978.

Albert Speer, *Inside the Third Reich: Memoirs*, trans. Richard and Clara Winston, New York 1970.

B. John Zavrel, *Arno Breker: His Art and Life*, New York 1985.

B. John Zavrel, *Arno Breker: The Divine Beauty in Art*, New York 1986.

'Arno Breker wurde Mitläufer', *Augsburger Allgemeine Zeitung*, 2 October 1948.

'Memorien. Breker: Lebender Leichnam', *Der Spiegel*, 28 December 1970, pp.80-1.

––––

Daniel Buren, *Painting-Sculpture* (*Painting I* and *Painting II*) 1971

Alexander Alberro, 'The Turn of the Screw: Daniel Buren, Dan Flavin, and the Sixth Guggenheim International Exhibition', *October*, vol.80, Spring 1997, pp.57-84.

Alexander Alberro and Blake Stimson (eds.), *Institutional Critique: An Anthology of Artists' Writings*, Cambridge MA 2009.

Daniel Buren: Eye of the Storm, edited by Bernard Blistène, Susan Cross and Lisa Dennison, exh. cat., Solomon R. Guggenheim Museum, New York 2005.

Daniel Buren: Mot à Mot, exh. cat., Centre Pompidou, Paris 2002.

Guggenheim International Exhibition 1971, exh. cat., Solomon R. Guggenheim Museum, New York 1971.

Guy Lelong, *Daniel Buren*, Paris 2002.

'Gurgles around the Guggenheim', *Studio International*, vol.181, no.934, 1971, pp.246-50.

'Correspondence', *Studio International*, vol.182, no.935, 1971, pp.4-6.

––––

Alexander Calder, *Bent Propeller* 1970

Alexander Calder Foundation website, http://www.calder.org

Carmen Gimenez and Alexander S.C. Rower (eds.), *Calder: Gravity and Grace*, London 2004.

Dorothy Miller, *Art for the Public: The Collection of the Port Authority of New York and New Jersey*, New York 1982.

Interview with Katherine Kuh in *The Artist's Voice: Talks with Seventeen Artists*, New York and Evanston, Illinois 1962.

––––

Christo and Jeanne-Claude, *Wrapped Reichstag, Berlin 1971-95* 1971-95

Jacob Baal-Teshuva (ed.), *Christo: The Reichstag and Urban Projects*, exh. cat., Kunsthaus Wien, Munich 1993.

Christo and Jeanne-Claude official website: http://www.christojeanne-claude.net/wr.shtml#

Christo: Project for Wrapped Reichstag, Berlin, exh. cat., Annely Juda Fine Art, London 1977.

Christo and Jeanne-Claude: Three Works in Progress, exh. cat., Annely Juda Fine Art, London 1995.

Paul Goldberger, 'Christo's Wrapped Reichstag: Symbol for the New Germany', *New York Times*, 23 June 1995.

Monika Maron, 'Ein gigantisches Spielzeug', *Der Spiegel*, 3 July 1995, pp.24-5.

Francesca Rogier, 'Growing Pains: From the Opening of the Wall to the Wrapping of the Reichstag', *Assemblage*, no.29, April 1996, pp.40-71.

––––

Willem de Kooning, *Untitled* c.1950s

Cornelia H. Butler, Paul Schimmel, Richard Schiff and Anne M. Wagner, *Willem de Kooning: Tracing the Figure*, exh. cat., Los Angeles 2002.

Paul Cummings, Jörn Merkert and Claire Stoullig, *Willem de Kooning: Drawings Paintings Sculpture*, exh. cat., New York 1983.

Dario Gamboni, *The Destruction of Art: Iconoclasm and Vandalism since the French Revolution*, London 1997.

Walter Hopps and Susan Davidson, *Robert Rauschenberg: A Retrospective*, exh. cat., New York 1997.

Leo Steinberg, *Encounters with Rauschenberg (A Lavishly Illustrated Lecture)*, Chicago 2000.

Mark Stevens and Annalyn Swan, *de Kooning: An American Master*, New York 2004.

Calvin Tomkins, *Off the Wall: Robert Rauschenberg and the Art World of Our Time*, New York 1980.

––––

Otto Dix, *The Trench* 1920-3

Dora Apel, '"Heroes" and "Whores": The Politics of Gender in Weimar Antiwar Imagery', *Art Bulletin*, vol.79, no.3, September 1997, pp.366-84.

Dennis Crockett, 'The Most Famous Painting of the "Golden Twenties"? Otto Dix and the Trench Affair', *Art Journal*, vol.51, no.1, *Uneasy Pieces*, Spring 1992, pp.72-80.

Philippe Dagen, *Otto Dix: The War*, Milan 2003.

Eva Karcher, *Otto Dix 1891-1969, His Life and Works*, Cologne 1988.

Fritz Löffler, *Otto Dix: Life and Work*, 5th edn, trans. R.J. Hollingdale, New York and London 1982.

Ulrike Lorenz, *Otto Dix*, exh. cat., Fundación Juan March, Madrid 2006.

Linda F. McGreevy, *Bitter Witness: Otto Dix and the Great War*, New York 2001.

Jörg Martin Merz, 'Otto Dix Kriegsbilder. Motivationen - Intentionen - Rezeptionen', *Marburger Jahrbuch für Kunstwissenschaft*, vol.26, 1999, pp.189-226.

Olaf Peters (ed.), *Otto Dix*, Munich, Berlin, London and New York 2010.

Frank Whitford et al., *Otto Dix: 1891-1969*, exh. cat., Tate Gallery, London 1992.

––––

Marcel Duchamp, *Fountain* 1917

William Camfield, *Marcel Duchamp: Fountain*, Houston 1989.

Elena Filipovic, 'A Museum that is Not', *e-flux*, March 2009, http://www.e-flux.com/journal/view/50.

Francis Naumann, 'The Big Show: The First Exhibition of the Society of Independent Artists', *Artforum*, February and April 1979.

Francis Naumann, *New York Dada 1915-23*, New York 1998.

Francis Naumann, *Marcel Duchamp: The Art of Making Art in the Age of Mechanical Reproduction*, New York 1999.

––––

Tracey Emin, *Everyone I Have Ever Slept With 1963-1995* 1995

Neal Brown, *Tracey Emin*, London 2006.

Patrick Elliott (ed.), *Tracey Emin: 20 Years*, exh. cat., National Galleries of Scotland 2008.

James Meek, 'Art into Ashes', *Guardian*, 23 September 2004.

Mandy Merck and Christopher Townsend (eds.), *The Art of Tracey Emin*, London 2002.

––––

Jacob Epstein, *Sculptures for the British Medical Association Building* 1908

Richard Buckle, *Jacob Epstein: Sculptor*, London 1963.

Richard Cork, *Art Beyond the Gallery in Early 20th Century England*, New Haven and London 1985.

Richard Cork, *Jacob Epstein*, London 1999.

Richard Cork, *Wild Thing: Epstein, Gaudier-Brzeska, Gill*, exh. cat., Royal Academy, London 2009.

Penelope Curtis and Keith Wilson (eds.), *Modern British Sculpture*, exh. cat., Royal Academy, London 2011.

Jacob Epstein, *Let There Be Sculpture: An Autobiography*, London 1942.

Stephen Gardiner, *Epstein: Artist Against the Establishment*, New York 1993.

Raquel Gilboa, *And There Was Sculpture: Jacob Epstein's Formative Years 1880-1930*, London 2009.

June Rose, *Daemons and Angels: A Life of Jacob Epstein*, London 2002.

––––

Lucian Freud, *Francis Bacon* 1952

William Feaver, *Lucian Freud*, New York 2007.

Robert Hughes, 'On Lucian Freud', in *Lucian Freud: Paintings*, exh. cat., Hayward Gallery, London 1988.

Sandy Nairne, *Art Theft and the Case of the Stolen Turners*, London 2011.

––––

Otto Freundlich, *The New Man* 1912

Otto Freundlich, *Un Peintre allemande à Paris: Souvenirs de la vie artistique à Paris avant la guerre de 14*, Auvers-Sur-Oise 1931.

Joachim Heusinger von Waldegg, *Otto Freundlich (1878-1943): Monographie mit Dokumentation und Werkverzeichnis*, exh. cat., Rheinisches Landesmuseum Bonn, Cologne and Bonn 1978.

M. Le Gac, 'L'Homme nouveau d'Otto Freundlich', *L'Écrit-Voir: Revue d'histoire des arts*, no.11, 1989.

Joël Mettay and Edda Maillet, *Otto Freundlich et la France: Un amour trahi*, Paris 2004.

Nadine Nieszawer, Marie Boye and Paul Fogel, *Peintre juifs à Paris: École de Paris*, Paris 2000.

Artistes d'Europe: Montparnasse déporté, exh. cat., Musée du Montparnasse, Paris 2005.

'Sensationelle Fund in Berlin: Entartete Kunst – Im Schutt der Geschichte', *Die Welt*, 9 November 2010.

––––

Naum Gabo, *Construction in Space: Two Cones* 1936, replica 1968

Naum Gabo, 'Sculpture: Carving and Construction in Space', in Leslie Martin, Ben Nicholson and Naum Gabo (eds.), *Circle: International Survey of Constructive Art*, London 1937, pp.103-11.

Stephen Hackney, 'Degradation of Naum Gabo's Plastic Sculpture: The Catalyst for the Workshop', *Tate Papers*, 2007, http://www.tate.org.uk/research/tateresearch/tatepapers/07autumn/hackney.htm

Martin Hammer and Christina Lodder, *Constructing Modernity: The Art and Career of Naum Gabo*, New Haven and London 2000.

Christina Lodder, 'Naum Gabo and the Quandaries of the Replica', *Tate Papers*, 2007, http://www.tate.org.uk/research/tateresearch/tatepapers/07autumn/lodder.htm

Beth Price, Sally Malenka, Ken Sutherland, Andrew Lins and Janice H. Carlson, 'Naum Gabo's *Construction in Space: Two Cones*: History and Materials', in Brenda Keneghan and Louise Egan (eds.), *Plastics: Looking at the Future, Learning from the Past*, London 2009.

Derek Pullen and Jackie Heuman, 'Cellulose Acetate Deterioration in the Sculptures of Naum Gabo', *Modern Organic Materials*, Preprints, The Scottish Society for Conservation and Restoration, Edinburgh 1988.

Elizabeth Rankin, 'A Betrayal of Material: Problems of Conservation in the Constructivist Sculpture of Naum Gabo and Antoine Pevsner', *Leonardo*, vol.21, no.3, 1988, pp.285–90.

————

Anya Gallaccio,
intensities and surfaces
1996

Jan van Adrichem, Norman Bryson, Briony Fer, Lucía Sanromán and Clarrie Wallis, *Anya Gallaccio*, London 2013.

Patricia Bickers and Andrew Wilson (eds.), *Talking Art: Interviews with Artists Since 1976*, London 2007.

Rebecca Fortnum, *Contemporary British Artists: In Their Own Words*, London 2006.

Anya Gallaccio, *Anya Gallaccio: beat*, exh. cat., Tate Britain, London 2002.

Judith Rugg, 'Regeneration or Reparation: Death, Loss and Absence in Anya Gallaccio's *intensities and surfaces* and *forest floor*', in Sarah Bennett and John Butler (eds.), *Advances in Art & Urban Futures: Volume 1, Locality, Regeneration*
and *Divers[c]ities*, Bristol 2000.

Ralph Rugoff, *Chasing Rainbows: Anya Gallaccio*, exh. cat., Tramway and Locus+, Glasgow 1999.

Jonathan Watkins (ed.), *Anya Gallaccio*, exh. cat., Ikon Gallery, Birmingham 2003.

————

Keith Haring,
Berlin Wall Mural 1986

Alexandra Anderson-Spivy, 'Bathed in Heraclitean Fire', http://www.haring.com/cgi-bin/essays.cgi?essay_id=04

Jeffrey Deitch, Suzanne Geiss and Julia Gruen, *Keith Haring*, New York 2008.

John Gruen, *Keith Haring: The Authorized Biography*, London 1991.

Art in Transit, introduction by Henry Geldzahler, New York 1984.

Drawing the Line: A Portrait of Keith Haring, dir. Elisabeth Aubert, Biografilm Associates, 1989.

http://www.galerie-noir.de/ (for information relating to Thierry Noir)

————

Eva Hesse,
Sans III 1969

Barry Barker, 'When Attitudes Become Form', *Flash Art*, no.275, November–December 2010, http://www.flashartonline.com/interno.php?pagina=articolo_det&id_art=672&det=ok&title=WHEN-ATTITUDES-BECOME-FORM

Bill Barrette, *Eva Hesse Sculpture Catalogue Raisonné*, New York 1989.

Briony Fer, *Eva Hesse Studiowork*, exh. cat., Fruitmarket Gallery, Edinburgh 2009.

Martin Langer, 'Latex', *Idstein*, March 1998.

Mignon Nixon (ed.), *Eva Hesse*, October Files 3, Cambridge MA 2002.
Mignon Nixon, 'Eva Hesse Retrospective: A Note on Milieu', *October*, no.104, Spring 2003, pp.149–56.

Barry Rosen and Renate Petzinger (eds.), *Eva Hesse Catalogue Raisonné. Volume 2: Sculpture*, New Haven and London 2006.

Elisabeth Sussman (ed.), *Eva Hesse*, SFMOMA, San Francisco 2002.

Elisabeth Sussman and F. Wasserman (eds.), *Eva Hesse Sculpture*, exh. cat., Jewish Museum, New York 2006.

————

Edward Ihnatowicz,
Senster 1970

http://www.senster.com/

http://www.kinetica-art-fair.com/?exhibitors/2010/edward-ihnatowicz

Jonathan Benthall, 'Edward Ihnatowicz's Senster', *Studio International*, November 1971, p.174.

Richard Ihnatowicz, 'Forty Is a Dangerous Age: A Memoir of Edward Ihnatowicz', in Paul Brown, Charlie Gere, Nicholas Lambert and Catherine Mason (eds.), *White Heat Cold Logic: British Computer Art 1960–1980*, Cambridge MA and London 2008.

Jasia Reichardt (ed.), *Cybernetic Serendipity: The Computer and the Arts*, exh. cat., Institute of Contemporary Arts, London 1968.

Aleksandar Zivanovic, '*SAM*, *The Senster* and *The Bandit*: Early Cybernetic Sculptures by Edward Ihnatowicz', *Robotics, Mechatronics and Animatronics in the Creative and Entertainment Industries and Arts Symposium*, AISB 2005 Convention, Hatfield, 13 April 2005.

Aleksandar Zivanovic, 'The Technologies of Edward Ihnatowicz', in Paul Brown, Charlie Gere, Nicholas Lambert and Catherine Mason (eds.), *White Heat Cold Logic: British Computer Art 1960–1980*, Cambridge MA and London 2008.

————

Frida Kahlo,
The Wounded Table 1940

Salomon Grimberg, *Frida Kahlo: The Little Deer*, exh. cat., Miami University, Oxford, Ohio 1997.

Salomon Grimberg, *Frida Kahlo: Song of Herself*, London and New York 2008.

Hayden Herrera, *Frida Kahlo: The Paintings*, New York 1991.

Helga Prignitz-Poda, *Frida Kahlo: The Painter and Her Work*, London 2003.

Dr Mariella Remund, 'Frida Kahlo's *The Wounded Table*', http://www.mexicolore. co.uk/index.php?one=azt&two =aaa&id=466&typ=reg,

Raquel Tibol, *Frida by Frida: Selection of Letters and Texts*, trans. Gregory Dechant, Mexico 2006.

––––
Wassily Kandinsky,
Composition I 1910

Magdalena Dabrowski, *Kandinsky Compositions*, New York 1995.

Vivian Endicott Barnett, *Kandinsky at the Guggenheim*, New York 1983.

Vivian Endicott Barnett, *Kandinsky: Werkverzeichnis der Aquarelle*, Munich 1994.

Will Grohmann, *Wassily Kandinsky: Leben und Werk*, Cologne 1958.

Peter Lufft, *Das Gaestebuch Otto Ralfs*, Braunschweig 1985.

Hans K. Rothel and Jean K. Benjamin, *Kandinsky: Werkverzeichnis der Ölgemälde*, Munich 1982.

––––
Michael Landy,
Break Down 2001

Artangel, *Michael Landy, Break Down*, http://www.artangel.org.uk/ projects/2001/break_down

Michael Landy, *Break Down*, exh. cat., Artangel, London 2001.

Michael Landy, *Break Down Inventory*, London 2001.

Michael Landy, *Michael Landy: Everything Must Go!*, London 2008.

Gerrie van Noord (ed.), *Off Limits: 40 Artangel Projects*, London 2002.

––––
Wyndham Lewis,
Kermesse 1912

Mark Antliff and Vivien Greene (eds.), *The Vorticists: Manifesto For A Modern World*, exh. cat., Tate Britain, London 2010.

Richard Cork, *Art Beyond the Gallery in Early 20th Century England*, New Haven and London, 1985

Paul Edwards, *Wyndham Lewis: Painter and Writer*, London 2000.

Anna Gruetzner Robins, *Modern Art in Britain 1910-1914*, London 1997.

Lisa Tickner, 'A Lost Lewis: The Mother and Child of 1912' and 'The Grafton Galleries', *Athenaeum*, no.4433, 12 October 1912, p.422.

Lisa Tickner, 'The Popular Culture of *Kermesse*', *Modernism/Modernity*, vol.4, no.2, 1997, pp. 67-120.

William C. Wees, *Vorticism and the English Avant-Garde*, Manchester 1972.

––––
Kasimir Malevich, *Peasant Funeral* 1911

Troels Anderson, *Malevich: Catalogue Raisonné of the Berlin exhibition 1927*, Amsterdam 1970.

Irina Arskaya (ed.), *Kasimir Malevich in the Russian Museum*, St Petersburg 2000.

Alfred Barr, *Cubism and Abstract Art*, exh. cat., Museum of Modern Art, New York 1936.

W.A.L. Beeren and J.M. Joosten (eds.), *Kasimir Malevich 1878-1935: Works from the State Russian Museum Leningrad, the State Tretiakov Gallery Moscow, the Stedelijk Museum Amsterdam, the State Theatre Museum Leningrad*

and the Museum of the Lomonosov Porcelain Factory, Amsterdam 1988.

E.F. Kovtun and Charlotte Douglas, 'Kasimir Malevich', *Art Journal*, vol.41, no.3, Autumn 1981.

Kasimir Malevich, *The World as Non Objectivity: Unpublished Writings 1922-1925*, trans. Xenia Glowacki-Prus and Edmund T. Little, Copenhagen 1976.

Andrei B. Nakov, *Kasimir Malevich*, London 1976.

Andrei B. Nakov, *Kasimir Malevich: Catalogue Raisonné*, Paris 2002.

Andrei B. Nakov, *Kasimir Malevich: Painting the Absolute*, Farnham and Burlington VT 2010.

Larissa A. Zhadova, *Malevich: Suprematism and Revolution in Russian Art 1910-1930*, London 1982.

––––
Joan Miró, *The Reaper* 1937

Jacques Dupin and Ariane Lelong-Mainaud, *Joan Miró: Catalogue Raisonné – Paintings*, vol.2, 1931-41, Paris 2000.

Catherine Blanton Freedberg, *The Spanish Pavilion at the Paris World's Fair*, New York and London 1986.

Roland Penrose, *Joan Miró*, London 1990.

––––
Henry Moore, *Reclining Figure* 1969-70

Alan Bowness (ed.), *Henry Moore: Complete Sculpture – Volume 4 1964-73*, London 1977.

Christa Lichtenstern, *Henry Moore: Work – Theory – Impact*, London 2008.

David Mitchinson, *Celebrating Moore: Works from the Collection of The Henry Moore Foundation*, Berkeley and Los Angeles 1998.

Alan Wilkinson (ed.), *Henry Moore: Writings and Conversations*, Berkeley and Los Angeles 2002.

––––

Francis Picabia,
Hot Eyes 1921

Maria Lluïsa Borràs,
Picabia, London 1985.

William Camfield, *Francis Picabia: His Art, Life and Times*, Princeton NJ 1979.

Catalogue entry for Picabia's *The Fig-Leaf*, first published in 1988, Tate, http://www.tate.org.uk/servlet/ViewWork?cgroupid=-1&workid=11848&searchid=18102&roomid=false&tabview=text&texttype=8

————

Diego Rivera, *Man at the Crossroads Looking with Uncertainty but with Hope and High Vision to the Choosing of a New and Better Future* 1933

Dora Apel, 'Diego Rivera and the Left: The Destruction and Recreation of the Rockefeller Center Mural', *Left History*, vol.6, no.1, 1999.

Lucienne Bloch, 'On Location with Diego Rivera', *Art in America*, February 1986 http://www.luciennebloch.com/pdfs/america.pdf

Pete Hamill, *Diego Rivera*, New York 1999.

Robert Linsley, 'Utopia Will Not Be Televised: Rivera at Rockefeller Center', *Oxford Art Journal*, vol.17, no.2, 1994, pp.48–62.

Luis-Martín Lozano and Juan Rafael Coronel Rivera, *Diego Rivera: The Complete Murals*, London 2008.

Matthew Morgan, *A Failure in Patronage: Diego Rivera and the Rockefeller Center Mural*, MA dissertation, Courtauld Institute of Art, University of London 1997.

Diego Rivera with Gladys March, *My Art, My Life: An Autobiography*, New York 1992.

————

Egon Schiele,
Self-Seer 1910

Neue Kunst: Die Zweite Ausstellung der Redaktion der Blaue Reiter Schwarz Weiss, exh. cat., Hans Goltz Galerie, Munich 15 February–15 March 1912.

Internationale Kunstausstellung des Sonderbunds w. Deutscher Kunstfreund und Kunstler, exh. cat., Städische Austellungshalle, Cologne 25 May–30 September 1912.

Egon Schiele, exh. cat., Neue Galerie, Vienna November–December 1923.

Gedächtnisausstellung Egon Schiele, exh. cat., Neue Galerie, Vienna and Vienna Hagenbund November 1928.

Gemma Blackshaw, 'The Pathological Body: Modernist Strategising in Egon Schiele's Self Portraiture', *Oxford Art Journal*, no.30, 2007, pp.377–401.

Alessandra Comini, *Egon Schiele's Portraits*, Berkeley 1974.

Paris von Gütersloh, *Egon Schiele: Versuch einer Vorrede*, Vienna 1911.

Jane Kallir, *Egon Schiele: The Complete Works*, London 1998.

Rudolf Leopold, *Egon Schiele: Gemälde, Aquarelle, Zeichnungen*, Salzburg 1972.

Christian M. Nebehay (ed.), *Egon Schiele 1890–1918: Leben, Briefe, Gedichte*, Salzburg and Vienna 1979.

Sonja Niederacher, *Dossier Fritz Grünbaum*, produced by the Provenance Research Department of the BMUKK, Vienna 30 June 2010.

René Price (ed.), *Egon Schiele: The Ronald S. Lauder and Serge Sabarsky Collections*, New York 2005.

————

Kurt Schwitters,
Merzbau c.1923–37

Elizabeth Burns Gamard, *Kurt Schwitters' Merzbau: The Cathedral of Erotic Misery*, New York 1998.

Roger Cardinal and Gwendolen Webster, *Kurt Schwitters*, Ostfildern 2011.

John Elderfield, 'The Last Work of Kurt Schwitters', *Artforum*, October 1969.

Sarah MacDougall and Rachel Dickson (eds.), *Forced Journeys: Artists in Exile in Britain c.1933–45*, London 2009.

Susanne Meyer-Büser and Karin Orchard, *Merz: In the Beginning was Merz – From Kurt Schwitters to the Present Day*, Ostfildern-Ruit 2000.

Annja Müller-Alsbach and Heinz Stahlhut, *Kurt Schwitters: MERZ, A Total Vision of the World*, Bern 2004.

Karin Orchard and Isabel Schulz (eds.), *Kurt Schwitters: Catalogue Raisonné*, Ostfildern-Ruit 2006.

Isabel Schulz (ed.), *Kurt Schwitters: Color and Collage*, New Haven and London 2010.

The World of Imagination: An Exhibition of 'Doddles', Abstracts, Surrealism, 'Merz' – Sculpture, Constructivism and Symbolism, exh. cat., Modern Art Gallery, London 1944.

————

Richard Serra,
Tilted Arc 1981

Dario Gamboni, *The Destruction of Art: Iconoclasm and Vandalism Since the French Revolution*, London 2007.

Eleanor Heartney, 'Introductory Essay', *GSA Art In Architecture: Selected Artworks, 1997–2008*, Washington, DC 2008.

Harriet F. Senie, The 'Tilted Arc' Controversy: Dangerous Precedent?, Minnesota 2001.

Richard Serra and Clara Weyergraf-Serra, Richard Serra: Interviews, Etc., 1970-1980, New York 1980.

Richard Serra, Writings Interviews, Chicago and London 1994.

Clara Weyergraf-Serra and Martha Buskirk (eds.), The Destruction of Tilted Arc: Documents, Cambridge MA and London 1991.

New York Architecture Images: Jacob K. Javits Federal Office Building, http://www.nyc-architecture.com/SCC/SCC032.htm

Serra vs. U.S. General Services Administration, http://65.49.16.213/art-law/op-serra.cfm

Robert Smithson, Partially Buried Woodshed 1970

John Fitzgerald O'Hara, 'Kent State/May 4 and Postwar Memory', American Quarterly, vol.58, no.2, June 2006, pp.301-28.

Dorothy Shinn, Robert Smithson's Partially Buried Woodshed, exh. cat., Kent State University School of Art, Ohio 1990.

Robert Smithson, 'Entropy and the New Monuments', Artforum, June 1966, p.26, http://www.robertsmithson.com/essays/entropy_and.htm

Robert Smithson, 'Entropy Made Visible', interview with Alison Sky 1973, Robert Smithson: The Collected Writings, ed. by Jack Flam, Berkeley, 1996, p.308, http://www.robertsmithson.com/essays/entropy.htm

Graham Sutherland, Portrait of Sir Winston Churchill 1954

Roger Berthoud, Graham Sutherland, London 1982.

John Hayes, The Art of Graham Sutherland, London 1980.

Joseph L. Sax, Playing Darts with a Rembrandt: Public and Private Rights in Cultural Treasures, Ann Arbor, MI 1999.

BBC ON THIS DAY 1954: Winston Churchill turns 80, http://news.bbc.co.uk/onthisday/hi/dates/stories/november/30/newsid_3280000/3280401.stm

Vladimir Tatlin, Monument to the Third International 1920

Nathalie Leleu, 'The Model of Vladimir Tatlin's Monument to the Third International: Reconstruction as an Instrument of Research and States of Knowledge', Tate Papers, Autumn 2007, http://www.tate.org.uk/research/tateresearch/tatepapers/07autumn/leleu.htm

Christine Lodder, 'Lenin's Plan for Monumental Propaganda', in Matthew Bown and Brandon Taylor (eds.), Art of the Soviets: Painting, Sculpture and Architecture in a One-Party State, Manchester 1993.

Norbert Lynton, Tatlin's Tower: Monument to Revolution, New Haven and London 2009.

Nikolai Punin, The Monument to the Third International, Petrograd 1920.

Larissa Alekseevna Zhadova (ed.), Tatlin, London 1988.

Configuration 1910-1940 and Seven Tatlin Reconstructions, exh. cat., Annely Juda Fine Art, London 1 July-26 September 1981.

Paul Thek, The Tomb 1967

Harald Falckenberg and Peter Weibel (eds.), Paul Thek: Artist's Artist, ZKM/Museum of Contemporary Art, exh. cat., Cambridge MA 2008.

Matthew Israel, 'Finding Thek's Tomb', Art in America, November 2010 http://www.artinamericamagazine.com/features/finding-theks-tomb/

Robert Pincus-Witten, 'Thek's Tomb', Artforum, vol.6, no.3, 1967, pp.24-5.

Elisabeth Sussman and Lynn Zelevansky, Paul Thek: Diver, A Retrospective, exh. cat., New York 2010.

Ann Wilson et al., Paul Thek: The Wonderful World That Almost Was, exh. cat., Barcelona 1996.

Jean Tinguely, Homage to New York 1960

K.G. Pontus Hultén, Jean Tinguely 'Méta', London 1975.

Laurence Sillars (ed.), Joyous Machines: Michael Landy and Jean Tinguely, exh. cat., Tate Liverpool 2009.

Heidi E. Violand-Hobi, Jean Tinguely: Life and Work, Munich and New York 1995.

Robert Rauschenberg - Jean Tinguely: Collaborations, exh. cat., Bielefeld 2009.

Rachel Whiteread, House 1993

James Lingwood (ed.), Rachel Whiteread: House, London 1995.

Charlotte Mullins, Rachel Whiteread, London 2004.

Rachel Whiteread House, film, dir. Helen Silverlock and John Kelly, UK 1994, 26 min, http://www.artangel.org.uk//projects/1993/house/video/video_rachel_whiteread_house

Five Paintings, Musée d'Art Moderne de la Ville de Paris

John E. Conklin, Art Crime, Connecticut 1994.

Noah Charney, Art and Crime: Exploring the Dark Side of the Art World, Connecticut 2009.

Sandy Nairne, Art Theft and the Case of the Stolen Turners, London 2011.

Jonathan Webb and Julian Radcliffe, Stolen: The Gallery of Missing Masterpieces, London 2008.

Acknowledgements

Developed from the virtual exhibition called *The Gallery of Lost Art* (July 2012 – June 2013), this book owes a great debt to the sponsors of the original website project, which included not only Tate but also Channel 4 and the Arts and Humanities Research Council. I should like to express my thanks to Claire McArdle, Stuart Cosgrove and Susan Amor for their enthusiastic support for this innovative project.

The online project was shaped and created by a large team, and I should like to pay tribute here to them all. Jane Burton, Head of Content and Creative Director at Tate, first conceived the idea of an online exhibition about the subject of lost art, brokered the relationships that made the project possible, framed and edited the commissioned films, and creatively steered the project through to its delivery. Damien Smith and Mark Breslin at the digital design company ISO presented a compelling vision for the exhibition from the first, with their team, notably Jamie Gillespie, helping to develop a visually engaging and multi-levelled experience for the user. Karin Mueller was extraordinary in her picture research and clearing of copyright permissions, while Susan Doyon made twenty new short films that echoed or extended the project's content in highly original ways.

Research for the project was undertaken by a small team based in Tate's Research Department. This included the project's main researcher Fiontán Moran, who helped scope the project in its initial phase and guide its development. I am personally very grateful to him, and to all those who helped research and frame the narratives of loss explored in the project. Below is a list of the team's researchers and the subjects they worked on:

Jon Crabb: Daniel Buren, Alexander Calder, Tracey Emin, Lucian Freud, Michael Landy, Wyndham Lewis, Henry Moore, Richard Serra, Robert Smithson, Graham Sutherland, Rachel Whiteread, and the theft of paintings from the Musée d'Art Moderne de la Ville de Paris. Stephanie Forrest: Edward Ihnatowicz. Iris Kapelouzou: Joseph Beuys, Naum Gabo, Anya Gallaccio, Eva Hesse. Fiontán Moran: Bas Jan Ader, John Baldessari, Georges Braque, Christo and Jeanne-Claude, Otto Dix, Keith Haring, Frida Kahlo, Wyndham Lewis, Diego Rivera, Graham Sutherland, Paul Thek, Jean Tinguely, Rachel Whiteread. Lucy Watling: Francis Bacon, John Baldessari, Joseph Beuys, Georges Braque, Arno Breker, Christo and Jeanne-Claude, Jacob Epstein, Otto Freundlich, Wassily Kandinsky, Kasimir Malevich, Egon Schiele, Kurt Schwitters, Vladimir Tatlin.

I thank all of them warmly for their varied and creative contributions.

During the research, a number of artists were particularly supportive of the project and my thanks go to each of them: John Baldessari, Daniel Buren, Jake Chapman, Michael Landy, Thierry Noir, Xan and Jonathan Yeo. Artists' families, foundations and estates have played a crucial role in supplying information and insights, and I should like to express my gratitude to Mary Sue Andersen, Eva Beuys, Shannon Haskett (Bas Jan Ader Estate at Patrick Painter Editions), Olga and Richard Ihnatowicz, Barry Joule, Shelley Lee and Justin Brancato (Roy Lichtenstein Foundation), Christy MacLear (Robert Rauschenberg Foundation), Alexis Marott (Calder Foundation), Annelise E. Ream (Keith Haring Foundation), Barry Rosen (Estate of Eva Hesse), Amy Schichtel and Ricki Lynn Moskowitz (Willem de Kooning Foundation), and The Henry Moore Foundation (notably, Charles Joint, Anita Feldman, Michael Phipps, Claire Smith, Emma Stower, Emily Peters and James Copper).

Many individuals have also supplied information that has proved invaluable to the project. In particular, I should like to express my personal thanks to Sarah Roberts and Maria Luisa Lax for their invaluable assistance, and to Francis Naumann for his generous and helpful comments. Others who should be thanked include Katherine D. Alcauskas, Lucienne Allen, Arlene Baltansky, Rachel Barker, Malcolm Barr-Hamilton, Shulamith Behr, Allie Biswas, René Block, Helena Bonett, Alison Bracker, MaryKate Cleary, Mark Dalrymple, Douglas Dodds, Paul Edwards, Matthew Fuller, Rashell George, Salomon Grimberg, Anna Haward, Reuben Hoggett, Jon Humphries, Heinz J. Kuzdas, Pedro de Llano, Martin Langer, Mary-Anne Martin, Karin Minger, Beth Price, Helga Prignitz-Poda, Sophie Raikes, Rolf Ricke, Norberto L. Rivera, Sabine Röder, Jorg Schellman, Catherine Sezgin, Paulina Shearing, Lisa Tickner and Aleksandar Zivanovic and Karolina Zychowicz.

In addition, I should like to acknowledge the support of institutions such as the Art Loss Register, Association for Research into Crimes against Art, Bundesarchiv in Berlin, Kent State University Special Collections and Archive, Lux Art Agency, Rockefeller Family Archive and the Rockefeller Center Archive, Royal College of Art Library, and the Tower Hamlets Local History Library and Archives.

At Tate I should like to express my gratitude to Professor Nigel Llewellyn, Head of Research, for reading the manuscript and to my colleagues in the Research Department for their support of this project. The staff of the Library and Archive were unfailingly helpful, and special thanks are owed to Krzysztof Cieszkowski and Christopher Bastock. I also drew on the knowledge of conservators at Tate, and I should to thank here Annette King, Lyndsey Morgan and Patricia Smithen for their advice and insights. Finally, I should like to thank the editor of this book, Alice Chasey, ably assisted by Christopher Mooney, for her work in seeing it to production, and, above all, my husband Christopher and children Amy and Tom, who have been wonderfully supportive.

Credits

Yale Center for British Art, Paul Mellon Fund, USA, Gift of Neil and Ivan Phillips in memory of Rosalie Phillips. The Bridgeman Art Library p.65

Pigeon with Peas, 1911 (oil on canvas), Picasso, Pablo (1881-1973) / Musee d'Art Moderne de la Ville de Paris, Paris, France / The Bridgeman Art Library p.268 bottom left

Woman with a Fan, 1919 (oil on canvas), Modigliani, Amedeo (1884-1920) / Musee d'Art Moderne de la Ville de Paris, Paris, France / The Bridgeman Art Library top left, p.268 top right

Still Life with Candlestick, 1922 (oil on canvas), Leger, Fernand (1881-1955) / Musee d'Art Moderne de la Ville de Paris, Paris, France / The Bridgeman Art Library p.268 bottom right

© The British Library, Manuscript No. or BL Shelfmark: S.C.AAA / System No.: 004113565 p.64

Photo: © Larry Burrows p.96

Photo courtesy Calder Foundation, New York / Art Resource, NY p.155

Photo: Anne Chauvet p.111

Image courtesy James Cohan Gallery, New York / Shangai p.213

Courtesy Thomas Dane Gallery, London p.234

Photo: Hugh Glendinning. Courtesy of Artangel, London and Thomas Dane Gallery, London p.241

Images provided courtesy of Ewbank Auctioneers p.173

Photo: Sue Omerod. Courtesy Gagosian Gallery p.222

Photo: David Wing / John Baldessari. Courtesy the artist and Marian Goodman Gallery pp.181, 182

Photo: Robert E. Mates and Paul Katz © Solomon R. Guggenheim Foundation, New York p. 105

Photo: Tseng Kwong Chi, 1986 used by permission of Keith Haring Foundation p.216

Photo: John A. Ferrari, New York. Courtesy Hauser and Wirth, Zurich / London p.193

Reproduced by permission of The Henry Moore Foundation p.264

Courtesy of Olga Ihnatowicz p.48

Photograph from the Lauren Archives, published by Nicole Worms de Rommily in 1982 p.20

Rudolf Leopold Collection, Vienna, Austria p.118

Courtesy of the Francis Loeb Library, Harvard Graduate School of Design p.36

Photo: Jacques Brinon / AP / Press Association p.271

© 2013. Digital image, The Museum of Modern Art, New York / Scala, Florence p.24

Image, The Museum of Modern Art, New York / Scala, Florence p.24

Image courtesy Museum of Modern Art in San Francisco p.178

Photo: Successió Miró Photo Archive p.34

Henri-Pierre Roché / The Philadelphia Museum of Art p.28

Photo: Wilhelm Redemann, Kurt Schwitters Archives at The Sprengel Museum Hannover. Reproduction courtesy Michael Herling / Aline Gwose, Sprengel Museum Hannover p.140

SLUB Dresden-Deutsche Fotothek p.130

Photograph © Alfred Stieglitz. Courtesy Francis M. Naumann Fine Art, NY p.26

Photo: Tate Archives 1981 p.196

Tate Photography. Courtesy Comité Picabia, Paris p.167

Tate Photography pp.186, 260

Photo: Bernard G. Silberstein. Courtesy Spencer Throckmorton p.78 bottom

© ullsteinbild / Topfoto p.246

© Roger-Viollet / Topfoto p.268 middle left

© VG Bild-Kunst, Bonn 2013 p.132

Photo: Stephen White. Courtesy Jay Jopling / White Cube p.159

Index

Page numbers in *italic* type refer to pictures.